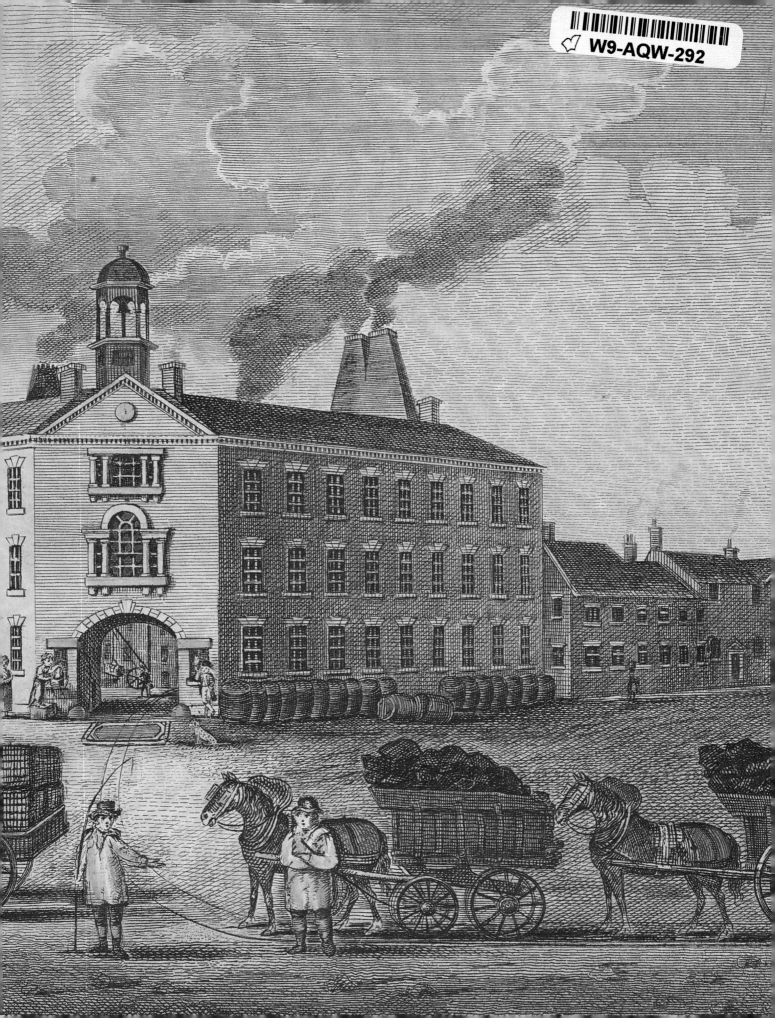

*Ceramics in America*

# CERAMICS

# IN AMERICA

# 2001

*Edited by Robert Hunter*

Published by the CHIPSTONE FOUNDATION

Distributed by University Press of New England

Hanover and London

EDITOR
Robert Hunter

NEW DISCOVERIES EDITOR
Merry A. Outlaw

BOOK AND EXHIBITION REVIEW EDITOR
Amy C. Earls

*Cover Illustration:* Detail of decorated shell-edged pearlware plate, Staffordshire, ca. 1815. (Private collection.)

*Design:* Wynne Patterson
*Photography:* Gavin Ashworth
*Printing:* Meridian Printing
*Type:* Aardvark Type

Published by the Chipstone Foundation, 7820 North Club Circle, Milwaukee, WI 53217
Distributed by University Press of New England, Hanover, NH 03755
© 2001 by the Chipstone Foundation
All rights reserved
Printed in the United States of America  5 4 3 2 1
ISSN 1533–7154
ISBN 1–58465–133–4

# Contents

# Editorial Statement

*Ceramics in America* is an interdisciplinary journal intended for collectors, historical archaeologists, curators, decorative arts students, social historians, and contemporary studio potters. Authors are encouraged to submit articles on the broad role of historical ceramics in the American context including essays on ceramic history, archaeological research, ceramic technology, social history, studio pottery, and ceramic collecting. Short illustrated notes on new ceramic discoveries are particularly wanted. References to be compiled in an annual bibliography, including electronic sources, may also be submitted. Manuscripts must be typed, double-spaced, illustrated with high-quality color transparencies, and prepared in accordance with the *Chicago Manual of Style*. Computer disk copy is requested but not required. The Chipstone Foundation will offer significant honoraria for manuscripts accepted for publication and reimburse authors for all photography approved in writing by the editor.

*Robert Hunter*

*Robert Hunter*

# Introduction

▼ AT THE BEGINNING OF the twenty-first century, scholarly attention in ceramics is at an all-time high. Professional organizations with interest in the topic abound. In the United States, these include the American Ceramic Circle, the Wedgwood International Seminar, the Wedgwood Society of New York, the Society for Historical Archaeology, the American Ceramic Society, and the National Council on Education for the Ceramic Arts. In England, major ceramic groups include the English Ceramic Circle, the Northern Ceramic Society, and the Society for Post-Medieval Archaeology. All of these societies have publications and newsletters that are widely distributed. Regional study groups and collectors clubs such as the Boston China Students Club, the Washington Ceramic Seminar, the Transferware Collectors Club, and the San Francisco Ceramic Circle provide a regularly distributed bulletin or newsletter.

The continuous stream of publications that flows from both established and private presses reflects the current interest in ceramics. *Antiques,* The *Winterthur Portfolio: A Journal of Early American Culture,* and the *Journal of Early Southern Decorative Arts,* among other periodical publications, offer material culture essays on ceramic topics. The ceramic catalogs of the world's major auction houses remain a significant source of documentation and reference as well. With the advent of the Internet, web pages proliferate for every type of ceramic subject, and this development promises to continue at a staggering rate.

Perhaps the largest audience for ceramic publications is made up of those who actually make pots. Working ceramists are well served with a number of publications, including *Ceramics Monthly* and *The Studio Potter,* both published in this country. Such internationally distributed periodicals as *Ceramic Review,* published in England, and *Ceramics: Art and Perception,* published in Australia, aim at the ceramic practitioner and the collector of contemporary works.

In light of this considerable professional interest and the diversity of publications, is the time right for a new member of the international ceramic community? The Chipstone Foundation believes that *Ceramics in America* is a much needed addition. In a time when specialization increasingly defines the professional ceramic circles and publications, this journal strives to offer an alternative model. Its aim is to explore the broad cultural role that ceramics have played in North America from the first European settlement to the development of American ceramic industries to the present. To make this happen, *Ceramics in America* must provide ceramic scholars

with an interdisciplinary forum from the fields of decorative arts, art history, historical archaeology, social history, economic history, and contemporary studio pottery. In short, this publication seeks synthesis by crossing many of the traditional boundaries that demarcate disciplines of the ceramics world.

The inaugural issue of *Ceramics in America* offers a diverse lineup of essays by an equally diverse group of authors. With any interdisciplinary undertaking, consensus is not usually possible, nor is it even the intended goal. While most ceramic specialists share a nearly inexpressible passion for the material, opinions and specific interests vary considerably.

The close relationship between ceramic collecting and ceramic scholarship often raises challenging ethical issues both for individuals and institutions. Ivor Noël Hume's essay offers a personal perspective on the practical choices that scholars sometimes face. With his encyclopedic guides for identifying and dating historical ceramics, his contribution to the field of historical archaeology is legendary. Yet it is Noël Hume's ability to find and to tell the story embodied in virtually any ceramic object that gives such life to his rigorous scholarship.

With the development of material culture studies in the 1970s, students of ceramics have adopted theories and methods from the fields of anthropology, art history, linguistics, and literary criticism, among others. Ann Smart Martin shares her approach for finding the hidden meanings in the ceramics made and/or used in America. As a material culture teacher, her challenge is to provide a framework for the uninitiated student looking at ceramics in new and creative ways.

Archaeological research continues to lead the way in providing the best contextual data for ceramics scholars. Bly Straube, curator for the Jamestown Rediscovery Project, is conducting exciting new research at the site of America's first permanent English-speaking colony. Her article challenges many long-standing notions about the types of ceramics used in early America. Diehard Anglophile collectors will be surprised to see that America's early ceramic heritage was anything but English in character. Curators of seventeenth-century "period rooms" should take particular note of the culturally diverse profusion of color, pattern, and form represented in the broken ceramic fragments at Jamestown.

The crown eventually made sure that the preponderance of goods brought to the colonies in America was of English manufacture. With the establishment of trade acts in the 1660s, England began to protect its domestic ceramic industry. The rise of the great potting centers soon followed, coinciding with the growing interest in fashion, commerce, and the introduction of new ceramic technologies. David Barker's article discusses the importance of understanding the Staffordshire potters, who produced virtually all the household ceramics used in America until well into the nineteenth century.

At the heart of all ceramic stories are the technological processes of manufacture, some of them thousands of years old. Potters generally have remained silent, sometimes leaving behind only recipe books with their

clay body and glaze formulas. The finished product is usually left to speak for itself. Ceramic historians have tried to decipher the technology behind the pot but their observations are often inadequate. *Ceramics in America* will include a regular series of illustrated essays that investigate the technological history of ceramic production. In this initial volume, Michelle Erickson and this author explore a variety of seventeenth- and eighteenth-century decorative treatments common to English slipwares. Donald Carpentier and Jonathan Rickard pick up the story by discussing the slip-decorating techniques of the industrial age, beginning in the late eighteenth century. The mechanization of this time-honored method of ceramic decoration offers a fascinating glimpse into a potting tradition that merged with modern technology.

The search for cross-disciplinary synthesis in *Ceramics in America* also extends to significant investigations of terminology—both past and present. A central part of artifact analysis is the exploration of distinctive descriptive terms used by potters, consumers, and today's scholars. For instance, a contextual reconstruction of how potters described their ideas, processes, and materials is a useful first step that promises to lead toward a deeper understanding of the meaning or intent behind historical ceramic terms. Using documentary sources and archaeological evidence, George Miller and this author challenge the relatively well-established term "pearlware," used today almost universally by archaeologists, collectors, and curators.

The presentation of innovative scholarly methodologies is also a goal of this journal. Diana and J. Garrison Stradling provide a model of research that illustrates many points raised by other authors in this issue. In telling the story of an early-nineteenth-century earthenware pottery in Louisville, Kentucky, the Stradlings use a wonderful combination of historical research, traditional connoisseurship, archaeology, and ceramics technology analysis.

One regular feature will be collectors' essays, which will more fully introduce into the scholarly discourse an examination of questions relating to all of us who collect things. The first-person essay by Troy D. Chappell provides the opportunity to hear the motives of one American collector. An unusually high level of precise thought and purpose informs Chappell's collection of English ceramics.

Another exciting aspect of this publication is the inclusion of "New Discoveries," edited by Merry Outlaw. Readers are encouraged to contribute those important bits of ceramic information that might otherwise not appear in print. While some of this information will be generated by actual new discoveries, there is much research yet to be conducted in the drawers and cabinets of existing archaeological collections. *Ceramics in America* also intends to play an important role in the history of ceramic scholarship by directing the reader's attention to the wide range of scholarly work in the ceramic field. With the ever-growing number of professional organizations, an expanding base of collectors, and an increased number archaeological protection excavations, the book reviews and annual bibliography, edited and compiled by Amy Earls, will emerge as an essential reference.

The first volume of *Ceramics in America* is just that: a first volume. The goal of the editorial staff and the Chipstone Foundation is to be attentive to the needs of the readers and to the evolution of ceramic scholarship, to provide an innovative and well-reasoned merging of multiple voices, and to be open to new approaches of study. For the moment, however, *Ceramics in America* offers a starting point for a new level of dialogue regarding the production, use, and meaning of historic ceramics in America.

*Ceramics in America*

*Figure 1* A collection of fourteenth- to seventeenth-century earthenware and stoneware sherds found in London. (Ex-Burnett Collection; photo, Gavin Ashworth.) For a museum registrar, an embryonic storage problem; for a ceramics historian a crock of gold.

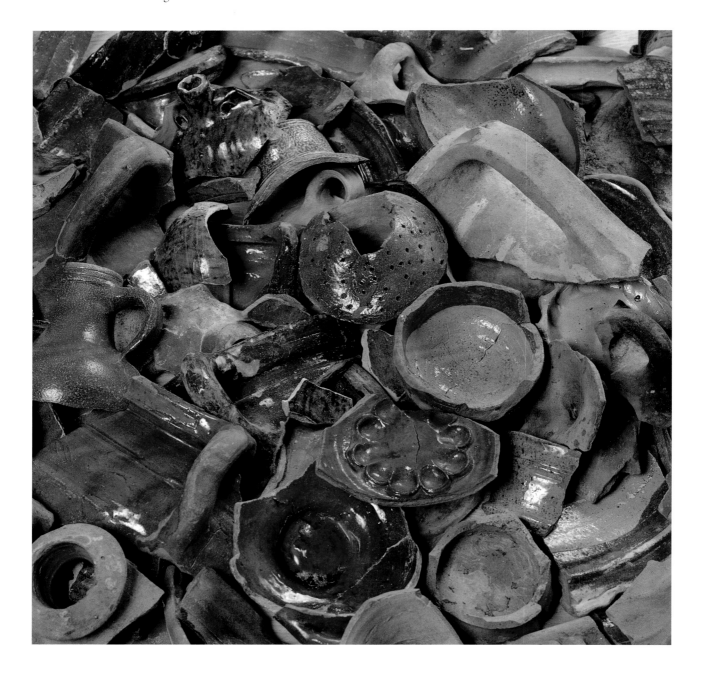

*Ivor Noël Hume*

## Potsherds and Pragmatism: One Collector's Perspective

▼ C O L L E C T O R S   O F   fine furniture, silver, paintings, textiles—indeed, more or less everything other than ceramics—represent a small but clearly defined segment of a nation's population. But pot people are much more diverse in their approaches and as collectors are likely to be more controversial. They range all the way from connoisseurs of specific wares who will pay a minor king's ransom for a single delftware plate to those who desecrate Indian graves or delve into garbage dumps in search of not very old stoneware beer bottles. Somewhere in between stand the archaeologists for whom pottery and porcelain are—or should be—the warp and weft of their profession. To their ranks belong the practical students of ceramics whose goal is to understand manufacturing processes and thereby date their sherds, as well as those with an anthropological approach who see pottery as a means of picking apart the people of the past to see what made them do what they did and think what they thought. By and large, however, today's archaeologists are more gatherers than collectors. They do not much care what happens to their pots once they have studied and learned from them (fig. 1). This is understandable because ownership of numerous bags of potsherds can be more of a storage liability than a curio cabinet asset.

Archaeologists of yore—which means any time but yours—were less interested in fragments than they were in whole vessels. Only relatively recently have we seen a proliferation of professional archaeologists for whom emotional detachment is an academically correct prerequisite. The joy of discovery, the thrill of reaching out to come within a hand's touch of the past or to stand on the very ground that someone memorable once trod, these are to be expected of amateurs more schooled in the darkness of movie theaters than in the sterile objectivity of the classroom. Nevertheless, the history of archaeology has been umbilically linked to collecting, and those who dug, or who paid others to dig, did so to acquire for their sponsors or for themselves.

The ethics of possession can be debated ad infinitum, and those of us with heads big enough to wear two hats can make the case both for and against collecting. I know that I can, and in consequence I am sympathetic rather than antagonistic toward those who believe that collecting excavated antique ceramics is snatching plums from the cake of time. Far less debatable is archaeology's lack of interest in providing information to help collectors better understand what they have. With rare exceptions, archaeological reports are written to be read only by archaeologists, and even within those

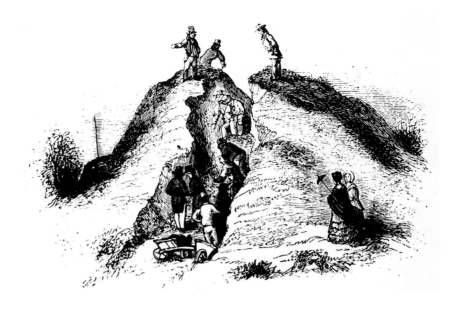

*Figure 2* Engraving, England, nineteenth century. (Illustrations courtesy of the author unless otherwise noted.) Ceramic collecting Victorian style: ruining a Bronze Age burial mound.

*Figure 3* Engraving, England, nineteenth century. Sending one's servants groping for Roman pots in the mud of the Kentish marshes.

parameters, many American reports have paid only lip service to artifacts. Relegated to the back, shown only in photographs, and circulated in photocopies that reduce the images to black blobs of varying density, potsherds so illustrated are of no use to anyone. Then, too, computer technology has allowed report compilers to substitute for drawings or even for fuzzy photos, numerical and distributional printouts. Such reporting implies an arrogance that says "I don't need to show you what I've found. You'll just have to take my word for it that my identifications and interpretations are right."[1]

I would argue that in the field of ceramic history, particularly in those centuries that fall within the sphere of American cultural history, archaeologists and collectors have much to teach each other. For my part, I know that virtually every time I visit a private collection I learn something new — often something that calls for a reassessment of assumptions I have previously considered carved in stone.[2]

Through the centuries preceding, perhaps, the mid-twentieth, the history of European ceramic collecting has been fairly equally divided

*Figure 4* Howard Carter and Arthur Mace, 1923. One the robbers missed. Carter and Mace are demolishing an inconvenient wall in the tomb of Tutankhamun.

*Figure 5* Giovanni Belzoni's watercolor showing his workmen moving the "Young Memnon" from Thebes, 1816.

*Figure 6* Stone sculpture. With help from friends in high places, British Consul General Henry Salt made this delivery to the British Museum in 1817.

between chapters penned by private and by public collectors. On the one hand stood the country clergyman who set his parishioners to digging into ancient British burial mounds in search of pots to grace his cabinet (figs. 2, 3), and on the other were great museums whose trustees bankrolled archaeological explorers to ransack the ruins of Nineveh or to haul treasures from the depths of Theban tombs (fig. 4). Today, of course, such practices are deemed to be several light years beyond the pale. But no matter how deplorable we may think our predecessors were, the fact remains that very few museums are standing in line to return their ill-gotten goodies to demanding nations that, in the first instance, gave firmans to the diggers and assisted them with the packing and shipping (figs. 5, 6).

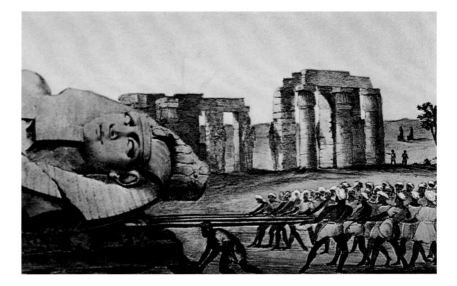

One might suppose that today's archaeological museums no longer desire to expand their collections and are content to let their galleries remain forever static. While that may be true of some, others retain an ethical loophole that allows artifacts to slip in by merit of having been found by professional archaeologists. The rationale is twofold: first, that the objects are being secured for the public good, and second, that the digging has been conducted to a sufficiently high standard to ensure that no related information has been lost. These are praiseworthy goals, though some might question what the museums do with the information so carefully and expensively garnered.[3]

In the summer of 1999, the Museum of London's archaeological holdings included 120,000 boxes of unprocessed artifacts, most of them potsherds.[4] On a lesser scale, museums everywhere that accept archaeological material (there often being nowhere else to house it) have storerooms stacked with boxes retained only because they ought to be. In 1957 when I took charge of Colonial Willamsburg's archaeology department I recall being appalled to find a bus garage stacked with crates of unwashed artifacts from twenty years of digging, and being advised by my superior to secretly dump them into the York River (fig. 7). My outrage was real but,

*Figure 7* Archaeological artifacts at Colonial Williamsburg. An awkward inheritance: part of the unwashed and unloved legacy of digging in Williamsburg prior to 1957.

in retrospect, ill-founded. Saved without any detailed archaeological context, the material was worthless, its messages from the past torn up the moment it was stripped from its stratigraphic matrix. What, if anything, does all this have to with the collecting and studying of ceramics in the context of American decorative arts? I would answer: A great deal, particularly when the history of imported British ceramics is in review. It is fair to say, I think, that 90 percent of all British pottery dating prior to the mid-seventeenth century has come not from the cellars of foreclosed mansions but out of the ground. Be it Bronze Age burial urns, Roman kitchen wares, medieval jugs, or Elizabethan porringers, virtually all have survived through having been buried with their owners or lost down their wells, thrown into castle moats, or broken and tossed into trash pits (fig. 8). Without them, more than three thousand years of British pottery would be a closed book.

Most famous, privately built ceramic collections now in museums—such as the Burnap Collection in the Nelson–Atkins Museum of Art in Kansas City, the Schreiber Collection in London's Victoria and Albert Museum, and the Glaisher Collection in the Fitzwilliam Museum at Cambridge—all begin with specimens older than their collectors' principal focus. This is as it should be, for as in all else, and for better or sometimes worse, we live in an evolving world. Achievement can only be measured against the yardstick of what went before.

The masterpiece mania that across the years has driven the acquisition policies of so many great museums was put into words in a 1913 position paper from the Victoria and Albert Museum's ceramics curator, Frank Church. Addressing it to the "Sub-Committees upon the Principal Deficiencies in the Collections," and quoting the Chinese philosopher Hseih Ho, he asserted that the first principle of any good collection has to be the acquisition of masterpieces. These alone, he added, "are the source of inspiration—and by the number of its masterpieces a collection is finally judged" (fig. 9). Reading on, it becomes clear that Church's concern was

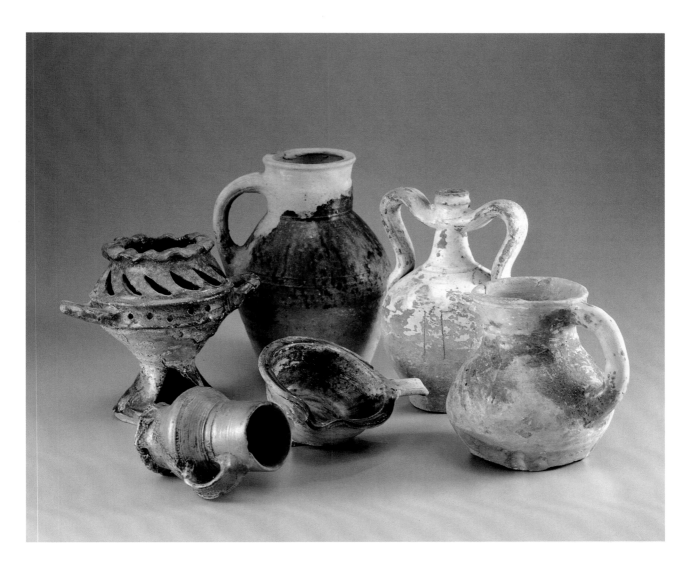

*Figure 8* A group of sixteenth- and seventeenth-century earthenware and stoneware vessels. (Noël Hume Collection; photo, Gavin Ashworth.) Like daffodils and oak trees, these are the kinds of ceramics that only come out of the ground.

*Figure 9* Museum exhibit of seventeenth- and eighteenth-century English delftware, a presentation designed to display more than to instruct. (Courtesy, Colonial Williamsburg.)

*Figure 10* Caudle or posset pot, London, ca. 1640. Tin-glazed earthenware. H. 5½". (Noël Hume Collection; photo, Gavin Ashworth.) The importance of a ceramics collection depends less on what it cost than on what its pieces have to say about themselves and the times in which they were made and used (see figs. 11 and 12).

*Figure 11* Reverse of plate, Staffordshire or Yorkshire, ca. 1780. D. 9½". Cream-ware. (Noël Hume Collection; photo, Gavin Ashworth.) This plate bears the ghostly imprint of the painted decoration from a plate stacked beneath.

*Figure 12* Jug, London, early eighteenth century. Stoneware with both salt-glaze and tin glaze. H. 5". (Noël Hume Collection; photo, Gavin Ashworth.)

not only for the august reputation of the collection but for that of its custodian. Curators, he insisted were "gifted by nature to feel the difference between a masterpiece and an average work—and entitled after years of training to become heads of departments." He also believed that, by restrictive budgeting, curators would be forced to "fall back upon what is cheap . . . the fatal snare of the second-rate collector" who "soon finds his collection *déclassé*."[5]

No one will deny that to be important a collection must contain specimens of above average significance and interest. But that does not mean that they have to be masterpieces. A hitherto unrecorded shape of an undecorated delftware posset pot (fig. 10), a plate with a design on its back that shouldn't be there (fig. 11), or a pitcher half one ware and half another (fig. 12), indeed any vessel that tells us something we did not already know, can elevate a ho-hum collection to memorable heights.

Taken literally, a masterpiece is a test product of a journeyman in any craft deemed to be of sufficient quality for his peers to accept him as a master of his trade. Although London was the center for the quality control in most seventeenth-century trades and housed worshipful companies of dozens of crafts from apothecaries to woolpackers, the essential craft of the potter was conspicuously absent. Used more loosely, the word MASTER-*piece* was defined in Nathaniel Bailey's *Etymological English Dictionary* (1749 edition) as "a most exact or excellent Piece of Workmanship in any Art." But how does one judge excellence?[6]

More often than not we are content to take someone else's word for it. To do otherwise, it is beholden upon us to have seen and studied enough in the same genre to determine for ourselves that this or that example is superior to any other. Fortunately for our lexicon of superlatives, few ceramic objects aspire to masterpiece status. Besides, a pot that we now consider superior to all others in its class may not have been so considered in the context of its own time. I venture to suggest, therefore, that the rightly respected Frank Church had it wrong and that his successors' buying policy, which reflected his views, resulted in exhibitions that gave a disconcertingly distorted view of ceramic history. That elitist outlook required visitors to be content to accept the premise that curators of long experience (as well as of tooth) were indeed "gifted by nature" to tell the museum visitors what they should admire. The notion that the public deserved to be given the opportunity to make its own determination by seeing the great alongside the not-so-great (and even the positively awful), would have had curators handing in their resignations while reaching for their top hats. Not only would such ceramic diversity have been déclassé, it would have taken up space otherwise available to be packed pot-to-pitcher with yet more masterpieces.

I well remember asking my boss and chief curator at London's Guildhall Museum why it was necessary to write labels in abbreviated Latin that only a classicist would understand. "Young man," he replied, "it keeps small boys from coming in and breathing on the cases." He should, of course, have been right. But he wasn't. Small boys *did* come in, and although they

*Figure 13* A Romano-Gaulish Samian ware bowl. The kind of object on whose exhibit case small boys were supposed not to breathe.

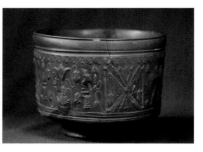

*Figure 14* Detail from William Hogarth's (1697–1764) *Night* from the series *The Four Times of the Day*, 1739.

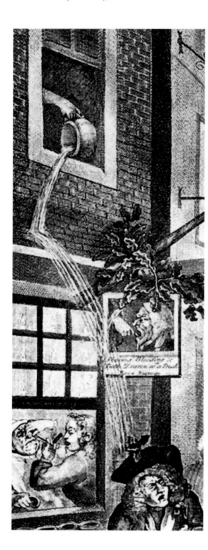

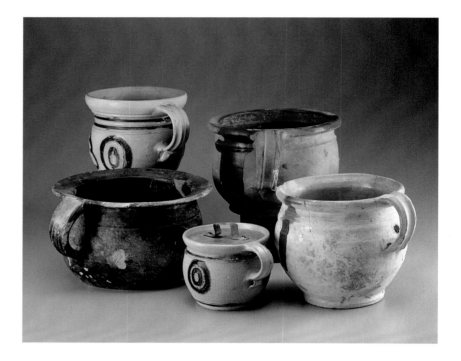

*Figure 15* Group of seventeenth- and eighteenth-century stoneware and earthenware chamberpots. (Noël Hume Collection; photo, Gavin Ashworth.) Both Hogarth (fig. 14) and Gilray (fig. 16) portrayed these unmentionable ceramic vessels with disarming candor.

ignored the labels, they were thrilled to see the pots and even sat down to draw them. There was magic in the thought that eighteen hundred years ago (way beyond *1066 and All That*) their ancestor had been eating from cups and bowls far more decorative than those the kids had at home (fig. 13).[7]

Just as English-speaking playwrights like Eugene O'Neil and John Osborne lured us toward the kitchen sink and away from "Tennis anyone?" drawing-room comedy, so the warts-and-all anti-establishment philosophies of the 1960s have invaded the museum world. At Colonial Williamsburg, as elsewhere, the gentility of the post–World War II generation, with its emphasis on bowing and ball gowns, has been replaced by interpreta-

tions that call a powder room a privy and a slave a slave. In so changed an atmosphere the lead-glazed chamber pot and close stool pan have gained an acceptance (if not admiration) denied them since the days of Hogarth, Rowlandson, and Gilray (figs. 14–16).

In England, as in America, students of everyday earthenwares and stonewares are for the first time studying them with the care and enthusiasm hitherto devoted to naught else but porcelain and the best of Wedgwood. Kiln sites of lowly wares—for instance, those of the sgraffito slipwares of

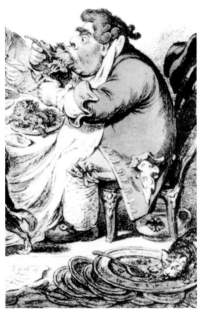

*Figure 16*  Detail from James Gilray's (1757–1815) *Germans Eating Sour-Krout,* colored etching, 1803.

*Figure 17*  Archaeological excavation of earthenware fragments from the production of Virginia potter Thomas Ward at Martin's Hundred, Virginia, ca. 1622.

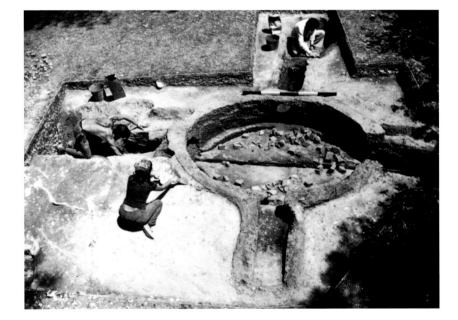

*Figure 18*  Photograph of archaeological excavation at Morgan Jones Kiln Site, Westmoreland County, Virginia, ca. 1672. (Photo, William Kelso.)

Donyatt and the yellows and greens of Elizabethan potters working in Surrey and Hampshire—are being excavated skillfully in England while comparable factories have been explored in Martin's Hundred near Williamsburg in Virginia (fig. 17), and in the same state's Westmoreland County (fig. 18). In England, too, the stoneware factory of John Dwight of Fulham has been extensively excavated and published, while the same has been true of earthenware and stoneware manufacturer William Rogers, whose kilns at Yorktown have been explored and reported on. At last the common man and his common wares are becoming respectable. But are they collectable?[8]

*Figure 19* Cinerary urn, Anglo-Saxon, 500–600 A.D. Unglazed earthenware. H. 10⅜". (Courtesy, Chipstone Foundation; photo, Gavin Ashworth.) This example is not every collector's dream pot.

*Figure 20* Dish, Rouen, France, ca. 1780. Tin-enameled earthenware. L. 13". (Noël Hume Collection; photo, Gavin Ashworth.) Even this modest eighteenth-century dish becomes a marketable celebrity once it gets its picture in the paper.

As the lad from Stratford-on-Avon would have us say, "Aye, there's the rub!"

Collecting interest is fostered and sustained by availability. Intact but plain earthenwares lacking the "keep me" factor that discouraged estate strippers from tossing away decorated or dated examples, have become rarer than "masterpieces." And what we cannot buy, we tell ourselves we do not want (fig. 19). I know that in my own collecting career I have shifted from one ware to another as examples became harder and harder to find or

were priced out of my league. A French faience dish I had bought for two dollars before unwisely writing about it in *Antiques* prompted a dealer-reader to offer me another just like it at two hundred dollars. Alas, these heavy and none-too-attractive dishes have never reverted to what I still consider a fair, two-bucks price (fig. 20).[9]

Like Amsterdam today, London between the two World Wars was a prime source for intact sixteenth- and seventeenth-century pottery found on city construction sites. In those days the London Museum's agent, G. F. Lawrence (who doubled as a dealer), became known to every building-site laborer as "Stony Jack," to whom they would trade dug-up pots for beer money. In the same period, Frank Lambert, the city's own Guildhall Museum clerk (the name "curator" being thought too elevated) would also buy from laborers. However, the old hands assured me that Jack paid best. Nevertheless, both museums greatly enlarged their collections at that time, and those pots that slipped by them wound up in street markets or were sold directly to "gents" who met the laborers and "wetted their whistles" in city pubs.[10]

Several pieces in my collection bear faded labels telling me that they were found on this site or that street, information which, to me, enhances their interest and is carefully recorded in the hope that it will always remain with them. But while such knowledge is better than none, it has little probative value. A mid-seventeenth-century earthenware pipkin in the collection contains a shriveled label with a message typed in red telling a previous owner (who wisely copied it before it became illegible) that the vessel was "a cooking pot found 5ft from surface in gravel while excavating for foundations at Upper Smithfield new Good Depot," and was "stated to be 15th century manufacture." Because most of London is built on Thames Valley gravel and the label does not define what was meant by "surface" or how the pot got to be five feet down, the information is worthless (fig. 21).

*Figure 21* Pipkin, probably England, 1640–1670. Lead-glazed earthenware. H. 6¾". (Noël Hume Collection; photo, Gavin Ashworth.)

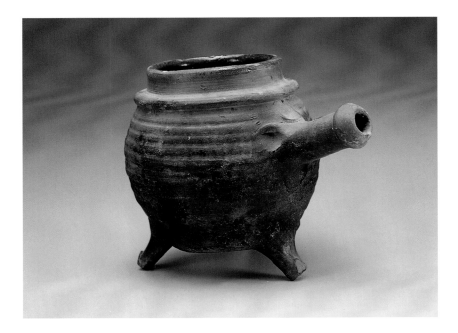

*Figure 22* Graybeards galore. Museum storerooms were and are replete with pots the public never sees. (Photo, William Gordon Davis.)

The same is true of the vast majority of the anonymously sourced early ceramics in the collections of the now combined London and Guildhall Museums (fig. 22).

Unlike the masterpiece-hungry decorative art museums, the London history museums became far stronger in their medieval and immediately post-medieval earthenware and stoneware collections than in the later white saltglaze, creamware, pearlware and the like—and for a very simple reason: To the salvaging, beer-money-expectant laborers, such wares did not look old enough to be worth anything. Besides, with so many decorative examples surviving above ground, the finders were right. No one wanted a cracked, run-of-the-mill creamware plate, and nobody cared to rub the dirt off the back of it to reveal an unrecorded potter's mark before throwing it aside. No less saddening is the fact that to the eye of a builder's laborer, anything broken was not worth saving. Consequently, countless highly significant ceramic objects that were uncovered and could have been saved were discarded, while complete pots with little or nothing new to say were salvaged and sold.

My wife's and my eighteenth-century and later collecting began around 1958 when, after moving to the United States, we realized that we had much to learn and needed to do it in a hurry. In those days, neither curators nor collectors could abide cracks or chips. I clearly remember Audrey airily dismissing a splendid David Rhodes-style creamware teapot because its spout was chipped. A month later, having thought better of it, we returned to the shop hoping to find it still there. It was not. Around that point in our collecting we realized that for study or teaching purposes, cracks and chips translated into both "desirable" and "affordable." But times change, and looking today through the catalogs of Sotheby's or Christie's one finds that terms like "minor damage" and "some restoration" are no longer marks of Cain and do not betoken sale-room bargains. Since the 1950s, a proliferation of private collectors on both sides of the Atlantic, as well as in the Far East, has thinned out the good stuff to a point where yesteryear's second rate has moved to front and center. Besides, there are restorers who can mix plaster or plastic as readily as I can mix a metaphor, thereby turning a ceramic sow's ear into a pearl of great price.

The assumption that a bowl, a dish, or whatever that was repaired in its useful lifetime is thereby rendered undesirable, depends very much on one's reason for collecting. My own view—and throughout this essay these *are* my own views—is that such repairs can make an object more rather than less interesting. Nevertheless, I cannot deny that there is a significant difference between an *original* repair and one made after an object became a carelessly handled antique.

When a Roman era inhabitant of Britain dropped his or her Samian ware bowl and sent it to the repairer to be drilled and lead riveted, we know with absolute certainty that it had been sufficiently valued to merit such attention (fig. 23). But on what, one asks onself, was that valuation based? Did the bowl have sentimental value? If so, what do we know about sentimentality in Roman Britain? Or were bowls of this shape in such short supply

*Figure 23* When a Roman someone cared enough to mend her very best. (Noël Hume Collection; photo, Gavin Ashworth.)

*Figure 24* When Virginia potter Thomas Ward tried to fix his worst. (Courtesy, National Geographic Society; photo, Ira Block.)

that it was easier and cheaper to mend the old? Or was it a question of money? What would a Samian bowl have cost at the end of the first century A.D.—a silver denarius, a bronze sestertius, or a humble copper quadrans? We may never learn the answer, but the very act of wanting to do so breathes new life into a dead potsherd.[11]

I have not found evidence of repairing among medieval earthenwares. Why not? An obvious answer is that I have not seen enough medieval pottery to make an intelligent judgment. But another could be that the economic and societal gulf between rich and poor, master and man, was such that decorated wares used by the wealthy were actually handled only by servants who thought it best to quickly and secretly dump into the nearest garderobe the evidence of their carelessness.

By the time we reach the mid-sixteenth century and the rise of an English middle, or merchant class, relatively well-made earthenwares were plentiful and available in homes directly controlled by the women who owned the items, whom one might expect to be more inclined to have their pots repaired. But here again, I have no evidence to support such a proposition. The earliest example of common earthenware repairing known to me came not from England but from the site of Thomas Ward's ceramic manufacturing in Virginia's Martin's Hundred immediately before the Indian attack of 1622. A large creampan had cracked while being sun dried, but rather than discarding it, the potter smeared ribbons of clay into the cracks prior to glazing and firing it. The remedy did not work, and after opening the kiln Ward (or his helper) threw the unsaleable pan into the pit from which he had dug his clay. Had the ruse worked, I have no doubt that Ward would have sold his dish (fig. 24).[12]

If, in the collecting world, a repair goes undetected, is the buyer's satisfaction in any way impaired? The answer, clearly, is *No*—until the deception is revealed, at which time fury and disappointment converge in a maelstrom of vituperation. But what harm, one might also ask, is done if the buyer uses his own misjudgment and thereby derives unjustified satisfaction from believing his treasure to be something that it is not? This, of course, is akin to arguing whether or not a tree falling in a forest is silent unless someone is there to hear the crash. A recent addition to my own col-

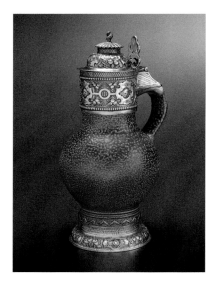

*Figure 25* Jug, probably Doulton, ca. 1910. Stoneware with silver mounts. H. 11¾". (Noël Hume Collection; photo, Gavin Ashworth.)To pull or not to pull the petals off a gilded lily? That is the question.

lection was acquired for just such a reason. What I took to be a fine yet originally plain example of a Frechen stoneware jug of ca. 1590 had been converted into a thing of no little grandeur by the addition of a silver foot, collar, and lid (fig. 25). Virtually every detail of the mount's decoration had its origin in the late Elizabethan era when such embellisment was common among English silversmiths. Nevertheless, the combination was stylistically wrong and made the mug taller and more imposing than would have been the case in the sixteenth century. So how should this piece be judged: as an unsuccessful fake or as a wonderfully satisfying combination of old and new?[13]

There were, however, details that bothered me. The mottled salt-glazing was too uniform, and there was no sharp cordon atop its shoulder, as was common among Rhenish wares of this type. The longer I studied the jug, the more uneasy I became. I knew it had been sold at Christie's only three months earlier, and so I endeavored to trace its travels back to the auction house. The catalog had described it thusly:

> A German brown-glazed stoneware silver-mounted jug and hinged cover with globular body and cylindrical neck, the silver mounts embossed in the Renaissance style, the jug 17th century, the mounts hallmarked for Chester 1911 ... 27 cm. high. £300–500.[14]

However, I also knew that auction catalogs are by no means written on Biblical tablets. Consequently, I asked English antiquarian ceramics dealer, Jonathan Horne, why he had not bought this incredibly handsome stoneware mug? He replied that he preferred to leave silver-mounted pieces to silver dealers to fight over. Then he asked "Are you sure the mug isn't Doulton?"

I remember his question as one of those "Oh, my God!" moments. I had not known that Doulton had made copies of Rhenish stonewares, but looking at the mug again with that thought in mind, I realized that the evenness of the salt-glazing and the richness of the color was, indeed, paralleled among wares from Doulton of Lambeth and Burslem in the late nineteenth century. Looking carefully at the very even and rounded cordoning at the base and comparing that to the sharp-edged ridges around fragments from genuine Rhineland mugs of the sixteenth century, I became certain that Jonathan was right—and kicked myself blue for having failed to recognize the warning before buying. Two lessons are to be learned from this story. First the obvious: There is truth in the old adage that if it looks too good to be true, it probably is. The second is that if one lacks the breadth of knowledge to recognize the warning, the bell will not ring.

Returning to my original theme, one might reasonably ask whether the apparent is any less satisfying to the owner than is the reality. Is the object rendered any less pleasing to the eye by knowing that it is three centuries younger than one thought? Unfortunately, when one discovers that the "treasure" is not as the auctioneers listed it, one's aesthetic and philosophical judgments become hard to separate from monetary reality.

Supposing, however, that the mug *had* been from the sixteenth century, should one have removed the late silver mounts to restore its original

integrity? The question is not as abstruse as it might appear, being one that goes to the root of all preservation and restoration endeavors. Although, compared to the alleged age of the mug, the silver mounts would be relatively modern, they nevertheless are a hundred years old and would represent nearly a third of its history. Restorers of eighteenth-century houses have gladly stripped away a hundred years of their evolution to take them back to what they, the preservationists, have considered in their wisdom to be the *right* period. But is any one period more right than another, and on whose judgment shall a building's or a mug's fate depend?

I do not proffer an answer and ask the question only because it is something we should ponder whenever, as the custodians of history, we contemplate sacrificing the decades that fail to interest us so as to get back to those that do.

Stories of ceramic fraud are legion, and many a reputable dealer has helped good customers into bad buys—subterfuges or oversights that may not show up until decades later. Not until the coloring of repairs change or a potential new owner brings his own "black light" does the seller discover that long, long ago he had been deceived. But does it really matter? A skillfully hidden repair had eliminated the scars of household strife and returned the wounded to health and a long life. However, an undetectable ceramic restoration is not the same as owning a Han van Meegeren while believing it to be a De Hoogh, for in such an instance the collector is being hoodwinked into believing that he is seeing into a room in Delft through the eyes of the painter. The restored vase, on the other hand, is still the same one that a lady of quality chose from the stock of Messrs. Davies and Minnit "at their Glass, China and Earthen-Ware Store" in New York on January 2, 1772. It was not cracked then and to all intents and purposes it is not now. I am aware that this is not a rationale employed by professional appraisers, but it is one that has served me well through half a century of ceramic collecting and has assured the survival of many a piece that might not otherwise have found so forgiving or appreciative a home.[15]

Although the term "China" would come to be very loosely employed to mean any table ceramics, in the eighteenth century the reference was most often applied to Oriental porcelain which, although coming predominantly from China, was unhelpfully called India China because it had been brought to Europe aboard ships of the East India companies. Professional china menders seem to have meant Chinese export porcelain when they advertised their skills in the columns of newspapers. In 1760, James Walker, fresh from London, informed New Yorkers that he "mended broken China in the neatest and strongest Manner, with Rivets and cramps, and where Pieces were wanting in broken Bowls, supplied the defects and made Spouts and handles to Tea-pots, in the same Manner as done in the East-Indies."[16] It is not clear whether craftsman Walker was saying that spouts and handles were repaired in the Orient before being shipped out as new, or whether he meant that he would re-attach the parts by the same fired means employed in the wares' manufacture. Nevertheless, as figure 26 shows, repairing was a skill practiced in China in the eighteenth century.

*Figure 26* Colored engraving of a *Mender of Porcelain,* London, England, 1799. (Private collection; photo; Gavin Ashworth.)

Another New York repairer was ready to use "a cement so strong and durable, that it [the vessel] may be used either in heat or cold without separating or loosening the joints." Yet another put his trust in rivets, which he priced at two shillings each in silver (or one shilling if you provided your own), ninepence in brass, and sixpence in white metal. The latter craftsman, Nathaniel Lane of Warren Street, New York, advertised in 1763 that he also repaired "Delft," this at a time when the popularity of tin-glazed wares was in sharp decline.[17]

I have never been a porcelain enthusiast, but my collection does include a few representative examples of both English and Chinese porcelains principally to demonstrate the difference between hard- and soft-paste wares.

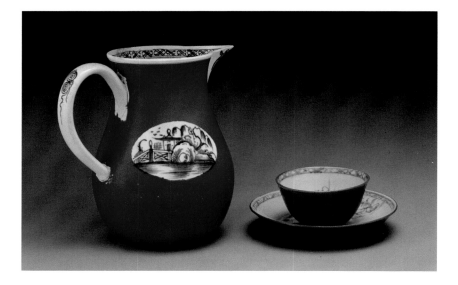

*Figure 27* (*Left*) Jug, Staffordshire or Yorkshire, ca. 1785. Pearlware. H. 6¾". (*Right*) Tea bowl and saucer, Ching-tê-chên, China, ca. 1751. Hard-paste porcelain. (Noël Hume Collection; photo, Gavin Ashworth.) Pearlware and porcelain in the "Batavian" style, yet neither piece was made there.

Among the former is a "Batavia"-style tea bowl that provided a design source for brown-surfaced pearlware of the late eighteenth century (fig. 27). Possession of the Chinese tea bowl and saucer raises questions (and hackles) that have a profound impact on what may become the twenty-first century's premier source of collectable ceramics.[18]

No discussion of the propriety of ceramic acquisition can escape the whirlpool of controversy surrounding the underwater resources that have been opened to collectors in the years since diving ceased to be a lead-footed endeavor. Beginning with the Aqualung and continuing with the deep-sea recovery capabilities characterized by the Russian research vessel *Keldesh,* intact cargoes that have lain for centuries beyond Man's reach are today finding their way into sales catalogs. But lifting crates of Chinese porcelain from their resting place in the South China Sea has also raised ethical questions that pit archaeologists against museums and collectors, indeed anyone with a yen to possess a piece of the action.

The issues are diverse, but the single example of the R.M.S. *Titanic* touches them all. When first discovered in 1985 by Robert Ballard and a team from the Woods Hole Oceanographic Institution and the French Institute colloquially known by the acronym IFREMER, an uneasy world

was assured that this was a "look-see" expedition and that as an historic grave site, nothing would be disturbed. In December 1985 *National Geographic* published the first pictures alongside Dr. Ballard's account, which ended with the words "It is a quiet and peaceful place—a fitting place for the remains of this greatest of sea tragedies to rest. Forever may it remain that way" (fig. 28). Survivors had echoed his hope, praying that the "*Titanic* should be left intact as a memorial to those who went down with her." But in the frantic, make-a-buck world of the late twentieth century "forever" was no longer infinite. Soon a French expedition was bringing up anything it could grab and carrying it home to be professionally conserved—on behalf of ticket-selling exhibitors.[19]

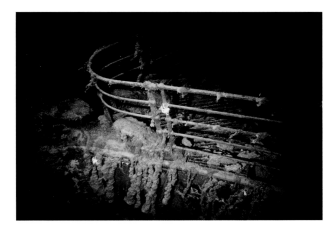

*Figure 28* Photograph of the bow of the *Titanic*. (Courtesy, Woods Hole Oceanographic Institution.) Asleep in the deep, R.M.S. *Titanic* as first seen—before a Virginia judge issued a license to an entertainment company to remove artifacts.

*Figure 29* Underwater photograph of a *Titanic* chamber pot. (Courtesy, Woods Hole Oceanographic Institution.) What price would a dealer put on this chamber pot, which might have been used by John Jacob Astor?

Archaeologists and some museum curators deplored the salvage, rightly arguing that it served no evidentiary purpose and pandered to the public's prurient fascination with fires, car accidents, and trapeze artists who might miss the net. Unfazed by that disquieting thought, museum managers and trustees emulated Rome's imperial fiddler and voted for bread and circuses. If the visitors had a taste for vicarious disaster watching, why not sell it to them? And so they did. *Titanic* shows at such renowned institutions as Britain's National Maritime Museum and Virginia's Mariners' Museum at Newport News exceeded all visitor expectations.

And the money keeps pouring in—yet too slowly to satisfy the stockholders of R.M.S. Titanic Inc., who fired the company's founder and C.E.O. for failing to bring up artifacts fast enough to keep pace with its need to fulfill its contract with an exhibit-mounting entertainment company. Titanic Inc.'s new head explained that it, too, is an entertainment company "with a responsibility for the historic preservation and integrity of the vessel." But how long, we may wonder, will it be before a chamber pot from a first-class stateroom and emblazoned with the *Titanic* logo (fig. 29) will be for sale to the highest bidder?[20]

Cynics may answer: So what? It may even occur to them that archaeologists who deplore the looting of the *Titanic* on the grounds that it is a grave site voiced no such objections when the 1545 wreck of the *Mary Rose* was dug out and raised even though it was the burial place of more than

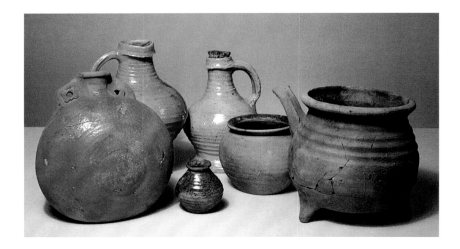

*Figure 30* A group of earthenwares and stonewares excavated from the *Mary Rose* (1545). (Courtesy, Margaret Rule.) Although these vessels were brilliantly excavated and conserved, like the *Titanic*, the *Mary Rose* was a mass grave site.

five hundred seamen and soldiers (fig. 30). No less dramatic and pot-providing was the 1961 raising of the Swedish *Vasa*, which sank in 1628 with the loss of fifty or more lives. In truth, most ships lost beyond the reach of land are the grave sites of people no less worthy of the peace and quiet that Dr. Ballard so eloquently described.[21]

The grave site issue is, of course, an emotional one, yet one that becomes less contentious after the last great-grandfather ceases to be a lost loved one. Nationalism, too, plays its part. No American would countenance the salvaging of saleable ceramics from the U.S.S. *Arizona,* but few would fuss if a company ripped open the *Bismark* for the same purpose. Consequently, academic vituperation at the well-remembered sale of the 1752 porcelain cargo of the V.O.C.'s (Dutch East India Company's) *Geldermalsen,* had more to do with technique and a professed abhorrence to profit than reverence for dead Dutchmen.[22]

Just as land archaeologists are generally more interested in building remains than in potsherds (though it beats me why that should be), so underwater archaeologists focus on ships' architecture rather than on their cargoes. It is not a position taken by most ceramic historians and collectors who see cargoes as the provider of information more accurate than can be secured in any other way. A lost ship has what we call a *terminus ante quem* — a finite date before which everything aboard had to have been made or used.[23]

Ideally, every strake and rudder gudgeon should be recorded and analyzed in situ to ensure that no scrap of potential information is overlooked. The same is true of the equipment and cargo. Each barrel stave and tea bowl (of which the *Geldermalsen* yielded several thousand) should be mapped and studied in place, the packaging being deemed as important as the pots (fig. 31). But in underwater recovery, ideals and reality can be many bubbles apart. The cost of even shallow wreck diving becomes incredibly expensive incredibly fast, and only investors who expect a return for their money are willing to bankroll such expeditions. Not surprisingly, their diving director's mandate is to do the best that is possible in the shortest time.

I have hesitated to use the word "salvage," knowing that every archaeologist blanches at the sound of it. But having begun my career as the Guildhall Museum's salvage archaeologist, I am satisfied that I was doing the best I could with the limited time and resources available to me. My better-supported successors have been generous enough to allow that had I not done what I did—selective and minimalistically focused as it had to be—much that is now appreciated would have been lost. Similarly, had not Captain Michael Hatcher's salvage company brought up the *Geldermalsen*'s

*Figure 31* Underwater photograph of porcelain cargo. (Courtesy, Christie's.) Without saving the shreds of their packing material, were the *Geldermalsen*'s porcelains worth salvaging?

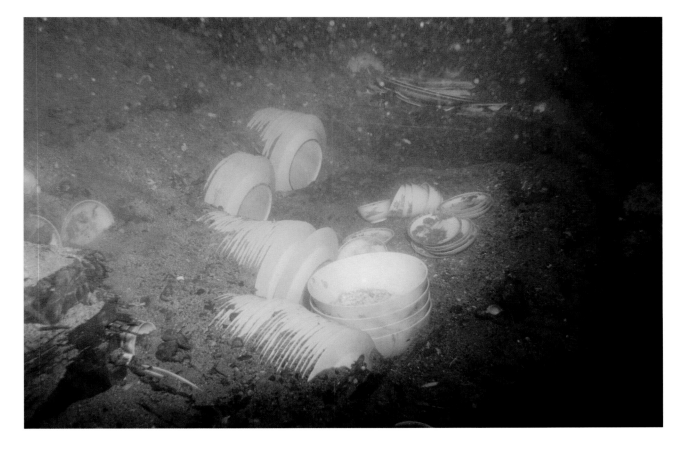

huge cargo, we would today know far less about mid-eighteenth-century Chinese export porcelain than we do. The opportunity to see the unpacked wares ranged along Christie's Amsterdam shelves, much as they would have been seen in the V.O.C.'s Canton factory by the Dutch merchants of 1751, was in itself a unique educational experience (fig. 32).

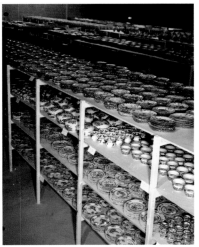

*Figure 32* Photograph of the *Geldermalsen*'s porcelain at Christie's Amsterdam. (Courtesy, Christie's.) Nearly two hundred years late, the porcelain awaited buyers, few of whom, if any, arrived wearing knee-britches or wigs.

In an impassioned but carefully reasoned assault on virtually everyone associated with the *Geldermalsen* project and her cargo's subsequent sale, ceramic historian George Miller described the site as being "strip-mined" and "scavenged," and Christie's as "the major force in the destruction" of the wreck. Having condemned the very idea of selling its porcelain, Miller went on to say this:

> Some archaeologists might argue that Geldermalsen would never have been excavated by professional archaeologists because of the logistics involved. However, any wreck that produces $16 million at an auction could have been funded for legitimate excavation.[24]

The thrust of this argument seems to imply that if professional archaeologists could have been assured of selling the cargo for big bucks, they would have been able to secure the financing for the wreck's excavation and the porcelain's recovery.

Hatcher was quoted in *Reader's Digest* as saying that his team had been engaged in "a race against time to get what they could before being interrupted by weather, rivals, pirates or some government."[25] The statement has been seen as an admission that he knew the wreck to be in someone's territorial waters and that his expressed fears were otherwise unfounded. However, Hatcher's next salvage venture was to justify them all. In 1992, though in no one's territorial waters, the largely stoneware cargo of a Chinese junk from the twelfth century was seized by Thai naval personnel and not seen again until pieces from it were reported on sale in Bangkok markets. The aborted expedition had cost close to a million dollars. Whether the outcome would have been any different had Hatcher's divers been professional archaeologists is anyone's guess.

The High Seas seizure of the twelfth-century cargo had deprived students of the opportunity to analyze either the state of early Oriental stoneware art or the trading practices of shippers in that remote period. Measured against this yardstick, therefore, the fate of the *Geldermalsen*'s relatively recent porcelain was much to be preferred. The ship was excavated in the spring of 1985, and almost exactly a year later a 272-page catalog with 115 color photographs (some showing a dozen or more items) was available to anyone interested in Chinese porcelain. The year 1986 also saw the publication of C. J. A. Jörg's well-illustrated *The Geldermalsen History and Porcelain*. Never in the history of underwater recovery had the results been so quickly and so thoroughly published. Yet archaeological critics still cried foul! They condemned Christie's for the sale as well as any and every purchaser—on the grounds that money derived from the auction would be used by Hatcher and his team to go back and "loot" another wreck for profit. Wrecks, the buyers were scolded, are a nonrenewable resource and once disturbed could never be put back together. They should be left until professional archaeologists have the time and money to do the job properly.[26]

Writing for the *Washington Post* in the context of the *Titanic* debate, reporter Michael Fletcher correctly stated that "to many historians, the contributions that the sunken vessels can make to the understanding of world history are even more valuable than gold. And they want to ensure

that history is not lost in the scramble for riches."[27] But what, we may wonder, are the legitimate contributions that make recovery acceptable?

A French wreck of ca. 1760 found amid Bermuda reefs was excavated over a period of eight years and yielded no gold but thousands of fragments of French ceramics that provided an unparalleled time capsule of common stonewares, lead-glazed earthenwares, and faience in use at that date (fig. 33). Working under a license from the Bermudian government, the diver fulfilled his obligation to offer the artifacts to it at a fair price (in

*Figure 33* Earthenware sherds from a ca. 1760 French wreck. (Sherds courtesy of E. B. "Teddy" Tuckev; photo by author.) Because they were not found by professional archaeologists, these fragments have been deemed worthless.

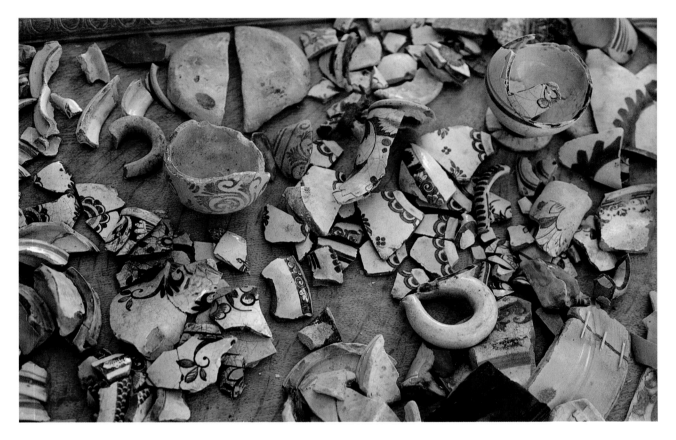

this case, the cost of excavation), but had his offer rejected on the grounds that the sherds were not recovered by professional archaeologists and therefore were deemed worthless. Freed of his legal commitment, the disgusted salvager threatened to throw the whole lot back into the sea.

Examples like this drive an ever deeper wedge between "go by the book" scholars and would-be "do it right" amateurs and commercial salvagers.[28] So, with neither side always right or always wrong, it seems time for an international agreement calling on each country to appoint licensing committees evenly balanced between social and maritime historians, archaeologists, commercial salvagers, museum curators, representatives of the tax-paying public, and, yes, even collectors, to determine the expected educational worth of every proposed wreck-disturbing project. In some instances the need for information about a ship's construction would take precedence; in others it could be the armament, the cargo, or even the

source of the ballast. One would hope that on a case-by-case basis the tenets of ideology versus pragmatism would be debated and adjudicated—leaving the wreck undisturbed being one of the several options.

In theory, the knowledge-seeking and protecting purists are absolutely right, but a realist might be forgiven for arguing otherwise. The doubtlessly unintentional "worthier than thou" posture supposes (a) that at some future Utopian date sufficient money will be forthcoming, and (b) that it does not matter that our generation is to be denied information (incomplete though it may be) made possible by the recovery of cargoes like that of the *Geldermalsen*. The same realist might contend that future generations are likely to become even more philistine and that Man's brief evolution and existence on the planet will soon self-terminate, leaving it strewn with his unstudied garbage. Aesop's ancient fount of common sense had this to say:

> Most Men are so inclin'd to private Gains,
> That 'till the Power of Justice them contrains,
> They'll rather useless hoard, than part with what
> May beneficial be to th' Publick State.[29]

An obvious solution to this pedagogic impasse would be for Hatcher and others like him to add professional and practical archaeologists to their teams to record so much about ship structural remains as budgets and on-site time allow. Unfortunately, so seemingly Solomon-like a solution is unworkable because any professional archaeologists associating themselves with a salvage project would be ostracized from their profession and have their air hoses confiscated.[30]

On land, as underwater, the need is for amateurs to be freed from the stigma of the "pot hunter" or wreck looter, to work alongside the professionals for the good and enlightenment of both. In the field of ceramic studies there is much to be done to help better understand what pottery and porcelain can tell us about their manufacture, marketing, transportation, and usage. Some analyses call for quantification (though numbers can be misleading), others for the study of on-site distribution, and more for correlation with import records, sales ledgers, and household inventories. In short, ceramics are words ripped from the pages of history, and when properly recorded and reassembled, they have the ability to excite, amaze, and delight. I firmly believe that those sensations are most acutely experienced by collecting—by having and holding these historical bridges, and by living with them until we ourselves are consigned to the clay from which they sprang.

ACKNOWLEDGMENTS

I am indebted to Chipstone Foundation director Jonathan Prown, and to *Ceramics in America* journal editor Robert Hunter for reviewing and constructively commenting on this essay, and also to George Miller for providing me with a copy of his important, 1985 contribution to *The American Neptune*. I am also eternally grateful to Sir David and Lady Burnett who enabled me to work with their collection of ceramic sherds from London's

Hays Wharf properties, of which Sir David was Chairman and C.E.O. and from which I have learned so much.

1. There are exceptions to every rule. Notable among archaeologists who have become collectors and have shouldered their responsibility to share their archaeological knowledge with the museum-going public was Kenneth J. Barton, one of the founders of the British Society for Post-Medieval Archaeology and a pioneer in the study of common earthenwares of the eighteenth and nineteenth centuries. K. J. Barton, *Catalogue of the Barton Collection of Earthenware Pottery* (Guernsey: Guernsey Museum & Art Gallery, 1982). On the other hand, it is possible to pick a random issue of the American *Journal of the Society for Historical Archaeology* (e.g., 1995) and search in vain for a single ceramic illustration.

2. My first visit to the Chipstone Foundation's collection showed me that I had been wrong in assuming that by 1810 quality hand-painting on English pearlware was a skill of the past. The collection's large "William Wotton" pitcher, dated 1821, exhibited painting one would accept as dating around 1790.

3. In reality, strictly archaeological museums are a small minority. Most museums are more eclectic and confine archaeological exhibits to one gallery or department among many.

4. Hedley Swain, "Taking London Archaeology to Londoners," *The London Archaeologist* 9, no.1 (Summer 1999): 4.

5. Cited by Frank Herman, *The English as Collectors: A Documentary Chrestomathy* (London, 1972), p. 47, quoting the Victoria and Albert Museum's Advisory Council's "Report of the Sub-Committees upon the Principal Deficiencies in the Collection," 1913.

6. It seems curious that in seventeenth- and eighteenth-century London tobacco-pipe makers had their own guild, albeit sharing premises with the curriers, but that potters were unlisted. It seems that their commercial interests were handled through the Glass-sellers' Company, which met quarterly at the Antwerp Tavern in Bartholomew Lane. Nevertheless, in January 1673/4, while debating the imposition of new import duties to encourage British manufacturing and jobs for the poor, the House of Lords heard from "Mr. King, for the Wardens of the Company of Earthen Wares." However, it is evident from his testimony that his company was in the business of selling rather than manufacturing. *Ninth Report of the Royal Commission on Historical Manuscripts,* pt. 2 (London: Stationary Office, 1884), p. 32.

7. For the benefit of any ceramic collector who may imagine from all this aesthetic and museo-ethical posturing that archaeology is as abstruse as genomen analysis, let me explain: The art and mystery of digging archaeology rests on a very simple, two-brick foundation. One requires that we take the ground apart layer by layer, the last to go down being the first to come out. The other states that each layer or intrusion into it must be dated by the most recently manufactured pot (or other artifact) found in it. It is as simple as that. But simple or not, if the sequential information is not correctly recorded, any thesis built on it will sooner or later collapse. Care and common sense are an excavator's primary credentials.

8. R. Coleman-Smith and T. Pearson, *Excavations in the Donyatt Potteries* (Chichester, Eng.: Phillimore, 1988). Jacqueline Pearce, *Border Wares, Post-Medieval Pottery in London 1500–1700,* vol. 1 (London: Her Majesty's Stationary Office for the Museum of London, 1992). Thomas Ward was potting in Martin's Hundred immediately prior to the 1622 massacre. Ivor and Audrey Noël Hume, *The Archaeology of Martin's Hundred,* 2 vols. (Philadelphia: University of Pennsylvania Press, 2001). The 1677 Morgan Jones kiln in Westmoreland County, Virginia, was in operation for less than a year. Edward A. Chappell, "Morgan Jones and Dennis White: Country Potters in Seventeenth-century Virginia," *Virginia Cavalcade* 24, no. 4 (Spring 1975): 148–155. Chris Green, *John Dwight's Fulham Pottery Excavations 1971–1979* (London: English Heritage, 1999). Norman Barka, et al., *The "Poor Potter" of Yorktown: A Study of a Colonial Pottery Factory,* 3 vols. (Denver: United States National Park Service, 1984).

9. "Rouen faïence in eighteenth-century America," *Antiques* 78, no. 6 (Dec. 1960): 599–561.

10. Although professional archaeologists undertake salvage excavations on Dutch construction sites, many of the sixteenth- and seventeenth-century earthenwares and stonewares sold by British antique dealers have come from Amsterdam and other urban contexts. No one is going to applaud this practice on the jingoistic grounds that the protection of Dutch antiquities is somehow less worthy or necessary than saving comparable material from British or U.S. sites; but like animal lovers who become vegetarians in the hope of shaming their carnivorous neighbors, purists who spurn a dealer's imported pot will quickly be followed by

another customer with the necessary thirty pieces of silver—or thereabouts. Indeed, such high-mindedness is likely to result in the loss of information that could otherwise have been analyzed and shared. Ralph Merrifield, *The Roman City of London* (London: Ernest Benn Ltd., 1965), pp. 9–10. Merrifield rightly noted that any such transactions were illegal as any object found on private property belonged to the ground landlord. As a pragmatist (as well as arguably the best archaeo-curator of the second half of the twentieth century), Ralph recognized that "Human nature being what it is, however, in order to collect casual finds on building sites at all, it is usually necessary to come to terms with the finder." Ibid. *Catalogue of the Collection of London Antiquities in the Guildhall Museum,* 2nd ed. (London: Corporation of London, 1908), p. viii. In his introduction to the catalogue Edward M. Borrajo observed that "Any doubt as to whether a sufficient number of London antiquities could be brought together to fill the new apartment was dispelled by the many important finds which were soon to crowd the available space to such an extent as to render the adequate display of the objects impossible." He added that "It is also to be regretted that the exigencies of the design for the new building obliged the architect to place the museum below the street level." Among many decorative arts curators, the fact that archaeological artifacts come from below ground still makes the basement the best place for them.

11. I am aware that in numismatics the bronze alloy is correctly termed *orichalcum,* but it seemed pretentious to say so.

12. Ivor Noël Hume, *Discoveries in Martin's Hundred* (Williamsburg Va.: Colonial Williamsburg Foundation, 1983), p. 44, fig. 33.

13. The lion passant gardant and the cursive "L" date letter indicate a Chester origin in 1911.

14. "British and Continental Ceramics," April 20, 2000. London: Christie's South Kensington, lot 90.

15. Legitimate repairs or replacements are limited to putting back what is known to have been there. A broken rim can be infilled because one still has part of it to copy. The trouble comes when a restorer puts back a spout for which he has no physical evidence or adds a second handle on the grounds that bowls of that type *usually* had two. Only in the certainty that such bowls *always* had two would the replacement be justified. In every kind of restoration, be it in pots or palaces, less is best. Rita Susswein Gottesman, ed., *The Arts and Crafts in New York 1726–1776* (New York: New-York Historical Society, 1938), p. 88; *The New-York Journal,* January 2, 1772. Through my decades as director of Colonial Williamsburg's archaeological laboratory, it was my policy to restore broken pottery as skillfully as the artist was able to do, but only on the side visible to the museum-visiting public. The other was left uncolored so that an examiner could immediately see what was original and what was not.

16. Gottesman, *The Arts and Crafts in New York,* p. 87, citing *The New-York Gazette or the Weekly Post-Boy,* November 20, 1760.

17. Ibid., p. 86, citing *The New-York Journal or General Advertiser,* October 12, 1769. Ibid., pp. 86–87, citing *The New-York Journal or the General Advertiser,* July 6, 1767, and *The New-York Gazette,* January 31, 1763.

18. Probably because I have a meat-and-potatoes, tavern-table mentality rather than that of a drawing-room, tea table conversationalist.

19. Robert D. Ballard, "How We Found Titanic," *National Geographic* 168, no. 6 (December 1985), p. 718.

20. Associated Press, "Titanic seeker forced to abandon ship," *Daily Press,* Newport News, Va. June 26, 2000, p. A2. The salvage agreement governing the *Titanic* project currently forbids the sale of any of the more than five thousand recovered artifacts.

21. The excavation and subsequent research and conservation of the *Mary Rose* represented the twentieth century's greatest accomplishment in underwater archaeology.

22. George L. Miller, "The Second Destruction of the *Geldermalsen,*" *The American Neptune* 47, no. 4 (Fall 1987).

23. In both spheres one provides context for the other. Building remains are best dated and interpreted by reference to ceramics and other artifacts found in and around them, and shipwrecks similarly are served by their surviving equipment and cargoes. However, buildings and ships were, and remain, picture frames surrounding the life of the past represented by the portable artifacts.

24. Miller, "The Second Destruction of the *Geldermalsen,*" p. 277. This presupposes that they would first have had the money to mount a nonrefundable, time-consuming fishing expedition in search of the ship. It remains one of archaeology's best kept secrets that archaeologists are, themselves, the profession's principal beneficiaries.

25. J. Dyson, "Captain Hatcher's Richest Find," *Reader's Digest* (October 1986): 144.

26. "The Nanking Cargo," Christie's Amsterdam; sale beginning April 28, 1986. George Miller's employer, the Colonial Williamsburg Foundation, had invested several thousands of dollars in purchasing examples of the cargo that matched fragments found in Williamsburg excavations. The auction was seen as a unique opportunity for Williamsburg's curators to acquire the range of common export porcelains appropriate for inclusion in the furnishings of mid-eighteenth-century Virginia homes. It was to denounce this purchase that George Miller "felt it was necessary to speak out concerning the destruction of an important archaeological site and to make an attempt at educating people concerning the ethical and legal questions related to such acquisitions." Miller, "The Second Destruction of the *Geldermalsen*," p. 281. Miller also questioned whether Christie's deliberately kept the identity of the wreck secret to avoid legal entanglements with the Dutch and/or Indonesian governments (Ibid., p. 279). However, the published sources suggest otherwise. In the introduction to his book, Jörg stated that he was not told of the discovery until December 1985 and that his subsequent research led to his unequivocal identification of the ship as the *Geldermalsen*, his evidence put forward in his manuscript dated to February 1986. Christie's catalog was dated as being printed in December 1985, *before* the ship's identity was made known.

27. "Divisions Run Deep Over Protecting The Titanic," *The Washington Post,* July 5, 2000, p. A19.

28. There can be no denying that one lucrative salvage operation breeds another. In November 2000, Hatcher auctioned 350,000 pieces of porcelain from the Chinese junk *Tek Sing,* which sank in 1822, thereby providing porcelain students with a hitherto unparalleled opportunity to study wares made for the Oriental rather than the Occidental trade. See Nigel Pickford, "The Legacy of the Tek Sing," abridged by Robin Ph. Straub, as an overview accompanying "The Treasure of the Tek Sing" exhibition prior to its sale by Nagel Auctions, Frankfurt, Nov. 17–15, 2000.

29. *Aesop's Fables, with their Morals in Prose and Verse Grammatically Translated,* 18th ed. (London: J. Phillips and J. Taylor, 1721), p. 61.

30. Professional archaeologists in their polemic against all who improperly disturb the past do not distinguish between land sites and those beneath the oceans. There is, however, a fundamental difference. Save for the desecration of graves by pot hunters and the looting of battlefield sites by curio-hungry collectors, few land sites offer the return for effort or investment characteristic of shipwrecks. Consequently, the recovery of ceramics from dry contexts is invariably the accidental by-product of urban development. In my own experience as a salvage archaeologist I have known building contractors to deliberately cover over or rip out potentially rewarding pits and well shafts rather than face archaeologists standing in the way of construction.

*Figure 1* Engraving of teapot, earthenware with colored clay ornament; Messrs. Clay and Edge of Burslem, Staffordshire. This drawing appeared in the *Art Journal Illustrated Catalogue: The Industry of All Nations, 1851*, reprinted as *Great Exhibition: London's Crystal Palace Exposition of 1851* (New York: Gramercy Books, 1995), p. 41. The catalog entry for this teapot reads, "A patented branch of their [Clay and Edge] business is devoted to the ornamentation of similar articles by inlaying clays of various tints, thus producing an indestructible colouring for the leaves and other ornaments." At the end of Eliza Cook's tales, she gives a charge to 'good Summerley and his disciples' to 'beautify what thou canst for the people' and 'give beauty to poor places'" (p. 46). Summerley was none other than Sir Henry Cole, who had introduced the *Journal of Design and Manufacture* in 1847 and was one of the chief organizers of the 1851 exhibition.

*Figure 2* Jug, Minton and Company, Stoke-on-Trent, Staffordshire, 1840–1860. Stoneware. H. 6¼". (Private collection; photo, Gavin Ashworth.) The "Felix Summerley" tea-set designed by Cole (discussed above) was produced by Minton and Company. Herbert Minton made a wide array of table and tea wares in earthen, stone, and Parian wares, and he developed many lower-priced colored bodies, including the colors turquoise, blue, and "blue suck." The jug depicted here is similar to those awarded prizes by the Royal Society of Arts in the late 1840s (Joan Jones, *Minton: The First Two Hundred Years of Design and Production* [Shrewsbury: Swan Hill Press, 1993]).

*Ann Smart Martin*

# Magical, Mythical, Practical, and Sublime: The Meanings and Uses of Ceramics in America

▼ T H E  P O W E R  O F  B E A U T Y in everyday things underlies a long and enchanting tale from the mid-nineteenth century. The story begins in a disheveled crockery shop that, reflecting the nature of its proprietors, is filled with cheap, "dusty cups and saucers, of the coarsest kind and ugliest shapes."[1] In this dismal setting, two women meet by chance: one, a good-hearted seamstress whose teapot has just been broken; the other, the daughter of a pottery manufacturer, left penniless by her father's untimely death. In the throes of poverty, the young maid has come to sell her most prized possession—a brilliant blue china teapot described as having the shape of a melon, with richly colored buds, leaves, and flowers, and tendrils of honeysuckle (fig. 1).

The good-hearted seamstress took the beautiful vessel home, which immediately improved the tea-table behavior of the girls employed in her sewing shop. The teapot's former owner was able to overcome her financial distress and opened her own neighborhood crockery shop. Stocked with inexpensive but beautiful new wares, the little shop brought a whole new level of interest in art and refinement to the neighborhood's working class. They came in droves to buy new dishes and figurines to adorn their simple homes. A happy ending for all! And why not? After all, the "vital impulse necessary to artistic love and artistic excellence may be given to the child by the figure on his dinner-plate, or the form of his drinking cup." The artistry of these new wares continued to influence the local populace: "the little black classic figures upon the teapots have led to a taste for plaster casts; [such as] the Girl taking a thorn from her Foot, the dancing Hebe, the Child at Prayer, Eve at the Fountain."[2]

For those in this story, the availability of new and better wares engendered aesthetic appreciation, better manners, and a more pleasant domestic environment. Scattered throughout their dwellings were "small efforts of refinement, humble as they are on chimney-piece, spare table, or buffet." At the end of the tale, such pleasing homes could lead men and women away from the gin shops. In these everyday vessels, "a germ may be set . . . [to] elevate the moral being"[3] (fig. 2).

"The New Crockery Shop" by Eliza Cook is one of many Victorian morality tales peopled with stock players—poor beauties, good-hearted strangers, and wealthy blackguards. The catalyst for moral elevation is an innocuous set of objects: available, affordable, and desirable ceramics. The result? Redemption by aesthetics into a better world. As the story's narrator intoned, "art is invested with a sublime prerogative."[4]

Behind every good story lies an essence of truth. Teapots of the mid-nineteenth century could, indeed, be coarse and brown or refined and iridescently colorful. Several generations of technological advances in the potting industry—plaster molds, transfer printing, refined clays—had produced an explosion of highly decorated wares reaching new levels of beauty. In reality, the story's characters reflect the early modern world's delight with thinner ceramic forms and more vibrant colors, resulting from centuries of "china mania." The working people of Cooke's story represent an entire social class "passionately fond of crockery."[5] Part of their passion came from the novelty of the products: new, everyday wares that were more colorful, exciting, and elegant than ever before. And, as importantly, lower prices enabled more households to enjoy them. Nevertheless, their fondness for crockery also emanated from deeply rooted, often unconscious, and slow-changing cultural values embodied in the wares.

Some say ceramic dishes have powers. At one time or another, ceramic wares have been thought of as mythical, magical, practical, and sublime objects. After all, according to Judeo-Christian tradition, humanity itself was shaped in clay (fig. 3). The process of making a cooking pot, while no longer considered a divine act, is a transformation of what is natural to what is artificial. This act can be expressed as an opposition: nature (clay) versus culture (cooking pot). Another opposition is expressed in the function of the cooking pot. Cooking pots transform natural products (raw) to foodstuffs (cooked) (fig. 4). This most basic opposition is a direct way to analyze the role of ceramics, not only in our own society but also in other cultures of the world.

In nineteenth-century Silesia, people still believed there was a mountain from which cups and jugs sprang spontaneously, "like mushrooms from the soil."[6] Since food is elemental to life—and its processing and sharing a basic cultural form—the pots and dishes in which it is prepared and served can have a deep, hidden significance. Multiple cultures even record tales of magical cooking pots that refill themselves with food when dearth threatens.

Pottery's cultural significance is part of the realm of myth and magic. Ceramic vessels are practical containers for the sacred essence of life—food and water. Their use is nearly universal, crossing cultures, classes, and time. Ceramic vessels, because they are made from an easily malleable medium, can readily express the culturally prescribed notions of beauty. Ceramic objects are earth that, by the hand and eye of the potter, becomes art. The objects can be practical or ornamental, although all fit somewhere on a continuum of convenience and aesthetics. They can be beautiful in their inherent characteristics of form, glaze, texture, and decoration. And they can be sacred, as statues or vessels used in ritual ceremonies (fig. 5).

Thus, ceramics leap and soar through multiple categories of analysis. Just as some wares can be mysterious and elemental, others can be practical. The analysis of meanings may require an understanding of the complex interrelationships between commerce, science, and art. For example, when Josiah Wedgwood and Thomas Bentley purchased the Comte de Caylus's seven-volume work *Recueil d'Antiquitiés* to study the latest antiq-

*Figure 3* Tea bowl and saucer, Ching-tê-chên, China, circa 1730. Hard paste porcelain. D. of saucer: 4⅜". (Private collection; photo, Gavin Ashworth.) Images of Adam and Eve, while common on English delftwares of the seventeenth and early eighteenth centuries, are rare on Chinese porcelain. This tea bowl and saucer were enameled in the Netherlands.

Fig. 2.—Bowl of the Stone Age.

*Figure 4* "Cooking pot of the Stone Age" illustrated in Charles Wyllis Elliott, "Unglazed Pottery," *Art Journal,* 2nd series, vol. 3 (New York: D. Appleton and Co., 1877), p. 117.

*Figure 5* Portland vase and Peruvian stirrup vessel. Portland vase, marked "Wedgwood," Staffordshire, 1820–40. Jasperware. H. 9⅞". Stirrup vessel, Moche culture, Peru. H. 8⅞". Earthenware. (Private collection; photo, Gavin Ashworth.) Note the use of relief decoration to depict cultural myths.

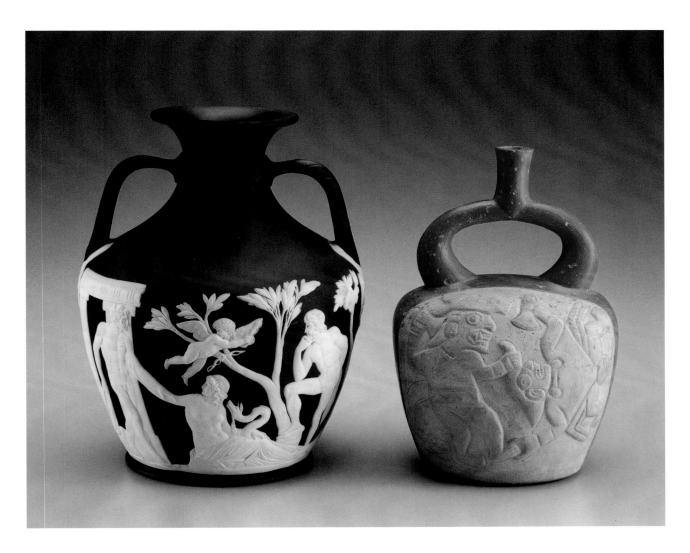

uities uncovered from the classical world, they were connoisseurs of art. When Wedgwood or Bentley customized specific vessel drawings by sketching in an additional handle or foot, they were businessmen who understood what modern eighteenth-century amenities would appeal to the buying public (fig. 6). When they needed to devise new manufacturing methods and find new materials, Wedgwood, an industrial scientist, drew upon his considerable technological knowledge and relied upon continuous experimentation.[7]

The possibilities for the study of ceramics are dizzying. Ceramics have much to say about everyday life. As material culture, their creation, use, and interpretation can be expressed as tangible products of human behavior. Because of their range of functions and widespread use, many observers of human behavior rely upon pottery as a ready source of data. Pottery has a myriad of archaeological, historical, economic, artistic, and social stories to tell. The folklorist Henry Glassie avers that pottery is the most intense of the arts; that is, pottery packs more cultural information into the smallest amount of space.[8]

The challenge, then, is to find an orderly method for its study. The following brief analysis illustrates the methods I use to organize thoughts about a wide array of ceramics. The model of study I propose is simple. Just like fictional tales or paintings, ceramic vessels speak. Numerous issues and themes, from economics to behavioral conventions, link ceramics across place and time. By identifying these relationships we can begin to pull together a kind of order or matrix that organizes them.[9]

To understand the use of ceramic wares in a given place and time, we must look at the *makers,* the *buyers,* and the *users* (not often the same person in early modern Western society). Issues of technology, time, space, function, and human behavior are only a few of the variables that are part of the matrix of ceramics study. In considering the making of an object, variables include the potter's vision, skills, and tools. A given design is enabled or constrained through multiple factors ranging from the availability of quality clay to the ease of transporting finished products to the consumer. Once the object is made for the market, it steps into an arena of consumer choice and use. The area of choice is the interim space between economic systems and the human passion for particular things. Finally, when we speak about *use,* we ask questions about variations of the relationship between object utility and human behavior.

Ceramics are dense carriers of meaning. Multiple questions can be asked of any one object but not every object answers every question best. The most useful questions often come from the object itself and may take the analyst in unexpected directions (fig. 7). As an example, the summary of questions and answers that is presented in figure 8 outlines one study method for approaching a ceramic artifact.

Along with those summary questions and answers, the larger sketch that follows is a wide-ranging account of such objects in seventeenth- through nineteenth-century Anglo-America. Together, they ultimately move the scholar from looking at objects to looking at a culture.

To begin: studying ceramics *in* America—a carefully chosen phrase—denotes complexity. Americans nearly always had choices among wares imported from (or through) Europe, as well as from those made locally. Before the twentieth century, American men and women were likely to eat food stored in American-made ceramic wares, but served on wares made in England. Beverages were often drunk out of hollow vessels from Germany (alcohol) or China (tea). Thus, two loose categories of study concerning the maker emerge: (1) wares made in America and (2) wares made abroad and imported to America.

*Figure 6* Head cantharus, plate 57, vol. 1. From Anne Claude Phillippe Caylus, comte de, *Recueil d'Antiquitiés egyptiennes, etrusques, grecques et romaines,* nouvelle edition (Paris: chez Desaint et Saillant, 1761). (Courtesy, Chipstone Foundation.) These books, originally owned by Josiah Wedgwood, contain a number of pencil annotations to the engravings. In this instance, note the addition of a base to the front-facing engraving.

The people indigenous to the Americas made pottery long before European occupation and supplied "Indian pots" to European settlements long after their arrival. African slaves brought ceramic technology with them and made low-fired earthenware often shaped and decorated to reflect their own cultural preferences and iconography. European and, later, American potters supplied earthenware and, eventually, utilitarian stoneware to a rapidly expanding colonial population. The creolization of people and cultures from Europe, Africa, and America can be traced in our ceramic heritage, and is, perhaps, one of the most exciting new ways to think about both ceramics and America.[10]

*Figure 7* Plate, Staffordshire, ca. 1815. Pearlware. D. 8⅜". (Private collection; photo, Gavin Ashworth.)

Figure 8 A study method for analyzing the plate with American eagle motif illustrated in fig. 7. By answering these questions, the analyst moves outward from an object to the societies that produced and used it. Later, comparisons and relationships with other objects or classes of artifacts are sought. Creative juxtapositions across time, space, and cultures raise new questions again structured in a matrix of time, space, technology, use, value, and aesthetics—and refine these answers.

APPEARANCE

Is there evidence of a maker—a signature or mark? *No. (Who made it then?)*

Has it been damaged, repaired, or altered? *Yes, four metal staples have been used to stabilize an old crack through the plate.* (What does this effort of curation suggest about market value or is it sentimental or personal value? When was it repaired?)

How was it decorated? *It was painted by hand.* (Is all the decoration original? Any evidence of later decoration or overpainting?)

What is its decorative formula? *Painted center motif and painted, molded edge.* (Why wasn't a copper plate cut with a detailed naturalistic image of the bird and transfer-printed on ware? Why not a more naturalistic depiction of the eagle?)

What is the decorative treatment of the edge? *Molded and edged by paint brush.* (How detailed is the molding and brushwork? This helps date the piece which among other variables suggests it was made in the 1815–1825 period.)

TIME

How old is it? *The slight blue tint in the lead glaze denotes the addition of cobalt to best imitate porcelain. This was common in the Staffordshire potteries from the end of the eighteenth to the beginning of the nineteenth century. The detail of the molding and brushwork suggests a date from the 1815–1825 period.*

What was its use life? (An economist would ask if it was a consumable or a durable.) *While breakable, this was a sturdy ceramic. Marks made by knives demonstrate that it was used as tableware before relegated to heirloom or antique.*

SPACE

Was it made for self or market? *At the time this plate was made, the Staffordshire industry shipped throughout Europe but the United States was its largest market.*

What was the political/trade system that produced and marketed it? *There was a complex set of tariffs after the War of 1812 but English wares still flooded American markets.*

How did it move through space from maker to user? *Probably via a path of land, canal, ocean, land.*

How were the wares vended? *Retail trade, both general stores and specialized emporiums. Also peddling.*

TECHNOLOGY

What is its body? *The clay is refined earthenware.* (What does "refined clay" mean and how did that innovation improve the look of wares and the overall process of making ceramics in the industry?)

How was it made? *It is factory produced.* (What did the word "factory" denote in the period?)

Was it molded? *The plate was formed by a mold. Decorative molding was an undulating edge to suggest a shell.* (How detailed is the molding and brushwork? How is this a form of reduction of labor, hence cost?)

USE

What was the vessel's function? *A flat container for serving food, with slightly curved edges to prevent rolling or spilling.* (What does that tell you about cuisine? Semi-liquid diet? Meat-starch?)

Was there a ritualized use? *Dining/eating, probably family, private/everyday. Less likely in an orchestrated public or special meal. Not considered a particularly high-status ware. Archaeological evidence places these wares on middle-class sites.*

Was it used for display only? *Knive marks and other scratches on the surface suggest it was used on the table.*

What was the human physical interaction with it? *Limited. Probably separated by utensils in hands, but probably carried. Felt smooth and light.*

What was its visual use? *Symbolic or metaphorical* (Is its symbolic power patriotic, in reference to the new nation, or classical, in reference to eagles as a European decorative technique? Is its shell motif allied with the interest in nature/classification?)

VALUE

Was it a common plate when it was made? *Shell edge wares were extremely popular; simple edged forms were common; hand-painted ones less numerous.*

Was it expensive then? *Relative to other plates (i.e. silver, pewter or porcelain), these were low to lower-medium priced ceramic table ware. Low priced competitors were redwares. More expensive ceramic forms were porcelains. Other non-ceramic competitors were wooden wares (treen) and the old and new metals (pewter and tin).*

Is it rare today? *Yes.*

Is it expensive today? *Relative to other earthenware plates from the period, yes.*

AESTHETICS

Is it "attractive" to the modern viewer? *For some, its clean lines are modern. For others, simple plates like these are popular forms of Americana. The American eagle is a desirable motif.*

Is it attractive to you? *To me, yes.*

Was it attractive to the viewer in the past? *The eagle motif appeared on multiple forms of decorative art in the period. Depictions of birds were extremely popular subjects of artistry.* (What other kinds of things looked like this? What was the visual universe in domestic settings in 1815?)

Was this simple painting a time-saver for lower cost? Or does it demonstrate a lack of training? *Perhaps, but not necessarily. There may have been an aesthetic alternative to three-dimensional realism in the form of flat color fields. This has been proposed as a possible explanation for the look of popular portraits made by self-taught itinerant artisan painters in the early nineteenth century.*

*Figure 9* Jug, Shelton, Staffordshire, 1803–1805. Creamware. H. 7¾". (Courtesy, Chipstone Foundation; photo, Gavin Ashworth.)

A number of significant trends occurred in the exportation of ceramic wares to America. Ceramic vessels were an important commodity that flowed from the places that expertly made them (Holland, China, Germany, England) to the places that wanted and needed them. Ironically, the English people sometimes ate and drank from the wares of their greatest political rivals. Most wares found in the American colonies after 1660 were controlled by the English merchants as specified in the Navigation and Trade Acts. With the development of the Staffordshire pottery industry in the late seventeenth century, virtually all imported wares were of English origin.

But what happened after colonists fought a revolution, ultimately to break the shackles of a foreign power? Politics changed, but pottery did not. Plates and dishes poured across the Atlantic for a century after political independence. The flood of images that celebrated the apotheosis of George Washington to mythic greatness was printed on English wares (fig. 9). The proud eagle that became a motif and sign of American nationalism was painted on English wares (see fig. 7). The forms of decoration changed, but the source of pottery did not.

Nevertheless, even if the Americans did not make their own plates, they did have a considerable say in what those wares looked like. The colonies were marginal to the profits of Staffordshire in 1770, and shipment of various new styles often lagged years behind their initial introduction. By 1824, however, a historic event like the landing of the Revolutionary War hero Marie-Joseph Lafayette in New York could be recorded as a print, transferred to earthenware, and be en route to the United States market in only five months' time (fig. 10).[11]

Throughout the nineteenth century, many Americans considered English wares superior to any others available to the American market. American merchants continued to advertise their stock of the latest and best imports. Jonathan Ludlow of Charleston, for one, trumpeted that he stocked fashionable imported crockery by printing the claim on the wares themselves (figs. 11, 12). European and English pottery factories have continued their reputation for fine quality wares today. By the late nineteenth century, however, the growth of American firms succeeded in filling multiple market niches for ceramics.

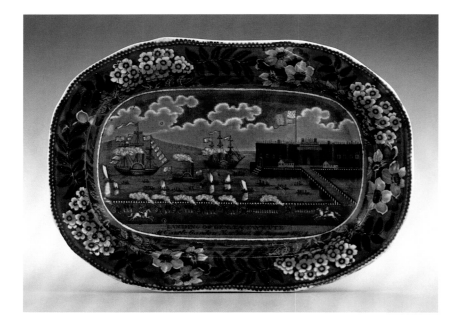

*Figure 10* Dish, James and Ralph Clews, Staffordshire, ca. 1825. L. 9½". (Courtesy, Chipstone Foundation; photo, Gavin Ashworth.) Landing of Lafayette.

In sum, to organize the study of the making of ceramics used in America, the researcher might first see the task as both local and global. In my own work, I generally think of three concepts that express degrees of variability. A person thinking visually might imagine a series of axes along which any vessel could be placed. The first line represents technology, ranging from simple, low-fired earthenware to complex, high-fired porcelain. The second line, representing time, attempts to assess the extraordinary cultural changes reflected in the history of ceramics. And the third line delineates space, or place. A ceramic can be made and used virtually in situ. More often it was made locally or imported from faraway cultures and regions, like Europe or East Asia.

Thus, issues about the making of ceramics may begin, literally, with the ground underfoot, but can quickly lead to questions about important institutional changes, massive economic forces of trade and industrialization, and elements of power and competition. Our matrix is partially built.

A researcher who goes on to study how ceramics are used adds more constructs, more lines to the matrix. He or she can address the intimate details of daily life or the public performances of parlor. Arcing through these stories of ceramic use is the extraordinary variety of function and allied human behavior. Nearly all humans use ceramics. But *how* they are used is usually quite culturally specific and often ritualized. Ritual use can mean the pouring of holy waters in a religious rite. However, in a more everyday sense—as learned and repeated behavior—ritual is manifested in building practices, foodways, and intimate social activities. If we wash our face in the sink, not in the toilet, we are displaying our sensibilities about human waste and care for the body. We are free to choose the toilet for our washing, but few, if any, do.

To begin the story of ceramic use, nothing is more integrally linked with ceramics than food and water. When storing, preparing, and serving food,

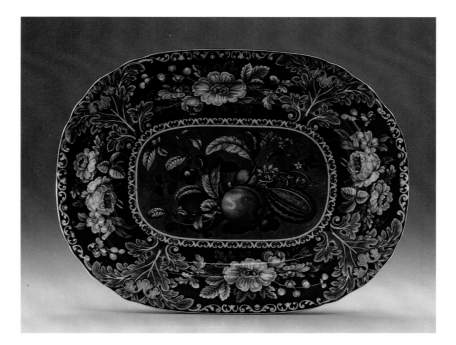

*Figure 11* Dish, Joseph Stubbs, Burslem, Staffordshire, 1822–1835. White earthenware. L. 16¾". (Courtesy, Chipstone Foundation; photo, Gavin Ashworth.)

*Figure 12* Detail of importer's mark for Ludlow and Co. of Charleston, South Carolina, on the reverse of dish illustrated in fig. 11. (Courtesy, Chipstone Foundation; photo, Gavin Ashworth.)

*Figure 13* Jar, eastern Virginia, 1840–1860. Stoneware. H. 9¼". (Private collection; photo, Gavin Ashworth.) The cobalt decoration and the added incised inscription of "Mary Bishop" is atypical of the utilitarian nature of these common vessels made and used throughout America in the nineteenth century.

people act in prescribed ways and with a myriad of objects that show how behavior is patterned and transmitted within a given culture. Before refrigeration, foodstuffs were often pickled in acidic media to stave off hunger through the lean days of winter. Glazed and fired clay vessels, such as stoneware, were the preferred type for protecting perishables. Hence, food storage was probably the most common use of clay vessels in eighteenth- and nineteenth-century homes (fig. 13). Preparing food also necessitated bowls, dishes, cooking pots, and other ceramic implements. These vessels for food storage and preparation were common and their forms and decorations were relatively constrained. This characteristic expressed both their utilitarian function and their place in domestic space; that is, usually out of public view.

Objects used in food serving, on the other hand, were more sensitive to cultural variability. The changes in tableware during the short history of Western people in America are part of a dramatic storyline. Significant transformations took place over time (and continue to do so). For example, a *single* large serving dish was an object appropriate for the tables of even well-to-do households in 1660. And like the palette on the large charger made by Ralph Simpson, many of these household vessels were largely the colors of earth, forest, or mine (fig. 14).

A century later, a well-set table of the upper class would include *multiple* individual plates, hollow serving vessels for sauces, dishes for culinary complements to meat, and an array of objects to serve extra courses. All were available in a broad variety of forms with a variety of decorations (fig. 15). The changes in the forms of everyday wares that followed reflected a continuing formalization of behavior. Dining was a theatrical performance of learned manners. Dishes became props. Those who dined used implements to separate their bodies from their food. Forks and knives became surrogate fingers (fig. 16).

*Figure 14* Dish, Ralph Simpson, probably Burslem, Staffordshire, 1680–1720. Slipware. D. 18¼". (Courtesy, Chipstone Foundation; photo, Gavin Ashworth.)

*Figure 15* Pair of sauce boats, London, ca. 1760. Tin-glazed earthenware. L. 8¼". (Courtesy, Chipstone Foundation; photo, Gavin Ashworth.)

Styles of decoration also ebbed and flowed, but the sum effect of technological breakthroughs and ever-changing desires was that mid-eighteenth-century consumers had more choices than ever before. Understanding those choices demonstrates how complicated the world of pottery had become. Case in point: the use of large platters continued into the early 1800s as the honorific stage for an expensive cut of meat. A common form of late-eighteenth-century and early-nineteenth-century decoration was a painted, feathered rim resembling the edge of a shell (hence, the name "shell edge") (fig. 17). To produce this decoration, a manufacturer had to choose the levels of skill, time, and materials involved and, consequently, the cost and potential profit. Thus, one shell-edged platter might display gilt; another, blue paint. The more expensive gilt-edged version might be decorated with classical motifs of the latest fashion; the less expensive,

blue-painted one, with a time-honored Asian design such as the Chinese house pattern (fig. 18).

To elaborate on the stylistic variables popular with Anglo-American consumers by the end of the eighteenth century, Josiah Wedgwood and a host of potters responded to, and helped shape, the public's excitement for newly discovered classical antiquities by producing modern copies and interpretations. This trend arose in the midst of a century-long passion for Asian design. But one did not replace the other. Potters produced classical vases and

pots for the elite, who followed the latest fashion as a means of communicating their wealth and social status. The "middling"- and lower-class customers still enjoyed Western versions of Asian designs, which were increasingly affordable as prices declined. Thus, any search for a progression of taste and style is filled with crosscurrents inherent in any complex social system.

By the late eighteenth century and beyond, upper- and middle-class families did share the belief that a matching set of dishes was a good first step toward proper dining decorum. Today, informality of daily life increasingly challenges this structured use of tableware. Specialized spaces for dining have diminished and family mealtimes are under challenge. Equally significant, the taboos that arose during the Renaissance against touching food with the hands in polite society have eroded.[12]

This twentieth-century reversal partially came about from the most innocuous of sources—the sandwich. With the sandwich, we can now use bread to avoid touching the meat. Cutlery is unnecessary. And with paper food wrappers, even the plate is no longer needed. This type of on-the-go, throw-away mealtime has become the norm. We retain vestiges of social relations that were new to the eighteenth century when we gather around the table at Thanksgiving. Then, once more, the ceremonial stage gains prominence with clean linens, gleaming tableware, and the turkey platter, the table's central podium.

The history of ceramics and food consumption are inextricably intertwined. Ceramics, however, fulfilled many less obvious needs. Standards of hygiene, for example, like ideals about cuisine, grew increasingly structured as the eighteenth century progressed. Just as keeping one's body clean became more routine, vessels for washing and shaving became more necessary. The corollary to a purer body would be a more adorned body, necessitating the use of cache or small ointment pots to store color and powder. All of these taboos about nature and natural appearances (unwelcome dirt, hair, or skin condition) expanded to include ideas about the removal of bodily waste. People welcomed an increasing number of chamber pots (fig. 19). The particular shapes and sizes of chamber pots were significant, with preference presumably based on utility: number and sex of users, frequency of emptying (and by whom), and even stability if accidentally kicked in a dark bedroom. As the vessels became more common, they also became more varied. One store inventory in 1800 listed five different sizes of chamber pots.[13]

Even while the deeply symbolic movement from nature to culture was ongoing, an admiration of nature and its classification led to a fashion for disguising and replicating nature in artificial forms. A gentleman who gardened grew masterful fruit. A gentleman who dined ate from masterful ceramic fruit (fig. 20). A gentleman interested in archaeology might drink from a teapot replicating a Greek vessel or one whose body mimicked geological processes (fig. 21). Both form and decoration could replicate nature.

Nonetheless, ceramics did not merely illustrate the larger world. Ceramics taught people. Popular forms and decorations allowed the viewer to trace the vines or the ribs of the shell. After the advent of transfer printing, one who gazed at a ceramic vessel might more easily read poetry, or be urged to moral certitude by the aphorisms of Poor Richard, or the sloganeering of the abolition trade (fig. 22). Most significantly, ceramics allowed imaginary travel to unknown places. The Western world's affection for the exotic products of Asia led to massive production for millions of curious consumers. Not realizing (or perhaps not caring) that the images of China were fantastical, Europeans could travel to the Far East through the tracings on their teacups. They could gaze at "courtly Mandarins" or delicate Chinese women "stepping into a little fairy boat, moored on this side of a calm garden river."[14] Indeed, Robert Southey believed that "the plates and tea-saucers have made us better acquainted with the Chinese than we are any distant people" (fig. 23).[15]

*Figure 19* Chamber pot, Donyatt, North Devon, 1680–1700. Slipware. H. 6¾". (Courtesy, Chipstone Foundation; photo, Gavin Ashworth.)

*Figure 20* Tureen, Staffordshire, ca. 1765. Creamware. H. 8¾". (Courtesy, Chipstone Foundation; photo, Gavin Ashworth.)

*Figure 21* Teapot, probably Yorkshire or Staffordshire, ca. 1765. Creamware. H. 5⅜". (Courtesy, Chipstone Foundation; photo, Gavin Ashworth.) Enameled in the so-called fossil pattern.

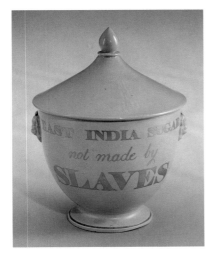

*Figure 22* Sugar bowl and lid, Staffordshire or Sunderland, ca. 1820. Earthenware. H. 6". (Courtesy, Chipstone Foundation; photo, Gavin Ashworth.) Inscribed "EAST INDIA SUGAR NOT MADE BY SLAVES," these antislavery slogans on ceramics were often commissioned for abolitionist societies.

*Figure 23* Coffee or chocolate pot, probably Yorkshire or Staffordshire, 1775–1790. Creamware. H. 8⅞". (Courtesy, Chipstone Foundation; photo, Gavin Ashworth.)

So far we have imagined the physical interaction between ceramics and humans as cool or warm clay meeting hands and fingers or, if one is balancing a heavy burden, perhaps encountering even a hip, shoulder, or waist. We have allowed eyes to read and brain to enjoy rich color and cool hue. But a significant interaction between human and ceramic remains. Both cups and people have *lips* and the shared name may be no accident. Often the two, mouth and cup, would meet. Here again, the range of

activities, formal and informal, everyday and special, produced an astonishing array of forms.

Vessels for consuming alcohol, whether used medicinally or simply to help forget the daily grind, were common in both households and taverns. Even more than ceramic wares used for dining, the extraordinary shapes of drinking vessels demonstrate ritual use. Many of the vessel forms for drinking alcohol embodied the communal aspects of the drinking. Seventeenth-century multihandled forms, such as tygs, give ample evidence of their use: a centrally placed drinking vessel that could be reached from multiple sides or passed from person to person (fig. 24). Punch bowls, too, went hand to mouth around a group. To our twentieth-century eyes, some of the most whimsical vessels of the past are the puzzle jugs, whose purpose was as much to promote merriment and camaraderie as to serve alcohol. In the same way, the form of the harvest jug tells much about the action of farmers and field workers, often neighbors, who joined forces to bring in the harvest. Passed hand to hand, these large storage vessels quenched the thirst of a hard day's labor. What the ditties and poems celebrated in writing, the form often did in clay (figs. 25, 26). Moreover, the flood of individual-size stoneware mugs of the eighteenth century suggests that, like dining, drinking had become a more independent pursuit.

The rituals of drinking have changed markedly in the history of America. Centuries-old puzzle jugs seem whimsical, but we also wonder at today's martini hour and all its associated accoutrements for measuring, shaking, and serving. Gathering around a punch bowl has been mostly reduced to the ceremonial occasions of weddings and holidays (as is usually the case with a dying custom) or to those nonalcoholic public events of church and state. Mugs are for coffee, not beer.

*Figure 25* Harvest jug, Barnstaple or Bideford, North Devon, 1748. Slipware. H. 12⅛". (Courtesy, Chipstone Foundation; photo, Gavin Ashworth.)

*Figure 26* Detail of the jug illustrated in fig. 22. "Now I am come for to Supply your workmen when in harvest dry when they do Labour hard and Sweat good drink is better fare then meat also in winter when tis cold I like wise then good drink can hold both Seasons do the Same require and most men do good drink desire John Hockin 1748." (Courtesy, Chipstone Foundation; photo, Gavin Ashworth.)

Even more arcane and incomprehensible to some of us today is the elaborate social ceremony surrounding tea time of one or more centuries ago. But remember, it was a teapot that led to redemption in "The New Crockery Shop." It was the improved tea-table behavior of the shop girls that was evidence of moral improvement. It was the pleasant home and warmth of the tea table that led the poor away from the gin shops. Poetic license of storytelling aside, public alcohol consumption did decline in the nineteenth century, coincident with the rise of private tea drinking. There, two activities were also dialectically opposed in their gender connotations. When men drank alcohol at home in a formal setting, women left the room. When men drank tea, women controlled the room.

When people took tea, they were loosely or tightly grouped around a set of objects, quite specialized to the task of sipping tea. A table, whose form was new and specifically functional to serving tea, was often center stage. Upon it was a host of paraphernalia necessary for precise performance of a ritualized event. A set of rules, from proper pouring technique to polite conversation, grounded this elaborate performance. Of course, as shown in figures 27 and 28, performances did not always follow the script. And at absolute center stage was the teapot. While silver and other lesser metals were used, porcelain and earthenware teapots were often thought to be the most beautiful and produce the best-tasting tea. The unknown "M. Wolfe"'s stunning green glaze and gilt teapot was beautiful, but a name was added to assure prominence (fig. 29). That extraordinary centrality of the teapot in eighteenth- and nineteenth-century life, first for the well-to-do, then for the working class, is comparable to the 1960s television set that clustered family and friends together around one object,

Figure 27 Hand-colored engraving, "The Advantages of Wearing Muslin Dresses!," James Gilray. Published Feb. 15, 1802, by H. Humphrey, 27 St. James Street, London. (Private collection.)

Figure 28 Detail of the engraving illustrated in fig. 23.

perhaps with a new-fangled *ceramic* snack set. (Today, the family members may be scattered though the house watching television and drinking coffee from personalized mugs.)

In this way, teapots became the daily prop that was handled by the star of the household and admired by all. People closely followed their changing forms and decorations. They were as much a part of evolving fashion as female clothing. For others, such as the good-hearted seamstress of "The New Crockery Shop," the teapot's value came from years of daily sharing—the pot became a physical symbol of passing time and pleasant company. Hence, her gasp as the pot crashed to the floor was for more than shattered crockery.

This essay opened with a story of a beautiful blue teapot. The tale worked because it expressed for its author and its audience what they thought, imagined, or wished to be real. Paintings, too, record a kind of truth and fiction. For example, in 1864, a flood inundated Sheffield, England. A con-

*Figure 29* Teapot, probably Derbyshire, ca. 1770. Creamware. H. 6". (Courtesy, Chipstone Foundation; photo, Gavin Ashworth.) An unusual green-glazed creamware teapot with the added embellishment of cold-gilding and the inscription "M. Wolfe".

*Figure 30 A Flood*, Sir John Everett Millais, 1870. (Courtesy, Manchester City Art Galleries.)

temporary poem recorded that a cradle, with child and kitten still asleep inside, had been swept out of a cottage by the watery deluge. Sir John Millais recorded the scene in an 1870 painting, simply titled *A Flood* (fig. 30). In Millais's painting, the baby awakens in surprise and delight at the scene before her and the kitten mews in half-drenched misery. No less a tale of Victorian pathos than "The New Crockery Shop," the sentimental scene suggests both the horror and the miracles of such a natural disaster. The household furniture, the infant, and the pet—all combine to create a domestic scene. A ceramic jug, floating in the bottom corner of the picture, is only half submerged. It floats almost magically along with child and cat—the survival of each, a symbol of hope.

The jug was not in the original painting. Fifteen years after its execution, Millais "re-touched the picture extensively with the view to re-storing to it some of the sparkle of which Time had robbed it."[16] The jug was added to the space on the canvas that had formerly been occupied by a pig. Replacing the pig with the simple mochaware water jug was the perfect imaginary

and artistic touch. The jug was a simple, practical vessel for carrying water, drinking, bathing, and for household chores too many to count. Finally, like many utilitarian objects, it was hardly plain. The yellow ceramic body with hints of white and blue bobbing in the murky browns of the painting was sublime. The vessel was magical, mythical, practical, and sublime. The artist John Millais and the writer Eliza Cook both knew vessels carried more than water or tea. They could be used every day, but they could carry deep meaning.

ACKNOWLEDGMENTS
Many people helped with specific tasks in creating this work. These include Eleanor Gadsden, Nancy Sazama, Cate Cooney, Amy Ortiz Holmes,

Jacob Esselstrom, Ryan Grover, Nancy Marshall, Frank Horlbeck, Anna Andrzejewski, Patricia Samford, Jon Prown, George Miller, and Rob Hunter. I am also grateful to Carl and Katherine Martin who had the uncanny ability to know whether to leave me alone or distract me away. All are due my thanks.

1. "The New Crockery Shop," *Eliza Cook's Journal,* vol. 1 (London: John Owen Clarke, 1849), p. 21. *History of Women* (Woodbridge, Conn.: Research Publication Series), microfilm, reels 52–53.

2. *Eliza Cook's Journal,* vol. 1, p. 36.

3. Ibid.

4. Ibid.

5. Ibid., p. 21.

6. Charles Wyllis Elliott, "Unglazed Pottery," *Art Journal,* 2nd series, vol. 3 (New York: D. Appleton and Comp., 1877), p. 117.

7. Head Cantharus, vol. 1, pl. fifty-seven. Anne Claude Phillippe Caylus, comte de, *Recueil d'Antiquitiés egyptiennes, etrusques, grecques et romaines,* Nouvelle edition (Paris: chez Desaint et Saillant, 1761). The Chipstone Foundation has recently acquired the seven-volume set owned by Josiah Wedgwood and research is beginning into the series of annotated drawings and marks.

8. Henry Glassie, *Material Culture* (Bloomington, Ind.: Indiana University Press, 1999), p. 222.

9. An earlier version of this kind of method can be seen in Ann Smart Martin, "Makers, Buyers, and Users: Consumerism as a Material Culture Framework," *Winterthur Portfolio* 28, no. 2/3 (Autumn 1993): 141–157.

10. For Africans-Americans, see Leland Ferguson, *Uncommon Ground: Archaeology and Early African America, 1650–1800* (Washington, D.C.: Smithsonian Institution Press, 1992). For an argument supporting the continued role of indigenous Americans, see L. Daniel Mouer, Mary Ellen N. Hodges, Stephen R. Potter, Susan L. Henry Renaud, Ivor Noël Hume, Dennis J. Pogue, Martha W. McCartney, and Thomas E. Davidson, "Colonoware Pottery, Chesapeake Pipes, and 'Uncritical Assumptions,'" in Theresa A. Singleton, *"I, Too, an America": Archaeological Studies of African-American Life* (Charlottesville: University Press of Virginia, 1999), pp. 83–115 . Ferguson, *Uncommon Ground.*

11. George L. Miller, Ann Smart Martin, and Nancy S. Dickinson, "Changing Consumption Patterns: English Ceramics and the American Market, a Case Study," in *Everyday Life in the Early Republic, 1789–1820* (New York: W. W. Norton for the Winterthur Museum, 1994).

12. Charles L. Venable, Ellen P. Denker, Katherine C. Grier, Stephen G. Harrison, *China and Glass in America 1880–1980: From Tabletop to TV Tray* (New York: Harry N. Abrams for Dallas Museum of Art, 2000).

13. Edward Dramgoole Store Inventory, October 1, 1800, Brunswick County, Virginia. Dramgoole Family Papers, Library of Virginia, Richmond, Virginia.

14. Charles Lamb (1775–1834) "Old China," in *A Book of English Essays,* edited by W. E. Williams (New York: Penguin English Library, 1980), pp. 92–100.

15. Robert Southey, *Letters from England,* edited by Jack Simmons (London: 1807; reprint, London: The Cresset Press, 1961), pp. 191–192.

16. John Guille Millais, *The Life and Letters of Sir John Everett Millais,* vol. 2 (New York: Frederick A. Stokes Co., 1899), pp. 18–19. M. H. Spielmann, *Millais and His Works* (Edinburgh and London: William Blackwood and Sons, 1898), pp. 115–116.

*Beverly Straube*

# European Ceramics in the New World: The Jamestown Example

*Figure 1* Archaeological excavation at Jamestown, Virginia. Overview (looking west) of area opened up on the banks of the James River on Jamestown Island that revealed traces of the fort erected by the English in 1607. (Courtesy, Association for the Preservation of Virginia Antiquities; photo, David M. Doody.)

▼ A R C H A E O L O G I S T S   L O V E to find ceramics on their sites and, luckily, because of the nature of clay vessels, they are usually not disappointed. Ceramic material, being of the earth, seems to form a symbiotic relationship with the soil that surrounds it. Unlike iron objects that rust away, glass materials that devitrify into splinters, and bone and wood artifacts that rot into mush, pottery endures. The sherds may break apart and get smaller as nature or people move them around, the glazes may begin to separate from the fabrics, but the wares will still be identifiable.

Ceramics have been used throughout history to ship, store, prepare, and consume food and beverage. In addition, they have functioned to provide heat, light, and other day-to-day comforts. And they were often used as a sign of social status.

The use of pottery in everyday life subjects it to frequent breakage and disposal, but its relative durability ensures that the fragments survive. Ceramics, therefore, are one of the most important classes of artifacts excavated by archaeologists. They can reveal information about date, status, function, trading patterns, changes in eating or drinking habits, and migrations of populations.

This said, it must be mentioned that ceramics are all but invisible in the historical record. They are rarely listed on probate inventories and, if so, only in general terms. Shipping and customs records seem interested in ceramics only secondarily, as containers of goods. Indeed, there are no references in English importation records of pottery being the sole or most important cargo. It is up to archaeology to help fill the gaps in our knowledge.

The Jamestown Rediscovery excavations in Jamestown, Virginia, have uncovered more than twenty thousand fragments of pottery since 1994 (figs. 1–4). Most of these sherds are from contexts within what was known as "James Fort." Built by the 104 men and boys who arrived from London in May 1607, James Fort is the site of the earliest permanent English settlement in the New World. It is where the United States of America began. What more fitting place to study some of the earliest European ceramics used in America?[1]

The Jamestown colonists did not attempt pottery production in Virginia until the 1630s. Before that time they had to rely on vessels produced elsewhere. Besides England, the countries of origin represented in the Jamestown Rediscovery ceramic assemblages are China, France, Germany, Belgium, Italy, the Netherlands, Portugal, and Spain. These countries were not directly trading with Jamestown, however.

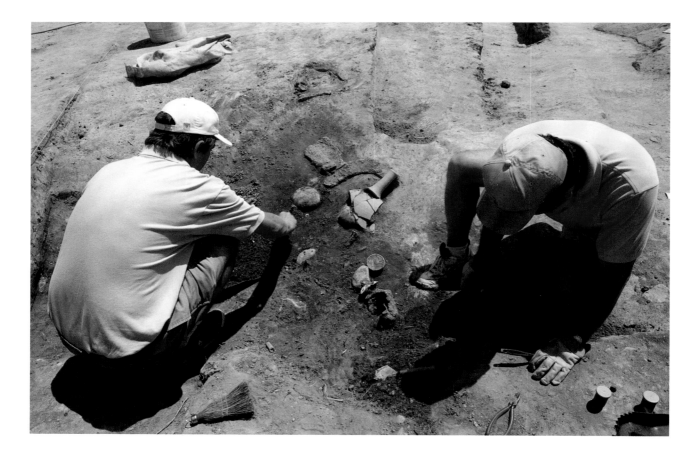

*Figure 2* APVA archaeologists excavating artifacts from what proved to be a cellar, possibly to a blockhouse of James Fort, that was filled ca. 1610. (Courtesy, Association for the Preservation of Virginia Antiquities.)

*Figure 3* Detail of a London distilling flask as found in the course of excavation of the ca. 1610 cellar. (Courtesy, Association for the Preservation of Virginia Antiquities.)

*Figure 4* Distilling flask, London, 1600–1610. Unglazed earthenware. H. 15". (Courtesy, Association for the Preservation of Virginia Antiquities; photo, Gavin Ashworth.) The mended flask as seen in fig 3. One of a number of London coarsewares that have been recovered from James Fort's earliest contexts. Distilling flasks are frequently found in London contexts dating to the sixteenth and seventeenth centuries. Most often associated with metal-working sites, these flasks are believed to be cucurbits, or the bottom elements of stills.

From its inception until 1624, the colony of Virginia was under the control of the Virginia Company of London. This group of entrepreneurs, made up largely of London merchants and craftsmen, supplied the settlement out of London whenever possible, most often for their own enrichment. The Virginia Company provided the household ceramics for Jamestown beyond those brought by the individual colonists as part of their personal possessions. As such, the diversity of Jamestown's ceramics reflects the cosmopolitan nature of London in the early seventeenth century.

What can these silent but durable, sometimes colorful, objects tell us about America's colonial past? Why, for instance, is Italian comedic theater represented at Jamestown? How does a small Chinese porcelain vessel link Jamestown, Virginia, with another Jamestown island off the African coast, and thereby to the Dutch trading monopoly with the East? What does a German count, who was instrumental in the political play foreshadowing the Thirty Years' War, have to do with the Virginia settlement?

These and other questions will be addressed in the following review of just a few of the many important ceramics types that have been excavated during Jamestown Rediscovery's excavations of James Fort. This review is intended to provide a glimpse into many years of future research that will cast new light on the early American ceramic assemblages that have generally received little attention by decorative arts scholars. As discoveries continue to be made at the site of America's first permanent English settlement, our understanding of the cosmopolitan nature of ceramics trade and usage will be further refined in the next decade of exciting archaeological research.

## Chinese Porcelain

The most obvious aspect of Dutch artist Christoffel van den Berghe's painting is, as the title *Bouquet of Flowers in Glass* suggests, the beautiful central floral arrangement (fig. 5). But a closer look will reveal such exotica as seashells of the family *Conidae,* coming from the western Pacific, and

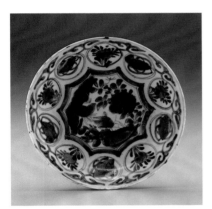

*Figure 5 Bouquet of Flowers in Glass,* Christoffel van den Berghe, 1617. (Courtesy, Philadelphia Museum of Art, John G. Johnson Collection.)

*Figure 6* Dish, China, 1613. Hard-paste porcelain. D. 8¼". (Private collection; photo, Gavin Ashworth.) An example of Chinese porcelain recovered from the *Witte Leeuw.* The central medallion contains a grasshopper on a rock and a peony. The border is decorated with alternating flowers and symbols.

tiny porcelain wine cups from China. The date of the painting is 1617, just fifteen years after the establishment of the United East India Company (Vereenigde Oostindische Compagnie), generally referred to as "V.O.C."

In 1613 the V.O.C. ship *Witte Leeuw (White Lion)* sank in Jamestown Bay, a South Atlantic inlet off of Africa's west coast, during a battle with two Portuguese merchant vessels. The settlement there, on the tiny island of St. Helena, was called Jamestown, half a world away from the colony founded by Englishmen in the New World. The two Jamestowns are inextricably linked however, by diminutive Chinese porcelain cups like those depicted in the van den Berghe painting.

The *Witte Leeuw* had stopped at St. Helena to take on fresh supplies for the rest of her trip back to the Netherlands, with a cargo of spices, diamonds, and porcelains from the East. This respite proved disastrous when two Portuguese carracks laden with goods from India chose the same protective anchorage. In the era's struggle for dominance in the Eastern trade, the Portuguese and Dutch customarily sank or seized each other's ships. And there was no exception this time. An English eyewitness to the ensuing battle revealed that a cannon on the *Witte Leeuw* "broke over his Powder Roome . . . and the shippe blew up all to pieces."[2]

The *Witte Leeuw* was excavated in 1976. Among the many artifacts recovered by archaeologists are over three hundred complete or nearly complete Chinese porcelain vessels, plus another one hundred fifty to two hundred pounds of porcelain fragments (fig. 6). According to the divers on the wreck, the recovery probably represents only a quarter of the total porcelain cargo carried by the ship. These findings are surprising since the ship's loading list made no mention of porcelain. Possibly the vessels were the personal goods of the captain, officers, or passengers, but the sheer quantity of material, the multiple sets of forms, and the decoration suggest that it was a cargo paid for and ordered by the Dutch V.O.C.[3]

Part of the porcelain assemblage includes at least forty small, thinly potted wine cups. Some are plain, but most are neatly painted, in underglaze blue just above the foot ring, with a band of scrolls under a flame pattern. "The shape is typical Chinese and resembles the well-known winecup or, in Japan, the sake-cup."[4] The wine cups are of the type known as fine porcelain, and until their recovery from the *Witte Leeuw* it was not known that this quality of porcelain had been exported at such an early date. Fine porcelain in the early seventeenth century was customarily considered Imperial ware, reserved for use by the Chinese elite. Since the *Witte Leeuw* discoveries, however, these same wine cups have been recognized elsewhere, including another Dutch shipwreck, the *Banda* (which sank at Mauritius in 1615), thereby substantiating their use as export ware.

The wine cups reached the Netherlands at least by 1617, as evidenced by the Dutch still-life painting of that date depicting two of these vessels. The latest context in which these cups have been found is the 1640s shipwreck of a Chinese merchantman, known as the "Hatcher wreck," in the South China Sea. Predating *any* of these examples is the wine cup excavated from a circa 1610 context within James Fort (fig. 7).

More than a dozen of these fine wine cups have been found on seventeenth-century archaeological sites along the James River in Virginia. Because of the wide range of contexts (ca. 1610–1640) in which these vessels have been found, the cups do not appear to have been part of a single shipment. In addition, the cups from the latter part of the period display different typological characteristics. The later vessels are thicker than the early examples and the decorative scroll-and-flame frieze is painted higher up on the body.[5]

The wine cup at James Fort was most assuredly brought by, or sent to, one of the gentlemen in the colony. A gentleman's position in that society was assured as much by the material goods he possessed and the way he dressed as by any inherited title. As a rare and expensive object, the Chinese porcelain wine cup would be quite fitting as a status indicator for an upper-class individual.

The vessel may have been used to drink a strong alcoholic beverage such as the *aqua vitae* listed as part of each colonist's provisions, or it may have been simply for ostentatious display. It was quite fashionable among European nobility and upper classes to assemble curiosity cabinets in the early seventeenth century. These displays consisted of objects, collected around the world, that were scientifically interesting, exotic, or precious. According to one art historian, "*Naturalia—objets trouvés* such as pearls and shells—were mixed quite happily with *arteficialia,* that is, precious man-made objects including coins, medals, paintings, sculptures, Nautilus goblets, astronomical gadgetry, etc."[6] Porcelains, often mounted in silver or gold, were frequently part of these exhibits. In fact, a cabinet assembled between 1625 and 1631 for King Gustavus Adolphus II of Sweden contained three of the flame frieze wine cups.[7]

The Jamestown wine cup was most likely part of a Dutch shipment of goods from the East that was traded in London. The English were doing very little trade with China, even after the founding of the English East India Company in 1600. It was the Dutch East India Company that, in the late sixteenth century, wrested control of the East Indian trade from the Portuguese. Portugal had been the conduit for Chinese porcelains into Europe from the turn of the fifteenth century. The Dutch continued to hold the porcelain trade throughout the seventeenth century.

## Portuguese Tin-Glazed Wares

By the late sixteenth century, the Portuguese potters had begun to produce a blue-and-white faience, reflecting their love of Chinese porcelain. The opaque white tin glaze made an appropriate background for the blue-painted Chinese motifs. The earliest known dated Portuguese faience is a bowl inscribed "1621." The exterior of the bowl is decorated in panels of flower sprays and columns, in close imitation of Chinese Wan-Li models, like other vessels produced in the first quarter of the seventeenth century.[8]

By the second quarter of the seventeenth century, armorial motifs and other Western devices were introduced and the Chinese elements had become much more stylized. By the third quarter, manganese-colored outlines were introduced to the blue palette and large spiderlike devices were popular rim motifs (fig. 8).[9]

*Figure 8* Dish, Portugal, ca. 1660. Tin-glazed earthenware. D. 14⅝". (Private collection; photo, Gavin Ashworth.) An example of a Portuguese enameled dish painted in blue with manganese outlines of the Wan-Li-style decoration. Large dishes of this type have been excavated at Jamestown. A similar dish with this rabbit motif was excavated from another seventeenth-century site near Jamestown.

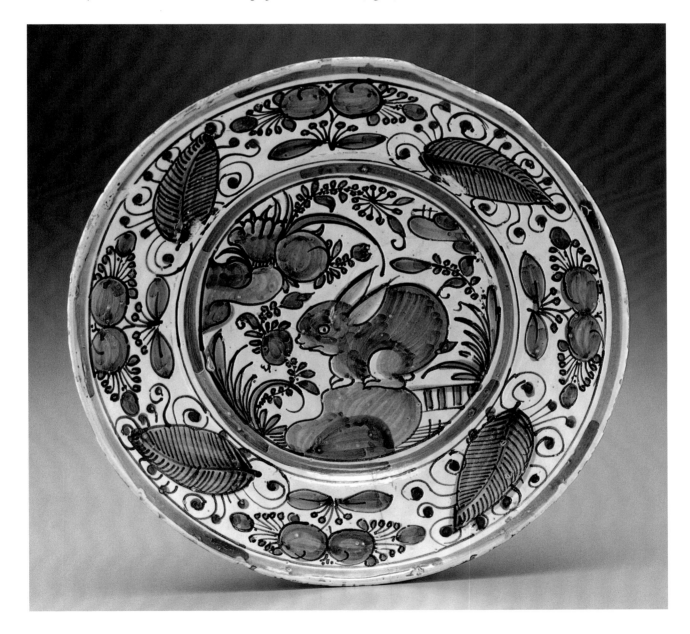

Portuguese chinoiserie was not very popular in England or the Netherlands; these countries were producing their own tin-glazed earthenware copies of Chinese porcelain. However, significant quantities of Portuguese faience have been recovered from archaeological sites in New England. This is believed to be the result of intense Anglo-Portuguese trade—which included fish and wood exports from New England—after Portugal's independence from Spain in 1640.[10]

This pattern does not hold for the seventeenth-century Chesapeake Bay area of Maryland and Virginia. Very little Portuguese faience has been found on sites that would have been supplied by the English and the Dutch. The one exception occurs in the environs of Jamestown, where numerous vessels from contexts dating to the second and third quarters of the seventeenth century have been recovered (figs. 9, 10).

*Figure 9* Bowl section, Portugal, ca. 1640. Tin-glazed earthenware. H. 2⁹⁄₁₆". (Courtesy, City of Newport News, Virginia, Boldrop Collection; photo, Gavin Ashworth.)

*Figure 10* Shallow dish fragment, Portugal, ca. 1640. Tin-glazed earthenware. (Courtesy, The National Park Service, Colonial Historical National Park; photo, Gavin Ashworth.)

One large dish fragment in the Jamestown collection is painted with a duck on its interior base (fig. 11). The dish resembles the Chinese porcelain dishes painted with waterfowl that were also found on the *Witte Leeuw* shipwreck. The elements are somewhat debased, however, and represent a departure from strict adherence to the Chinese design.

Another series of at least six dishes, decorated with hastily executed striped borders radiating from a central floral motif (fig. 12), was found in

*Figure 11*  Dish, Portugal, 1620–1640. Tin-glazed earthenware. D. 9". (Private collection; photo, Gavin Ashworth.)

*Figure 12*  Dish fragment, Portugal, 1630–1650. Tin-glazed earthenware. D. 8". (Courtesy, Association for the Preservation of Virginia Antiquities, George Sandys Site Collection; photo, Gavin Ashworth.)

the Jamestown area.[11] These dishes are from contexts dating to the second quarter of the seventeenth century. The same simple design, which may have been adapted to speed up production of export wares, has widespread distribution on New England sites dating from circa 1635 to 1675.[12]

These stylized designs do not appear to have a precedent in Chinese porcelain and may have evolved from Islamic origins. One author has suggested that their prevalence on North American sites "may have inspired the distinctive slip decoration of New England earthenwares in the late seventeenth century."[13]

### French Martincamp Ware

Well over four hundred neck and body pieces of odd-looking flasks known as "Martincamp" ware have been found in the Jamestown Rediscovery excavations (fig. 13). They also have been excavated from Virginia and Maryland sites dating to the first half of the seventeenth century. Martin-

*Figure 13* Flask, northern France, 1600–1610. Unglazed earthenware. H. 8". (Courtesy, Association for the Preservation of Virginia Antiquities; photo, Gavin Ashworth.) Example excavated from the James Fort site.

camp flasks must have been produced solely for export, as they are rarely found in France where they were produced. But they are very common on sixteenth- and seventeenth-century sites in England along the eastern coast and the eastern half of the southern coast. In London they are found most frequently in seventeenth-century contexts with the highest concentration from circa 1650–1700. Surprisingly, no examples have been recognized in the Low Countries.[14]

Martincamp is a village in northern France situated between Dieppe and Beauvais. The flasks were called "Martincamp" because it was believed that this was the location of the kilns. Currently, ceramic historians believe that this attribution is too restrictive and that the ware may have been produced in a much wider area. Substantiating this belief is the fact that the Martincamp area has yielded neither large numbers of these flasks nor wasters.[15] (Wasters are defective vessels that are unusable, generally because of firing flaws, and are therefore discarded. They usually abound on kiln sites, providing the archaeologists with valuable information on the date and origin of wares.)

Three distinct body fabrics have been identified for Martincamp flasks. Type I flasks are earthenware with a date range of 1475–1550. Type II flasks are stoneware and are commonly found in the sixteenth century. Type III, which is rounder in form than the previous two types, has an earthenware fabric that usually is a low-fired orange color, but it can be fired to near-stoneware and appear reddish orange.[16] Only Type III flasks have been found at Jamestown.

Although other forms—rotund pots, chamber pots, and costrels—have been identified with the same fabrics in France, the only form found in Virginia is a thinly potted globular flask with a long tapering neck. The body of the flask is wheel thrown into a sphere. Once the sphere is leather-hard, the neck, which was thrown separately, is applied over a hole crudely punched in one end.

It is likely that Martincamp flasks were exported empty to serve as canteens for field workers and soldiers. This assumption has been derived from studying sixteenth- and seventeenth-century English trade records, which log in the values of cargo for tax purposes. The flasks, described in the port books as "earthen bottles," are very inexpensive compared to the glass bottles that were exported with them from France. The low cost plus the lack of mention of any contents, which would have been subject to duty, suggest that the flasks were empty.[17]

The flasks would work quite well as water containers, for they were fired to a near-stoneware consistency. They could hold liquid, but since they were unglazed there would be some seepage, which would serve to keep the contents of the vessel cooler. In addition, the rounded shape of the vessel provided a form that could withstand more abuse without breaking. Since there are no handles, the only apparent problem as a field flask is transport. Customs documents provide an answer to this question as well.

Martincamp flasks are identifiable as the "bottles of earth covered with wicker" imported from French ports. Italian glass wine bottles having the same rounded shape were also encased in wicker at this time (fig. 14). The

*Figure 14* *Le Dessert de Gaufreetes,* Lubin Baugin, ca. 1610–1663. (Courtesy, Louvre; photo, Gerard Blot.) The wicker-covered bottle in this painting is probably made of glass but it reflects the same shape as wickered Martincamp flasks.

wicker covering on the glass bottles protected the wine from exposure to the ruinous effects of light. The same covering on the flasks would provide a way for attaching a strap so the vessel could be easily slung across a shoulder. In addition, a standing ring of wicker woven at the rounded base of the flask furnished the means for the flask to stand upright, thereby making it a costrel.[18]

*Figure 15* Costrel base fragment, northern Italy, 1600–1640. (Courtesy, The National Park Service, Colonial Historical National Park; photo, Gavin Ashworth.)

*Figure 16* Costrel, northern Italy. Slipware. H. 11¼". (Private collection; photo, Gavin Ashworth.)

*Figure 17 Still Life with Glasses and Bottle,* Sebastian Stosskopf, 1641–1644. (Courtesy, Gemäldegalerie, Staatliche Museen Zu Berlin, Preussischer Kulturbesitz; photo, Jorg P. Anders.) The northern Italian slipware costrel, standing next to a wicker-encased glass bottle, has a cord handle looped through integral lugs.

## North Italian Wares

Earthenware costrels from Italy are found occasionally on seventeenth-century Virginia sites (fig. 15). The form exhibits a long, narrow neck with either a rounded or baluster-shaped body on a turned foot (fig. 16). Unlike the Martincamp flask, it has integral attachment lugs—often in the shape of stylized lion heads—on each side of the body, through which a cord can be looped (fig. 17). A slip-decorated earthenware, costrels are made of the red-firing alluvial clays of northern Italy, particularly from the vicinity of Pisa. In the sixteenth and seventeenth centuries the area along the Arno River between Pisa and Montelupo was the largest producer of exported Italian pottery. The Arno empties into the Ligurian Sea allowing easy distribution of the wares through the Mediterranean to northwest Europe and even to the Americas.[19]

These costrels are referred to as "North Italian marbled slipware," since two or more colors of slip or liquid clay are swirled together on the surface of the vessel to create a marbled appearance. The colors can be a mix of just white and red or include a polychrome palette of orange, brown, and green.

North Italian marbled slipware was also produced in the form of dishes and bowls, with the latter comprising the most common export. A section of a very unusual bowl was recovered from an area within James Fort in a

*Figure 18* Bowl fragment, northern Italy, 1625–1635. Slipware. H. 4¾". (Courtesy, Association for the Preservation of Virginia Antiquities; photo, Gavin Ashworth.) Example excavated from the James Fort site.

a circa 1625 context (fig. 18). The very wide vessel is decorated entirely with a dabbed, rather than swirled, white-and-red slip. Copper oxide in the lead glaze gives it an additional green mottled and streaked appearance.

Also made in Pisa, but less common than the marbled wares, are slipware dishes and bowls decorated with the sgraffito technique. Geometric and stylized zoomorphic or botanical motifs have been scratched through the white slip on the interiors of the vessels, creating a striking contrast between the red body and the yellow-appearing lead glaze (figs. 19, 20).

*Figure 19* Bowl, northern Italy, 1620–1640. Slipware. D. 9¾". (Courtesy, The National Park Service, Colonial Historical National Park; photo, Gavin Ashworth.)

*Figure 20* Reverse of the bowl illustrated in fig. 19. (Courtesy, The National Park Service, Colonial Historical National Park; photo, Gavin Ashworth.)

*Figure 21* Tazza fragment, Montelupo, Italy, 1620–1640. Tin-glazed earthenware. (Courtesy, The National Park Service, Colonial Historical National Park; photo, Gavin Ashworth.)

There is another ware type that was commonly lumped with seventeenth-century "Pisanware" even though it was made in Montelupo, another city on the Arno River. Unlike the red-firing alluvial clays of Pisa, Montelupo had fine buff fabrics that were suitable for tin glazing. In the sixteenth century, Montelupo faiences dominated the market and were widely distributed

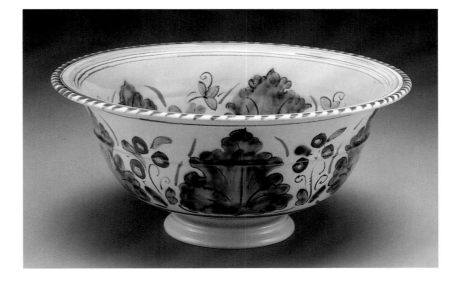

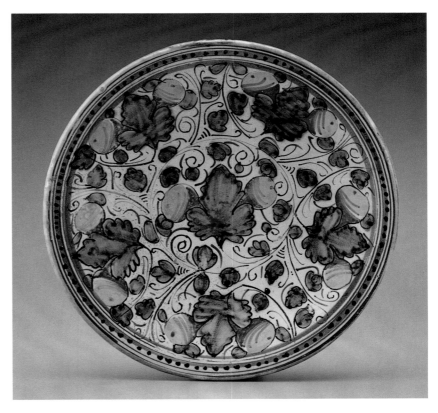

*Figure 22* A replica of the Montelupo tazza or footed bowl represented by the archaeological fragment shown in fig. 21. H. 7". (Courtesy, Michelle Erickson; photo, Gavin Ashworth.)

*Figure 23* Dish, Montelupo, Italy, 1620–1640. Tin-glazed earthenware. D. 12". (Private collection; photo, Gavin Ashworth.)

throughout Europe. By the seventeenth century the center of production for faience, also known as delftware, had shifted to France and the Netherlands.

Montelupo vessels are found infrequently on Virginia sites. When they are, they most often take the form of dishes and tazze—pedestaled shallow bowls or vases—painted in a polychrome palette of broad brushstrokes (figs. 21, 22). The design on the tazze is similar to the orange fruit with large oak leaves on the dish illustrated in figure 23. The most common motif on dishes of the early seventeenth century is figurative, usually depicting a

soldier against a landscape holding various weapons or flags (fig. 24). The backs of the dishes are painted with parallel manganese concentric rings, which distinguish them from copies made in France and the Netherlands.[20]

Also known are Montelupo dishes with commedia dell'arte iconography. The commedia was an improvisational theater that developed in six-

*Figure 24* Dish, Montelupo, Italy, 1620–1640. Tin-glazed earthenware. D. 12". (Private collection; photo, Gavin Ashworth.)

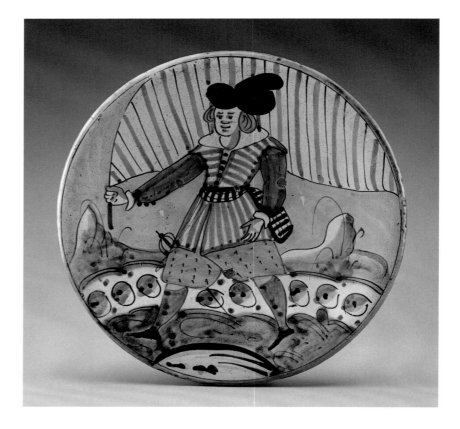

*Figure 25* Dish fragment, Montelupo, Italy, 1630–1650. Tin-glazed earthenware. (Courtesy, Association for the Preservation of Virginia Antiquities, the Reverend Richard Buck Site Collection; photo, Gavin Ashworth.)

*Figure 26* Reverse of the dish illustrated in fig. 25. (Photo, Gavin Ashworth.)

teenth-century Tuscany, but rapidly spread through Europe. Popular into the eighteenth century, it incorporated mime, gymnastics, and both scripted and unscripted dialogue. The commedia dell'arte performances would take place on outdoor stages, where they were accessible to the common people, as well as in the traditional theatres. Each actor in the traveling troupe would play the same role from among several stock characters, and although the actor was following a largely improvised script of one of several standard scenarios, there would be immediate audience recognition of the character from the costume and mannerisms.

A commedia dell'arte Montelupo dish was excavated from a circa 1635 to 1645 site adjacent to Jamestown Island, believed to have been inhabited by indentured servants.[21] The dish is decorated with a masked, bearded man wearing a black beret and holding a black cape in one hand while wielding what appears to be a dagger in the other (figs. 25, 26). This masked figure is one of the comic servants, or Zanni, who were among the central characters around which most of the plot focused. "At the heart of early *commedia dell'arte* plots," explains one scholar, "lies the interplay between the masked duo of the servant Zanni and his master, Magnifico."[22]

There are many variants of the Zanni costume, some worn by actors who portrayed the comic servant under a personalized stage name (fig. 27).

*Figure 27  Le tombeau de Maître Andre,* Claude Gillot, 1673–1723. Oil on canvas. (Courtesy, Louvre; photo, Eric Lessing.)

These differences have not been sufficiently documented to enable positive identification of this particular Zanni, although his costume is compatible with a circa 1630 date.[23]

Since the commedia dell'arte performances had reached England by the seventeenth century, it is almost certain that the owners of the dish in Virginia were aware of the identity and significance of the depicted character. Although a rare find in Virginia, the dish would not have been a high status object in England. Its rustic style of painting is very much in the folk tradition like the English slipwares that were produced primarily for the poor to "middling" classes. Even so, the dish was probably a one-of-a-kind vessel in the household of Virginia servants and intended for display rather than use.

While North Italian wares are found widely distributed in Britain, they do not occur in large quantities and are most heavily concentrated in London and coastal towns. Examination of trade records for these towns reveals a problem that can be encountered while attempting to define trading patterns based on the appearance of ceramics. The archival record shows little evidence of Italian shipping in English ports during the late sixteenth and early seventeenth centuries. Just because the wares are present does not mean that there is direct contact with their country of origin.[24]

Pottery was often sold and resold as it was imported to and redistributed in foreign lands. Spain is believed to have been the intermediary between Italy and the Spanish colonial sites in the Americas, where North Italian slipware has been found in contexts dating to the first half of the seventeenth century. Spain is also thought to be responsible for the redistribution of the ware in the southern English port of Exeter during the late sixteenth and early seventeenth centuries.[25]

North Italian wares occur on Virginia sites dating to the second quarter of the seventeenth century, a context coinciding with intense Dutch trade in the English colonies. This transatlantic commerce is believed responsible for the presence of these Italian wares on Virginia sites.

*Raeren Stoneware*
Even a quick glance at the Floris van Schooten painting *A Kitchen Scene* informs the viewer that he is looking at a wealthy Dutch household (fig. 28). Not only is there an abundance of food, but the metal cookware and the row of pewter dishes behind three matching Chinese porcelain bowls show the family's ability to invest in high-priced vessels for the preparation, storage, and consumption of food.

Hanging beneath the shelf of porcelain and pewter are two blue-and-gray stoneware jugs mounted with pewter lids. These highly decorated baluster jugs were made in Raeren, Germany (now Belgium), specifically for decanting into drinking vessels of glass or precious metal. Primarily utilitarian, the jugs' intricate molded designs, derived from contemporary printed sources, propelled them into objects of conspicuous display. "Relief-decorated stoneware quickly became a medium of social competition among the emerging mercantile and artisanal classes of northern Europe."[26]

*Figure 28 A Kitchen Scene,* Floris van Schooten, ca. 1620–1630. (Courtesy, National Gallery of Art, Heinz Family Collection.) The painting shows Raeren stoneware jugs with the Seven Electors motif hanging in the background. The jugs are mounted with silver or pewter lids which increase their value and reveal their high status among seventeenth-century tablewares.

Raeren potters molded many different designs on the central panel of baluster jugs, including biblical and mythological scenes, details from popular contemporary prints, and armorial and political imagery. The important social role of these stonewares in European society contributed to their use by potters and by consumers who commissioned their wares to convey religious and political allegiances. Furthermore, "with the political and religious upheavals of the period, vessels decorated with the arms and portraits of contemporary rulers or historical figures were popular among gentry and mercantile class alike, both groups eager to display their fealty and political sympathies, even within the home environment."[27]

The two jugs in the van Schooten painting promote a political stance through a very popular motif known as the "Seven Electors." The seven electors (*Kurfursten*) comprised the Electoral College of the Holy Roman Empire. As such, they selected the emperor to rule the Germanic dominion that encompassed most of central Europe and Italy. The pope was the spiritual head of the empire, ruled by German kings from 962 until 1806. While the position of emperor was elective, by the seventeenth century it was solidly in the hands of the Austrian Habsburgs, part of the Catholic dynasty that commanded Spain, Portugal, a large part of Italy, and the southern Netherlands. The electors, who were not all Catholic, were

*Figure 29* Jug, Raeren, 1600–1620. Salt-glazed stoneware. H. 10¼". (Private collection; photo, Gavin Ashworth.)

*Figure 30* Jug fragment, Raeren, 1600–1610. Salt-glazed stoneware. (Courtesy, Association for the Preservation of Virginia Antiquities; photo, Gavin Ashworth.) This excavated example contains a portion of a mid-girth Seven Electors motif.

hereditary office holders of the empire and included the bishops of Trier, Cologne, and Mainz, the king of Bohemia, the count palatine of the Rhine, and the dukes of Saxony and Brandenburg.

Raeren potters produced Seven Electors jugs in the first ten years of the seventeenth century for export and domestic use. Judging by the examples that have been excavated or that have survived in European museum collections, it was the most prevalently depicted theme on Raeren-molded baluster jugs. The design advertises political allegiance to the Habsburg-ruled Holy Roman Empire at a time of abounding political-religious conflicts in Europe. Catholic and Protestant rivalries were rife even among the German nation-states of the empire. Indeed, one of the electors, the count palatine of the Rhine, was a Calvinist who in 1609 encouraged the Protestant German states to form the Protestant Union. In response, the Catholic German states formed the Catholic League, supported by Spain, thus paving the way to the Thirty Years' War.[28]

The Netherlands comprised a particular area of turmoil as Spain attempted to prevail over the Dutch territories. As one scholar has noted, Raeren's proximity to these military struggles explains many of the designs employed by the potters working there.[29] Today, the village of Raeren lies in Belgium about one kilometer from the German border, but during the peak of its stoneware potting industry, four hundred to five hundred years ago, Raeren was a part of Germany located on the border

*Figure 31* Photo illustration. (Courtesy, Association for the Preservation of Virginia Antiquities; graphic, Jamie May.) If the coat of arms on the Raeren jug from James Fort illustrated in fig. 30 had been complete, it would have depicted the bust of the count palatine of the Rhine behind his coat of arms. In 1613 King James's daughter, Elizabeth Stuart, married Frederick V, the elector palatine and successor to Frederick IV, who is represented on the jug from James Fort.

of the regions collectively known as the "Spanish Netherlands." As the Raeren potters attempted to appeal to as large a market as possible, they produced equal numbers of wares bearing the coat of arms or symbols of Spain or of the Habsburg family as they did those representing anti-Habsburg factions.[30]

The base section of a Raeren Seven Electors jug was recovered from a ditch within James Fort (fig. 30). Only a tiny fragment remains of the mid-girth frieze that, if complete, would have consisted of the arcaded busts of the seven electors, each behind a shield bearing his hereditary coat of arms (fig.31). The jug fragment has a rampant lion holding an orb, which is the coat of arms of the count palatine of the Rhine. The palatine had its capital at Heidelberg and included strategically important land on both sides of the Rhine River between the Main and Neckar Rivers. The count palatine from 1583 to 1610, when the stoneware jug would have been made, was Frederick IV the Upright. Frederick IV practiced Calvinism and it was he who, in 1609, instigated formation of the Protestant Union.

If the Seven Electors jug was designed to advertise political loyalty with the Spanish-Habsburg dominion, what was it doing at Jamestown? The answer can, perhaps, be found in the policies of King James. A confirmed pacifist, one of James's first acts as king was negotiating the end of the Anglo-Spanish war with the controversial 1604 Treaty of London. One historian states that peace with Spain was driven by James's "desire for a dynastic union with Habsburg Spain as a mode of entry into the highest circle of European power and prestige."[31] His apparent Spanish sympathies emboldened Hispanophiles in the Jacobean Court, such as the Earl of Northampton, to become more vocal in advancing Spanish and Catholic interests. Anti-Spanish groups, promoting an aggressive Protestant foreign policy, countered these actions. James had need for both and attempted to accommodate all factions by trying to forge alliances to strengthen his position. For instance, at the same time that his daughter married Protestant Elector Palatine Frederick V, he was arranging for the union of his son with the Catholic Infanta of Spain.

In short, English foreign policy at the time of Jamestown's settlement was driven by the king's alignments with the royal houses of Europe amidst political and religious dissension. So, the English fortified themselves at Jamestown with a wary eye cast in Spain's direction; at the same time, Spain kept track of every move of the Virginia venture through spies

and counterintelligence. The Seven Electors jug would not be out of place in such an environment. It was probably owned by a gentleman and was used or displayed to advertise his status in society.

The jug was one of the symbols of a Jacobean gentleman who moved in courtly or upper-class circles and affiliated himself with the strength and prestige of the Habsburgs no matter what their religious leanings. One such gentleman was Edward-Maria Wingfield, first president of the council in Virginia. In his own words Wingfield sums up the conflicting views of the upper class in response to charges that he had colluded with Spain to the detriment of the colony:

> I confesse I haue alwayes admyred any noble vertue & prowesse, as well in the Spanniards (as in other nations); but naturally I haue alwayes distrusted and disliked their neighborhoode.[32]

### Frechen Stoneware

Another stoneware vessel recovered from within James Fort also contains iconography that is reflective of pro-Catholic sentiments. It is a brown salt-glazed jug or bottle from Frechen, a village to the west of Cologne, Germany (fig. 32). Frechen stonewares dominated the English market from the

*Figure 32* Bottle, Frechen, Germany, ca. 1600. Stoneware. H. 8". (Courtesy, Association for the Preservation of Virginia Antiquities; photo, Gavin Ashworth.) Example excavated from the James Fort site.

*Figure 33* *Soldiers in a Tavern*, Gerald Terborch, 1658. (Courtesy, Philadelphia Museum of Art, John G. Johnson Collection.) This painting depicts a Bartmann bottle standing by the feet of a soldier who is drinking beer from a glass. These durable stoneware containers quickly evolved in status to decanters that could be used at the table in conjunction with drinking vessels made of other materials.

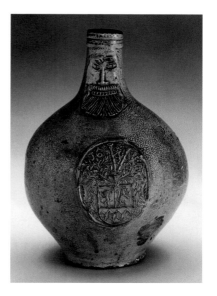

*Figure 34* Bottle, Frechen, Germany, 1605. Stoneware. H. 9¼". (Guthman collection; photo, Gavin Ashworth.) An antique example of a single medallion Bellarmine, dated 1605.

*Figure 35* Detail of medallion on the bottle illustrated in fig. 32. (Courtesy, Association for the Preservation of Virginia Antiquities; photo, Beverly Straube.)

mid-sixteenth century to the late seventeenth century, when the large-scale production of glass bottles and the development of English stoneware finally replaced them.

The jugs were primarily used for storage and serving beverages, a purpose for which they were ideally suited. The durable, non-porous stoneware body resulted in a vessel that could be easily cleansed of any odiferous substances and could contain liquids safely even under abusive circumstances. These stoneware jugs are often illustrated in Dutch tavern scenes sitting on the floor as decanting vessels while the drinker consumes beer or wine from a glass (fig. 33).

These bottles are known as "Bartmann" or "bearded man" for the bewhiskered face that adorns the neck (fig. 34). Bartmann jugs are also identified in the literature as Bellarmines, a term popularly believed to be a satiric reference to the much-despised Cardinal Robert Bellarmino (1542–1621). In 1606 Bellarmino, who, historically, has been described as "a zealous opponent of Protestantism in the Low Countries and northern Germany,"[33] publicly rebuked King James I for his treatment of English Catholics. While the English and Dutch may have made the association between the bulbous, grimacing jug and the Catholic prelate during the tempestuous religious climate of the early seventeenth century, it is unlikely that the form originated as a caricature: the first *Bartmänner* were produced around 1550 when Bellarmino was only eight years old.

The Bartmann jug, excavated from a circa 1607–1610 context within the palisaded walls of James Fort, exhibits parts of what would have been three ovoid medallions applied to its belly. Medallions on *Bartmänner* are often armorial, reflecting the coat of arms of affluent patrons, European cities and royal houses, ecclesiastical offices, or even the potter's own *Hausmarke* or symbol.

The medallion on the James Fort jug consists of a crowned shield that has been divided into four quarters (fig. 35). In heraldic terms, the first and third quarters each exhibit a single lion *passant,* which means that he is walking with his right paw raised. The second and fourth quarters each have two lions *passant.* In the first quarter, which is the upper left-hand corner of the shield, there is a heraldic device known as a *fess with a label on chief.* This is the band across the upper third of the escutcheon that is carrying three stylized fleurs-de-lis. It is this label that identifies the medallion as Italian and, more specifically, as representing a member of the Tuscan Anjou party or Guelfs, who from medieval times were staunch supporters of the pope.[34] The Guelfs' principal rivals in thirteenth-century Tuscany were the Ghibellines who backed the imperial power of the Holy Roman Emperor. These political factions had originated in Germany where they had comprised two feuding powerful families—the Wuelfs and the Hohenstaufen. The latter were the hereditary occupants of the imperial throne and once in Italy they, then known as the Ghibellines, had the support of the aristocracy. Artisans and lesser nobles supported the Guelf party. It was a political struggle that was to divide Tuscany until 1282 when, with the support of the pope (who resented the threat of imperial

authority in Italy), the Guelfs finally prevailed. They continued to be fiercely loyal to the papacy into the seventeenth century.

The Guelf coat of arms has never before been recorded on German stoneware. Further, there is no documented trade of the ware in Italy, so the Bartmann jug from James Fort is extremely rare. An individual must have commissioned it, perhaps an Italian merchant, who had trade or other contacts with northwest Europe. But what was the jug doing at Jamestown? While potters produced armorial stoneware with an eye to where it would be marketed, finds of heraldic medallions should not be strictly used to identify locations of individuals. Marketing practices of the international stoneware trade resulted in random geographical distribution of armorial stoneware. Early-seventeenth-century Frechen jugs found in England were, for the most part, purchased in bulk by Dutch merchants who then shipped them to London where they were redistributed to English markets. The jugs changed hands many times as they were bought and resold, thus resulting in widespread dispersal of motifs.[35]

It may never be determined why this rare coat of arms with medieval connotations, showing Italian connections with the Rhineland and deference to papal authority, ended up at Jamestown. Was it the result of random distribution to a consumer oblivious to the jug's symbolism or was it a purposeful statement by one of the colonists with papist leanings?

This question, as well as many others posed by the ceramic assemblages from the Jamestown Rediscovery excavations, is opening up new areas of historical consideration that have not been posed by the written record. Ceramic research at Jamestown will continue for years to come as discoveries are made—on both sides of the Atlantic. Every bit a primary source, the same as a letter or account written four hundred years ago, each vessel has a story to tell if we only learn to decipher the codes.

1. This article is adapted from Beverly Straube, *Jamestown Rediscovery V* (Richmond, Va.: Association for the Preservation of Virginia Antiquities, 1999).

2. *Hakluytus Posthumus, or Purchas his Pilgrims,* vol. 1 (London: n.p., 1925), as cited in *The Ceramic Load of the Witte Leeuw,* edited by C. L. van der Pijl-Ketel (Amsterdam: Rijksmuseum, 1982), p. 19.

3. Ibid., p. 25.

4. Ibid., p. 143.

5. Julia B.Curtis, "Chinese Ceramics and the Dutch Connection in Early Seventeenth Century Virginia," *Vereninging van Vrienden der Aziatische Kunst Amsterdam* (1985): I:6.

6. Norbert Schneider, *Still Life* (Cologne: Benedict Taschen, 1994), p. 158.

7. Van der Pijl-Ketel, *Ceramic Load,* pp. 28–29.

8. Joào Pedro Monteiro, *Oriental Influence on 17th Century Portuguese Ceramics* (Lisbon: Museu Nacional do Azulejo, 1994).

9. Stephen R. Pendry, "Portuguese Tin-glazed Earthenware in Seventeenth-Century New England: A Preliminary Study," *Historical Archaeology* 33, no. 4 (1999): 64.

10. Ibid., p. 64.

11. Two were excavated from Martin's Hundred (Ivor Noël Hume, *Martin's Hundred* [New York: A Delta Book, 1982], p. 100) and four were found at the George Sandys site (Seth Mallios, *At the Edge of the Precipice: Frontier Ventures, Jamestown's Hinterland, and the Archaeology of 44JC802* [Richmond, Va.: Association for the Preservation of Virginia Antiquities, 2000]).

12. Pendry, "Portuguese Tin-glazed Earthenware," p. 73.

13. Ibid., p. 73.

14. French researchers attribute these vessels to Noron, south of Bayeux in Lower Normandy, even though scientific analysis of the fabric has been inconclusive (Louise Décarie, *Le grès français de Place-Royale* [Québec: Government of Québec, 1999], pp. 17–18).

15. Pierre Ickowicz, "Martincamp Ware: A Problem of Attribution," *Medieval Ceramics* (1993): 58.

16. John G. Hurst, David S. Neal, and H. J. E. van Beuningen, "Pottery Produced and Traded in North-West Europe, 1350–1650," *Rotterdam Papers VI* (Rotterdam: Museum Boymans–van Beuningen, 1986), pp. 103–104.

17. John Allan, "Some Post-Medieval Documentary Evidence for the Trade in Ceramics," in *Ceramics and Trade,* edited by Peter Davey and Richard Hodges (Sheffield: University of Sheffield, 1983), p. 42.

18. John Allan, *Medieval and Post-Medieval Finds From Exeter, 1971–1980* (Exeter, Eng.: Exeter City Council and the University of Exeter, 1984), p. 113; Dennis Haselgrove, "Imported Pottery in the 'Book of Rates': English Customs: Categories in the Sixteenth and Seventeenth Centuries," in *Everyday and Exotic Pottery from Europe, Studies in Honour of John G. Hurst,* edited by David Gaimster and Mark Redknap (Exeter, Eng.: Short Run Press, 1992), p. 327.

19. Hurst, Neal, and van Beuningen, "Pottery Produced and Traded in North-West Europe," p. 30.

20. Ibid., p. 14.

21. Seth Mallios, *Archaeological Excavations at 44JC568, The Reverend Richard Buck Site* (Richmond, Va.: Association for the Preservation of Virginia Antiquities, 1999).

22. M. A. Katritsky, "Harlequin in Renaissance Pictures," *Renaissance Studies* 11, no. 4 (1997): 381.

23. Dr. M. A. Katritsky, personal communication with author, 2000.

24. David Crossley, *Post-Medieval Archaeology in Britain* (New York: Leicester University Press, 1990), p. 256.

25. Kathleen Deagan, *Artifacts of the Spanish Colonies of Florida and the Caribbean 1500–1800,* vol. 1: Ceramics, Glassware, and Beads (Washington, D.C.: Smithsonian Institution Press, 1987), p. 47; and Allan, "Some Post-Medieval Documentary Evidence," p. 44.

26. David Gaimster, *German Stoneware 1200–1900* (London: British Museum Press, 1997), p. 143.

27. Ibid., p. 153.

28. Gisela Reineking von Bock, *Steinzeug* (Cologne: Kunstegewerbemuseum, 1986), p. 273.

29. Gaimster, *German Stoneware,* p. 224.

30. Ibid., p. 224.

31. John Reeve, "Britain and the World Under the Stuarts, 1603–1689," *The Oxford Illustrated History of Tudor and Stuart Britain,* edited by John Morrill (Oxford: Oxford University Press, 1996), p. 416.

32. Edward-Maria Wingfield, "Discourse," 1608, Lambeth Palace Library, MS 250, folios 382–96, cited in Phillip L. Barbour, *The Jamestown Voyages Under the First Charter 1606–1609,* vol. 1 (Cambridge: Cambridge University Press for the Hakluyt Society, 1969), p. 229.

33. Gaimster, *German Stoneware,* p. 209.

34. John Hurst, personal communication with author, 1997.

35. Gaimster, *German Stoneware,* p. 82.

*Figure 1* A map detail showing North Staffordshire. Published by Henry Teesdale & Co., London, 1832. (Courtesy, Chipstone Foundation.)

*David Barker*

# "The Usual Classes of Useful Articles": Staffordshire Ceramics Reconsidered

▼ I N 1 7 6 0 T H E N O R T H Staffordshire Potteries[1] were a major force on the world market. By 1850 they were dominant, with Staffordshire wares dictating trends in consumer behavior from North America to Australia and influencing pottery manufacture throughout much of Europe and North America. Documentary sources, and the evidence of a multitude of surviving pieces, are the traditional means of learning about the industry and its development, but increasingly archaeological investigation is contributing a new dimension to research. Recent archaeological excavation in Stoke-on-Trent has resulted in important discoveries that promise an exciting future for the study of ceramics.

Nearly a century ago, Arnold Bennett painted a literary portrait of Staffordshire's potting industry:

> you cannot drink tea out of a teacup without the aid of the Five Towns; . . . you cannot eat a meal in decency without the aid of the Five Towns. For this the architecture of the Five Towns is an architecture of ovens and chimneys; for this its atmosphere is as black as mud; for this it burns and smokes all night, so that [it] has been compared to hell; . . . for this it exists—that you may drink tea out of a teacup and toy with a chop on a plate. All the everyday crockery used in the kingdom is made in the Five Towns—all, and much besides. . . . [W]henever and wherever in all England a woman washes up, she washes up the product of the district; . . . whenever and wherever in all England a plate is broken the fracture means new business for the district.[2]

This 1908 description of the importance of the thinly disguised *Six Towns* of Stoke-on-Trent is clear. Even when allowances are made for the author's license in this work of fiction, and even when it is remembered that pottery has always been made in other parts of Great Britain, the dominant place of the north Staffordshire pottery industry must be admitted. The growth of this industry was rapid, corresponding to the increased consumption of its products within Britain, Europe, North America, and beyond. It should be obvious, therefore, that a thorough knowledge of this industry and its products is central to understanding ceramic consumption in the American context.

Yet the study of the Staffordshire industry and its products remains fragmented and frequently lacks academic rigor. The tradition of connoisseurship, for example, remains strong, with its emphasis upon the classification of wares, on the basis of style and decoration, into groups that clearly have no relationship to the context in which they were produced or consumed. The dominant theme of that type of ceramic study, whether dependent

upon stylistic comparison or documentary research, is attribution or "who made what?"

Of course this approach can be very helpful, and properly constructed factory product profiles are useful for determining factory-market relationships, the chronology of ceramic development, and the degree of interaction between producers. In some cases, the factory of origin was significant to the consumer, Wedgwood being the obvious example. But this was the exception. In the main, this obsession with the products of individual factories has led to the perpetuation of myths surrounding manufacture, manufacturers, and the importance of their products, and has detracted from the full potential of the subject.

This approach has also detracted from a real appreciation of the process of industrialization within ceramic manufacture, and of both the true nature and the significance of the Staffordshire industry. Relatively minor factories have always attracted more than their fair share of scholarly attention. The Leeds factory, an important producer of creamwares and other ware types in the eighteenth century, is a case in point, being credited today with an impossible number of creamwares for the size of the factory and the duration of its production.

In the 1970s it was believed, perhaps wrongly, that a creamware factory had existed in the 1770s at Melbourne in Derbyshire. Numerous attributions to the Melbourne creamware factory resulted. Bovey Tracey in Devon is the creamware factory presently attracting attributions of creamwares and pearlwares. Who knows what the next few years will bring? Emphasis upon factory-focused study has also diverted attention away from other aspects of the ceramic story: the marketing and distribution of wares and their eventual consumption by ordinary people. In short, factory-based research misses the big picture.

So where do the potteries of north Staffordshire fit into this picture, and why are their products so important to an understanding of ceramic development and ceramic use throughout much of the world?

The Staffordshire ceramic industry is important primarily by virtue of its size and the variety of potteries operating there (fig. 1). A unique combination of social and economic factors led to the initial development of pottery manufacture in north Staffordshire, an area that would appear to be one of the least advantageous for the development of an industry dependent upon trade. It was poorly situated for communication, being about fifty miles from the sea and thirty or so miles from the nearest navigable river ports—Bridgnorth on the Severn to the south, Chester on the Dee to the north, Winsford on the Weaver to the west, and Willington on the Trent to the east. Even after the improvements to river navigation in the first half of the eighteenth century, north Staffordshire was not ideally placed to develop either a major internal trade or a significant export trade. Roads, too, were notoriously bad and road transport was frequently a complaint. Despite these major disadvantages, pottery production flourished. Before the end of the seventeenth century, Staffordshire slipwares, mottled wares, and butter pots were being sold throughout much of

*Figure 2* Dishes, Burslem, ca. 1690. Slipware. (*Left*) D. 13¼". (Courtesy, Potteries Museum & Art Gallery; photo, David Barker.) These badly warped slipware dishes, recovered from a waste pit in Burslem, are one of the most common types of vessel produced at this time. Almost ninety dishes were found on this site. Very similar dishes have been found at Port Royal, Jamaica, where they were lost during the devastating earthquake of 1692.

*Figure 3* Various vessels, Staffordshire, ca. 1690. Slipware. Two-handled cup. H. 4⅝". (Courtesy, Potteries Museum & Art Gallery; photo, David Barker.) These slipware vessels excavated from Burslem Market Place (the so-called Sadler's Site) provide a cross section of typical decorated wares of the late seventeenth century. Drinking vessels predominate, and slip decoration, while commonplace, is generally simple.

England (fig. 2). These wares also found their way in great quantities to the English possessions in the Caribbean and North America (fig. 3).

North Staffordshire's natural resources more than compensated for its disadvantaged location. Coal and clays of many different types and grades were readily available in the area, enabling good quality wares to be made cheaply. So cheaply in fact that, even after the cost of transportation was added, the Staffordshire potters were able to undercut their competitors.

By the beginning of the eighteenth century there were already fifty pottery workshops in the region producing quality wares for a wide market. For that time period, this sizable concentration of manufacturers constituted a major regional industry. By the end of the eighteenth century, how-

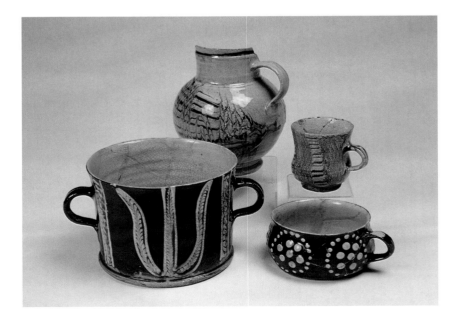

ever, the industry had been revolutionized and Staffordshire earthenwares and stonewares were dominant in the home market, in much of Europe, and were becoming a major force in North America. Production had increased throughout the century and the north Staffordshire industry had expanded in size, enabling it to deluge world markets with wares. In 1762 there were approximately 150 separate pottery factories employing 7,000 people;[3] by 1800 the number of workers in the industry had risen to between 15,000 and 20,000,[4] a figure that was to increase throughout the nineteenth century.

The diversity and quality of the factories' products were also on the upswing. White salt-glazed stonewares and refined red earthenwares brought about the all-important break with the past and traditional wares, a development that was to transform the Staffordshire industry after 1720. Thereafter, new wares were constantly added. White salt-glazed stonewares and early cream-colored earthenwares established a significant international demand for Staffordshire ceramics, which itself was to stimulate the growth of the industry.

Creamware's growing popularity, particularly after Josiah Wedgwood's successful promotion of this improved ware during the 1760s, guaranteed the industry's continued success into the nineteenth century, although at the expense of other sectors of the home ceramics industry. In the face of competition from superior quality earthenwares and stonewares from Staffordshire, the delftware or tin-glazed earthenware industries of London, Bristol, Liverpool, Dublin, and Glasgow began a rapid and terminal decline during the final quarter of the eighteenth century.

In other areas of the country, however, the influence of the Staffordshire wares was more beneficial, stimulating rather than undermining production and promoting new manufacturing ventures. Indeed, it can be argued that, as early as the mid-eighteenth century, a considerable proportion of ceramic manufacture within Britain was being driven by the Staffordshire pottery industry.

The growth of manufacture in Staffordshire, with more and more people making their living from pottery production, led to a tremendous concentration of technical and creative talent in the area, giving rise to an industrial infrastructure that supported the pottery factories. This infrastructure included the carriers who imported raw materials and who carried out the finished products, millers who prepared flint and clays for factory use, freelance decorators and engravers, toolmakers and engineers, and the crate makers in whose willow crates the wares were transported.

This concentration of talent was doubtless the reason that many of the most significant technical innovations in ceramic manufacture originated in Staffordshire—or came to be employed there on a grand scale—and that most of the dominant types of eighteenth-century earthenware and stoneware were developed there. White-bodied salt-glazed stonewares may have been introduced first by John Dwight of Fulham in the 1680s,[5] but it was in 1720s Staffordshire that they began their evolution into fine quality wares suitable for the tea tables and dining tables of a large body of the population.

The increased demand for refined earthenwares and stonewares in the eighteenth century encouraged the establishment of factories in many parts of the country, all of which produced Staffordshire-type wares. The production of creamware was begun in Liverpool, Hull, Bristol, Shropshire, London, Bovey Tracey, Sunderland, Newcastle-upon-Tyne, South Wales, at numerous centers in Yorkshire, and in Scotland. While many of these centers came to adopt particular styles of their own, it is clear that north Staffordshire industry set the standard for manufacturing.

At first the influence of the Staffordshire industry was spread by migration of potters. The movement of Staffordshire potters to other parts of the country is well documented from the seventeenth century. Clearly, they took with them well-established techniques and styles of ware that they would continue to manufacture in their new homes.

Staffordshire potters were found producing slipwares in Cumbria from the late 1690s[6] and along the banks of the Severn in Shropshire from the 1710s.[7] Staffordshire potters are documented in Bovey Tracey in the first half of the eighteenth century,[8] in Yorkshire,[9] Newcastle-upon-Tyne,[10] Scotland,[11] and elsewhere in the second half of the eighteenth century. There were also Staffordshire men in London during the early days of porcelain manufacture in the 1740s,[12] and it is likely that they were responsible for bringing the techniques of porcelain manufacture back to their home towns.

This migration continued so that, by the nineteenth century, wherever there was a factory making creamwares, pearlwares, and other dominant fine wares, there were likely to be Staffordshire potters involved in some aspect of the business. This was clearly an important factor in the dissemination of Staffordshire styles and technology, but it alone cannot explain the overwhelming influence of the Staffordshire industry. Rather, the sheer size of the industry and its supporting infrastructure of myriad ancillary trades ensured its dominance.

The nature of production in north Staffordshire, and the comparatively small size of most of its factories, necessitated extensive external support to provide raw materials, tools, and equipment. While the best-known firms of the late eighteenth and nineteenth centuries generally employed in excess of five hundred workers, the vast majority of factories operated with far fewer. As late as 1851, more than 60 percent of the north Staffordshire earthenware factories had a workforce of fewer than twenty.[13] Production on such a scale could not have survived without specialist suppliers for most of its needs. Besides raw materials (clays, flint, glazes, colors, etc.), the smaller factories, financially unable to employ their own engravers, turned to specialist engraving shops for their copper plates. As even fewer factories had the resources to employ their own modelers and block makers, they also used freelance mold makers, who sold block molds to all the factories. It seems likely that during the 1750s and 1760s there were very few modelers operating in Staffordshire, but one of these, Aaron Wood, is documented as a freelancer and was "modeler to all the potters in Staffordshire at the latter end of the time that white stoneware was made."[14]

The late eighteenth and early nineteenth centuries also saw an increase in the number of engineering companies that specialized in the equipment and machinery used in the pottery industry. By the mid-nineteenth century, there were specialist manufacturers of kiln furniture mass-producing stilts and spurs used to support wares during firing. The presence of these companies ensured that Staffordshire kiln furniture was going to be used by manufacturers throughout Britain and beyond.

Only in Staffordshire did this range of pottery-related expertise accumulate in such abundance. It was inevitable that this expertise would also serve and supply new factories established elsewhere within Britain and abroad. By the end of the eighteenth century these industries were coming to rely upon Staffordshire skills and products in many areas, avoiding the expense of producing their own costly equipment.

The proliferation of specialist suppliers greatly increased the influence of the Staffordshire potteries, and by the end of the eighteenth century Staffordshire-type wares were the industry standard. There was no change during the nineteenth century. Wherever pottery factories were involved in the manufacture of fine earthenware, it was Staffordshire-type wares they produced, using tools and equipment purchased from Staffordshire companies and the manufacturing processes developed there. This influence can be seen at factories as far apart as Bovey Tracey, Plymouth, South Wales, Liverpool, Newcastle-upon-Tyne, and Glasgow, all of which were producing Staffordshire-type wares.

An inevitable consequence of industrialization and developing reliance upon freelance suppliers was the increasing standardization of wares. Product uniformity was a feature from the very outset of industrial-scale production in Staffordshire in the early eighteenth century. The introduction of certain standardized processes, although still very much dependent upon workers' skills, was essentially the same in all factories. The widespread use of the lathe, for example, reduced the individuality of the thrower and the variations that might occur in throwing. From the 1720s all hand-thrown wares were lathe turned, adding to the uniformity of a factory's products.

The growing importance of molding as a manufacturing method since the 1740s further reduced the possibility of variation in wares. All vessels made from the same working mold would be identical, as would all working molds made from the same master mold. Because many factories were buying their molds from specialist suppliers, it was unavoidable that specific designs would be commonplace.

In the eighteenth and nineteenth centuries, transfer printing from engraved copper plates also increased the uniformity of decoration by providing potters with a plethora of established patterns, such as Broseley or Willow. It was inevitable that this conformity spread throughout the industry, and that the wares of one Staffordshire factory were largely indistinguishable from those of its neighbors and even those of its more distant competitors. The wares illustrated in the catalogs of the Leeds, Whitehead (Hanley), Don (Doncaster), and St. Anthony's (Newcastle-upon-Tyne) potteries are, for example, virtually interchangeable.

*Figure 4* Plate, Staffordshire, ca. 1830. Whiteware. D. 4½". (Courtesy, Donald Carpentier; photo, Gavin Ashworth.) The sentiment expressed on this plate from the 1830s, "COMMERCE, The Staffordshire Potteries/And free trade with all the world," would have been shared by all the Staffordshire manufacturers of the period. This transfer-printed pattern highlights the importance of trade to the survival of the Staffordshire pottery industry.

A consequence of this was that the practice of in-trading between factories became commonplace, buying-in wares from neighbors to fill orders. This could only have happened in an industry whose products were identical. There is ample evidence for this practice of dealing between factories from an early date (and indeed, it is still a normal part of the pottery business today).

In the 1750s and 1760s, for example, John and Thomas Wedgwood, then the largest potters in Burslem, bought wares from more than twenty local manufacturers, while selling to fifty.[15] John and Thomas's more famous second cousin, Josiah Wedgwood, conducted business in much the same vein, buying-in wares from at least fifty other factories.[16] One of the better known of these is the factory of William Greatbatch of Fenton.

Greatbatch's well-documented dealings with Wedgwood can be viewed from both historical and archaeological perspectives, following the excavation of his factory's waster dump. Detailed records show that in just over two years, from December 1762 to January 1765, Wedgwood bought more

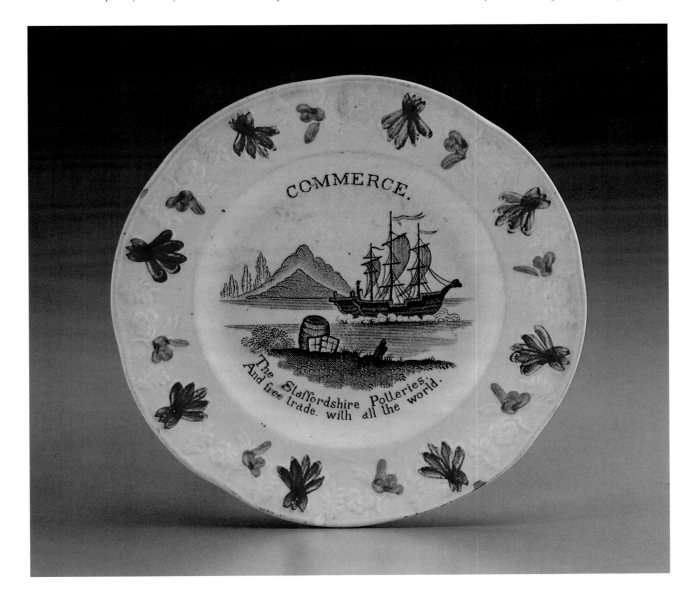

*Figure 5* "From the Trent to the Mersey." Unpublished letterhead, Navigation Office, Stoke, 1800. (John Wood Archives, Potteries Museum & Art Gallery.) The canal, completed in 1777, gave the Staffordshire potteries direct access to the sea. This facilitated an already flourishing trade and significantly reduced the cost of moving raw materials and finished goods.

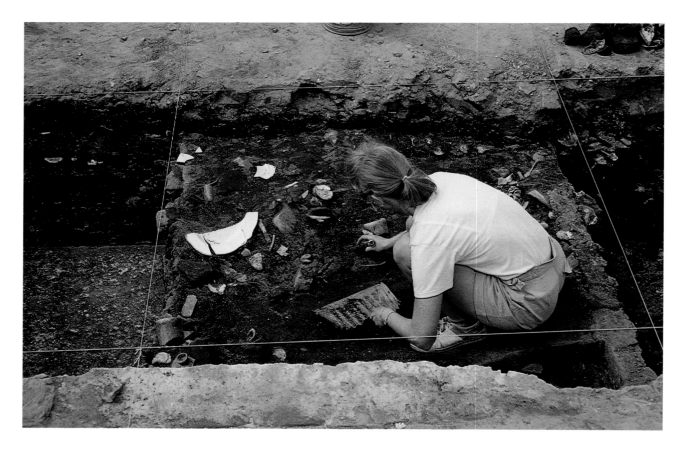

*Figure 6* Archaeological excavation showing large fragments of Staffordshire creamware in a large circa 1780 refuse deposit at a Virginia plantation site. (Photo, Robert Hunter.)

*Figure 7* Teapot fragment and lid, Staffordshire, ca. 1770. Creamware. (Photo, Robert Hunter.) An example of a typical Staffordshire product exported to North America.

than 560 crates of wares, the equivalent of almost a quarter of a million pieces, from Greatbatch.[17] This was no small trade either for Greatbatch or for Wedgwood.

The situation could not, therefore, be more complicated for the student of ceramics interested in attribution. Not only did factories buy their molds and copper plates from central suppliers, they also had access to molds, plates, and other tools and equipment from the sales that followed the all-too-frequent bankruptcies of pottery businesses. Therefore, attributions based solely upon stylistic matches, whether of body form or decoration, must be viewed with suspicion.

By the late eighteenth century most of Staffordshire's factories were involved in long-distance trade of some kind. As early as 1762, potters were able to state that "The Ware of these Potteries is exported in vast Quantities from London, Bristol, Liverpool, Hull, and other Sea Ports, to our several Colonies in America and the West Indies, as well as to almost every Port in Europe."[18] The growth of trade stimulated the development of pottery manufacture both in Staffordshire and elsewhere (fig. 4). By the late 1820s more than five-sixths of Staffordshire's trade was abroad.[19]

In the 1760s Staffordshire manufacturers began to invest in improvements in transport, turnpike roads, and canals that would greatly facilitate home and overseas trade. The opening of the Trent and Mersey Canal in 1777 was particularly significant in providing the Staffordshire potteries direct access to the sea and entrée to foreign trade through the ports of Liverpool and Hull (fig. 5). These new inroads enabled an already thriving trade to blossom, and domination of the world trade in ceramics followed rapidly.

The success of the Staffordshire manufacturers in international trade was largely due to the appeal of their products in the mass-consuming lower, lower-middle, and middle sections of the market, for whom price was as significant a consideration as quality (figs. 6, 7). However, Staffordshire firms were less successful at the top end of the market, where Chinese and then French porcelains had a commanding lead, particularly in the United States. In the 1850s, recognizing the appeal of French porcelain to their American customers, Staffordshire potters tried to create the impression that they were equal to their European counterparts, using such terms as "porcelaine opaque," "porcelaine de terre," and "new fayence" for their earthenware and ironstone.

Although much attention has been devoted to an examination of the trade between Staffordshire and North America, it was trade with Europe that accounted for the majority of Staffordshire's exports until 1835.[20] Only after this date did the United States serve as the main destination for Staffordshire wares. Of course trade with North America had been increasing steadily for more than a century.

Interestingly, a long-accepted view has been that the Staffordshire potters regarded the North American colonies as a convenient dumping ground for old-fashioned, substandard, or poorly regarded wares unacceptable to the British consumer. While there is good evidence that this did indeed occur, as echoed by Wedgwood's comments of 1766,[21] the general-

ization oversimplifies what was a much more complex and organized trade.

The development of the United States trade has been examined by Neil Ewins, paying particular attention to the manner in which manufacturers established and maintained links with their American customers. Larger manufacturers were able to keep their own outlets or agents in the main American ports; however, for the majority of firms this was impossible. The smaller firms depended upon the merchant dealers, who became increasingly important as the nineteenth century progressed. Ewins also draws attention to the development of American taste—as distinct from that which British manufacturers thought would appeal—and the divergence of production for the British and United States markets as American preferences developed. The American market was so important that manufacturers needed to know what would sell, relying on the merchant dealers for this information. The beginnings of this divergence can be seen in the 1840s with the popularity of flow blue-printed earthenware and white ironstone china, or white granite, neither of which appealed to the British consumer.

By the middle of the nineteenth century, the importance of American trade was such that many factories were entirely devoted to it. This was particularly true of many of the factories in Tunstall, where the level of business with America was such that the town had its own United States consul.[22]

The influence of Staffordshire extended to North America in ways other than direct trade. As early as 1765, Staffordshire manufacturers had set up production in the colonies with Hanley potter John Bartlam in South Carolina.[23] By the nineteenth century there was a more regular movement of potters from Britain to America, and industries were established at East Liverpool, Ohio; Troy, New York; Cincinnati, Ohio; Louisville, Kentucky; Trenton and Jersey City, New Jersey; and Bennington, Vermont. In many cases the potters themselves were from Staffordshire—notable examples being James Clews and the Mayer brothers—undertaking in a new country the type of production with which they were familiar at home.

Many of the American factories also employed British workers. However, whether or not the operatives and owners were themselves potters from Britain, it is important to emphasize that Staffordshire directly influenced the wares being produced. White granite wares made at Trenton, East Liverpool, and most other American pottery-producing centers competed directly with Staffordshire products. Some American factory names suggested a Staffordshire connection to enhance the status and market potential of American-made wares, a good example being the Etruria Pottery, in Trenton. Manufacturers' marks, too, were often in the style of those used by Staffordshire and other British makers, even down to the use of the royal arms.

The influence of Staffordshire technology and design was strong. The American factories used processes transplanted directly from factories in Britain, and Staffordshire in particular. The factories initially relied upon imported machinery and equipment as well.

The use of Staffordshire-made molds is also well documented; a definitive example is the hound-handled pitcher model made by Phillips

and Bagster of Hanley and also used by D. J. Henderson at Jersey City around 1830.[24] Copper plates were also brought in from Britain, while mass-produced kiln furniture from specialist Staffordshire producers has been excavated at St. John's Pottery, Ontario.

Traditional approaches to ceramics have failed to present an accurate picture in several significant ways. An emphasis upon what has survived or what has been deemed worthy of addition to a collection will inevitably focus attention upon wares that are exceptionally fine, unusually or elaborately decorated, uncommon in form, marked, or unique in some other way. These wares tell us a great deal about collectors, but little about the production and consumption of ceramics. Museums in particular, and ceramic research in general, have overlooked "the usual classes of useful articles,"[25] the ordinary wares that made up the vast majority of any factory's output and that have not survived. In short, we have inherited an extremely middle-class and aesthetically biased view of the products of an industry which was mass-producing with one consideration in mind—profit. In times of depression, however, a major consideration for many factories may simply have been survival. At the very least we can be certain that the artistic merits of a factory's products were subordinate to the need to sell those products in quantity.

There are documentary sources—factory records, merchants' records, and so on—that give a more balanced view of the production and distribution of wares, but these are frequently incomplete. Archaeological evidence, by contrast, provides an abundance of detail and is, therefore, extremely important to the study of ceramics. Archaeology presents us with the physical manifestation of invoices, advertisements, and price-fixing lists. North American archaeology, with its emphasis on domestic occupation sites, has helped construct a framework for ceramic consumption within the limitations of international trade and the possibilities of home production. The archaeology of ceramic production, however, can bring its own important perspective to research and reinforces the point that production and consumption are inextricably linked as parts of the same broad process of industrialization.

Archaeology in Stoke-on-Trent is uniquely placed to provide this perspective. Only through the excavation of factory waster dumps can a true picture of an individual factory's products be formed. Pottery recovered in this way will not be subject to the bias of subsequent selection. The evidence may be incomplete, but it is the most representative sample of a factory's output that can be obtained. Such recovery includes both the special and ordinary wares in proportions that are meaningful, at least in the context of manufacture. The archaeology of production sites also illuminates the manufacturing processes that influenced the ceramic production beyond north Staffordshire. It is becoming increasingly clear that an understanding of ceramics requires us to know exactly how they were made.

Forty years of archaeological investigation in Stoke-on-Trent have enabled us to have a fair understanding of the development of the pottery industry and its products during the seventeenth and early eighteenth centuries,

although each new site produces surprises. The picture gained from a study of production waste closely matches that from domestic site archaeology in Britain and in North America. Archaeology has revealed the range of undecorated or simply decorated wares that constitute the majority of ceramics produced.

The late-seventeenth-century Thomas Toft–type slipware dishes and the inscribed and elaborately decorated posset pots that are an important feature of modern collections are barely represented among the archaeological material. Of course, we would expect this to be the case, given that such pieces are special, but it is reassuring to have clear, indisputable evidence for the uniqueness of these objects.

During the past twenty-five years progress has been made in the study of eighteenth-century refined wares, with major excavations on the sites of well-known manufacturers like John Astbury, Thomas Whieldon,[26] Thomas Barker,[27] William Greatbatch, and Josiah Wedgwood. Admittedly, little archaeological evidence survives from Wedgwood's two-and-a-half-year occupation of the Ivy House Works in Burslem (1759–1762), but an interesting picture has emerged of the later life of this famous factory after Wedgwood's tenure. Of course, it is usually forgotten that factories invariably outlived their best-known occupants.

A circa 1760 waster dump was salvaged in Hanley, possibly linked to the potter Humphrey Palmer, who is documented on the site a few years later. Although the wasters cannot be definitely tied to Palmer, this is not important. What is important is that a complete cross section of a factory's wares was recovered from the 1760 period, revealing both the diversity of types produced and the uniformity of molded details that were used. Invaluable technical evidence was also recovered.

Excavations at Shelton Farm, however, presented a different picture — that of a factory's development over an eighty-year period. During this time, from 1720 until the first decade of the nineteenth century, there was a succession of tenants, none of whom is well known apart from John Astbury (working 1727–1744). Finds show a marked change in the nature, range, and quality of production, with good quality red earthenwares and white salt-glazed stonewares giving way to mediocre creamwares and red stoneware by the mid-eighteenth century. By the end of the century, production had been restricted to engine-turned red stonewares, red earthenwares, and black basalts. This is an important factory story that is unfolding.[28]

The Fenton potter William Greatbatch is well known for his business dealings with Josiah Wedgwood between 1762 and early 1765, and for his prolific output of quality printed and painted wares (fig. 8). There is no documentary evidence for any involvement in international trade, but archaeological evidence from Europe and North America points to widespread distribution of the factory's products. Greatbatch's importance is the greater as a result of the thorough archaeological investigation of his factory's waster dump.[29] This feature contained the entirety of twenty years of production, with valuable dating evidence contained in the sequence of dumping. The proportions of wares recovered are meaningful, and important

*Figure 8* Tea canister, attributed to William Greatbatch, Staffordshire, 1765–1770. Creamware. H. 4¼". (Courtesy, Troy Chappell; photo, Gavin Ashworth.)

changes to bodies, decoration, and manufacturing processes can be closely dated. The changes in the creamware body, glazes, and methods of decoration over a twenty-year period are significant indicators of developments within the wider industry, as are the introduction of new ware types and the decline of others.

Archaeology within the United Kingdom has been slow to respond to the challenge of investigating the more recent past. In Stoke-on-Trent, the archaeological study of nineteenth-century sites has been a new undertaking. Nineteenth-century sites now figure prominently among archaeological watching briefs, evaluations, and excavations within the city. Some considerable advances have been made, and a new range of material has been recovered to complement the fine bone chinas, blue-printed earthenwares, stonewares, and flat-back figures that constitute the majority of the ceramic collection at Stoke-on-Trent.

To the British collector, until recently, ironstone china meant Mason's Ironstone Patent China of 1813, or the other stone chinas produced about the same time by firms like Turner's and Spode. The white granite wares that were exported in vast quantities from the 1840s, and that are so much a feature of both American collecting and nineteenth-century archaeological assemblages, were rarely mentioned. It is no real surprise, therefore, that the ceramics collection of the Potteries Museum & Art Gallery in Stoke-on-Trent did not possess a single piece of white granite until 1996.

The first significant archaeological deposit of white granite was excavated in 1985 from a factory waster dump in Hanley (fig. 9). A large quantity of wasters bore marks of the factories Livesley, Powell & Co., and J. W. Pankhurst & Co. It was not until 1996, however, that this material was processed, researched, and published in summary form.[30] This group, dating from the mid-1850s to the mid-1860s, includes other contemporary wares with printed, painted, sponged, and slip decoration, as well as figures and vessels in bone china and stoneware bodies. The evidence sug-

*Figure 9* Biscuit and glazed sherds, Livesley, Powell & Co. and J. W. Pankhurst & Co, Hanley, 1850–1862. Whiteware. (Courtesy, Potteries Museum & Art Gallery; photo, David Barker.) These wares, often called white granite or ironstone china, were excavated in Hanley from a waste dump used by these two local firms.

*Figure 10* Plate and archaeological fragments, Podmore, Walker & Co., Tunstall, ca. 1845. Whiteware. D. 7⅝". (Courtesy, Potteries Museum & Art Gallery; photo, David Barker.) This company had extensive trade with North America. Sherds of the pattern "Manilla," printed in flow blue and recovered from one of the firm's waste dumps, are shown alongside a finished plate with the same design.

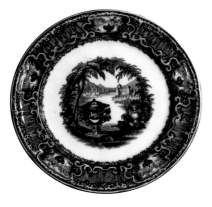

*Figure 11* Plate, Podmore, Walker & Co., Tunstall, ca. 1845. Whiteware. D. 9⅞". (Private collection; photo, David Barker.) This plate is printed in the "Washington Vase" pattern in flow mulberry.

*Figure 12* Printed sherds, Podmore, Walker & Co., Tunstall, ca. 1845. Whiteware. Examples of the "Washington Vase" pattern, found in one of the firm's Tunstall waste dumps. (Courtesy, Potteries Museum & Art Gallery; photo, David Barker.)

gests, therefore, that these two Hanley factories produced the full range of wares, and that the export trade—as evidenced by the dominant quantities of white granite—was significant.

Sherds recovered from another factory waster dump have provided an insight into the Tunstall firm of Podmore, Walker & Co., which operated three factories between 1839 and 1859 (figs. 10–12). Extant wares, largely to be found in North America, show that they produced a range of transfer-printed earthenwares in blue, brown, flow blue, and flow mulberry (fig. 13). The flow blue- and flow mulberry-printed wares are virtually unknown in the United Kingdom, the majority clearly being made for export.

The Podmore, Walker & Co. dump has given us our largest archaeological assemblage of this material so far and offers important comparisons with extant wares. The finds have also provided evidence for common types of wares that would otherwise have been anonymous—notably factory-

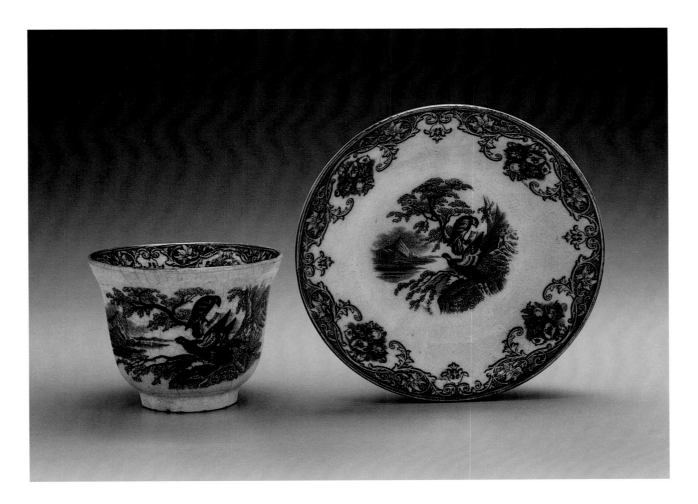

*Figure 13* Cup and saucer, Podmore, Walker & Co., Tunstall, ca. 1855. Whiteware. Saucer D. 4⅞". (Private collection; photo, Gavin Ashworth.) Fragments of the "Eagle" pattern have been recovered from domestic sites in the mid-Atlantic region of the United States.

made slipwares with wormed or common cable decoration, earthenwares with simple sponged decoration, shell-edged plates, and undecorated white ironstone wares. This range of products was aimed at the middle to lower end of the market, and an absence of bone china may suggest that production was mainly export driven.

Most of these cheaper wares are unmarked; both attributing them and dating them can present problems. Archaeological finds from known sites are helpful in this respect, and surprises are possible. Excavations of a factory waster dump in the center of Stoke brought to light not just the mid-nineteenth-century fine bone chinas and printed earthenwares of the Copeland & Garrett (1833–1847) and Copeland (1847 onwards) periods of the Spode factory, but also examples of the little-known "bread and butter" lines (fig. 14). These included brightly colored earthenware dishes with sponged and painted designs, and a variety of cups, saucers, and bowls with bold underglaze, painted floral patterns in chrome or the so-called Persian colors. A number of both undecorated and slip-decorated hemispherical bowls bear the impressed maker's mark "COPELAND," which is most unusual for this quality of ware.

Recently, attribution of a large quantity of unmarked earthenwares of the cheaper kind has been made to the leading Burslem manufacturers, Enoch

*Figure 14* Biscuit and glazed industrial or factory-made slipware waste, Copeland factory, ca. 1850. Whiteware with slip decoration. (Courtesy, Potteries Museum & Art Gallery; photo, David Barker.) These sherds were recovered from a dump adjacent to the Spode factory in Stoke-on-Trent. The sherds are all from "London shape" bowls and are unusual in that they bear the impressed mark "COPELAND."

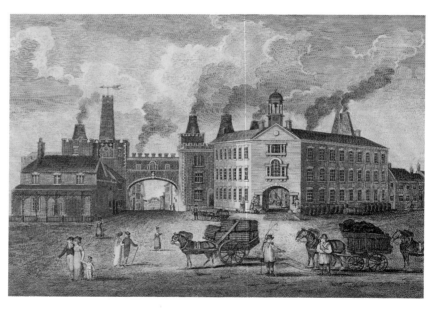

*Figure 15* "West view of the manufactory of Messrs. Enoch Wood & Sons—Burslem." Unknown artist and engraver, 1830–1840. (Courtesy, Chipstone Foundation.) The origin and history of this important print and the print illustrated in fig. 16 are unknown. They may be early proof copies dating to circa 1833. The handwritten titles conflict with later engraved versions, which have the direction information reversed. This view of the entrance of the Fountain Place Works shows a procession of tradesmen's carts before the elegant façade of the pottery works.

Wood & Sons (figs. 15, 16). Slip-decorated, painted, sponged, shell-edged, embossed, and undecorated wares were uncovered with marked printed wares, in a variety of designs (figs. 17, 18). The wares, found in Burslem Market Place, were part of a large cache of factory seconds (rather than wasters) deposited shortly before 1835. Catherine Banks describes this important deposit in a separate article in this publication.

Other work has provided more of a random "trawl" of wares from different factories. New road construction is indiscriminate in the archaeological remains it disturbs, and since the mid-1980s there has been an explosion in such work in north Staffordshire. Catherine Banks conducted one of the most productive archaeological watching briefs on the A50 road extension.

*Figure 16* "East view of the manufactory of Messrs. Enoch Wood & Sons— Burslem." Unknown artist and engraver, 1830–1840. (Courtesy, Chipstone Foundation.) A published version of this view is included in Ward's *History of Stoke-on-Trent* (1843). This view shows the extensive arrangement of the pottery works, Enoch Wood's house, and extensive gardens.

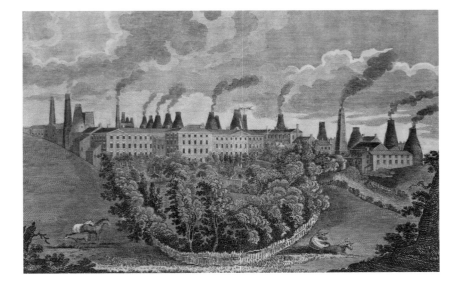

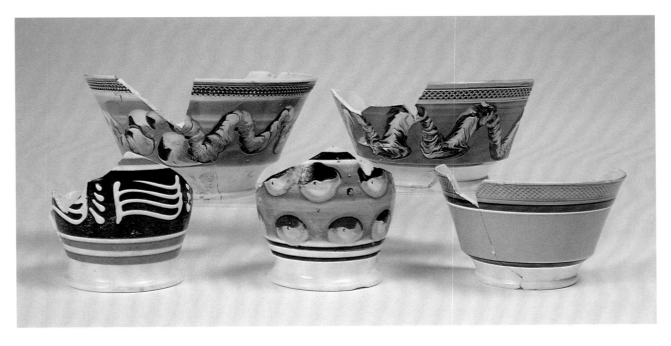

*Figure 17* Industrial or factory-made slipwares, Enoch Wood & Sons, Burslem, ca. 1835. Whiteware. (Courtesy, Potteries Museum & Art Gallery; photo, David Barker.) These fragments were recovered from a large town-center waste dump at Burslem Market Place. Although these types of low-priced wares were made by many manufacturers, it is unusual to be able to attribute them to a specific maker. Their discovery here with a mass of marked wares confirms their manufacture by Enoch Wood & Sons, and the archaeological context in which they were found dates them to circa 1835.

This project cut a swath up to thirty meters wide and ten to fifteen meters deep, adjacent to the town centre of Longton, the most southerly of the six potteries towns.[31] This work unearthed finds from numerous eighteenth- and nineteenth-century factories, including those of Thomas Harley, Jacob Marsh, Charles Bourne, J. & T. Lockett, Sampson Bridgwood & Son, John Edwards & Co., and many more.

Significant finds have also been made in Fenton on two sites: one associated with the factory of William Baker (fig. 19), the other with that of James Edwards. Both sites contained white granite wares, painted, sponged and slip-decorated earthenwares, and smaller quantities of transfer-printed wares. Edwards is best known for his extensive American trade, and among the finds are numerous sherds of vessels of the "Royal"

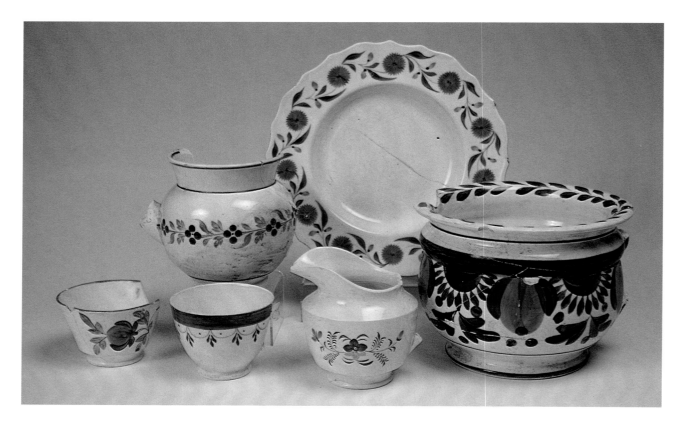

*Figure 18* Various painted vessels, Enoch Wood & Sons, Burslem, ca. 1835. Pearlware and whiteware. (Courtesy, Potteries Museum & Art Gallery; photo, David Barker.) Some examples of a wide range of painted earthenwares by Enoch Wood & Sons. These were excavated from the Burslem Market Place waste dump, where they were deposited in circa 1835.

*Figure 19* Sponge-decorated sherds, probably from William Baker & Co., Fenton, ca. 1860. Whiteware. (Courtesy, Potteries Museum & Art Gallery; photo, David Barker.) Increasing quantities of archaeologically recovered sponged wares now highlight the importance of these cheap wares from the Staffordshire pottery industry and its export trade.

*Figure 20* Sherds, James Edwards, Fenton, 1875–1890. Whiteware. (Courtesy, Potteries Museum & Art Gallery; photo, David Barker.) A selection of late-nineteenth-century wares made for export and excavated in the vicinity of James Edwards's King Street Works. The "Royal" pattern, the subject of a lawsuit over copyright infringement, appears in the sauceboat base shown in the bottom center image; an unclear impressed diamond registration mark is probably for 1877.

pattern (fig. 20), which was the subject of a lawsuit in New York for the infringement of a patent held by the French firm Haviland.[32] Among the marks found on the Edwards wasters are printed pattern names on earthenwares and ironstones, which include the body name "porcelaine de terre" and register numbers for the 1890s. A Central American and, more specifically, Cuban trade is indicated by a printed Cuban pottery importer's mark, "[?]PE QUESADA Y CA. CIENFUEGOS *Importadores,*"[33] and the use of the body name "porcelaine de terra" with a register number for 1894.

These forgotten ware types are now very much in evidence among archaeologically recovered material from Stoke-on-Trent, providing a more balanced profile of nineteenth-century production that mirrors the documentary evidence and the evidence from domestic site archaeology in North America.

At the time of this writing, Jonathan Goodwin of the Potteries Museum & Art Gallery is processing other nineteenth-century ceramic groups. These groups come from the Tunstall factory sites of William Adams, Johnson Brothers, Wedgwood & Co., John Wedg Wood, W. H. Grindley & Co., and the Longport New Bridge Pottery of George Phillips and later Davenport, Bodley & Sons, and Edward Clarke. Evidence from these sites will be an important addition to our knowledge of ceramic developments of the nineteenth century.

*Conclusion*

Staffordshire ceramics had a profound influence upon the world market. In the nineteenth century, consumers had access either to Staffordshire wares or to wares made in other centers within Britain that exactly paralleled them in form, decoration, and method of manufacture. To study ceramics and ceramic use in America, one must take into account the developments within the Staffordshire potteries.

British ceramic study has primarily concentrated upon the finer wares—the more expensive fine porcelains, stonewares, and transfer-printed earthenwares—and emphasis has been very much on the manufacturer and his products. This approach has tended to overlook a significant proportion of the factories' output, namely the cheaper wares, the vast majority of which were exported. Evidence for this international trade is forthcoming from documentary sources and from domestic site archaeology in the United States, Canada, and many other countries. Archaeological work on production sites in Britain, most notably in Stoke-on-Trent, examines this trade at its very source—the factory—and provides a firm basis for ceramic study. A knowledge of precisely *what* factories were making, and *how,* is an important first step in understanding the life cycle of the humble and the less humble pot—from factory floor to trash pit.

1. The collective name by which Burslem, Fenton, Hanley, Longton, Stoke-upon-Trent, and Tunstall—the six towns of the modern city of Stoke-on-Trent—are known.

2. Arnold Bennett, *The Old Wives' Tale* (London: Chapman Hall, 1908), p. 3.

3. Potters' petition to Parliament, quoted in A. R. Mountford, *The Illustrated Guide to Staffordshire Salt-Glazed Stoneware* (London: Barrie and Jenkins, 1971), p. 11.

4. Frank Burchill and Richard Ross, *A History of the Potters' Union* (Hanley, Stoke-on-Trent, Eng.: Ceramic and Allied Trades Union, 1977), p. 27.

5. Chris Green, *Fulham Pottery Excavations 1971–79* (London: English Heritage, 1999), pp. 125–26.

6. Hugh Tait, "Burslem Potters in Cumbria Around 1700," *Ars Ceramica* 7 (1990): 30–32.

7. David Higgins, unpublished research; Maurice Hawes, "The Migration of Pottery Workers between Stoke-on-Trent and the Broseley Area in the Eighteenth Century," *Journal of the Wilkinson Society* 2 (1974): 7–9.

8. Brian Adams and Anthony Thomas, *A Potwork in Devonshire: The History and Products of the Bovey Tracey Potteries 1750–1836* (Devon, Eng.: Sayce Publishing, 1996), p. 12.

9. Too numerous to mention, but Ralph Wedgwood is perhaps the best known, working briefly at Ferrybride from 1798. See Heather Lawrence, *Yorkshire Pots and Potteries* (Newton Abbott and North Pomfret, Vt.: David & Charles, 1974), pp. 148–49, 268–81, passim.

10. Elizabeth Adams and David Redstone, *Bow Porcelain* (London: Faber & Faber, 1981), p. 72.

11. Staffordshire workmen are recorded at the Gallowgate and Delftfield Potteries in Glasgow from 1770. Jonathan Kinghorn and Gerard Quail, *Delftfield: A Glasgow Pottery, 1748–1823* (Glasgow: Museums and Art Galleries, 1986), p. 23.

12. Adams and Redstone, *Bow Porcelain,* pp. 62, 65–67, and 71.

13. 1851 census. Frank Burchill and Richard Ross, *A History of the Potters' Union* (Hanley, Stoke-on-Trent, Eng.: Ceramic and Allied Trades Union, 1977), p. 25.

14. Inscription by his son, Enoch Wood, on the reverse of the portrait of Aaron Wood by William Caddick, in the collection of the National Museum and Galleries on Merseyside.

15. A. R. Mountford, "John Wedgwood, Thomas Wedgwood, and Jonah Malkin, Potters of Burslem," (M.A. Thesis, University of Keele, 1972), p. 77.

16. Ex. Inf. Robin Gurnett, personal communication.

17. David Barker, *William Greatbatch: a Staffordshire Potter* (London: Jonathan Horne Publications, 1991), pp. 89–90.

18. Potters' petition to Parliament, quoted in Mountford, *Staffordshire Salt-Glazed Stoneware,* pp. 11–12.

19. Simeon Shaw, *History of the Staffordshire Potteries; and the Rise and Progress of the Manufacture of Pottery and Porcelain; with References to Genuine Specimens, and Notice of Eminent Potters* (Hanley, Staffordshire, Eng., 1829; reprint, Great Neck, N.Y.: Beatrice C. Weinstock, 1968), p. 16.

20. Neil Ewins, "'Supplying the Present Wants of Our Yankee Cousins...': Staffordshire Ceramics and the American Market 1775–1880," *Journal of Ceramic History* 15 (1997): 6.

21. "Pray sell all the green and gold for Pensacola, the new discover'd Islands, or where you

can"; see Katherine Euphemia Farrar, ed., *Letters of Josiah Wedgwood 1762–1770* (privately printed, 1903; reprinted by E. J. Morten, Didsbury, Manchester, and The Trustees of the Wedgwood Museum, Barlaston, Stoke-on-Trent, 1973), p. 96.

22. Francis Celoria, "Reports of the U.S. Consuls on the Staffordshire Potteries 1883–1892," *Journal of Ceramic History* 7 (1974): 43–67.

23. Bradford L. Rauschenberg, "John Bartlam, Who Established 'new Pottworks in South Carolina' and Became the First Successful Creamware Potter In America," *Journal of Early Southern Decorative Arts* 17, no. 2 (1991): 6.

24. Diana Stradling and Ellen Paul Denker, *Jersey City: Shaping America's Pottery Industry 1825–1892* (Jersey City, N.J.: Jersey City Museum, 1997), p. 5.

25. One of many ways in which ordinary wares were referred to by Llewellyn Jewitt, *The Ceramic Art of Great Britain: From Pre-Historic Times Down to the Present Day,* vol. 2 (London: Virtue & Company, 1878), p. 272. In writing of Ralph Hammersley's Overhouse Pottery, Burslem: "The goods produced are the ordinary description of earthenware in services of various kinds and in the usual classes of useful articles, which, besides a good home trade, are shipped in large quantities to the United States, Canada and Sweden."

26. A. R. Mountford, "Thomas Whieldon's Manufactory at Fenton Vivian," *English Ceramic Circle Transactions* 8, no. 2 (1972): 164–82.

27. David Barker, "A Group of Staffordshire Red Stonewares of the 18th Century," *English Ceramic Circle Transactions* 14, no. 2 (1991): 177–98.

28. Report in preparation.

29. Barker, *William Greatbatch.*

30. Katey Banks, "Excavation of White Ironstone China, Windsor Street, Hanley, Stoke-on-Trent," *White Ironstone Notes* 4, no. 2 (1997): 8–9.

31. C. A. M. Banks, "Under the road: An archaeological and historical study along the route of the A50, Longton," *Staffordshire Archaeological Studies* 8 (1997).

32. Noel Boothroyd, "Archaeological Watching Brief at Fenpark Road, Fenton, Stoke-on-Trent, Staffs," *Stoke-on-Trent City Museum Field Archaeology Unit Report* 62 (1999): 6–7.

33. Ibid., pp. 7, 15.

*Michelle Erickson*
*and*
*Robert Hunter*

# Dots, Dashes, and Squiggles: Early English Slipware Technology

▼ SEVENTEENTH- AND eighteenth-century slipware has long been considered one of the hallmarks of British ceramic history. Consequently, interest in these wares runs deep. Collectors admire the bold graphic designs and rich earthy colors and they favor the dates, names, or initials that are found on many surviving pieces. American archaeologists unearth English slipwares in prodigious quantities, providing dating information on seventeenth- and eighteenth-century historical sites. Art potters have found inspiration in traditional English slipwares, notably reflected in the twentieth-century work of Bernard Leach and his students (see opposite page). In the latter half of the twentieth century, the reproduction of English slipwares for the history-oriented market became a full-time occupation for many American and English potters.[1]

The collector's literature recounting the history of slipware extends for nearly a century and a half. Art historians have characterized slipware's aesthetic qualities relying upon terms such as "rustic," "folksy," "primitive," "crude," "delightful," and "naïve." Ceramic historians have continually described the technological processes involved with English slipware manufacturing, starting with Dr. Robert Plot's *History of the Staffordshire Potteries* (1686). Archaeologists, on the other hand, generally have not concerned themselves with the technical or aesthetic aspects of slipware beyond understanding the chronological history of types. Slipware is usually viewed as a staple product of the English potters (particularly the Staffordshire industry), a mainstay of domestic and utilitarian pottery for the masses, and a basis for understanding trade networks that extended over half the globe. The slipware tradition continues today in the works of contemporary potters around the world, involving both time-honored methods and new, highly sophisticated materials and applications.[2]

In light of these varied interests, our article provides a brief overview of English slipware technology focusing on the dynamics of the slip process and the techniques used to create decoration. The authors will demonstrate that although slipware is often considered "rustic" or "folksy," it is the inherent nature of the materials that dictates the aesthetic character of the ware, not the predisposition of the potter. We only touch on the general history of English slipwares, since excellent summaries have been prepared in recent years, particularly the work of ceramic historian Leslie Grigsby.[3] We should note that all English slipwares were coated with a lead glaze before firing. The lead was either applied as powder or in a liquid form. Glazing and firing strategies have been summarized elsewhere.[4]

Our approach most closely follows that of "experimental archaeology," which relies upon testing and replication to show how an artifact may have been made. By actually "going through the motions" employed by the early English potters we can better appreciate both the manual processes and the material aspects of slipware. Our research, ongoing for nearly ten years, continues to provide new insights into unrecorded methods of slipware manufacture. These insights range from why certain clays were used to the ability to distinguish the aesthetic success of surviving pieces of slipware.[5]

In the process of learning how to make old pots, it became increasingly apparent that the antique specimens contain clues to every aspect of manufacture, from the types of clays used to their arrangement in the kiln. These clues also provide a context for appreciating the larger production concerns of raw materials, division of labor, and the vast trading network that distributed these wares to the Caribbean and North America. Slipware is often considered a localized tradition, or a cottage industry (a term particularly favored in collecting circles). While small, seasonal potteries existed throughout England, supplying the immediate community, these should not be confused with the Staffordshire potteries and other manufacturing centers that arose in an effort to capture the considerable domestic and foreign markets.

To begin at the beginning, "slip" is best defined as a homogenous mixture of clay and water. The simplest of slips is nothing but clay and water. More sophisticated slips can contain colorants, feldspars, flint for hardness, and various fluxes and frits. English slipware potters typically used a clay for the slip that was finer and denser than the clay body to be covered. This clay was either mined and used in a natural form or refined through sieving, removing coarser particles.

As the properties of slip can vary from one extreme to the other, understanding its nature is important. Slip is a liquid that generally has a very short working life. As soon as slip comes into contact with a dryer surface, it begins to stiffen. It is analogous to working molten glass. Unlike glass, though, slip cannot be reheated or moistened to rework it. A mistake made in applying a slip means living with it or wiping it off and starting over.

When using slip, the clay particles tend to fall out of suspension fairly quickly so that the potter needs to stir the solution frequently. In some cases, the potter can be handling a dish with one hand and stirring a vat of slip with the other. In a factory setting, consistency of materials is a key ingredient in the success of the pottery production line. Care has to be taken from batch to batch to ensure that the viscosity of the slips is monitored constantly. Even so, there is a degree of randomness in the process. A potter who starts out decorating a vessel using a full slip trailer will have the consistency of the slip vary from the start of the process to the time the last drop is applied.

In most instances, slip is poured or dropped onto another surface. Rarely is it brushed on since the clay surface is usually damp, which causes the slip to be streaky or uneven. Although brushing can produce very accurate lines, it also necessitates building up several layers to achieve a smooth

surface. Pouring slip, however, instantly creates an opaque, even covering—making the best use of the materials and the time of the potter. But pouring is much harder to control and this is an important difference in contrasting the squiggles of the slipware potters with the better-defined brushwork of their counterparts, the delftware painters.

One amusing aspect associated with describing the process of creating slipware is the use of food analogies. Dr. Plot in 1686 described the slip mixture of clay and water as a "Syrup." Ceramic historian Lewis Solon depicted slip as "clay diluted with water to the consistence of a batter." Bernard Leach attributed the visual experience of spreading jam and Cornish clotted cream on his bread at tea time to his rediscovery of the combing or feathering technique on slipware. This close association with food preparation suggests that clay and water are very similar to flour and water. Importantly, it is the degree of moisture in the clay body and the density of the slip mixture that are the primary determining factors in the process.[6]

Most English slip decoration prior to 1760 was carried out by hand, the success of which was directly tied to the ability of the potter. Even with the steadiest of hands, creating a perfectly straight line can be difficult, particularly if the "flow" of the slip is interrupted (a common occurrence) during the process. After 1760, the individual skill necessary to apply slip decoration in a controlled fashion was somewhat negated by the use of the lathe. The fixed movement of the pot in a horizontal motion permitted the application of a uniform band of slip decoration in a straight line.

The early use of slip decoration in England can be traced to medieval times, when the decoration consisted of simple geometric designs painted on jugs and cups. Medieval English tile makers also used slip to add color and pattern to their products. With the importation of late-sixteenth-century European slipwares, English potters tried to create similar products, appropriating the various slip-decorating traditions as their own.

In copying these European traditions, the English potters had to adopt the local clays and these varied considerably from region to region. In general, though, most coarse red and buff earthenware clay deposits that were available to English potters were well suited to throwing and had great strength at relatively low firing temperatures. In contrast, the finer, white ball clays, while plastic, had to be fired to a much higher temperature to maintain body strength.

Although the white ball clays were inefficient bodies at low firing temperatures, they did adhere well to the coarse earthenware body. Perhaps more importantly, since the coarse redware clays were relatively porous, at least at the firing temperature achieved by the potters, the use of slip created a surface that allowed a much tighter bond for the lead glaze. In other words, although lead glazes were used throughout the earthenware potting traditions in England, they provided a more effective covering on a slip-covered vessel than on an uncoated, coarse earthenware. Thus, the use of slip was more than just decorative: it actually improved the efficacy of the lead glazes on the coarse earthenware bodies.

The use of slip also broadened the available palette of the Staffordshire

*Figure 1* Dish, North Devon, ca. 1670. Slipware. D. 12⅛". A sgraffito-decorated dish excavated at Jamestown, Virginia. (Collection of Colonial National Park, National Park Service; photo, Gavin Ashworth.) The pattern on this dish is representative of the bold, stylized floral designs found on much of the North Devon sgraffito slipware.

*Figure 2* White slip is poured on the upper surface of a wheel-thrown, North Devon–type dish. The dark-bodied charger is at the leather-hard stage. The excess slip is immediately poured off and the charger is set aside to dry. (All demonstration photography is by Gavin Ashworth.)

potters. White clay-coated slipwares offered a lighter-colored product, challenging the white tin glaze used by the delft potters. Although white clay was commonly used, the iron inclusions in the lead glazes of the period gave the white slip a rich golden appearance after the firing. Other combinations of naturally occurring clays, combined with metallic oxides, produced a range of contrasting colors. These oxides included iron (red), ochre (cinnamon), and manganese (black).

In the early seventeenth century, slipware was being produced in Somerset, North Devon, and Essex. The North Devon and Somerset areas produced slipware with sgraffito decoration, while the Essex potters are best known for their elaborate slip-trailed designs. The North Devon sgraffito wares are among the earliest slipwares found in America (fig. 1). Huge quantities were exported through the ports of Barnstaple and Bideford. The North Devon sgraffito technique was adapted from several European traditions and is the first one we discuss.[7]

### Sgraffito

Sgraffito decoration is used primarily on vessels that have been thrown on a wheel. A contrasting color slip, usually white, is applied by pouring or dipping, thus coating the darker clay body of a leather-hard form (fig. 2). "Leather hard" is defined as the stage when the plastic clay has become firm enough to handle without the danger of deformation yet retains a fair degree of moisture.

Hollowwares—jugs, cups, mugs—are ordinarily coated on the exposed outer surfaces, while dishes and plates are usually slipped only on the face.

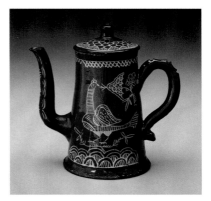

*Figure 3* Coffee pot and lid, Sussex, ca. 1790. Slipware. H. 7". (Courtesy, Chipstone Foundation; photo, Gavin Ashworth.) The design on this coffee pot was scratched or incised into the leather-hard, red clay body. A white slip was applied over the design and scraped or cut away, leaving the filled lines.

The slip is allowed to set up to a point where it retains a degree of moisture similar to the underlying body. Both the body and the covering slip must be comparatively moist to facilitate the ease of carving. If the slip is too wet, the pattern will smear. If too dry, the slip may flake irregularly along the lines or carved sections.

The process of sgraffito (the term is taken from the Italian "to scratch") begins with scratching through the slip veneer, using a pointed tool or stylus, to expose the underlying, contrasting clay body. Unlike other slip decorating techniques, this scratching is a *subtractive* process rather than an additive one. Exceptions to this can be found in the Sussex wares of the later eighteenth and early nineteenth centuries, in which the decoration was scratched first into a solid red body and filled or inlaid with a contrasting white slip (fig. 3).

While much of sgraffito decoration is done freehand, certain techniques are used to set up reference or register marks. For circular dishes and plates,

*Figure 4* Once the slip covering has set up to a leather-hard stage, the sgraffito design is begun. The initial framing of the design is done on the wheel with the layout of concentric circles. The stylus is simply held in a fixed position while the wheel rotates, cutting the lines.

*Figure 5* After laying out the initial design, the pattern is incised freehand. The lines are scratched quickly, in a very fluid, gestural movement. Mistakes at this stage are usually not easily corrected. Typical North Devon patterns are floral and geometric designs, although stylized birds and other natural motifs are often seen as well.

*Figure 6* A looped wire tool is used to remove larger areas of slip within the outlined areas.

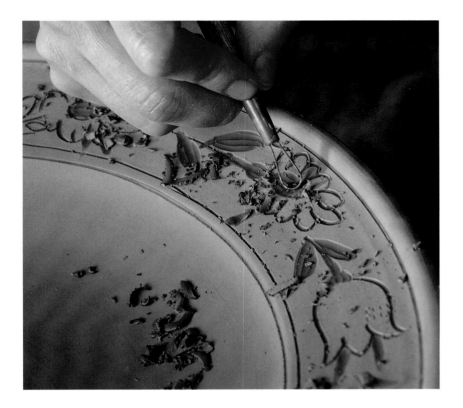

the wheel is used to generate concentric lines (figs. 4–6). Hollow forms may also be rotated on a wheel to produce reference lines. Simple compasses can be used to delineate cartouches as often seen on large harvest jugs. Other tools such as roulettes and coggles were used to repeat patterned decoration. Even with the use of such tools, grit or other inconsistencies in a clay body can cause a straight line to run astray of its intended path. Mistakes made during the sgraffito process are hard to correct without altering the pattern.

It should be pointed out that many of the sgraffito examples in museum collections are generally special pieces, prized by the maker and subsequent owners. Shipping records and archaeological evidence attest that the overwhelming majority of these wares were used, broken, and simply thrown away. The potters who decorated these everyday wares were interested in producing as many as possible. Even if the clay stayed moist enough to allow a potter to linger over a pot, the sgraffito technique required fluid, gestural lines to represent successfully the shape of a bird or the leaves of a flower. These lines had to be scratched quickly and skillfully.

### Slip Trailing

By the early seventeenth century, slip-trailed earthenwares were produced in areas south and east of London. Several pottery sites are known from Essex, where the slipware products are referred to as "Metropolitan slipwares," named such because London was the primary market. These Metropolitan wares were decorated with a white slip trailed directly onto a dark clay body. The city of Wrotham in Kent was another production center for

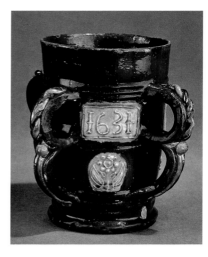

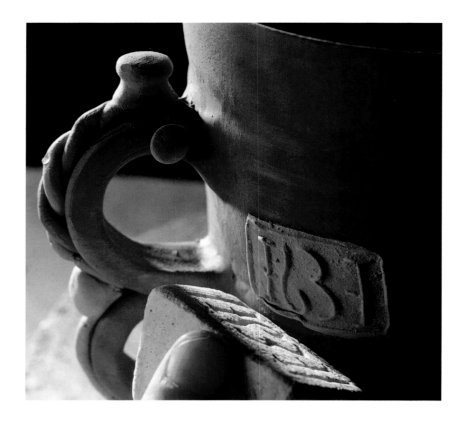

*Figure 7* Tyg, Wrotham, 1631. Slipware. H. 7¼". (Courtesy, Colonial Williamsburg Foundation.) The ornamentation on this tyg consists of coils and pads of white clay augmented with slip-trailed highlights. The white clay slip is applied directly to a red clay body.

*Figure 8* A pad of clay is applied to the leather-hard body and subsequently embossed with a plaster stamp. The clay pad needs to be soft and pliable at this stage in order to get a good impression. The red clay body of the cup, however, has to be fairly firm so that the pressure of the stamping does not deform the shape. Period examples often show evidence of the indentations of the potters' fingers behind the embossed pads on the inside of the vessel.

*Figure 9* After the clays pads are applied and embossed, white slip is trailed to complete the decoration. Note that strips of white clay have been applied to the handles.

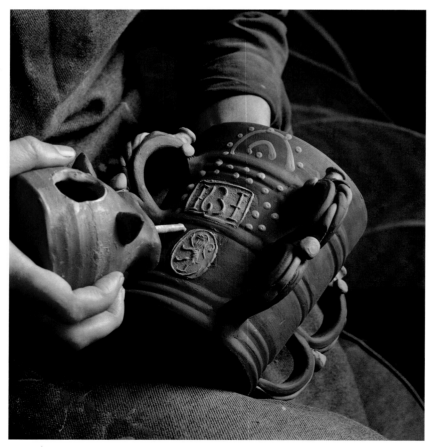

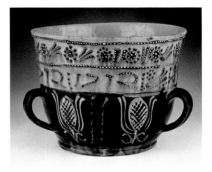

*Figure 10* Cup, Staffordshire, 1712. Slip-ware. H. 7⅝". (Courtesy, Colonial Williamsburg Foundation.)

*Figure 11* The wheel-thrown cup made of white or buff clay has been assembled with handles and the pleated clay flourishes. The bottom half of the cup is dipped in a black slip, the excess is allowed to drip away, and the bottom is wiped clean. The top half of the cup is then dipped into a white slip and both slips are allowed to firm up before decoration is applied.

early slip-trailed wares. In addition to trailing, the Wrotham wares were distinctly ornamented with pads of white clay that were embossed with a stamp directly onto the pot (figs. 7–9). In the late eighteenth century, slip trailing was used extensively by the Staffordshire potters.

The application of slip lines or dots over a contrasting clay body is the simplest of decorating techniques and one of the most frequently found on English slipwares (figs. 10–13). Conversely, it is one of the techniques most difficult to control. Unlike sgraffito decoration, slip trailing is an *additive* process.

The essential tool for slip trailing was the slip cup. Such cups, or trailers, were generally made to accommodate a single color of slip. The trailer itself was a small vessel, most often made of clay, although leather, fabric, or horn may have also been used. The concept of the trailer was simple. A small tube (a reed or quill) was inserted into the trailer, which would be filled through a top hole. The potter could regulate the flow of the slip by covering the top hole, which also served as a vent. In order for the slip to flow freely, its viscosity had to be maintained by frequently shaking the trailer, and by adding water or a thicker slip mixture throughout the process. Slip tubes clogged easily and had to be continually cleared. Multiple tubes were often used to create parallel line decoration. Multichambered slip trailers, containing a variety of colored slips, came into their own with the introduction of the so-called industrial slipware of the late eighteenth century.

The early trailing techniques in which slip is applied directly to a solid clay body are similar to drawing. The slip quill, or tube, can actually touch

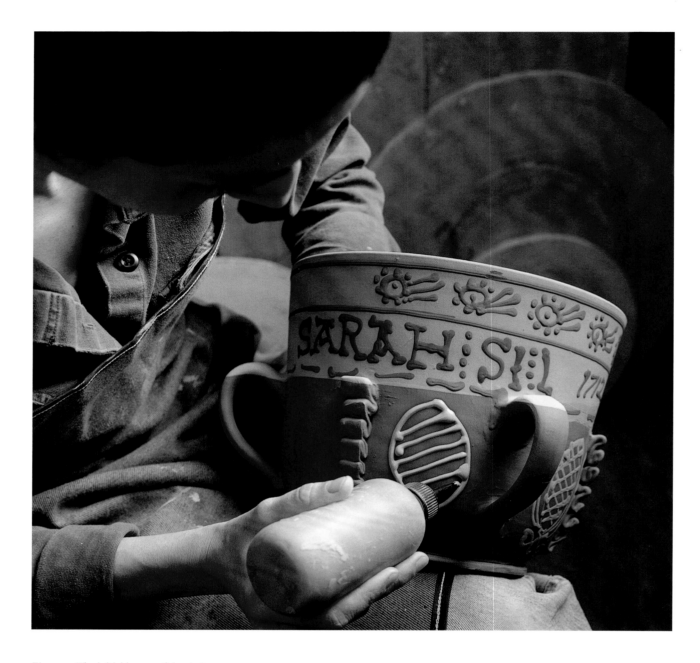

*Figure 12* The initial layout of the design
is started by applying concentric lines to
the pot on the wheel. Black slip is used
on the white ground slip where as a white
slip is applied over the black ground slip.
The decoration is done freehand and the
vessel has to be turned carefully to avoid
marring any of the previously applied
trailing. A modern slip squeeze bottle
is being used.

*Figure 13* A final embellishment known as "jeweling" is applied. Small dots of white slip are used on top of slip lettering from the previously trailed black slip decoration.

the clay surface without marring the design or clogging the opening. In contrast, when slip is trailed over another slipped surface, the quill cannot come in contact with that surface without the risk of marring or clogging (figs. 14–18).

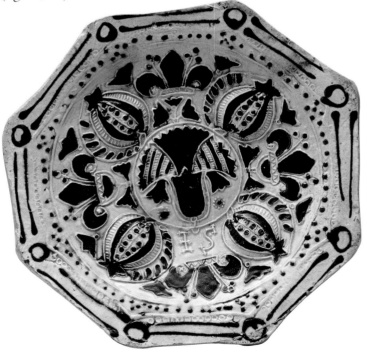

*Figure 14* Dish, Staffordshire, probably Burslem, 1700–1725. Slipware. D. 13¼". (Courtesy, Chipstone Foundation; photo, Gavin Ashworth.) Slipware press-molded dish with pomegranates and fleurs de lis. A master mold had to be carved to create the relief decoration on these types of dishes.

*Figure 15* A circular clay slab is draped over a carved plaster mold. The clay is moist and very plastic at this stage. Period molds appear to have been made of fired clay.

*Figure 16* The depth of the carved relief requires that the slab be firmly pressed into the recesses. Slapping or pummeling the slab with a closed fist accomplishes this. After the dish firms up, it is removed and the edges are trimmed.

*Figure 17* The reverse of the original pomegranate dish illustrated in fig. 14, showing the indentation caused by pressing the clay slab into the deep recesses of the mold. Note that the back of this dish has been neither slipped nor glazed.

*Figure 18* After the slab dries to a leather-hard state, a white ground slip is poured over the interior surface only. Subsequent highlighting of the designs is done with red and black slips using a trailer.

*Figure 19* Dish, Staffordshire or Midlands, 1720–1750. Slipware. D. 13¾". (Courtesy, Colonial Williamsburg Foundation.) This press-molded, marbled-slip dish is among the most competent examples of this decorating technique.

## Marbling and Combing

These two techniques are closely related in that they rely upon the movement of contrasting colored slips. Marbling is a process whereby two or more colored slips are laid down and manipulated to create a variegated appearance (fig. 19). Gravity and centrifugal force are key elements in inducing the movement or flow of the slips. Combing, on the other hand, uses a tool to move the slips through one another physically in order to create patterns after they are initially laid down.

The English technique of marbling may have had its origins in the early-seventeenth-century marbled slipwares of Northern Italy. The term "joggling" is used to describe the physical act of controlling the movement of the wet slips. This process can require very specific, and somewhat awkward-looking, body and arm movements. The degree of aesthetic success is directly linked to the skill of the potter in controlling the flow of the slips.

The clays used for making the slips must have similar shrinkage and drying rates. The slips then have to be prepared with similar viscosity. Poorly prepared slips can produce an unsatisfactory flow and impede the marbling process. Inadequate preparation appears fairly common, as shown by archaeological examples (excavated in America) that exhibit a wide range of aesthetic competency. It is not surprising that the marbled slipwares that have survived, primarily in museum collections, are unusually well executed examples.

*Figure 20* Creating a marbled-slip dish begins with a black ground slip poured over a *flat,* circular, red earthen clay slab, previously prepared and supported by a wooden bat. Slabs were prepared by rolling out the clay to an equal thickness.

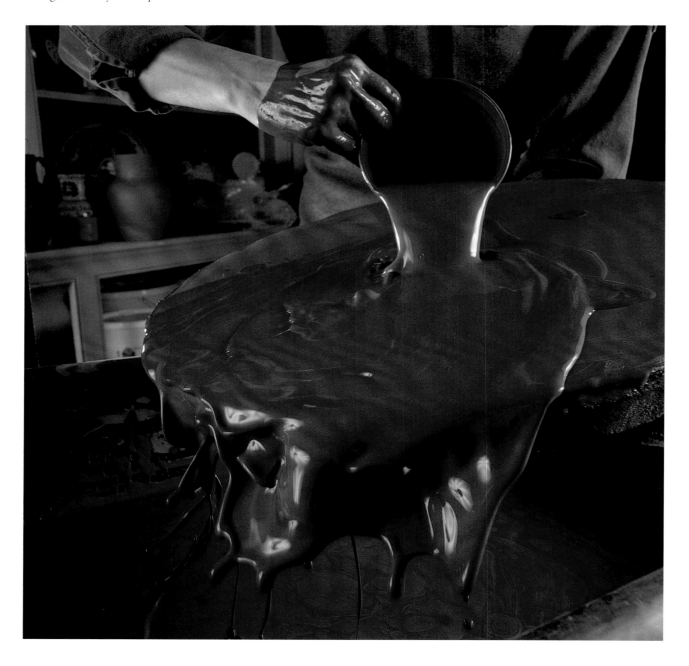

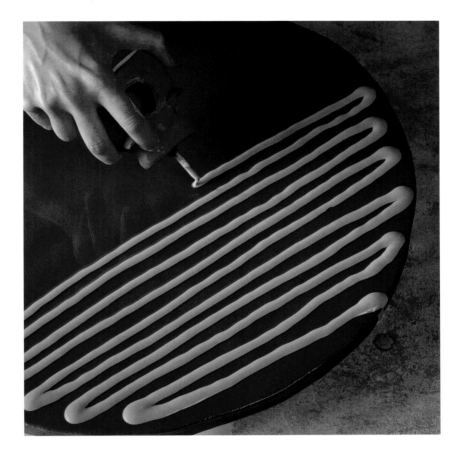

*Figure 21* Parallel lines of white slip are immediately trailed onto the wet ground slip. The consistency and moisture content of the slips must allow both to flow easily without running. The width of the lines is dictated by the distance of the tip of the slip tube from the surface of the ground slip: the further from the surface, the wider the line.

*Figure 22* The prepared slab immediately before joggling. Note how the white slip lines have overlapped the edge of the slab.

*Figure 23* Detail of the marbled dish illustrated in fig. 19. This detail shows the white slip lines, which have overlapped the edge in the making.

Marbling on dishes begins with a flat clay disk or slab rolled out in a consistent thickness. The slab is carried with a board or bat to support the wet and still-plastic clay. A coating layer of slip is poured over the slab covering the entire exposed surface (fig. 20). Immediately thereafter, a series of contrasting lines is trailed across the entire surface (fig. 21). The tip of the slip tube should not touch the wet base slip and is held above the surface. Evidence from original examples suggests that the lines were laid down in very specific, prescribed patterns—a deduction that runs contrary to the belief that the marbling process used a more random application of slips (figs. 22, 23). Indeed, it is interesting to note the words of Bernard Leach, who suggested turning slip-trailing mistakes into marbled decoration:

*Figure 24* The beginning of the marbleization process. The slab, resting on the bat, has been rotated or "joggled" to start the flow of the slips.

*Figure 25* The marbleized slab in the process of joggling. Because both slips tend to dry fairly quickly, the potter must have good control over the process and the decision to stop is an important aesthetic, as well as practical, concern. Elapsed time for joggling is usually no more than a minute or two.

*Figure 26* The marbleization process is complete. Note that the decoration is still on a flat slab. Before the vessel is formed, the slips must be allowed to set up to prevent marring of the marbleized surface, yet the slab and the newly slipped surface must remain pliable. If the slab becomes too dry, it will crack. If the slips are still too wet, they will stick to the surface of the mold.

"When one or more slips have been *unsuccessfully* [emphasis added] trailed over a wet background . . . it is sometimes a good plan to try for a marbled effect by violently shaking and twisting the board upon which the clay rests." Our research suggests that the initial placement of the slip lines was crucial to creating a successful marbled pattern, contrary to Leach's suggestion.[8]

After the slip lines are *systematically* applied, the clay slab, still supported by the bat, is then tipped and rotated (figs. 24–26), using gravity to coax the slips to "flow." This process will create a pattern of swirls. If the slip is too watery, the lines will run and blur. If the slip dries too quickly, the slips will not flow properly. The potter also has two conscious decisions to make: (1) how much time can be expended before the wet slips stop flowing, and (2) how to judge when to stop before the lines of color lose their separation and become muddy.

The now-marbled slab is set aside to allow the slips to dry further. After the slips are no longer tacky or wet to the touch, the entire slab, which is still plastic, is removed from the bat and placed faced down over a mold. The slab is then carefully pressed into shape (fig. 27). In the case of most English flatware, the marbled or combed decoration is created *before* the form.

Marbleizing on hollow forms takes place, however, after the vessel has been created, usually by throwing (fig. 28). The ground slip is either

*Figure 27* After sufficient drying, the slab is draped over a hump mold and pressed into place to form the dish. These molds were typically made of fired clay, although a plaster one is being shown here. The dish is now allowed to dry further, to a leather-hard stage. The irregular edge is trimmed with a knife to form a completely circular form and the rim is then crimped or coggled. This molding process helps flatten the slips. After glazing, the surface is smooth.

*Figure 28* Cup, Staffordshire, dated 1704. Slipware. H. 4¼". (Courtesy, Colonial Williamsburg Foundation.) An early example of a fine-grained, combed slipware cup. Trailing and jeweling have been used on the upper portion of the cup.

*Figure 29* The lower half of a thrown mug of buff-colored earthenware is dipped into a black slip. The black slip is immediately sponged off the bottom of the mug.

*Figure 30* Using a multinozzled slip trailer, white parallel lines are applied over the wet, black slip. Experimentation has suggested that the mug was supported horizontally, perhaps on a lathe or similar device, to facilitate the application of the slip.

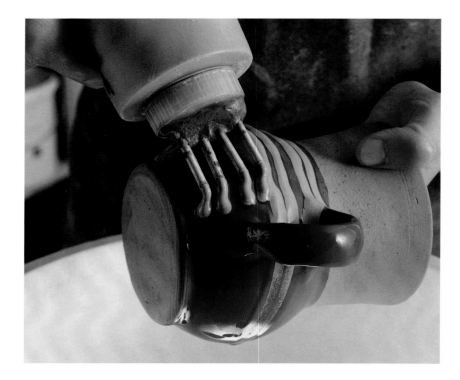

*Figure 31* A comb, fashioned with bristles or filament, is drawn through the wet slips to create the feathered effect. The bristles drag the overlying white slip through underlying black slip.

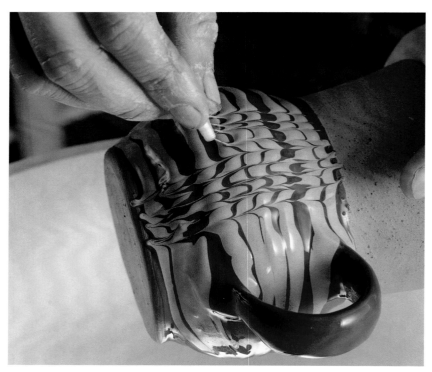

poured over the vessel or it is dipped into a container of slip (fig. 29). Contrasting colored slip is then trailed on while the vessel is held horizontally and rotated—either by hand or affixed to a lathe. Our research suggests that a multiple-nozzle slip cup (as opposed to a single nozzle) was used to apply the contrasting concentric slip lines on Staffordshire hollowware

forms (fig. 30). The vessel is then tilted and rotated to control the gravitational flow of the slip, creating a variegation of the wet slips. Combing can take place after marbleization or as a stand-alone decorative treatment after the initial trailing of slip lines (fig. 31).

The moisture content of the clay body and the slip has to be carefully monitored when producing marbled or combed slipware. If the clay body becomes too wet, the form will slump or actually fall apart. If the clay body is too dry, the slips will not flow properly. Many of these potential difficulties can be observed in the flaws found on antique or archaeological specimens like those shown in figure 32.

*Figure 32* English slipware sherds from a late-seventeenth-/early-eighteenth-century archaeological context; Hampton, Virginia. Examples of North Devon sgraffito and Staffordshire combed and marbled wares. (City of Hampton Collection; photo, Robert Hunter.)

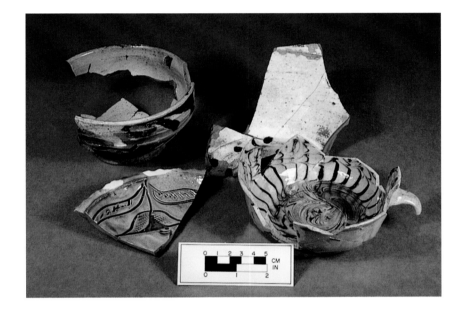

*Conclusion*

We hope this brief overview has offered a slightly different perspective on the relationship between materials and techniques that produced the design elements on English slipwares. Reading about slipware technology from nearly three hundred years of written descriptions provides some understanding of course. And, as our illustrations included here demonstrate, we certainly feel that a picture is worth a thousand words. But the greatest insights always come from actually doing. For those who have not tried the act of slip trailing, it requires an amazing amount of dexterity to achieve the simplest design. If clay and slip are not available, try decorating your pancakes with maple syrup or honey at the next opportunity. You may be reminded to avoid the words "rustic" and "folksy" and substitute "skillful" or "accomplished" when describing English slipware decoration.

1. Bernard Leach, *A Potter's Book* (London: Faber and Faber Ltd., 1945); Irma Starr, *Irma Starr Demonstrates The Lost Art of 17th Century English Slipware Pottery* (Kansas City, Mo.: self-published, n.d.).

2. Louis Marc Solon, *The Art of the Old English Potter* (London: Bemrose & Sons, 1883); Robert Plot, *Natural History of Staffordshire* (Oxford, 1686); Gudrun Klix, "Commemorating

the Millennium," *Ceramics Art and Perception,* no. 40 (fall 2000): 33–44. Illustrated in this last article is a Thomas Toft–style slip charger by Lincoln Kirby-Bell titled "Australia 2000 Coat of Arms."

3. Leslie B. Grigsby, *English Slip-Decorated Earthenware at Williamsburg* (Williamsburg, Va.: The Colonial Williamsburg Foundation, 1993), and Leslie B. Grigsby, *The Longridge Collection of English Slipware and Delftware,* 2 vols. (London: Jonathan Horne Publications, 2000).

4. David Barker, *Slipware* (Buckinghamshire, England: Shire Publication, Ltd., 1993).

5. Robert F. Heizer and John A. Graham, *A Field Guide to Field Methods in Archaeology: Approaches to the Anthropology of the Dead* (Palo Alto, Ca.: The National Press, 1967), pp. 141–47.

6. Plot, *Natural History of Staffordshire,* pp. 123–24. Solon, *The Art of the Old English Potter,* p. 27. Bernard Leach, *Hamada Potter* (Tokyo: Kodansha International, 1990), pp. 125–26.

7. Alison Grant, *North Devon Pottery: The Seventeenth Century* (Exeter, Eng.: University of Exeter, 1983).

8. Leach, *A Potter's Book,* p. 114.

## Donald Carpentier
## and
## Jonathan Rickard

## Slip Decoration in the Age of Industrialization

*Figure 1* Two-handled cup, Staffordshire, dated 1766. Slipware. H. 7⅜". (Courtesy, Colonial Williamsburg Foundation.) White slip was applied to the red-bodied thrown form. The sgraffito decoration was done by hand on a lathe and augmented with freehand carving of the floral decoration and the date.

▼ T H I S   A R T I C L E   P R E S E N T S   an overview of slip decoration methods that were incorporated into the repertoire of mechanized techniques of the British potters beginning in the second half of the eighteenth century. Building upon earlier technology, slip decoration was employed on a wide range of earthenwares. At the high end of the economic scale, Josiah Wedgwood embellished his costly, neoclassical wares with slips (liquid clay). At the lower end, slip decoration was also used on an entire class of cheap utilitarian earthenwares generally referred to as "mocha" wares today but called "dipt" or "dipped" wares in the period. So prolific was the British manufacture and exportation of these bold, bright, and colorful dipped wares, that they are found on nearly every American domestic archaeological site of the early nineteenth century.

Today, when we look at the broad range of slip decoration on utilitarian pots made for everyday use, we do so with the knowledge of the principles of form from the Bauhaus, the theories on the interaction of color from Josef Albers, and the artistic freedom introduced by the abstract expressionists. We see things that were most likely not seen by the people who created these pots, just as we can look back at the poetry of Robert Frost and find symbolism that may or may not have been intended. For the most part, the mugs, jugs, and bowls illustrated here were meant to function and function well. In later years, the British government went so far as to establish the ideal jug shape for pouring most efficiently. Contrasting with that function was the element of chance that entered into the decoration of most dipped wares.

By the 1760s slip decoration had begun to be used in many ways beyond simple trailing. Lead-glazed red earthenware vessels were dipped in white slip and diced by hand to produce a rough checkerboard appearance. Dicing involved cutting through the slip to reveal the body color and scraping areas free of the slip. At least three known examples of two-handled presentation cups dated between 1759 and 1766 bear this type of decoration.[1] These examples are important because they relate chronologically and add to the small body of evidence leading to the development and use of the engine-turning lathe in the potteries (fig. 1).

Josiah Wedgwood, in letters to his friend and eventual partner, Thomas Bentley, wrote of his fascination with the possibilities offered by the engine-turning lathe. On May 28, 1764, he wrote:

[H]ave sent you a sample of one hobby horse [engine turning] w^ch., if Miss Oats will make use of she will do me honour. This

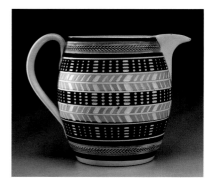

*Figure 2* Jug, Great Britain, ca. 1810. Pearlware. H. 6⅜". (All objects from the Jonathan Rickard Collection unless otherwise noted; photos, Gavin Ashworth.) The jug has toffee-colored and black slip bands and green-glazed rouletted bands, the central area decorated with designs cut through the slip on an engine-turning lathe, using only the edge cam to reveal the body color. The extruded strap handle has press-molded foliate terminals.

branch hath cost me a great deal of time & thought & must cost me more & am afraid some of my best friends will hardly escape. I have got an excellent book on the subject in french & latin. Have enclosed one chapter w^ch. if you can get translated for me it will oblige me much & will thankfully pay any expense attend^g to it.[2]

On July 6, 1765, Josiah wrote to Mr. John Wedgwood: "I shall be very proud of sending a box of patterns to the Queen, amongst which I intend sending two setts of Vases, Creamcolour engine turnd, & printed, for which purpose nothing could be more suitable than some copper plates I have by me."[3] In this letter, it appears that he was sending depictions of items which may or may not have yet been made.

A year later, in a letter apparently sent between October 12, 1767, and October 24, 1767, Wedgwood was further championing the potential of the engine-turning lathe:

> Inclosed are Engine Turning, Antiquitys, Plans, &c., & first, of the first, Engine Turning. I think you will meet with nothing very curious 'till you come to part the third, but I suppose you will skim the other part over. I hope you will read with a pen in your hand, & some sheets of blotting paper before you to enter the memoran^ms. as they occur to you & let me have the Identical sheets on which such memorand^ms. are made. You will readily conceive which of the Machines may, or may not be applicable to a Potter.[4]

Developed initially for the mechanical trades, the engine-turning lathe allowed potters to decorate vessel surfaces with geometrical precision, using the machine in two different ways. The first involved slip banding on a leather-hard pot using one or more colors. This process was most likely performed on a simple turning lathe. After the slip had set, the vessel was fixed to the engine-turning lathe in a horizontal position. By using a combination of fixed blades and an edge cam, a crown cam, or both, the machine would cut a precise pattern through the thin slip coating to reveal the body color (fig. 2). In the second technique, the leather-hard, undecorated pot was mounted on the engine-turning lathe and a shallow pattern of repeat squares and rectangles was cut into the body. The pot was then removed and dipped into a colored slip or banded with slip on the lathe. After the slip was allowed to set up, the pot was reaffixed to the lathe and the turner carefully shaved the slip away until the recessed pattern was revealed in the darker, inlaid color (figs. 3–5). These techniques were undoubtedly in use in the 1770s, although no documentary proof has yet been found.

Josiah Wedgwood also figured prominently in the development of slip marbling used to decorate the elaborate classical vessels for which the partnership of Wedgwood and Thomas Bentley (1769–1780) is best known. Many British potters later used this technique on the more utilitarian creamwares and pearlwares. In an attempt to imitate the natural geological surfaces of the ancient wares Bentley was sending back from Italy, Wedgwood employed several methods to create the appearance of marble. In addition to using slips, he also used multicolored clays wedged together and either turned or press-molded (known today as solid agate). When placed

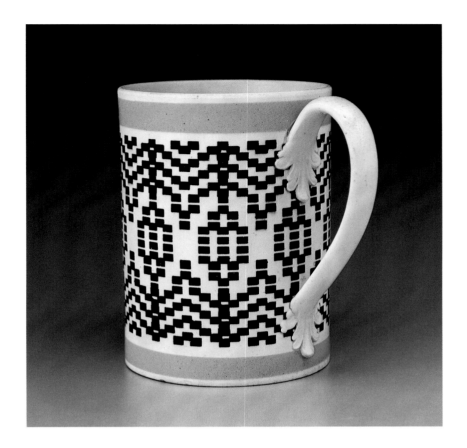

*Figure 3* Mug, Great Britain, ca. 1795. Creamware. H. 5¹⁵⁄₁₆". A quart mug with an engine-turned pattern cut into the pot's outer body and dipped with black slip, then scraped away to reveal only the slip remaining in the recesses. The extruded strap handle has press-molded foliate terminals.

on a simple lathe and shaved smooth, the solid agate body's surface produced the desired pattern of contrasting shades and colors.

The use of slip for marbled decoration required pouring several colors onto the vessel's surface as it revolved slowly on the lathe. Marbled slip, in contrast to agate decoration, appears more fluid, with longer, smoother divisions between shades and colors. Although known for his ornamental wares, Wedgwood may have used these techniques in the manufacture of utilitarian wares in his partnership with his cousin Thomas during the same period. The marbled slip could also be combed or feathered, giving the surface an appearance reminiscent of marbled end papers (fig. 6).

Archaeological evidence from the site of the Staffordshire potter William Greatbatch has been extensively documented and provides some insight into the production of marbled slip on creamwares and pearlwares.[5] Sherds deposited between 1775 and 1782 include marbled-slip tea wares, combed and uncombed. In some instances, the marbled-slip patterns are used in conjunction with blue-painted chinoiserie decoration (fig.7). The earliest evidence that these variegated wares were imported into America comes from a Rhode Island newspaper advertisement offering the contents of the brig *Three Sisters* in 1781.[6] The cargo included "blue and white, marbled and Cream-colour'd Crockery." A similar advertisement in the *Boston Gazette and Country Journal,* December 22, 1783, carried an advertisement for "CROCKERY WARE, Consisting of blue and white China glazed, red and white enamel'd, best printed, variegated &c cream colour'd ware."[7]

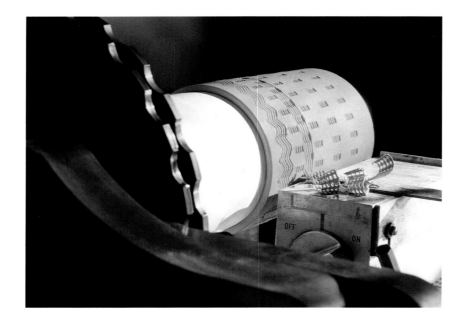

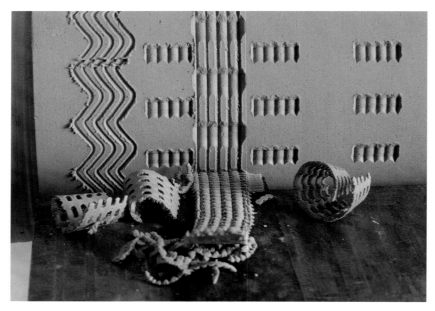

*Figure 4* A geometric pattern being cut into a leather-hard mug mounted on Donald Carpentier's engine-turning lathe.

*Figure 5* A detail of a leather-hard mug body as it is being cut. This is one of Carpentier's earliest attempts at engine turning on the lathe he had built for this purpose. A modified early engine-turning lathe at the Wedgwood Museum in Barlaston, Staffordshire, and an experimental example at the Nicholas Mosse Pottery in Kilkenny, Ireland, are the only other engine-turning lathes in existence for pottery use.

Another type of dipped ware was being used in America earlier, however. An archaeological investigation of (British) Fort Watson in South Carolina produced a hemispherically-shaped pearlware bowl with a black inlaid checkered rim above a powder blue speckled slip field (not unlike the surface Wedgwood called "porphyry"). Fort Watson was erected in December 1780 and captured and destroyed by American forces in April 1781.[8]

Similar wares were found in an underwater deposit left by the American ship *Washington* off the coast of Les Isles du Glénan. The ship is purported to have ripped a hole in its hull at that location in 1787. Sherds recovered from the site included examples of tea wares and mugs with solid and speckled slip fields below inlaid checkered rims, intertwined reeded handles

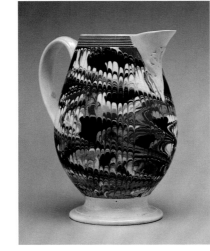

*Figure 6* Jug, Great Britain, ca. 1780. Creamware. H. 5⅝". Baluster-form jug with a press-molded snip (pouring lip) and a simple extruded strap handle. The rim has a green-glazed reeded band above a field of marbled and combed colored slip.

*Figure 7* Bowl, Great Britain, ca. 1775. Pearlware. D. 6". Hemispherical bowl in the Chinese shape, the rim painted inside and out in a familiar chinoiserie pattern above a field of marbled slip. This is one of a small group of known examples where areas of the white slip in the marbling have been enhanced with green glaze, much as examples of earlier solid agate possess areas of blue glaze. Sherds from the William Greatbatch factory site in Fenton, Stoke-on-Trent, have the same combination of blue-painted and marbled-slip decoration, but differ considerably in appearance from this example.

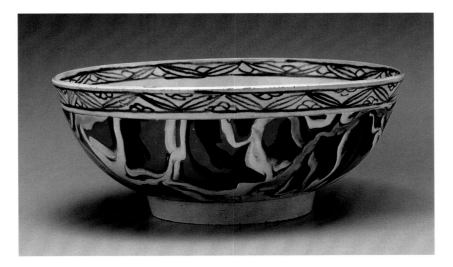

with elaborate foliate terminals, sprigged foliate devices on slip fields, and slip fields interrupted by horizontal grooved bands cut through the slip. The impressed backstamp "HEATH" occurred in the assemblage as well.[9]

Tea wares that survive with rouletted, checkered inlaid bands and solid or speckled slip fields sometimes have added types of slip decoration. The type most often found features a field of inlaid agate, so-called because the shallow inlay is made up of multicolored bits of clay adhered to the pot's surface with a thin coating of slip and turned smooth (fig. 8). A saucer of this type, which descended in the Hollister family of Glastonbury, Connecticut, was illustrated in the catalog accompanying the exhibition *The Great River: Art & Society of the Connecticut Valley 1635–1820* at the Wadsworth Atheneum, Hartford.[10]

While exuberant types of slip decoration usually receive the greatest attention, simple slip bands in one or many colors were used on a wide range of utilitarian vessels throughout the nearly 170-year period of dipped ware production. Heather Lawrence wrote about various pottery sites in Yorkshire where the sherd descriptions include entries such as, "one jug

*Figure 8* Coffee pot and cover, Great Britain, ca. 1785. Pearlware. H. 10⅝". Baluster-form body and cover having vertical reeding created on an engine-turning lathe, along with inlaid agate—tiny bits of different-colored clay adhered to the body with slip and turned smooth. The body also has a band of black slip-filled checkered rouletting, a press-molded spout, and an extruded strap handle with foliate terminals; the cover has a tipped acorn knop.

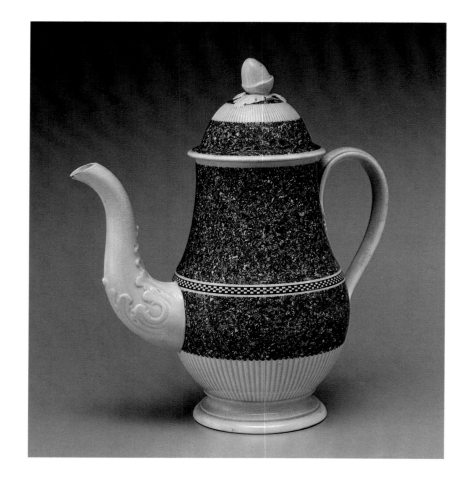

*Figure 9* Water bottle and basin, Great Britain, ca. 1775. Creamware. H. 10". This bottle and basin set was dipped in pale yellow slip and cut away in horizontal bands on the lathe. The basin has a rolled rim below which are sprigged bellflower swags touched with green glaze (copper oxide). The bottle has matching bellflower swags without the green glaze.

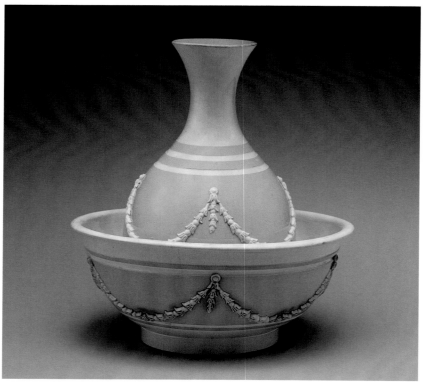

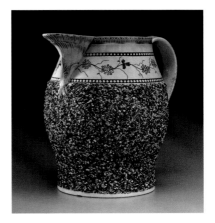

*Figure 10* Jug, probably Welsh, ca. 1795. Pearlware. H. 6⅞". Jug with green-glazed molded rim and press-molded snip, two bands of inlaid rouletted beads, painted vines, and a field of tiny clay fragments beneath the clear lead glaze. Donald Towner referred to this type of decoration as "encrusted." Nearly matching sherds from the Cambrian Pottery site, Swansea, Wales, are in the Swansea Museum.

has horizontal slip banding."[11] Similarly, Alwyn and Angela Cox, in their research on the Rockingham factory at Swillington, Yorkshire, refer to comparable sherds (fig. 9).[12]

Donald Towner, in his book *The Leeds Pottery,* calls another category of slip-decorated earthenware "encrusted ware."[13] The slip field in this case was replaced by a pebbly surface of bits of multicolored clay attached by slip. Predecessors of this type of decorative technique include the rough-coated Staffordshire and Nottinghamshire bear jugs and salt-glazed wares. This decoration has also been called "cole slaw" decoration, with ground bits of clay allowed to remain textured on the pot's surface (fig. 10).

Historical archaeologists on both sides of the Atlantic are beginning to understand how important it is to recognize the evolution of the different styles of slip decoration along with the more traditional attributions of body type and vessel form. The most common form of dipped wares found archaeologically is the bowl. The earliest shape of bowl is hemispherical, in imitation of the Chinese porcelain shape. British bowls of the last three decades of the eighteenth century are hemispherical with a comparatively tall foot ring, slightly tapered in profile. Most bowls of this shape were decorated with marbling, checkering, or engine turning.

In the first decade of the nineteenth century, the shape of these bowls changed quite abruptly. In 1807, the porcelain industry introduced the so-called London shape. It appears that earthenware manufacturers lost no time in copying this form. Although slip marbling is one of the most commonly found slip decorations on hemispherical bowls, it is rarely found on the London shape (figs. 11, 12).

*Figure 11* Bowl, Great Britain, 1800–1810. Pearlware. D. 7¼". Hemispherical bowl banded with black and rust-colored slips below a reeded band with scarcely encountered yellow glazing. The broader slip field has been embellished with mocha decoration, a black-colored acidic infusion touched to the still-wet slip, where it nearly instantaneously branches out in fine traceries.

*Figure 12* Bowl, Great Britain, ca. 1820. Pearlware. D. 6½". London-shape bowl, similar to the bowl illustrated in fig. 11 except that the rouletted rim has the more typical green glaze and the mocha decoration extends over different-colored slip bands.

It is important to know that slip colors and body composition relate to the evolution of dipped ware types. Composition of clay bodies varied not only among different potters, but also within each pottery from time to time. A potter may have experimented with different combinations of clay, flux, flint, and other materials to arrive at a "best body," but that best body could well have been superseded at any time.

The interaction between the leaded glazes and various earth colorants plays a part in the final appearance of many slip-decorated wares. A large percentage of surviving examples of dipped ware from the period 1770 to 1840 bear rouletted bands colored with copper oxide glaze, which produced a rich, translucent green. The green is dependent on the lead for its richness. Less frequently, rouletted bands are colored with cobalt and, rarely, with either antimony or uranium, which produce a brilliant yellow. The ingredients used to produce this yellow glazing proved to be highly toxic and their use was confined to a short period in the early nineteenth century, according to the late ceramic historian C. John Smith.[14]

As with most aspects of ceramic history, there are no absolutes. For example, some of the hemispherical bowl fragments found in the third deposition of the Greatbatch site (1775–1782) have rounded foot rings rather than tapered ones. The hemispherical shape can also be found on later nineteenth-century bowls after the London shape had fallen out of fashion. But the London-shape bowl is most often found with slip decoration that did not appear until the 1790s in one case, and after 1810 in other cases.

The 1790s saw the introduction of the true mocha decoration, or so existing documents would indicate. London merchants of the late eighteenth century imported a type of semiprecious stone from Arabia to set in jewelry. This stone, a moss agate, when fractured revealed a treelike or mossy pattern. The stones were shipped through the port of Mocha ("el Mukha") in Yemen, hence the name "mocha stone." The first reference to pottery with this type of marking comes from the potters Lakin and Poole via the nineteenth-century ceramic historian Llewellyn Jewitt. In his massive undertaking *The Ceramic Art of Great Britain* (1878), Jewitt listed the types of wares mentioned on various Lakin and Poole invoices dating from 1792 to 1796 and includes "mocoe tumblers."[15]

The mocha stone patterning was adopted as a component of slip decoration techniques. Lathe-mounted greenware (unfired pottery at the leather-hard stage) was first coated with bands of slip (figs. 13, 14). The turner dipped a "camel hair pencil" (an artist's brush) into an acidic solution the potters called "mocha tea" and applied it by touching the tip of the brush to still-wet slip bands (figs. 15–17). The chemical and physical reaction between the "tea" and the wet slip caused the dendritic design to form nearly instantaneously (fig. 18). An observer of the process in 1833 described it as follows:

> The "Moco" pattern on the outside of basons makes them appear as if delicate branches of seaweed had been laid upon their surfaces. This mock seaweed is not unlike the *fucus sauginens,* only it is not so red. The fluid employed is a preparation of tobacco-water; and in applying it the effect is brought out with but little waste of either time or labour. A camel's hair pencil full of this decoction is taken in the hand, and with the point of

Figure 13 Period descriptions of turners applying slip decoration often refer to the use of a "blowing bottle" to apply courses of colored thin bands. Here, Carpentier demonstrates the process using a blowing bottle that he made based on period references.

*Figure 14* Detail of the application of a single-color string band of slip through the blowing bottle.

*Figure 15* On the mug body banded with the blowing bottle, Carpentier applies mocha decoration. The acidic solution referred to in period documents as "mocha tea" spreads in a random branching pattern on the moist slip.

*Figure 16* A second drop of "mocha tea" is added as the mug is rotated slowly on the lathe.

*Figure 17* The completed rotation of the mug.

*Figure 18* Detail of the mocha process from start to finish. Elapsed time is generally two to three seconds.

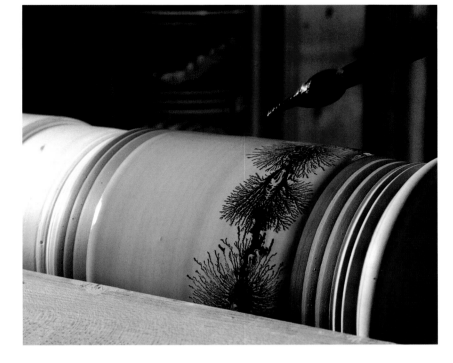

*Figure 19* "Moco" formula. Excerpt from a nineteenth-century potter's recipe book attributed to the Godwin pottery, Staffordshire. (Courtesy, Colonial Williamsburg Foundation.)

it the surface of the bason is dotted with two or three dots where the pattern is intended to be. The fluid instantly spreads and runs into these ramifications.[16]

It appears that most potters developed their own recipes for the mocha solution. Surviving period recipe books call for the inclusion, among other things, of printer's ink, hops, tansy, and urine (fig. 19). Thomas Brameld of the Rockingham factory at Swinton, Yorkshire, recorded his recipe as "1 iron scales, calcined; 1 Painter's Blue, calcined; and 1 Manganese [meaning equal parts thereof]. Memo: Being short of a good vinegar, James Barrow one day tried a small quantity of spirits of turpentine along with his old colour and it answered very well. May 1808. T .B."[17]

The various coloring agents had to be suspended in some form of acidic fluid that, on introduction to the alkaline of the slip, ramified into the tree-like patterns through a form of capillary action. With the earliest mention of this "mocha," "moco," or "mocoe" in the last decade of the eighteenth century, it is interesting to note that dendritic decoration remained in production until 1939 — nearly 150 years.

*Figure 20* Jug, Great Britain, ca. 1835. Pearlware. H. 6¾". Jug with tricolored cat's-eye and cable decoration below a blue slip band and a green-glazed band of rouletting. The extruded strap handle has foliate terminals.

*Figure 21* One of Carpentier's three-chambered slip cups showing the three compartments filled with slip. Period examples were made of tinplate or earthenware.

*Figure 22* Detail of the chambers of the slip cup illustrated in fig. 21 showing three colors of slip.

*Figure 23* Detail of the tip of the slip cup illustrated in fig. 21.

Another important category of slip decoration widely employed throughout the British potteries involved the use of the three-chambered slip cup (fig. 20). A unique tool was developed to permit multiple colored slips to be used in combination to create several related patterns (fig. 21). An early clue to the use of this tool can be found in the description of a patent granted to Richard Waters of Lambeth on October 23, 1811. The pertinent section reads as follows: "I do so mark or cloud the ware called Welsh ware by using a number of pipes or tubes at once instead of one pipe or tube through which the colouring slip or material is made to flow by which means the operation is better and more speedily performed."[18]

The documents relating to this patent have no drawings of the device. Waters's description suggests an object, believed to have been a slip pot, constructed with three separate compartments (fig. 22), each of which had a small hole into which a tube (in practice, a goose quill) was inserted. The tubes were arranged to form a conjoined spout (fig. 23) through which three separate and discrete colors could form a single fluid drop or stream (figs. 24, 25).

An 1833 observer describes the function of this tool, which was greatly employed throughout the potteries:

> On some [ornamenting common basins] was soon done by dropping mixtures of three or four different colours on the bason, from so many different spouts attached to one vessel containing the mixtures; but this vessel, of course, had several compartments within it.[19]

A single drop from the three-chambered slip cup produced a design that collectors have termed "cat's-eye" (fig. 26). A series of cat's-eyes, overlapped,

*Figure 24*  A close-up view of the three colors of slip as they emerge from the three tubes of the slip cup. They form a single droplet, yet maintain the individual colors that will compose any of the types of decoration for which this tool is used.

*Figure 25*  The tricolored droplet falling from the slip cup. Note the smaller, secondary droplet falling behind.

*Figure 26* Close-up view of a single cat's-eye, immediately after falling as a tricolored droplet onto a dry surface. When applied to a fairly dry slip field, the moisture in the slip is quickly absorbed by the underlying clay body, fixing the decoration in place. A secondary cat's-eye is visible in the center of the larger one. This is from the secondary droplet shown in fig. 24. Period cat's-eye decorations all seem to have this characteristic as well.

*Figure 27* Single cat's-eyes being dripped and starting to overlap.

*Figure 28* When cat's-eyes are quickly overlapped in a continuous line, they form the decoration known to collectors as "earthworm." The same decoration is referred to in period documents as "cable." This shows typical cable decoration before the moisture has been absorbed. In practice, conditions varied so that, for example, too much moisture in the body slowed the absorption rate, allowing the top layer of slip to continue moving as the object rotated on the lathe. Likewise, if slip dried too quickly, a quill might become blocked and only two colors would appear. Randomness played a part in the final appearance of these pots.

produced a pattern that the potters referred to as "cable" or "common cable" (figs. 27, 28). This device also produced a pattern called "twig" by collectors (fig. 29). This pattern was created by quickly trailing a series of opposing, connected curves onto the wet slip surface of a vessel (fig. 30). These twig patterns probably postdate 1807, as they do not appear on the earlier hemispherical bowls. They do, however, appear to continue to be used throughout the nineteenth century. Sherds from the Podmore, Walker & Co. Swan Bank site in Tunstall, Staffordshire, have both cat's-eye and cable decorations on fairly standard gray, blue, and black bands of this somewhat later period, 1853 to 1859 (fig. 31). By this time, slip decoration colors were more conservative and the practice of adding glaze colors to rouletted bands had disappeared.

Wares ornamented with cat's-eyes and cable decoration are well represented in tavern and household archaeological assemblages of the first half of the nineteenth century along America's eastern seaboard. Archaeological evidence suggests that the bowl was the most common form of dipped ware used in American households. A ground scatter at the late-eighteenth-century Nathan Southworth house in Deep River (originally Saybrook), Connecticut, produced evidence of eleven different dipped ware bowls among sherds encompassing many of the expected wares of the first half of the nineteenth century. These other wares included a dinner service in the Park Scenery pattern printed in black by G. Phillips & Co. of Longport, Staffordshire, red-and-green Canova pattern by T. Mayer of Stoke, an assortment of blue-and-green shell-edged wares, slip-trailed American red-

*Figure 29* Mug, Great Britain, ca. 1825. Pearlware. H. 4¾". Pint mug with tricolored cat's-eyes and twigs produced with a three-chambered slip cup. While the blue and black slips appear obvious, white slip is barely present in the designs. This deficiency may be the result of the white slip drying and partially clogging the tube, allowing little to flow onto the pot's surface. Alternatively, the white slip may have been more fluid and therefore ran out sooner than the other two colors.

*Figure 30* By dragging the tips of the three gathered quills in a series of connecting opposing motions, Carpentier replicates the pattern known to collectors as "twig."

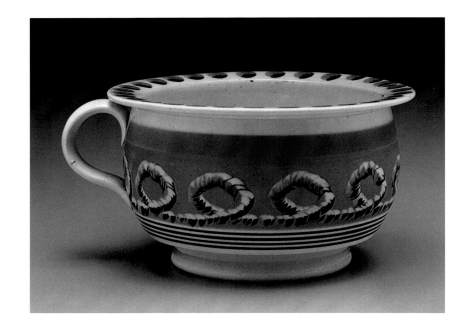

*Figure 31* Chamber pot, Staffordshire, 1853–1859. Pearlware. D. 8¾". Chamberpot decorated with cat's-eye and cable in a more subdued palette, indicating a later date of manufacture. The exterior decoration, in fact, matches sherds at the Potteries Museum, Stoke-on-Trent, from the Podmore, Walker & Co. factory site in Tunstall, Stoke-on-Trent.

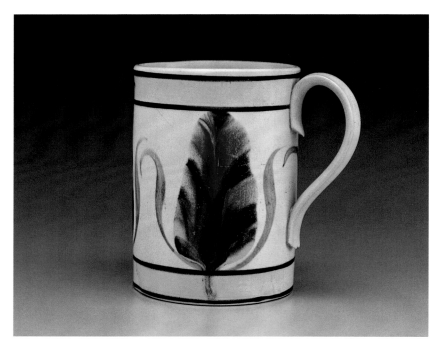

*Figure 32* Mug, Great Britain, ca. 1810. H. 4¾". Mug with brown slip bands enclosing yellow-glazed bands usually found on a rouletted surface but seen here on a plain surface. The mug has been further decorated by dipping it into a small pool of multicolored slip. The action of pulling the mug away from the pool of slip caused the slip to pull toward the center of the patch. When the mug was turned upright, the colors flowed toward the bottom. Further embellishment was added in the form of painted fronds on either side of each of the three *fans* on this rare mug.

ware, and portions of two black-glazed redware teapots of the type made by Thomas Crafts at Whately, Massachusetts.

Other types of slip decoration belong in this overview. We refer to one as "dipped fan," partly because of the process and partly because of the resulting effect (figs. 32–34). Collectors have given this design a variety of names, including "tobacco leaf," "balloon," "lollipop," and "palmate." Extant examples of this pattern are inexplicably scarce, but archaeological evidence shows that factories from Bovey Tracey in Devon to Mussel-borough in Scotland produced it. It may have also been produced at the

*Figure 33* In creating the dipped fan pattern, the object to be decorated was dipped partway into a pool of striped or marbled slip.

*Figure 34* Pulling the pot out of the slip caused the wet slip to maintain contact in a form of capillary action, resulting in the heaviest concentration of slip appearing in the center of the pattern. When the pot was placed in an upright position, if the slip was wet enough, gravity would cause the wettest portion to stream downward, creating the tail or stem usually seen on these examples.

Downshire creamware factory in Belfast, Northern Ireland.[20] Sherds of the fan pattern were found by the authors at the Clay Mill Pottery site in Baglan, near Port Talbot in Wales. The decoration on those fragments occurs on an earthenware body, the color of which varied from a pale buff to a dark red. Only one extant example of the fan pattern is known to bear a maker's mark, that of John Shorthose.[21]

Another decorative pattern is actually a continuation of the seventeenth-century method of slip trailing. In most cases, this was done with a single-chambered slip cup fitted with three or four parallel tubes. One method

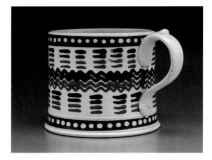

*Figure 35* Mug, probably Scotland, ca. 1840. Pearlware. H. 4⅛". Pearlware porter mug with several unusual features: the handle is press molded, as opposed to the normal extrusion; the interior is embellished with a painted, press-molded, life-sized frog; the thin brown slip bands near the rim and foot are decorated with white slip dots; and the exterior is trailed with four colors of slip, requiring a four-chambered slip pot. Most multiple, parallel trailed lines of slip found on dipped wares are a single color. To date, the only factory known to be associated with this type of decoration is that of John Thomson at the Annfield Pottery, Glasgow (1812–1884).

even involved the use of a four-chambered "worming" pot to apply parallel slip lines, each of a different color (fig. 35). Some recent archaeological evidence suggests these four-colored, slip-trailed examples are from the Annfield Pottery of John Thomson in Glasgow.

By the middle of the nineteenth century, the American market for British industrial slipwares was on the wane. The wares of the mid-nineteenth century and later lacked the brighter, earthier colors of the earlier wares. American pottery manufacturers were producing much plainer utilitarian wares for the home market in increasing numbers. Slip-banding traditions continued well into the late nineteenth century with the American yellowware manufactures in Ohio and Kentucky.

Production continued in England, however, with mocha mugs and jugs becoming certified units of measure for use in pubs and markets (fig. 36). Many of these later objects bear some form of capacity verification mark,

*Figure 36* Glass slide of British pub showing mocha tankards, 1890–1910. (Courtesy, Donald Carpentier.)

*Figure 37* Mug, probably Bristol, ca. 1915. Whiteware. H. 4⅞". Whiteware pint mug with mocha decoration in an unusual diagnostic color. The broad slip band on mugs of this period is usually in the tan- to olive-colored range. The blue and black bands are standard, though the sequence may vary from maker to maker. In this case, the manufacturer complied with prevailing English law requiring vessels of specific capacity to be so marked and verified by the weights and measures officials. The mark is sandblasted through the glaze and reads "GR 490," followed by either a "5" or an "s." The

"GR" signifies that George V (1910–1936) or George VI (1936–1952) was on the throne; undoubtedly it was the former, inasmuch as most mocha production had stopped by the 1920s. The "490" represents the Weights and Measures District of Bristol City. Above the verification mark is the printed mark of the Bell Hotel, Radstock, whose bar this mug was made for. Radstock is a small town south of the cathedral city of Wells and southeast of Bristol. Radstock was either within the Weights and Measures District of Bristol City or the verification took place at the factory.

*Figure 38* Jug, Staffordshire, probably Enoch Wood, ca. 1835. Pearlware. H. 7". Jug with cat's-eye and trailed-slip decoration and an unusual green-glazed, rouletting pattern. This jug has a history of ownership in Great Barrington, Massachusetts.

usually sand-blasted through the glaze. These marks include a reference to the throne, the date and the excise district number (fig. 37). An example would be E02R 379. The "ER" is for Edward Regis, the "02" for 1902, and the "379" for the excise district of Burton-on-Trent. It is likely that local potteries served local excise districts, so it is probable that a mug bearing that marking would have been made at T. G. Green & Co. in Church Gresley.

The contribution of the British slipware manufacturers cannot be overstated. A tremendous variety of these cheap, colorful utilitarian wares was available to the American consumer from the 1780s well into the 1850s. In viewing the relatively few examples that have survived intact, the visual impact that these wares had on the domestic landscape must have been considerable. Today, when archaeologists uncover large quantities of dipped sherds, the visual impact is still significant to the contemporary eye.

In 1998, a large cache of wasters attributed to the Enoch Wood factory (1831–1845) was discovered in Burslem. Sherds that parallel the jug illustrated in figure 38 were found in the assemblage. This particular jug has a long history of ownership in a house in Great Barrington, Massachusetts. It exhibits signs of heavy use, a common characteristic of surviving dipped wares, since these wares *were* intended for use. The fact that any survive is perhaps the best testament to the visual appeal of these bright and fancy wares and the ingenuity of the British slipware potters.

1. Leslie Grigsby, *English Slip-Decorated Earthenware at Williamsburg* (Williamsburg, Va.: The Colonial Williamsburg Foundation, 1993).

2. Cited in Katherine Eufemia Farrer, *Wedgwood's Letters to Bentley, 1762–1770* (London: For private circulation, 1903), pp. 17, 18.

3. Ibid., p. 47.

4. Ibid., p. 177.

5. David Barker, *William Greatbatch: A Staffordshire Potter* (London: Jonathan Horne, 1989).

6. John L. Seidel, "China Glaze Wares on Sites From the American Revolution," *Historical Archaeology* 24, no. 1 (1990): 91.

7. Ibid.

8. Leland G. Ferguson, "Analysis of Ceramic Materials from Fort Watson, December 1780–April 1781," in *Conference on Historic Site Archaeology Papers* edited by Stanley South (Columbia: University of South Carolina, 1973) vol. 8, pp. 2–28.

9. Bernard de Maisonneuve, in a report on marine excavation, "Sites des Faiences. XVIIIème Siècle/Iles de Glenan," Saint Gilles Croix de Vie, France (Association de Recherche Historique Maritime et Sous-Marine), January 2, 1990.

10. Elizabeth Pratt Fox, "Ceramics and Glass," in *The Great River: Art & Society of the Connecticut Valley, 1635–1820,* edited by Gerald W. Ward and William N. Hosley (Hartford, Conn.: Wadsworth Atheneum, 1985), p. 426, cat. no. 285.

11. Heather Lawrence, *Yorkshire Pots and Potteries* (Newton Abbot and North Pomfret, Vt.: David & Charles, 1974), p. 21.

12. Alwyn Cox and Angela Cox, *Rockingham Pottery and Porcelain 1745–1842* (London: Faber & Faber, 1983), pp. 48–52.

13. Donald Towner, *The Leeds Pottery* (London: Cory, Adams & Mackay, Ltd., 1963), p. 47.

14. C. John Smith, in a lecture at the Shelburne Museum, Shelburne, Vermont, October 1981.

15. Llewellyn Jewitt, *The Ceramic Art of Great Britain* (New York: Scribner, Welford, and Armstrong, 1878).

16. Peter Orlando Hutchinson, *Journal* (reprinted as *Longton,* 1833), *Annual Report & Transactions of the North Staffordshire Field Club,* vol. 49 (1914–15), p. 57.

17. Cited by Margaret E. Turnbull, "Mochaware," *The Antiques Journal* (August 1974): 42–43.

18. Pat. No. 54/8887/ PEN/1332.

19. Hutchinson, *Journal,* p. 57.

20. Peter Francis, "Irish Creamware: The Downshire Pottery In Belfast," *English Ceramic Circle Transactions* 15, part 3 (1995): pp. 400–25; cover illustration.

21. A cylindrical teapot illustrated in Jonathan Rickard, "Mocha Ware," *Antiques* (August 1993): 187.

George L. Miller
*and*
Robert Hunter

How Creamware
Got the Blues:
The Origins of
China Glaze and
Pearlware

▼ O N E   O F   T H E   M O S T   common earthenwares found on American archaeological sites dating from the 1780s until the 1830s has a bluish tint to its glaze. It is generally known by the term "pearlware," a name adopted from Josiah Wedgwood's Pearl White, which he introduced in 1779. The other Staffordshire potters, however, called this ware "China glaze" and appear to have begun producing it as early as 1775. This paper explores what led to the development of China glaze, and how its name disappeared from general usage until the mid-twentieth century.

*The Quest for Chinese-Style Porcelain in England*
Importation of Chinese porcelain into Europe provided a great catalyst for experimentation in the quest for the secret of making porcelain. That quest for the arcanum fathered a host of new wares and improvements in old ones. A variety of soft-paste porcelains was developed using fritted glass, soapstone, or calcined bone, in combination with white-firing clays and calcined flint. In addition to the soft-paste porcelains, the white-firing clays and calcined flint also became ingredients in whiter wares such as white salt-glazed stoneware, creamware, and stone china. The pursuit of the arcanum was spurred on by Johann Friedrich Böttger's success in producing a Chinese-style porcelain in Meissen, Germany, in 1710.[1]

The solution to the mystery of porcelain became clearer when the Jesuit missionary Père D'Entrecolles provided detailed descriptions of the production process and the materials used by the Chinese. D'Entrecolles was a missionary to the Ching-tê-chên region of China. From there, he sent two long, detailed descriptions of the porcelain-making process, one in 1712 and the other in 1722. Du Halde incorporated this information into his history of China, published in English in 1725.[2] Knowledge of how the Chinese made porcelain and the key ingredients used gave a new sense of direction for the quest by English potters. By the middle of the eighteenth century English soft-paste porcelain works had been established in Bow, Chelsea, Liverpool, and Worcester to make imitations of this coveted ware.

It was not until the 1740s, when William Cookworthy, a Quaker apothecary interested in chemistry, found extensive deposits of kaolin clay and petuntse in Cornwall that an English hard-paste porcelain could be produced.[3] Ceramic historian Bernard Watney states that William Cookworthy "at first followed Père D'Entrecolles's description meticulously, but he soon found that his formulae had to be amended" to make them work.[4] Cookworthy patented his hard-paste porcelain formula in 1768 and built a

*Figure 1* Plate, probably Staffordshire, ca. 1790. China glaze. D. 10". (All objects private collection, unless otherwise noted; all photography Gavin Ashworth, unless otherwise noted.) China glaze is most often associated with underglaze chinoiserie decoration. Unfortunately, these early China glaze wares were rarely marked by their manufacturers. One painted design appears to have been standardized by the English potters which Ivor Noël Hume and others have called the "Chinese house pattern." Innumerable variants of this design exist. The common thread between them is the formulaic layout of the pattern's primary features: trees, fence, house or pagoda, fence, and more trees. The foreground almost always consists of shimmering water with assorted rocks and plants. Although the specific origin of the pattern is unknown, it appears to have been adapted from chinoiserie patterns painted on English porcelains of the 1750s and 1760s rather than directly from Chinese prototypes.

factory to produce the wares in Plymouth, Cornwall, that same year. In 1774 Richard Champion, one of Cookworthy's partners, purchased his patent and moved the factory to Bristol. The production of a hard-paste porcelain had met with limited success and had absorbed a lot of capital. In an attempt to be sure that he would be able to recover his investment, Champion attempted to have the patent renewed by Parliament in 1775.[5]

Champion's request for the renewal of Cookworthy's patent was fought vigorously by Josiah Wedgwood on behalf of the Staffordshire potters. In his appeal for the renewal of the patent, Champion wrote about the great expense of producing the porcelain and described the difficulties they had to overcome. Champion stated:

> There is one branch of the manufacture, the blue and white, upon which he has just entered, this branch is likely to be most generally useful of any: but the giving of a blue color under the glaze, on so hard a material as he uses, has been found full of difficulty. This object he has persued [*sic*] at great expense by means of a foreign artificer; and can now venture to assert that he shall bring that to perfection which has been found so difficult in Europe in native clay.[6]

Wedgwood argued that Cookworthy and Champion had already had time enough to take advantage of their patent. He further argued that to extend the patent would deprive others of the opportunity to experiment with these materials and would also deprive landowners of the value of kaolin and petuntse, or Growan stone, deposits that existed in abundance. It is interesting to note that Wedgwood's Common Place Book for 1775 contains an account of the Chinese method of manufacturing porcelain.[7]

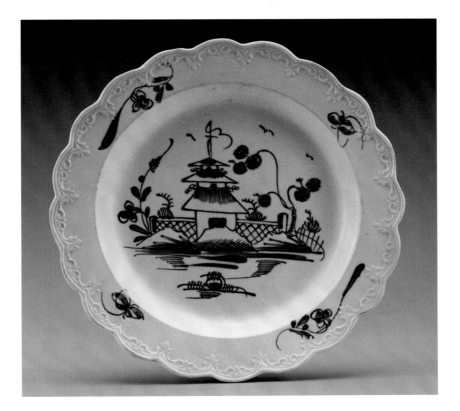

In May 1775 Parliament came up with a compromise that brought about major changes in the Staffordshire pottery industry. Champion's patent to make porcelain out of the materials from Cornwall was renewed; however, the rights to use kaolin and Growan stone were open to all potters so long as they did not make porcelain.

Within days of the patent renewal, Josiah Wedgwood, John Turner, and Thomas Griffiths traveled to Cornwall, secured mining rights to kaolin and Growan stone, and set up a cooperative to ship these materials to Staffordshire for anyone to purchase and use.[8] After setting up the cooperative, Wedgwood tried to establish a potters' organization to experiment with the new wares, but was unsuccessful.[9]

### Cobalt, Blue Painters, Enamelers, and the Staffordshire Potters

Cookworthy and Champion's problems in using cobalt blue under the glaze had been overcome by a number of potters producing soft paste well before the Cookworthy patent. Bernard Watney's *English Blue and White Porcelain of the Eighteenth Century* illustrates many blue-painted patterns in a Chinese style on vessels from Bow, Liverpool, and Worcester dating to the 1750s. The success of these potteries in producing blue-painted wares a couple of decades before Champion's patent renewal application suggests that Cookworthy and Champion's problems were due to their lack of a pottery background. Champion sold his patent to a group of Staffordshire potters who set up the New Hall Pottery in 1781 to produce hard-paste porcelain; the potters do not seem to have had any problem producing

*Figure 4* Mug, Staffordshire or Yorkshire, 1777. Creamware. H. 4". (Collection of Troy D. Chappell.) An early example of the Chinese house pattern on a creamware body.

*Figure 5* Reverse of the mug illustrated in fig. 4. (Collection of Troy D. Chappell.) The painted inscription reads: "It is an honour for a / man to ceace from/ strife but Every / fool will be meddling/ 1777." The date on this mug demonstrates that blue-painted chinoiserie patterns were being produced on earthenware before Josiah Wedgwood's introduction of Pearl White in 1779.

blue-painted wares.[10] In August 1778 Wedgwood summed up Champion's problems in a letter to his partner Thomas Bentley:

> Poor Champion is quite demolished...he had neither the professional knowledge, sufficient capital, nor scarcely any real acquaintance with the material he was working on.[11]

In some ways, cobalt blue was as important an element in the quest for porcelain as kaolin and Growan stone. Use of cobalt for decorating pottery began with the Dutch delft potters who established factories in England in the sixteenth century. Until the mid-eighteenth century, cobalt use in England was mostly limited to delftware. By the 1750s, the use of cobalt by the emerging soft-paste porcelain industry was becoming common. Cobalt was also becoming more common on Staffordshire products such as scratch-blue salt-glazed stoneware.

Decorators for the nascent porcelain industry were probably recruited from the delftware industry, which had been suffering a loss of market share to white salt-glazed stoneware, as well as from the success of new porcelains. Lorna Weatherill's dissertation provides estimates of the number of persons employed in the various types of potteries in England from 1740–1800. Table 1 clearly illustrates the takeoff of the porcelain and fine earthenware potteries in the last half of the eighteenth century and the rapid decline of the delftware industry.[12]

*Table 1.*
Weatherill's Estimates of the Number of Workers Employed
in Various Branches of the English Pottery Industry, 1740–1800

| Year | Delft | Stoneware | Fine earthenware | China |
|------|-------|-----------|------------------|-------|
| 1740 | 665 | 633 | 165 | |
| 1745 | 600 | 588 | 280 | 65 |
| 1750 | 635 | 656 | 610 | 270 |
| 1755 | 620 | 565 | 855 | 365 |
| 1760 | 640 | 577 | 1,335 | 445 |
| 1765 | 495 | 375 | 1,960 | 450 |
| 1770 | 380 | 350 | 2,635 | 280 |
| 1775 | 290 | 330 | 3,375 | 290 |
| 1780 | 120 | 270 | 4,325 | 390 |
| 1785 | 55 | 325 | 5,560 | 365 |
| 1790 | | 385 | 7,210 | 385 |
| 1795 | | 431 | 8,050 | 525 |
| 1800 | | 505 | 8,945 | 850 |

The delftware painters were blue painters as opposed to enamelers. Enamel painters, because they painted on top of a stable, fired glaze, were able to operate independently of the factory structure or as employees working outside the pottery factories. The fired blank wares from a porcelain factory could be safely transported elsewhere for enameling. In contrast, the delftware blue painters had to work within the potteries because

*Figure 6* Punch bowls. (*Left*): Leeds pottery, ca. 1780. China glaze. D. 10". (*Right*): Yorkshire or Staffordshire, 1777. Creamware. D. 8". (Courtesy, Colonial Williamsburg Foundation.) These bowls exemplify the close relationship between China glaze and the creamware bodies.

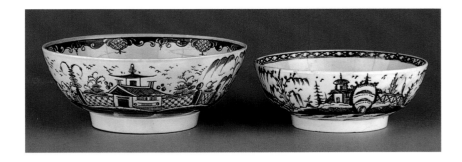

*Figure 7* Interiors of the punch bowls illustrated in fig. 6. (Courtesy, Colonial Williamsburg Foundation.) The decorated interiors of these bowls are reminiscent of inscribed delft punch bowls. The inscription on the left reads "May the / Evening Deversion [*sic*] / bear the / Mornings [*sic*] Reflection." The interior of the bowl on the right has a coat of arms with "1777" and "I. N."

*Figure 8* Detail of the foot rings of the punch bowls illustrated in fig. 6. (Courtesy, Colonial Williamsburg Foundation.) The pooling of cobalt in the foot ring is clearly evident in both examples.

they painted on a very friable, unfired glaze. After painting, the delftware had to be fired again in the high-temperature delft kilns.

The declining delftware industry could not provide the number of painters needed for the new porcelain industry. In a 1740 petition to Parliament, Nicholas Sprimont, a partner in the Chelsea porcelain works, asked for protection against losses caused by German porcelain smuggled into England. His justifications for protection cited the contribution their factory made to the economy. This included the establishment of a nursery of "thirty lads taken from the parishes and schools and bred to designing and painting," thus providing the poor with careers.[13]

Another indication of the shortage of painters comes from a help-wanted advertisement for "Painters in Blue and White," placed by the Worcester factory in 1761.[14] Wedgwood's letters to his partner Bentley made several references to looking for painters and the possibility of establishing a training school that would be needed after they opened an enameling shop in

*Figure 9* Spill vase, Yorkshire or Staffordshire, ca. 1775. Creamware. H. 6⅞".

*Figure 10* Reverse view of the spill vase illustrated in fig. 9. This early example combines elements of rococo design with the odd juxtaposition of the Chinese house pattern on the reverse of this molded vase.

Chelsea in 1769. Wedgwood asked Bentley to seek painters among the fan, coach, and fresco painters. Later that year, Wedgwood mentions looking for painters in Birmingham and suggests that they try to find painters at the Lambeth delft works.[15] In May 1770 Wedgwood wrote to Bentley concerning the recruiting and training of painters, underscoring the shortage of painters and the Staffordshire potters' expanding need for them.

> You observe very justly that few hands can be got to paint flowers in the style we want them. I may add, nor any other work we do. *We must make them.* There is no other way. We have stepped forward beyond the other manufacturers and must be content to train up hands to suit our purpose....We must be content to train up such Painters as offer to you and not turn them adrift because they cannot immediately form their hands to our new stile.[16]

The growing need for painters was a by-product of the success of Wedgwood's creamware. The demand created by its brilliant marketing caused a fall in the demand for English porcelains. Weatherill's estimates of the number of workers in the English pottery industry (see Table 1) show a drop in the number of porcelain workers from an estimated 450 in 1765 to 280 in 1770. During the same period, the number of fineware potters jumped from 1,333 in 1760 to 2,635 in 1770. In 1829, Simeon Shaw described the introduction of enamel-painted wares:

> Workmen were soon employed from Bristol, Chelsea, Worcester, and Liverpool where Tiles had long been made of Stone Ware and Porcelain; and who had been accustomed to enamel them upon white glaze, and occasionally to paint them under the glaze. For some years the branch of Enamelling was conducted by persons wholly unconnected with the manufacture of Pottery; in some instances altogether for the manufacturers; in other on private account of the Enamellers; but when there was great demand for these ornamental productions, a few of the more opulent manufacturers necessarily connected this branch with the others.[17]

Blue painters were among those coming into Staffordshire from the porcelain factories. Worcester is one of the best-documented English porcelain factories. Many of the blue-painted, Chinese-style patterns produced

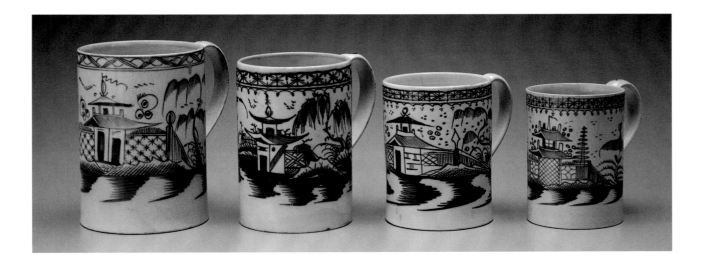

*Figure 11* Mugs, Staffordshire or Yorkshire, 1775–1810. China glaze. H. 4½" to 6". Mugs are among the most commonly recovered China glaze forms on American archaeological sites.

by Worcester have been illustrated both in photographs and drawings.[18] The blue-painted patterns began to be replaced by underglaze blue-printed patterns in the 1760s.[19] Excavations of a Worcester waster pit produced a series of stratigraphic levels that clearly show the transition. Table 2 presents the percentages of blue-printed versus blue-painted levels from that excavation.

*Table 2.*
Blue-Printed versus Blue-Painted Sherds from the Excavation of a Worcester Waster Pit[20]

| Level | Dates | Painted | Printed |
|---|---|---|---|
| 18 | ca. 1757–58 | 90.0% | 10.0% |
| 17 | ca. 1758–60 | 86.8% | 13.2% |
| 15 | ca. 1760 | 87.5% | 12.5% |
| 13 | ca. 1765 | 72.0% | 28.0% |
| 8 | ca. 1775 | 22.8% | 77.2% |

Table 2 illustrates the rapid shift from painted to printed wares after the mid-1760s. The Caughley porcelain factory, founded in 1775, concentrated on printed patterns and produced very few blue-painted patterns.[21] The Caughley production appears to match that of Worcester after 1775. Worcester was using underglaze blue printing by the late 1750s. Staffordshire did not begin underglaze printing until the 1780s. Blue-painted wares became a major decorative type for the Staffordshire potters after they were almost abandoned by the porcelain potters in the mid-1770s.

R. W. Binns, writing in 1909, mentions a strike at the Worcester factory in 1770 that he learned about from his father. The strike by the blue painters was in response to the introduction of blue printing.[22] Unfortunately, contemporary documents about the 1770 shutdown have not survived. There is, however, a letter by Josiah Wedgwood to Thomas Bentley dated June 25, 1769, in which he mentions that "near twenty painters are just now discharged from Worcester, several had been to Derby but were

*Figure 12* Mug, Staffordshire or Yorkshire, ca. 1790–1810. China glaze. H. 6¼". Polychrome-painted China glaze mugs are much less common than blue-painted ones. The introduction date for underglaze-painted colors has not been documented. One reason that polychrome pieces may be less common is that blue-painted patterns began twenty years before the polychrome-painted patterns were introduced.

*Figure 13* Detail of the underglaze pattern on the mug illustrated in fig. 12.

*Figure 14* Mug, Staffordshire or Yorkshire, 1790–1810. China glaze. H. 5¼". Another example of underglaze polychrome decoration used in combination with blue painting.

not taken in. Some are come here." Wedgwood goes on to describe an enameler named Willcox whom he had hired.[23] What relationship there may have been to the strike and the discharge of these painters is not clear. One factor was the change in technology; another could have been the stiff competition that creamware was giving the porcelain industry and its subsequent shrinking mentioned earlier. Wedgwood's letter fits well with Simeon Shaw's comment about the painters coming from "Bristol, Chelsea, Worcester, and Liverpool," all porcelain-producing areas. The painters displaced by blue printing left for Staffordshire and were soon confronted with the same problem. Shaw wrote:

> When *Blue Printing* was introduced, the enamellers waited upon Mr. Wedgwood to solicit his influence in preventing its establishment. We are informed that he religiously kept his promise, "I will give you my word, as a man, I have not made, neither will I make any Blue Printed Earthenware."[24]

This was a promise he kept. Hugh Owen's history of the Bristol pottery industry has an interesting parallel story about the introduction of blue printing:

> When printing was first introduced in Water Lane, one of the painters, apprehensive that the new art would injure the enameller's trade, became despondent and drown himself. This cup was his last work it is marked "J. Doe. Sept. 1787."[25]

The building of a furnace for the refining of cobalt facilitated production of blue-painted wares in Staffordshire. According to Simeon Shaw, a man named Roger Kinnaston was given the knowledge for the refining of cobalt by William Cookworthy and he set up a furnace in Cobridge in 1772. Shaw stated that Kinnaston "sold copies of the recipe for trifling sums, £10. or £12 . . . to gratify his Bacchanalian propensities."[26] Thus the knowl-

*Figure 15* Coffee pots, Staffordshire or Yorkshire, 1780–1810. China glaze. H. 12⅛" and 7⅜". Coffee pots are much less common than teapots in all painted and printed wares. The example on the left is unusual in that it has traces of original gilding.

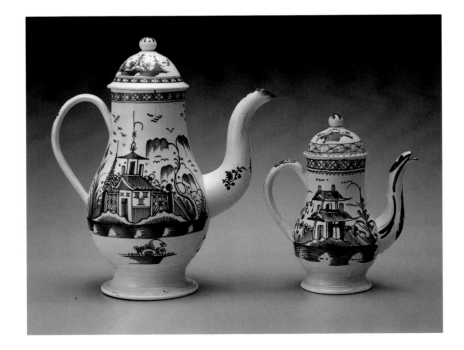

*Figure 16* Teapots, Staffordshire or Yorkshire, 1775–1800. China glaze. H. 6" and 6½". Egg-shaped teapots were common forms associated with the Chinese house pattern. The example on the left is unusual in having an overglaze enamel decoration.

*Figure 17* Teapot and tea canister, Staffordshire or Yorkshire, 1790–1810. China glaze. H. of teapot: 5⅜". An interesting use of the Chinese house pattern on a neoclassical form.

edge of how to refine cobalt became readily available to a number of potters and color makers.

By 1770 the market was glutted with ceramics, another factor that probably hastened the development of blue-painted earthenwares. The first Staffordshire potters' price-fixing agreement was written that same year. The 1770 agreement of the salt-glazed stoneware potters set the price of the wares to be sold to the earthenware potters, who had become the dominant force by that time.[27] By 1771 the Staffordshire potters were beginning to see price-cutting, and they attempted to come to an agreement on prices. In April of that year, Wedgwood, writing to Bentley about price-cutting in the potteries, stated:

*Figure 18* A group of tea wares, probably Staffordshire, 1775–1785. China glaze. H. of cream jug: 4⅝". For a short period of time, some China glaze tea wares were decorated with overglaze enameling and gilding in imitation of the Imari porcelains. Although no records exist, these were undoubtedly more costly China glaze items.

Mr. Baddeley who makes the best ware perhaps of any of the potters here, and a ovenfull of it Per Diem, has led the way, and the rest must follow unless he can be prevailed upon to raise it [his prices] again, which is not probable, though we are to see him tomorrow, about a dozen of us, for that purpose. . . . Mr. Baddeley has reduced the prices of the dishes to the prices of white stone.[28]

One result of the meeting with Baddeley was the reinstatement of the higher prices. Another result was the formation of the Potters Manufacturers Association for which Wedgwood was asked to "draw up a sort of preamble and a few articles to bind us together."[29] The earliest known price-fixing agreement listing the cost of creamware dates to 1787 and shows that prices continued to decline.[30] Given an oversupplied market and the changes that had taken place prior to 1770, the potters were looking for a product that would have more of a market and bring a better price for their efforts. That product was China glaze.

### China Glaze

China glaze was a copy of Chinese porcelain via the filter of English porcelain. The painted chinoiserie patterns on Staffordshire earthenware are not as detailed as those produced by Worcester, Bow, Chelsea, Caughley, or Lowestoft that preceded them; however, they found a much broader market at a cheaper price. In the ninth chapter of his history on the rise of the Staffordshire pottery industry, Simeon Shaw described the industry's ascendance in the 1770s:

> The Manufacturers of the district generally were now excited to unremitted exertions, and these with their previous knowledge, produced those various improvements which have brought the Pottery into repute. The superior kinds now became the medium of ornamental devices; at first in mere outline, and blue painted, rude and coarse; imitation of the foreign China, and gradually improved to fine delicate designs. A speci-

men is preserved of a quart mug, with a bluish glaze, which was painted by Dan[iel] Steele, in Blue, and well exhibits the defective nature of the process at that time.[31]

Shaw does not give a date for Daniel Steele's mug or the introduction of blue painting. He speaks of a great demand for painted and enameled pottery, causing the potters to use glue bat overglaze prints as outlines for the painters. Daniel Steele was one of the earliest potters to use this form of painting, which was introduced into the Staffordshire potteries around 1777.[32]

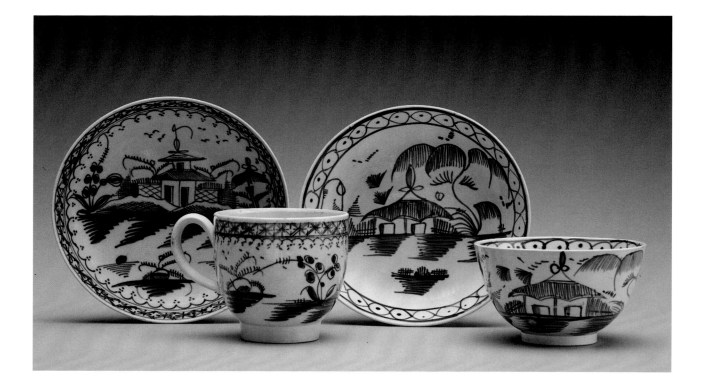

*Figure 19* Coffee cup and saucer, and tea bowl and saucer; Staffordshire or Yorkshire, 1775–1810. China glaze. H. of coffee cup: 3¼". Tea bowls and saucers appear frequently in the American archaeological record. They are far more common than China glaze plates and mugs. Most cups are handleless and in a Chinese tea bowl shape. Handled coffee cups are quite rare, however. We have not seen any marked or dated pieces of this form.

The demand for cobalt caused its price to go up considerably. A letter from Wedgwood to Bentley in March 1777 mentioned that a pound of cobalt cost thirty-six shillings. In November of the same year, the price had gone up to sixty-three shillings a pound, a 75 percent increase in price.[33] This may be a reflection of the great demand noted by Shaw and demonstrates that China glaze wares were on their way.

China glaze copied Chinese porcelain in four ways: (1) the duplication of Chinese painted patterns, (2) vessel shapes like the Chinese tea bowl shape and undercut foot rings, (3) the blue-tinted glaze giving the wares the look of Chinese porcelain, and (4) the name "China glaze." It is likely that China glaze production began in Staffordshire around 1775, when all of the necessary elements came together and the extension of the Champion patent prevented the potters from producing porcelain. Unfortunately, we have neither an exact date for its appearance, nor can we credit any potter or group of potters with its development.

## Summary of the Changes that Led to the Development of China Glaze

1. The quest for the secret of making porcelain brought new materials into the pottery industry such as kaolin, Growan stone, calcined bone, flint, and white-firing clays.

2. Publication in English of Père D'Entrecolles's description of how the Chinese made porcelain unlocked several mysteries of that process.

3. Open access to kaolin and Growan stone, and the establishment of a cooperative to bring these materials to Staffordshire in 1774, encouraged experimentation with the new materials.

4. The extension of Champion's patent prevented the potters from making porcelain with these specified materials, causing them to produce a close imitation of Chinese porcelain, i.e., China glaze.

5. The 1772 establishment of a furnace for refining cobalt in Cobridge made another one of the key ingredients more readily available to the Staffordshire potters.

6. The 1760s transition from blue-painted to blue-printed patterns in the English porcelain factories led painters to seek employment in Staffordshire. The displaced blue painters were already trained in rendering Chinese-style patterns.

7. The success of creamware in the 1760s, due to Wedgwood and Bentley's marketing, was the death knell for the British delft industry. Creamware production reduced the market for English porcelain, adding to the influx of painters to Staffordshire.

8. By the 1770s, creamware was an old product in a glutted market. Prices were falling and the potters, to survive, needed a new product. That new product was China glaze, which was probably in production by at least 1775, if not a few years earlier.

### How China Glaze Came to be Called "Pearlware"

Ceramic scholars and collectors have generally used the term "pearlware" to classify the China glaze wares. The names "China glaze" and "pearlware" dropped out of usage and were forgotten by the end of the eighteenth

*Figure 20* Cream jugs, Staffordshire or Yorkshire, 1775–1810. China glaze. H. 3⅛" to 3⅜". Cream jugs were made in a tremendous variety of shapes. Note the four different types of pouring lips. These shapes mimic the larger jug forms of the period.

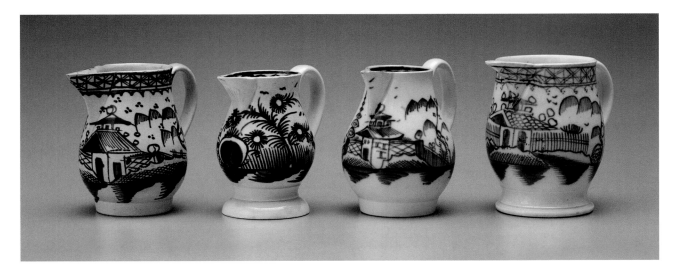

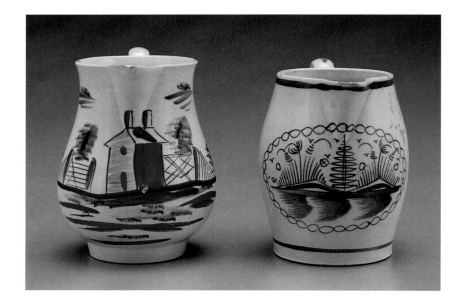

*Figure 21* Cream jugs. (*Left*): probably Staffordshire, ca. 1775. Creamware. H. 3½". (*Right*): Staffordshire or Yorkshire, 1790–1820. China glaze. H. 3¼". The example on the left is enamel-decorated in a European-style house pattern. The jug on the right is decorated under the glaze in a debased chinoserie pattern.

century; the terms did not come back into vogue until well into the twentieth century when collectors, historical archaeologists, and ceramic scholars began to take an interest in these wares.

References to "China glaze" and "pearlware" are very rare in nineteenth-century pottery documents and histories. For example, neither term appears in any of the eleven extant Staffordshire potters' price-fixing lists.[34] "China glaze" was a common term in the 1784 edition of *Bailey's Directory of the Potteries of Staffordshire*. Ten potters in that directory name themselves as producers of China glaze in addition to cream color, or Queen's ware. None of the potters was listed as producing pearlware. Unfortunately, the later Staffordshire directories are less detailed and generally only list earthenware or porcelain, rather than types of ware.[35] The terms "China glaze" and "pearlware" are, with a few exceptions, absent from potters' and merchants' invoices and correspondence. The terms are also absent from American probate records and newspaper advertisements.[36] Even the early collections of potters' recipes do not mention the terms "China glaze" or "pearlware."[37] And they are, for the most part, missing from the classic nineteenth-century references (i.e., Shaw, Ward, Jewitt, Chaffers, and Meteyard).[38] Even important twentieth-century authors, such as Towner and Hillier, do not have much information on these wares other than attributing the invention of pearlware to Josiah Wedgwood in 1779.[39]

*The Selected Letters of Josiah Wedgwood*, edited by Finer and Savage in 1965, provides easy access to Wedgwood's letters to Thomas Bentley, which record the development of "Pearl White." Three letters to Bentley by Wedgwood in 1779 have provided the main proof of Wedgwood's invention and introduction of pearlware that year.[40] One of the first scholars to give a detailed summary of the available information on pearlware and China glaze was Ivor Noël Hume in his seminal article "Pearlware: Forgotten Milestone of English Ceramic History."[41] For historical archaeologists working on sites occupied in the late eighteenth and the early nineteenth

Figure 22 Punch bowls. (*Left*): probably Staffordshire, ca. 1775. Creamware. D. 8⅞". (*Right*): Staffordshire or Yorkshire, 1790–1810. China glaze. D. 6". The creamware punch bowl is enamel-decorated in a European-style house pattern. The pearlware bowl is decorated in polychrome colors under the glaze.

centuries, the predominance of these blue-tinted wares guarantees that they cannot be ignored. The 1779 date that introduced Wedgwood's Pearl White became the *terminus post quem* for any context containing these wares.

Supporting evidence for Wedgwood as the developer of this blue-tinted glaze emerges from a manuscript biography of Josiah Wedgwood. The manuscript heading reads "Compiled by Mr. John Leslie, now Professor of Mathematics at Edinburgh, from a sketch drawn up by the late

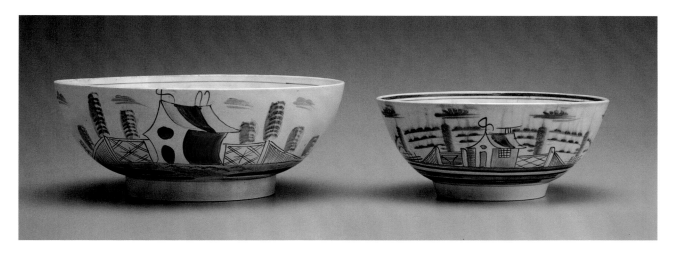

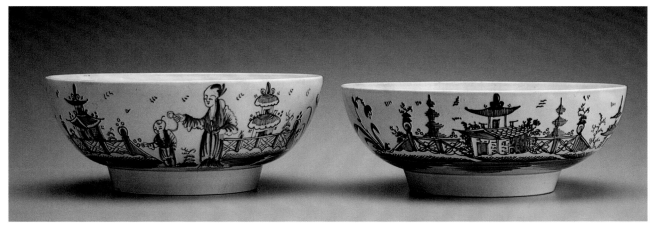

Figure 23 Punch bowls, Staffordshire or Yorkshire, 1775–1810. China glaze. D. 9¼" and 9⅞". Punch bowl forms in a wide variety of sizes appear ubiquitously in American archaeological sites.

W. Byerley and written before 1800." John Leslie was the tutor and companion to Josiah's son Thomas Wedgwood from 1790 to 1792.[42] Unfortunately no other reference to a W. Byerley has been found—only a reference to Thomas Byerley, a nephew of Josiah Wedgwood who was taken in as a partner by Josiah in 1790.[43]

The biography discusses the development of a blue-tinted glaze by Wedgwood after he developed Jasperware circa 1775.[44] The text of the manuscript states that Wedgwood worked toward improving his Queen's ware by whitening it and "invented a white glaze of a bluish cast . . . as practiced in the fabric of the oriental porcelain."[45] This glaze was used on the underglazed blue-shell edge. Leslie goes on to say that this improvement was

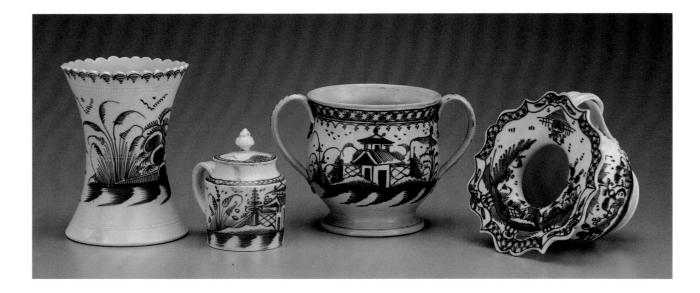

*Figure 24* Various China glaze forms. *Left to right:* spill vase, mustard pot, two-handled cup, and spitting cup; Yorkshire or Staffordshire, 1775–1810. China glaze. H. of vase: 6¼". Almost every imaginable form appears to have been made and decorated in the Chinese house pattern between 1775 and 1820. Blue-printed patterns continued to be used on virtually every form produced by the English potting industry well into the nineteenth century.

not well received and that the new ware was considered as a mere imitation of the porcelain wares. Leslie seems to imply that Wedgwood dropped the ware from production. He then goes on to state:

> But the idea was not lost in the Pottery. His ingenious neighbors afterwards adopted the white glaze which acquired the name of China glaze. They pursued and extended the discovery even beyond its original object insomuch as to cover the whole surface of the ware in blue paintings resembling the Chinese.... This white or China glaze was produced by means of some clays from Cornwall and Devonshire unknown before in the Pottery.[46]

Interestingly, the term "pearlware" or "Pearl White" does not occur in Leslie's manuscript. The manuscript also credits Chinese porcelain as the impetus for the development of a blue-tinted glaze that Wedgwood and the other potters were copying. The mention of the Cornwall and Devonshire clays also helps place the event after 1774, when the right to use these materials was gained after Champion's patent was renewed.

While the biography indicated that Wedgwood's improved blue-tinted glaze preceded China glaze, there is good evidence that this was not the case. The most meaningful indication that the order was reversed comes from both a combination of Wedgwood's letters to Bentley and evidence from archaeological sites. Unfortunately, Bentley's letters to Josiah Wedgwood have not survived, so we only have half of the correspondence on the development of their Pearl White. From Wedgwood's letters to Bentley, it is clear that Bentley was putting some pressure on him to produce a whiter firing ware. For example, in Wedgwood's letter of January 14, 1776, he responds to an enquiry from Bentley by stating that "But for *Useful China,* or such a *white-ware* as you mention, I must beg a longer time." He goes on to say that he wants to finish the development of Jasperware before turning his attention to the development of a white ware. Further, he wrote:

> You know very well that from the moment a finer ware than the Creamcolor is shewn [*sic*] at our Rooms, the sale of the latter will in great mea-

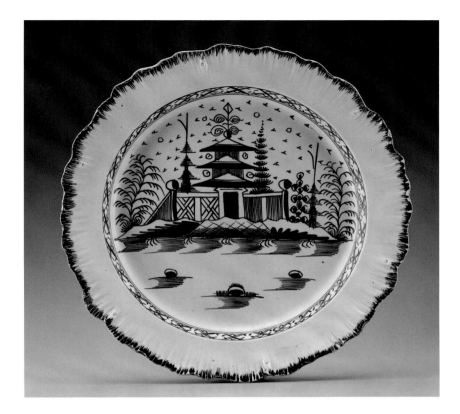

sure be over there. . . . I have not yet been able to take one step of any con-sequence toward making the useful ware, but I now intend to begin in earnest upon this subject.[47]

Pressure for a new white ware was increasing. Wedgwood's letter of April 18, 1778, stated:

> We are perswaded [*sic*] that the diminution of our sales...is owing chiefly to the very great difference between the price of our Queens ware (which is no longer that choice thing it used to be, since every shop, house, and cottage is full of it) and other people's and that without lowering the prices very considerably we shall not be able to continue our business.[48]

Under these pressures, Wedgwood finally produced his whiteware in 1779. In a letter at the end of February, Wedgwood asked Bentley to come up with a name for his new ware, and by June of 1779 they had settled on "Pearl White."[49] While they had their new Pearl White, they were not happy with the ware. In his letter to Bentley dated August 6, 1779, Wedg-wood states:

> Your idea of *creamcolour* having the merit of an original, and the *pearl white* being considered as an imitation of some of the blue and white fab-riques, either earthenware or porcelain is perfectly right, and I should not hesitate a moment in preferring the former if I consult my own taste and sentiment. . . . The pearl white must be considered as a *change* rather than an *improvement,* and I must have something ready to succeed it when the public is palled.[50]

Wedgwood's Pearl White did not come onto the market until late in 1779. The evidence suggests that the majority of the Pearl White produced

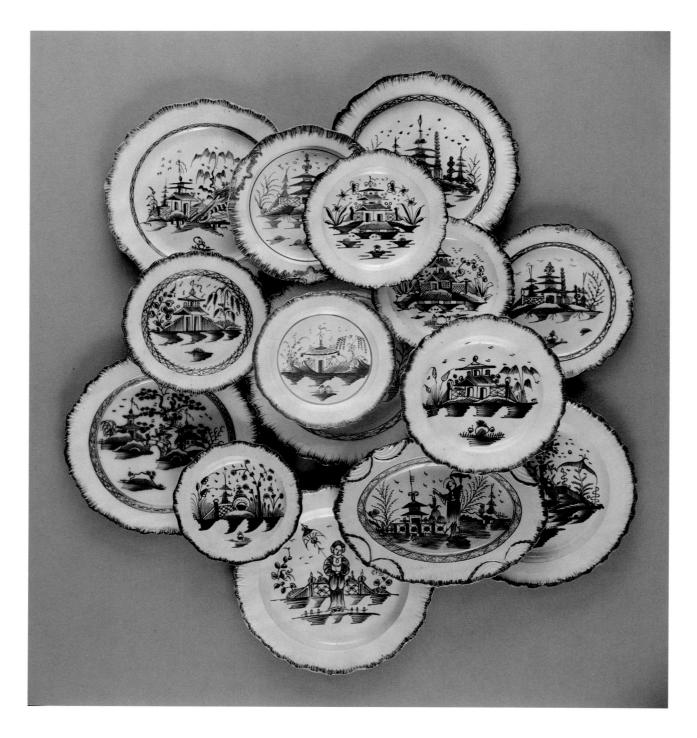

*Figure 26* Plates and dishes, Staffordshire or Yorkshire, 1775–1810. Creamware and China glaze. As suggested in this grouping, tremendous variations of the Chinese house pattern were used in conjunction with the shell-edged rim treatment on both creamware and pearlware dishes. This assemblage provides strong evidence that many potters produced these wares.

They are almost never marked, generally have rococo blue shell-edged rims, and date from 1775 to 1800. The introduction of underglaze transfer printing in Staffordshire in 1784 may have reduced the market for Chinese house pattern painted wares. The occurrence of plates and other tableware painted with the Chinese house pattern is relatively rare in the American archaeological record. Conversely, large numbers of antique plates and dishes seem to survive in England. This dissimilarity, perhaps reflecting a difference in the market, warrants further investigation.

was wares in the shell edge pattern. Robin Reilly's recent history of Wedgwood makes the comment that:

> [l]ittle of Wedgwood's work during the eighteenth century shows signs of Chinese influence. . . . Josiah was never interested in making blue-and-white, partly no doubt because there was already too much of it available from the earthenware and porcelain manufacturers. . . . [H]e appears to have had little taste for ceramics decorated in this type of ware.[51]

We have not recorded a single vessel produced by Wedgwood painted in a chinoiserie style with a blue tinted glaze.

Now let us consider the evidence for China glaze predating pearlware. The earliest recorded use of the term "China glaze" is from a 1783 invoice for some "green shell edged china glaz'd" plates sent to Tappahanock, Virginia.[52] The term China glaze was also used in the 1784 *Bailey's Directory of the Potteries of Staffordshire,* already discussed. Two interesting persons describing themselves as producing cream color and China glaze are Thomas Wedgwood of the Big House and Thomas Wedgwood of the Over House potteries.[53]

Thomas Wedgwood was a pretty common name during this period. In addition to these two Thomas Wedgwoods, there was of course Josiah's partner and cousin, Thomas Wedgwood, who was also known as "useful Thomas." The two Thomas Wedgwoods working in Burslem were distant cousins of Josiah Wedgwood, which makes their use of the term "China glaze" interesting. This suggests that Pearl White was probably limited to the products produced by Josiah Wedgwood and his partners and was not used by the other potters, even those related to Josiah.

The other dated reference for China glaze is a jug in the Victoria and Albert Museum that Noël Hume describes as a blue-painted pearlware jug with a black overglaze inscription that reads "A Butcher/A D 1777." In his article on pearlware, Noël Hume states that this date was applied sometime after 1779 because it could not predate Wedgwood's introduction of pearlware.[54] Given that China glaze predates pearlware, the 1777 date may be a good one, especially considering the preceding "A.D."

All of the evidence presented up to this point has been a series of circumstances and events that would have led toward the development of China glaze. What has been missing is evidence of pre-1779 blue-tinted glazed earthenware, a gap that has now been filled.

John Seidel's article on China glaze from American Revolution sites lists two occurrences that predate Wedgwood's introduction date. In one case, China glaze sherds were recovered from the wreck of the *Defense* that sank off the coast of Maine in August 1779. As Seidel notes, "Given the fact that Wedgwood was still trying to name his new white-bodied ware in August of 1779, the *Defense* find is surprisingly early." The second context was two China glaze sherds retrieved from the *HMS Orpheus,* which sank in August 1778.[55] These two finds clearly establish that China glaze predates Wedgwood's Pearl White or pearlware.

Perhaps the strongest evidence that China glaze may have been produced as early as 1775 comes from David Barker's excavation of potter

*Figure 27* Plate, Staffordshire or York- shire, 1785–1810. China glaze. D. 9¾". A variant of the Chinese house pattern on a pearlware plate; the rim decoration simu- lates molded relief panels and reserves. This rim type suggests a date after 1785.

William Greatbatch's waster tip in Fenton, Stoke-on-Trent. The waster tip contained wares that spanned the length of his potting operating between 1762 and 1782, including large quantities of blue-painted China glaze sherds with numerous variations on the Chinese house pattern. Greatbatch had gone bankrupt in 1782, just three years after Wedgwood's introduction of Pearl White. However, given the quantities of China glaze that were pro- duced by Greatbatch, Barker concurs that a circa 1775 development date for China glaze is "most welcome and reassuring."[56]

*The Significance of China Glaze in the Development of English Ceramics*
This paper is rather a long patchwork of isolated bits of information that we have pulled together to gain insight into the development of the English ceramics industry. It is not about moving the date of pearlware back a very few years or trying to take anything away from Josiah Wedgwood's incred- ible contribution to the development of the English ceramic industry. For far too long, those interested in ceramic history have been using simplistic descriptions of changes that took place by using such statements as "pearl- ware replaced creamware." That misses the importance of what happened.

China glaze and pearlware did not replace creamware: *decoration replaced creamware*. The vast majority of creamware is undecorated. China glaze and pearlware are almost never undecorated. The reasons the terms "China glaze" and "pearlware" were forgotten was because these wares became known by how they were decorated. They became "painted," "edged," "printed," or "dipt" wares. The decoration was what determined the price

*Figure 28* Plates, Staffordshire or York-
shire, 1775–1810. Creamware and China
glaze. These dinner plates, decorated with
the Chinese house pattern, all have differ-
ent molded or painted rim treatments.
Some of these rim treatments are shared
by undecorated creamware patterns.

*Figure 29* Plate, impressed "IH" for Joshua Heath of Tunstall, Staffordshire, ca. 1790. China glaze. D. 8". A black-printed China glaze shell-edged plate copying a Chinese pattern. This pre-Willow pattern print is line engraved. The "IH" mark is one of the few seen on China glaze wares.

of these wares, and it became the handle by which they were referred to in potters' price-fixing lists, invoices, merchants' account books, price lists, and catalogs.[57] Collectors, archaeologists, and ceramic historians have put an emphasis on the ware types, which is what the potters and their customers dropped in favor of a decoration terminology.

The differences between creamware and China glaze and/or pearlware are also important in terms of what it meant to the Staffordshire potteries. Creamware was a breakaway product that set the pace for at least two decades. Through the brilliant marketing of Wedgwood and Bentley, with sales to Queen Charlotte and Catherine the Great, they were able to raise an earthenware to a level where it competed with porcelain. Yet, undecorated creamware was affordable for the common household. Indeed, creamware actually cut into the sale of English porcelain and affected the development of the English porcelain industry. China glaze or pearlware was, in the words of Josiah Wedgwood, "an imitation of some of the blue and white fabriques" and as a copy it was never going to be able to compete with porcelain in status. The blue-painted chinoiserie patterns the Staffordshire potters picked in the 1770s were those that the English porcelain potters were using at least twenty years before and now abandoning. In the same way, the Staffordshire potters adopted underglaze printing almost two decades after the English porcelain factories were using it. Later, when bone china became popular, the earthenware potters switched to making the ware that we call whiteware.

*Figure 30* Dish, impressed "IH" for Joshua Heath of Tunstall, Staffordshire, ca. 1790. China glaze. L. 15½". (Courtesy, Chipstone Foundation.) A blue-printed example of the same print illustrated in fig. 29.

Where does China glaze end and pearlware begin? How many angels can dance on the head of a pin? Defining China glaze will always be a problem; however, we venture to suggest that China glaze wares be defined as those earthenwares that have a blue-tinted glaze, are decorated in Chinese-style patterns, and copy such Chinese vessel forms as the Chinese tea bowl shape and undercut foot rings.

Using that definition, it would appear that China glaze dates from circa 1775 to circa 1812 for American sites. There are later examples, such as a jug dated 1821 with a blue-painted Chinese house pattern, but they are outliers on the bell curve. Blue-printed wares with Chinese-style patterns were in production on China glaze for a longer time than the blue-painted China glaze wares. Most of the China glaze wares that fit this definition from American archaeological sites are cups and saucers, teapots, bowls, and jugs. There are some shell-edged plates with Chinese house patterns, but they seem to lose out to blue-printed patterns by around 1800. Other blue-tinted wares with floral motifs, plain shell-edged wares, and dipt wares could be called pearlware. This classification has some problems, but it will give more chronological control than calling everything "pearlware" and will give some acknowledgement of how these wares evolved.

Recognizing the term "China glaze" also forces us to acknowledge the incredible stylistic contribution of Chinese culture. The love affair with Chinese porcelain has continued for centuries. The incredible innovations of the English deftware, earthenware, and porcelain potters can be attributed to consumers' lust for something in the Chinese style. Josiah Wedgwood found his inspiration in Greek and Roman antiquities, and helped create a new market for things in the neoclassical taste. He named his pottery the "New Etruria," which was a further statement of his commitment to the classical style. The Bow porcelain factory on the other hand was named the "New Canton," which reflected the Chinese style that they and the other early English potters produced. It is ironic, in so many ways,

*Figure 31* Bowl, Ching-tê-chên, China, 1785–1820. Hard-paste porcelain. D. 4⅜". Blue-painted Chinese bowl in what collectors call the "Canton" pattern or ware. The Canton pattern is one of the most simplified of the well-known Chinese porcelain export wares for the West. It is commonly dated as beginning around 1785 when Americans began trading with China. Given the simplicity of this pattern, one wonders if it is a copy of some of the China glaze wares being made in Staffordshire. Is it a Chinese copy of an English earthenware copy of English porcelain that was a copy of Chinese porcelain? How may times has the compass spun?

*Figure 32* Dish, probably Staffordshire, ca. 1820. China glaze. L. 18½". A debased version of the Chinese house pattern painted on a shell-edged dish of about 1820, possibly even as late as 1830. Note that the "house" and "fences" are missing elements of the design. This design is identical to the one on the small creamware jug illustrated in fig. 21.

that the term "pearlware," coined by a potter who made virtually nothing in the Chinese style, has usurped the very meaning embodied in the name "China glaze."

ACKNOWLEDGMENTS
The research and the provision of time in which to gather the information were greatly facilitated by two NEH grants to George Miller (now archaeological laboratory director at URS Corporation) for research on the development of the American market for English ceramics in America. Those grants were National Endowment for the Humanities numbers RO-21158-86 while he was an employee of the Colonial Williamsburg Foundation, and RK-20004-93 while he was an employee of the University of Delaware Center for Archaeological Research. The first grant enabled Miller to spend three months in Staffordshire doing research in the Wedgwood, Spode, Minton, and other archives. This research in England was greatly facilitated by Robert Copeland, Gaye Blake Roberts, Pat Halfpenny, Martin Phillips, David Barker, Rodney and Eileen Hampson, Terry Lockett and was also dependent on information gathered during

*Figure 33* Jug, possibly Lancastershire, 1821. China glaze. H. 9". (Courtesy, Chipstone Foundation.) The elaborate painting on this jug would suggest a much earlier date than the one inscribed on this presentation piece.

two NEH Winterthur Fellowships, one in 1979 and one in 1991. The Winterthur Museum Library and the Downs Manuscript Collection have very extensive and well-indexed collections of rare books and manuscripts. Their usefulness is greatly enhanced by the head librarians, Neville Thompson and Richard McKinstry, who are wonderfully knowledgeable about the collections. These collections have been great resources while doing this research. Many colleagues have contributed to our research by pointing out examples of early China glaze and pearlware and references for our research. We would like to thank Garry Atkins, Lee and Joyce Hanes, Ivor Noël Hume, Lynne Sussman, and Arlene Palmer. We would especially like to thank once again Rodney Hampson for his careful reading of our paper and for pointing out areas that needed our attention and correction.

1. William Burton, *Porcelain: Its Nature, Art, and Manufacture* (London: B. T. Batsford, Ltd., 1906), p. 172.

2. Reference to Du Halde's history and its publication in English was taken from Ann Finer and George Savage, eds., *The Selected Letters of Josiah Wedgwood* (London: Cory, Adams & MacKay, 1965), p. 162.

3. Kenneth Hudson, *The History of English China Clays: Fifty Years of Pioneering and Growth* (Newton Abbot, England: David and Charles, 1969), p. 16.

4. Bernard Watney, *English Blue and White Porcelain of the 18th Century* (New York: Thomas Yoseloff Publisher, 1964), p. 125.

5. Ibid., pp. 119–22.

6. Ibid., p. 122.

7. Geoffrey A. Godden, *Godden's Guide to Ironstone, Stone and Granite Wares* (Woodbridge, Suffolk, England: Antique Collectors' Club, 1999), p. 57.

8. Finer and Savage, *Selected Letters*, pp. 179–81.

9. Ibid., p. 186.

10. Watney, *English Blue and White Porcelain*, p. 123.

11. Finer and Savage, *Selected Letters*, p. 179.

12. Lorna Weatherill, *The Growth of the Pottery Industry in England: 1660–1815* (New York: Garland Publishing, Inc., 1986), p. 451, table A1-7.

13. John Bedfor, *Chelsea and Derby China* (New York: Walker and Co., 1967), pp. 9–10.

14. Lawrence Branyan, Neal French and John Sandon, *Worcester Blue and White Porcelain: 1751–1790* (London: Barrie & Jenkins, 1981), p. 16.

15. Finer and Savage, *Selected Letters*, pp. 79, 84.

16. Ibid., p. 92, letter from Josiah Wedgwood to Thomas Bentley, 19 May 1770.

17. Simeon Shaw, *History of the Staffordshire Potteries; and the Rise and Progress of the Manufacture of Pottery and Porcelain; with References to Genuine Specimens, and Notice of Eminent Potters* (Hanley, Staffordshire, England, 1829; reprint, Great Neck, N.Y.: Beatrice C. Weinstock, 1968), p. 178.

18. Branyan, French and Sandon, *Worcester Blue and White Porcelain.*

19. Ibid., pp. 17–20.

20. Ibid. Table 2 was taken from p. 20.

21. Geoffrey A. Godden, *Caughley and Worcester Porcelains: 1775–1800* (Woodbridge, Suffolk, England: Antique Collectors' Club, Ltd., 1981), p. 15.

22. Branyan, French, and Sandon, *Worcester Blue and White Porcelain*, p. 17.

23. Finer and Savage, *Selected Letters*, p. 75.

24. Shaw, *History of the Staffordshire Potteries*, pp. 192–93.

25. Hugh Owen, *Two Centuries of Ceramic Art in Bristol: Being a History of True Porcelain by Richard Champion with a Biography compiled from Private Correspondence, Journals, and Family Papers* (Bristol, England: Bell & Dalby, 1873), pp. 353–54.

26. Shaw, *History of the Staffordshire Potteries*, p. 221.

27. This list was reproduced in Shaw, *History of the Staffordshire Potteries*, pp. 207–208, and in Arnold Mountford, "Documents Relating to English Ceramics of the 18th and 19th Centuries," *Journal of Ceramic History* 8, no. 99 (1975): 4–8.

28. Finer and Savage, *Selected Letters*, p. 106.

29. Ibid., p. 108.

30. "Prices of QUEEN'S WARE or CREAM COLOURED EARTHENWARE, established through the Potteries, from February 2d, 1787": a printed list bound with *The Ruin of Potters, and the Way to Avoid it* (Lane-end, Staffordshire, England: T. Orton, 1804).

31. Shaw, *History of the Staffordshire Potteries*, p. 210.

32. Ibid., p. 212.

33. Finer and Savage, *Selected Letters*, p. 204.

34. Extant price-fixing lists for the Staffordshire potters are known for the years 1770, 1783, 1787, 1795, 1796, 1808, 1814, 1825, 1846, 1853, and 1859. These price-fixing agreements are discussed in George L. Miller, "A Revised Set of CC Index Values for Classification and Economic Scaling of English Ceramics from 1787 to 1880," *Historical Archaeology* 25, no. 1 (1991): 1–25.

35. I would like to thank Jonathan Rickard for providing me with copies of his abstractions from a collection (Barks Library, Hanley, Stoke-on-Trent, England) of fourteen Staffordshire directories dating from 1781 to 1828/29. Jonathan Rickard, "The Makers of Pottery and Porcelain in Staffordshire: 1781–1841" (unpublished manuscript).

36. Surveys of probate records for Plymouth County, Massachusetts, and Providence, Rhode Island, did not find any listing of pearlware or China glaze. Marley Brown, "Ceramics from Plymouth, 1621–1800: The Documentary Record," *Ceramics in America,* edited by Ian M. G. Quimby, Winterthur Conference Report (1972) (Charlottesville, Va.: University Press of Virginia, for The Henry Francis duPont Winterthur Museum), pp. 41–74; and Barbara Gorely Teller, "Ceramics in Providence, 1750–1800," *Antiques* 94, no. 4 (October 1968): 570–77.

37. *The Valuable Receipts of the late Mr. Thomas Lakin, with Proper and necessary Directions for their Preparation and use in the Manufacture of Porcelain, Earthenware, and Stone China* (Leeds, England: Edward Baines, 1824), printed for Mrs. Lakin; Simeon Shaw, *The Chemistry of the several Natural and Artificial Heterogeneous Compounds used in Manufacturing Porcelain, Glass,*

*and Pottery* (1837; reprint, London: Scott Greenwood and Co., 1900); William Evans, *Art and History of the Potting Business, compiled from the most practical sources, for the especial use of working potters, by their devoted friend, William Evans* (Shelton, England: The Examiner Office, 1846), reprinted in *Journal of Ceramic History,* no. 2 (1970): 21–42.

38. Shaw, *History of the Staffordshire Potteries;* John Ward, *The Borough of Stoke-upon-Trent* (1843; reprint, Hanley, Stoke-on-Trent, England: Webberley, Ltd., 1984); Llewellynn Jewitt, *The Wedgwoods: Being a Life of Josiah Wedgwood; Notice of his Works and their Productions, Memories of the Wedgwood and other Families and a History of the Early Potteries of Staffordshire* (London: Virtue Brothers & Co., 1865); Llewellynn Jewitt, *The Ceramic Art of Great Britain* (1883; reprint, Poole, Dorset, England: New Orchard Editions, Ltd., 1985); Eliza Meteyard, *The Life of Josiah Wedgwood from his Private Correspondence and Family Papers…With an introductory Sketch of the Art of Pottery in England,* 2 vols. (1865–1866; reprint, Yorkshire, Eng.: Scolar Press, 1980); William Chaffers, *Marks and Monograms on European and Oriental Pottery and Porcelain* (1863; reprint, London: William Reeves, Bookseller, Ltd., 1965).

39. Bevis Hillier, *Master Potters of the Industrial Revolution: The Turners of Lane End* (London: Cory, Adams and MacKay, 1965); Donald Towner, *The Leeds Pottery* (London: Cory, Adams and MacKay, 1965).

40. The letters around the development of Wedgwood's Pearl White are discussed in George L. Miller, "Origins of Josiah Wedgwood's 'Pearlware,'" *Northeast Historical Archaeology* 16 (1987): 83–95; reprinted in *Thirty-Fourth Annual Wedgwood International Seminar: Pottery and Porcelain on Peach Street* (Conference held in Atlanta, 1989), pp. 167–184.

41. Ivor Noël Hume, "Pearlware: Forgotten Milestone of English Ceramic History," *Antiques* 95, no. 3 (1969): 390–397.

42. I am indebted to Rodney Hampson for sending me his article "The China Glaze," which provides the information from John Leslie's twenty-thousand-word biography of Josiah Wedgwood (Moseley manuscript WM 1127, Wedgwood Archives, Keele University, Keele, Staffordshire, England, n.d.). See Rodney Hampson, "The China Glaze," *Northern Ceramic Society Newsletter,* no. 37 (March 1980): 11–12.

43. Finer and Savage, *Selected Letters,* p. 350.

44. Ibid., pp. 170–72.

45. Hampson, "The China Glaze," p. 12.

46. Ibid.

47. Finer and Savage, *Selected Letters,* pp. 188–89.

48. Ibid., pp. 220–21.

49. Ibid., p. 231.

50. Ibid., p. 237. For a more detailed discussion of the pressure on Wedgwood to develop his whiteware, see Miller, "Origins of Josiah Wedgwood's 'Pearlware,'" pp. 83–95.

51. Robin Reilly, *Wedgwood* (London: McMillan, 1989), p. 99.

52. Ivor Noël Hume, "Corrections and Additions," *Antiques* 96 (December 1969): 922.

53. Chaffers, *Marks & Monograms,* p. 29.

54. Noël Hume, "Pearlware," p. 393.

55. John L. Seidel, "'China Glaze' Wares on Sites from the American Revolution: Pearlware before Wedgwood?" *Historical Archaeology* 24, no. 1 (1990): 82–95.

56. David Barker, *William Greatbatch: A Staffordshire Potter* (London: Jonathan Horne Publications, 1991), p. 167.

57. For a discussion of this, see Miller, "A Revised Set of CC Index Values," pp. 1–25.

*Figure 1* Miniature portrait, *Jabez Vodrey,* ca. 1827. Oil on copper. (Courtesy, the Vodrey family; photo, Helga Studio.) Probably painted as a keepsake for his wife, before he set sail for America in 1827.

## Diana and J. Garrison Stradling

## American Queensware— The Louisville Experience, 1829–1837

▼ W E  H A V E  L I V E D  with the spirit of Jabez Vodrey for a very long time. Little did we realize, when we traveled to East Liverpool, Ohio, to see the diary (still carefully preserved by descendants) of this early American potter, that we were about to embark on a lifetime of research.

By now we probably know more about the world of Jabez Vodrey than about our own. Born in Staffordshire, England, in 1794, Vodrey apprenticed in Tunstall and married Sarah Nixon there. He then went with William Frost to Derbyshire, where they worked for Joseph Thompson, who in 1818 had established the Hartshorne, or Wooden Box, Potteries between Burton-on-Trent and Ashby de la Zouche. They emigrated together to Pittsburgh in 1827 and relocated to Louisville, Kentucky, in 1829, where the Vodreys' three sons—William, James, and John—were born. Vodrey managed the Indiana Pottery Company in Troy, Indiana, from 1839 to 1847 and then moved on to East Liverpool, Ohio. His sons continued his trade long after his death there in 1860, becoming prominent manufacturers in the town hailed as the "Staffordshire of America."

The diary was really a "commonplace book," full of jottings, gleanings from newspapers, batch recipes, accounts, nostrums, and weather reports. Vodrey's recollections, written sometimes years after the event, provide insights into an earlier time. Begun in earnest in March 1839, when he was managing the Troy Pottery, the diary was a way of teaching his son William not only to write but to take pride in his daily accomplishments; it is a mine of information about his craft and about life in America. When we first read the diary, large sections had already been transcribed and typed by secretaries who struggled valiantly with the nineteenth-century script, correcting spellings as they went. "Diphtheria" became "dry heaves" and "druid snip" became "dread ship." The American Ceramic Circle agreed to publish the diary if we would properly transcribe it. This accomplished, we all agreed it had to be annotated or no one would understand the verbal shorthand, the language of the trade, or even the casual references to daily life on what was in every way, a different planet than the one we occupy today.

At the city's historical society, the Filson Club, we found an 1831 map of Louisville which showed the Lewis Pottery, where Vodrey had worked, on Jackson Street near the corner of Main. The location of the pottery was also bounded by an alley that traversed several blocks. Once the scene of many a goat race, it was named, appropriately, "Billy Goat Strut Alley." When visiting the lot, we found that two large buildings stood within its

original boundaries, but just on the spot where the map pinpointed the location of the Lewis Pottery, there was now a parking lot.

The answers to many of our long-standing questions seemed close at hand. Did Vodrey actually make the two thin, cream-colored plates that had always been attributed to him? Did he make the white rabbit seen only in an old photograph in the archives of the Filson Club? The family still had a tantalizing white-bodied plaque that Jabez and Sarah had signed in 1839, evidence that they could indeed have made these things. Only a thin layer of asphalt, already sinking from the weight of cars and trucks, stood in the way of discovery.

### The Queen's Ware Challenge

"Queen's Ware" was the term coined by English potter Josiah Wedgwood, sometime between 1765 and 1767, to tell the world that his cream-colored earthenware had obtained royal patronage. In 1779 he began to produce another type of ware (made whiter by the addition of bluing in the glaze) that he called "Pearl White," known today as "pearlware."[1] These achievements established standards of quality against which fine earthenware potters everywhere measured their success.

Emboldened by embargoes banning British imports before and during the War of 1812, American businessmen rose to the challenge and tried to replace English fineware with their own homemade dishes for the nation's tables. While the results of their efforts in the East, especially in Philadelphia, have often been described, less has been written about ventures west of the Allegheny Mountains, where as early as 1806 Samuel R. Bakewell announced that "Delft Ware" would soon be available from his pottery in Charlestown, Virginia.[2]

Shortly thereafter in Pittsburgh, William Price, who had come from England as a glassmaker, was manufacturing white clay smoking pipes. Apparently he also tried his hand at tableware: in the 1811 edition of *The Navigator,* Zadok Cramer reported, "Mr. William Price has attempted the making of 'delf' ware, and has produced some handsome specimens." Complaining that the cost of cartage from the Atlantic seaboard made western customers pay twice as much for tablewares as customers in the East, he added, "It would indeed be something handsome could we stop those hundreds, nay thousands of crates of ware from coming over the mountains, in which every man who eats off a plate is taxed one hundred per cent."[3]

Potters in Europe had long known that a coarse or discolored earthenware body could be successfully coated with a white enamel of glass and oxide of lead opacified by 2 or 3 percent of tin oxide to make what they variously called delft, faience, or maiolica.[4] Most potters in America, however, were trying to replicate the popular English wares, in which a white body was coated with a transparent or translucent lead glaze. This process required finding kaolin or a white-burning ball clay, and enough of it to make its use commercially feasible—which was only the first problem.[5]

Even potters trained in Staffordshire were unnerved to find that American ingredients would not behave like those at home, where such substances

*Figure 2* Price List, Vodrey Pottery Works, East Liverpool, Ohio, 1864–1865. (Courtesy, East Liverpool Historical Society.) The term Queen's ware outlived any resemblance to the thin creamware perfected by Wedgwood and made by Jabez Vodrey in Louisville. As perpetuated by Vodrey's sons, William H. and James N., and by other American potters, the term "yellow Queensware" had by the 1860s come to mean a high-fired stoneware of a deep straw color, made from the refractory clays found between coal seams. Collectors today know it as "yellowware." The addition of a transparent brown coating (Rockingham glaze) or splashes of color (variegated) seems to have added twenty-five cents to the price of a dozen pressed bowls. The earliest record thus far found of Rockingham glaze being made in America is dated 1843.

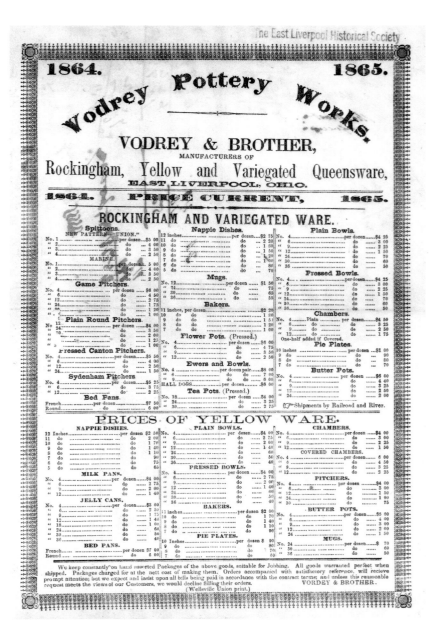

as "Cornish stone" and "Devon clay" were tried and true. Some bodies were stained by iron inclusions while others refused to hold a glaze, necessitating endless experiments that led to frustration and, ultimately, to compromise. For American manufacturers, the term "Queen's ware" represented what they hoped to make but eventually came to mean whatever they actually made, regardless of appearance, so long as it might possibly pass for English. In 1815, nine persons in Pittsburgh were reportedly employed in the manufacture of "yellow queensware,"[6] but the fledgling queensware manufacturers of the West were doomed before they got started.

Not long after the end of America's second war with England (December 1814), cheap merchandise began flooding into American ports.[7] On May 6, 1815, the *Kentucky Gazette* reported: "A boat loaded with QUEENS

*Figure 3* Pitcher, Frost & Vodrey, 1828. Yellow ware. H. 7". (Courtesy, Historical Society of Western Pennsylvania; photo, Helga Studio.) This pitcher was among the contents of a corner cupboard donated to the historical society in 1961 by Mrs. Frances W. Lane, a descendant of William Price, and was published many times as an example of midwestern manufacture. Not until the study of the Vodrey diary, however, did it become apparent that Frost & Vodrey must have been the potters who made it, and Sarah Vodrey, the decorator. Inscribed "Friendships Gift to Wm Price 1828," its hand-painted scenes recall Price's foundry, his round house, and his brief connection with the Fort Pitt Glass Works; an American eagle is emblazoned beneath his name under the spout.

WARE, passed Steubenville the 19th ult. on its passage from New-Orleans to Pittsburg. The carriage will be lower than the lowest waggon carriage from Philadelphia to the same place, and no risque of breaking the ware."[8] For Pittsburgh potters, the sight was devastating.

Merchandise hardly ever came upstream from New Orleans, not only because of the torturous trip against the current, but because the Falls of the Ohio at Louisville, Kentucky, brought all northbound river traffic to a halt. Upon reaching Shippingport, Kentucky, below the falls, cargo had to be off-loaded, portaged to Louisville, then reloaded onto other boats to continue its journey. Even southbound, the solid rock formations, two miles long with a drop of twenty-two feet, were passable only during high water—in spring and fall—when three channels or chutes allowed local pilots to guide vessels on a one-way journey over the falls.[9]

The United States Congress moved to protect the nation's infant industries by passing a comprehensive tariff act on April 27, 1816. As of June 30, a 20 percent duty would be levied on "china ware, earthen ware, stone ware, porcelain and glass manufactures other than window glass and black glass quart bottles."[10] However, these monetary handicaps did little to counter the long terms of credit offered American merchants by Staffordshire potteries or their discounts, as much as 28.8 percent on "C.C."

*Figure 4* Front view of pitcher illustrated in fig. 3.

*Figure 5* Reverse view of pitcher illustrated in fig. 3.

(originally denoted "cream-colored") wares.[11] The tariff was too little and too late, as the nation slipped into a deep financial depression that would come to be known as the Panic of 1819. One by one, the fires of western industry went out.[12]

That Americans were experiencing financial hardships failed to dissuade the Staffordshire potteries, which during the early 1820s came up with a new type of tableware. Entire services were introduced transfer-printed in dark blue with American scenery and important events in American history, such as the one titled "The Landing of Gen. Lafayette at Castle Garden, New York, 16 August 1824." Even American triumphs over the British in the War of 1812, such as Commodore MacDonnough's victory at Lake Champlain, were depicted on showy dishes aimed at the American market.[13]

It was not until the presidential campaign of 1823, amid the fervor for the "American System" drummed up by presidential candidate Henry Clay, that any western entrepreneur dared to consider making queensware again. Among the first was Jacob Lewis in Louisville, Kentucky. From western Pennsylvania, the son of a surveyor, Lewis had built the town's first stoneware pottery in 1815, located on the corner of Main and Jackson Streets.[14] He found Louisville to be the perfect place from which to sell his utilitarian salt-glazed crocks, pitchers, and churns. The market area was the Ohio River and its tributaries, and extended north to Cincinnati, west to St. Louis, and as far south as Alabama and New Orleans.[15] By 1823, he felt the time had come to put American-made dishes on American tables. When merchant W. L. Thompson was about to depart for Philadelphia, Lewis gave him a sample of clay to be tested at a queensware pottery there, but Thompson found the pottery had been "given up by the owners."[16]

In his next attempt, Lewis gave clay samples to Louisville tobacconist Charles Whittingham to be tested when the latter went to England in 1825, but Whittingham never got to the Staffordshire potteries. Instead he passed the samples along to someone else, who reported back that the clay sample was not large enough to be fully tested, but the preliminary results were quite favorable.

In Pittsburgh, William Price had come up with the same idea as Lewis. His neighbor, George Hatfield, recalled in later years, "Among the enterprises engaged in by William Price, was the manufacture of white clay tobacco pipes, he using German clay for the purpose. He afterwards experimented with a clay found in or near the city, and succeeded so well that he was led to suppose good earthenware could be made from the same." For this reason, Mr. Hatfield said, Price had traveled to England and convinced

*Figure 6* Photocopy of a rabbit figure attributed to the Lewis Pottery. (Photos, courtesy of the authors unless otherwise noted.) A Louisville resident remembered seeing this small white pottery rabbit in the collection of the Filson Club. About 4" long, it was a size that potters would have called a "toy." When the authors visited the collection, only an old 8" x 10" glossy remained in the file, inscribed on the back: "Photo of bunny made in the Lewis Pottery during the years of the pottery's existence 1829–1836. Given by Miss Mary Lee Warren, Louisville, Ky Oct. 1948." When the collection was revisited, the photo, too, had disappeared, leaving only this poor photocopy of the original to prove that the bunny ever existed.

The rabbit appears to have been press molded, with incised details at mouth and eyes, and given an applied tail. Its ears were broken. While there were some examples of press-molding found in the dig, there was nothing quite like the rabbit. However, the Vodreys did later have a pet rabbit for the boys — "to teach them tenderness," Jabez wrote.

William Frost and Jabez Vodrey to return with him, "bringing the necessary tools and machinery to enter upon the manufacture of white ware."[17] Both were Staffordshire men who had been working in Derbyshire for the past seven years.[18] Frost, a thrower, formed the ware on the wheel; Vodrey, a turner, trimmed and finished the piece on a horizontal lathe. Both skills were essential to the production of fine English earthenware.

The Pittsburgh newspaper, the *Commonwealth,* reported the following on December 27, 1827:

> *Queensware Manufactory.*—We are gratified to learn that an establishment for the manufacture of Queensware, will be in full operation in the precincts of this city, in the course of a few weeks, Messrs. *Frost and Vodrey* are the proprietors. They state that all the material for the manufacture of their work can be had in Western Pennsylvania and some of it on or near the premises. . . . Some of their work is what they call the *biscuit,* or unglazed state, which are creditable specimins of the quality of *ware* they will be able to manufacture."

The two potters soon realized that they could not find enough good clay near Pittsburgh to produce whiteware on a commercial basis. Vodrey, however, kept some small examples of wares made there until a fire destroyed them more than twenty years later. On March 10, 1849, he wrote in his diary, "I first used the Indurate clay in Pittsburgh 1827. It was the cleanest and whitest clay Picked from a Keel boat load brought from King's Creek near wheeling. Pieces of ware glazed with 15 per cent of this clay to glass and lead with a little tin have stood without crazing up to yesterday morning, when their loss was regretted very much."

George Hatfield recalled, "The clay here was not suitable for either white or yellow ware, and they drew their supplies for manufacturing the latter kind from the neighborhood of Perryopolis on the Monongahela river."[19] Here, a similar clay to that which Vodrey had used in Derbyshire was found between layers of coal.[20]

Hatfield added, "On market days, Frost and Vodrey could be seen trudging through the mud toward the market house, each with a basket of ware on his back, all of which they sold before nightfall. They made pitchers, bowls, vegetable dishes, plates, cups, saucers, egg cups—everything in the line of earthenware, in fact, and made it well."[21]

When George Hatfield's recollections were published in 1879, he had in his possession a covered dish, ordered from Frost and Vodrey as a gift for his wife. Inscribed on its top was "E. Hatfield, February, 1829." Hatfield explained, "The wife of Jabez Vodrey was the 'decorator' of the establishment, and would, when desired, put the names of the purchasers on their dishes. She used blue for this work."[22]

In 1828 Jacob Lewis had discovered what he believed to be an excellent source of kaolin in Missouri. When John P. Bull—partner with Samuel Casseday in selling imported queensware, glass, and china—was about to embark on a business trip to England, Lewis gave him samples of the clay to have tested at the Staffordshire potteries. Bull later reported, "I had a small pitcher made of it: it was mixed up and made in my presence, and marked with my name on the bottom: it was finished and sent on with

*Figure 7* Plates, Frost & Vodrey, 1832–1839. Cream-colored whiteware. D. 9¼" and 9¹/₁₆". (Courtesy, East Liverpool Museum of Art; photo, East Liverpool Camera Mart.) Long before the recent excavation, one of these plates was published in 1939 as made by Vodrey & Frost in Louisville, but no reason was given for the attribution. Findings at the Lewis Pottery site have elevated that attribution to a strong probability. Thinly potted "queensware" plates were indeed found there—although not of this plain, round form. Bits of underglaze-painted decoration were found, although in different colors. And edge lining in brown and black was everywhere, on rims of virtually every kind of vessel. Further, Vodrey's accounts have many references to "painted" pipes and pitchers, and the word "painted" specifically meant "underglaze decoration." Interestingly, the flat bottoms without a foot ring, as well as the decorative edge lining, are reminiscent of Wedgwood's queensware plates, a style with origins in the eighteenth century. Flatware making was a specialized skill and few American potteries ventured into its production. A bat of clay was rolled out to the desired thickness and was pressed face down into a mold that gave shape to what would be the upper surface; the reverse side was shaped by a profile tool held against the revolving clay by a knob or handle as the plate, in its mold, was turned on the wheel. In due time, the hand-held tool evolved into a shaped arm or lever that could be pulled down over the plate; this method was known as jiggering. The visible turning lines on the backs of these two plates might have been made by either method, but Vodrey gave no description of his process.

*Figure 8* Profile of plate illustrated in fig. 7. (Photo, Helga Studio.)

other ware. It can be easy seen that the quality is finer than the English ware. I gave it to Mr. Lewis when it arrived in 1829."[23]

With enough evidence in hand to convince Louisville merchants they should invest in a queensware company, Lewis increased his efforts to find qualified potters to run it. According to Jabez Vodrey,

> In 1827, Mr. William Frost and myself commenced a fine ware pottery in Pittsburgh, but could not procure clay to make white ware. In the spring of 1828, we received a letter from Jacob Lewis, informing us that he could furnish clay for white ware; and in August he came with several samples of clay that burnt white; we made him a small lot of ware out of it. In December following he brought more for us to try. In the spring following he came twice and we agreed to go with him to Louisville in the employment of the company.[24]

On December 15, 1829, the "Lewis Pottery Company for the purpose of manufacturing Queensware and China at Louisville" was incorporated by an act of the Kentucky legislature. Two hundred shares of stock were issued at five hundred dollars each, though the number actually sold is unknown.[25]

In 1830 Anne Royall, the nation's first famous female journalist, was traveling on her "Southern Tour" and dropped in at Louisville. Leaning over the boat rail to get a better look as she approached the town, Mrs. Royall was relieved of her small roll of banknotes. "Such is the grandeur of the entrance into Louisville from the point we approached that I might have been robbed of every thing I owned," she wrote. "Louisville stretches along the Ohio upon a plain of three miles, with handsome streets paved on the McAdams plan. The houses are elegant fresh brick buildings—the

*Figure 9* Oval plaque, Jabez and Sarah Vodrey, 1839. Whiteware. W. 5⅝". (Courtesy, the Vodrey family; photo by Helga Studio.) A glazed white-bodied plaque, press molded with the standing figure of a man leaning on his horse, holding a riding crop in one hand. The patch of grass is painted underglaze in olive green; the incised "rope" edge is black. This type of figure is seen on many relief-molded Staffordshire pitchers, and may have appeared on Staffordshire-made plaques as well.

*Figure 10* Reverse of plaque illustrated in fig. 9. Deeply incised on the back: "Jabez & Sarah/ Vodrey Louisville, Ky / 9th Jan^y 1839/ made in M Furguisons House." Signed with the names of both Vodreys and dated only weeks before Jabez left Louisville to take over the management of the Troy Pottery, this plaque is the only irrefutable document of their work in Louisville.

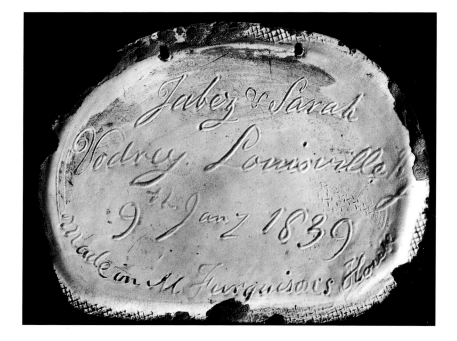

air of wealth and business, the Ohio river, the fertile state of Indiana on the opposite shore with Corn Islands, the roaring falls and the splendid canal is quite imposing. It is the handsomest town by far I have seen on my tour, and does an immense business."[26]

The canal mentioned by Mrs. Royall was being completed around the Falls of the Ohio. "It is about two miles in length, the whole of it cut through solid rock of the hardest kind. It is so wide and deep to see it now, that one would think it impossible to be the work of man. It is 300 feet wide at the top, and 24 feet tall, 12 deep, with two bridges of solid stone containing 5741 perches of masonry, and has 4 locks, the masonry of these

*Figure 11* Title page from *Plan of the City of Louisville And its environs in 1831.* (Courtesy, Filson Club.)

locks is superior to those of the grand canal, and doubtless the best in the world. There were 500 hands at work, and every one seemed to work for his life. This canal met with much opposition which I was surprised to hear; but it is done now, and will doubtless last to the end of time. It is intended for the passage of the largest vessels."[27]

Intrigued by the progress being made in Louisville, Mrs. Royall took the time to visit the new pottery. "The queensware factory belongs to a Mr. Lewis, a very clever and intelligent man," she wrote. "I saw several pieces of the ware, but they have not gone fully into business, for want of glazing and workmen acquainted with that part of the business—for which I understand he had sent to Europe. The pieces I saw were of a dull white and very smooth."[28]

By Jabez Vodrey's own admission, "We did not succeed in making all good ware in the first attempt of new materials. The company became discouraged and all of them abandoned it except Mr. Lewis. He continued and saved it from being lost to the State and country."[29]

In December 1830 a letter was dispatched to William Ellis Tucker who had established a successful porcelain manufactory in Philadelphia in 1826. The letter offered five thousand dollars if Tucker would bring his talents to Louisville and reorganize the Lewis Pottery. Tucker mistakenly believed the offer concerned the establishment of a new porcelain factory and initially was not opposed to the idea. When he eventually realized the object was to produce "Queens Ware," he refused the offer. In conveying the bad news to Jacob Lewis on January 22, however, William's father, Benjamin Tucker, added a few words of encouragement and also of caution.

> From the description thou hast given of your Clay, it is much to be wished that you may succeed, as it would not only be an individual but a national benefit—And in order to arive at the object; permit me to say, as you are yet unacquainted with the process of making a perfect ware, experiments upon a limited and economical scale will be much the most likely to succeed—These may be repeated without producing discouragement; And, if you can get a good body & a glaze to seal it; you need not be concerned about getting workmen to perform many of the other processes; the enterprising genius of Americans, if they are called in, at a proper age, will furnish you with equally excellent, and much more confidential work men than you can generally speaking, obtain from Europe—Some of the apprentices that my Son has brought up under his own hand fully verify this statement—The hostility and intrigue which many of his foreign work men displayed, proved highly injurious to his interests....A few good European workmen you will necessarily want in order to instruct American youths—And these by entrusting some confidential individual in Europe to send them out, might I should suppose be obtained.[30]

Several months later, Jacob Lewis submitted a sample of ware to the scrutiny of George D. Prentice, editor of the *Louisville Daily Journal*. An ardent supporter of the American system and biographer of Henry Clay, Prentice was only too happy to give the enterprise some publicity. The following appeared on April 28, 1831:

> QUEENSWARE—We were favored yesterday with some specimens of Queensware, manufactured at Mr. Lewis's Pottery in this town. They w[e]re really very handsome articles, and as we believe Mr. Lewis is the first man who has attempted the introduction of this species of manufacture in this country, we sincerely hope he may meet with a patronage commensurate with his skill and enterprise.

To this was added an appeal from Lewis:

> STAFFORDSHIRE POTTERS
>
> POTTERS, that can work on fine Ware on the Staffordshire plan, will meet with employment at Lewis's Pottery.—flat and hollow Ware Pressers are much wanted.
>
> Printers inclined to favor manufactures in our country, may promote the interests of it by giving this notice a few insertions in their papers.

Creating a pottery on the Staffordshire plan was ambitious. It was the beginning of the "factory system," whereby certain tasks were assigned to specialists, rather than two or three men who performed all jobs. Failing to attract the sort of skilled workers he required, Lewis turned to offering potters an interest in the business. The following appeared in the *Washington Intelligencer* on October 21, 1831:

> NOTICE.
>
> TO STAFFORDSHIRE POTTERS.
>
> A FINEWARE POTTERY has been established in
>
> Louisville, Kentucky; and the Ware made is of a superior quality; the sound, or ring of it, is more like glass or china than common imported ware; it stands hot water and change of temperature without injury. Fineware Potters in every branch of the business (of good habits) can have an interest in the business on advantageous terms. The cost of materials for making the ware are favorable, when compared with the cost of them at the manufactories in Europe, and the necessaries of life are much cheaper at this place.
>
> Letters postpaid will be duly attended to, by
> oct 21—3t                                        JACOB LEWIS[31]

In 1832, Jacob Lewis somehow managed to effect a reorganization of his queensware pottery. A new glost kiln was to be constructed and Jabez's brother-in-law George Nixon, "a fineware thrower," was taken in as a third partner with Vodrey and Lewis to run the Lewis pottery for the next five years. Under an indenture signed in June, which made no mention of William Frost, Vodrey and Nixon were to have two years' free rent, after which they would have to pay no more than three hundred dollars per year.[32]

There was already clay on hand, estimated at ten and one-half tons, and unburnt and unfinished ware. All expenses for this clay and the glost kiln, which was about to be completed, were to be shared equally, as were the

*Figure 12* Location index to the *Plan of the City of Louisville.* The pottery is referenced as "f". (Courtesy, Filson Club.)

*Figure 13* Detail of the *Plan of the City of Louisville,* showing the location of the pottery on Lot 76. (Courtesy, Filson Club.)

*Figure 14* View of the Lewis Pottery site as an asphalt-covered parking lot.

*Figure 15* Site Director Kim McBride guides the backhoe operator in clearing the asphalt and modern overburden, while archaeologist Jay Stottman (left) maps the trenches.

profits, from which each party was "to draw an equal amount of money every Saturday night, after meeting the running expenses of the week." No workmen were to be hired who were unacquainted with making fineware on the Staffordshire plan. The partnership would be known as the "Lewis Pottery," whose name would appear on all billheads and the ware "marked in a like manner."[33]

The role of each party to the agreement was specifically defined. Jacob Lewis was "to give his attention to the out door business, that is to laying in the materials, and making sales of ware at wholesale, making out bills &c and to assist in keeping the sales book for the Pottery," a role he had probably performed from his earliest days in the business. Vodrey and Nixon were to help apprentices acquire the skills of turning and throwing and to superintend all aspects of creating the ware. Bills for ware sold for cash were to be entered into a daybook at the time of delivery and carried into a ledger. Vodrey and Nixon would also be required to maintain a work book with daily entries describing amounts of ware sold and on hand, all expenses, and any debts due the pottery.[34]

There was, however, a clause in the five-year agreement that anticipated possible relocation of the pottery away from Louisville. If it was "deemed advisable before the expiration of said term to remove the pottery to a place where materials can be procured at a lefs expence, and with more cirtenty, they will try to purchase a situation and improve it jouintly for a Pottery."[35]

During the next two years, most of the problems of the past were overcome. Perhaps Lewis, along with Vodrey and Nixon, had paid heed to Benjamin Tucker's admonition to conduct experiments upon a limited and economical scale until success was achieved. William Frost was again identified as among those working with Vodrey and Nixon, and different clays, glazes, and decorating techniques were incorporated into the manufacture of a variety of wares.

Between May and the week of August 10, 1833, at least one other unnamed journeyman worked a total of fifty-three and one-half days, at $1.25

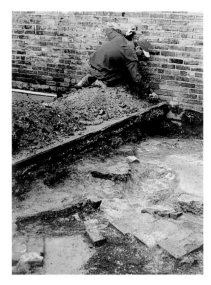

*Figure 16* Archaeologist Bob Genheimer exposes remains of a kiln foundation.

*Figure 17* Artifacts were carefully separated by hand from potters' clays kept moist in the earth, too viscous to be sifted.

per day, a respectable wage for the time. Starting with a six-day week, he worked an ever-decreasing number of days until he was down to one or one and one-half days a week. Finally, settling his account on August 16, he went off "down the river."[36] Whether this decline in his workdays reflected waning sales at the pottery or intemperance, which was an occupational hazard of potters at the time, is impossible to judge. Unfortunately, there is no surviving record of the pottery's output to help gauge its success. However, an 1834 invoice for crockery was found among the Vodrey papers. It includes large and small urns, three sizes of bowls, chamber pots in two sizes, nests of jars with covers, and two sizes of mugs.[37]

The canal surrounding the city had been completed in 1833. The new watercourse, enabling even the most colossal steamboats to bypass the Falls of the Ohio, caused a wrenching change in the way commerce was conducted in Louisville. Previously, numerous companies had concerned themselves entirely with receiving and forwarding the vast quantities of merchandise and produce destined for points on the waters above or below the Falls and throughout the West: now these companies had to think about making or selling products themselves.[38]

Although the pottery was not showing much profit, it was at least paying for itself, and Jacob Lewis was able to gather the signatures of more than fifty of Louisville's most prominent businessmen onto a petition to the United States Congress. Dated May 14, 1834, it read: "Praying that a preemption right to a tract of land be granted to Jacob Lewis for the establishment of a manufactory of fine earthenware, &c." further down the Ohio River or on the Mississippi—this petition was a first step in the foundation of a pottery center that would one day compete with and rival those in the towns of Staffordshire.[39]

On July 17, 1834, Jabez Vodrey became a citizen of the United States of America. On September 29 of the same year, William Frost was naturalized.[40] When the congressional petition, which had been referred to the Committee on Public Lands, was rejected that fall, the hopes of Jabez

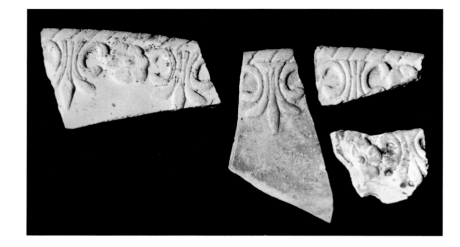

*Figure 18* White-bodied, embossed-edge sherds, Lewis Pottery, 1829–1837. To be able to supply white plates, made from native materials, for the dinner tables of the nation was to an American fineware potter the pinnacle of success. And once Staffordshire potters began to export white-bodied ware shortly after the War of 1812, it became an imperative.

These four fragments of plate rims are certainly white bodied—despite the stains absorbed from being in the earth for 170 years—and proof that the Lewis Pottery did achieve that goal, unheralded though the company was. The details of the mold are sharp, and the rim design borrows liberally from the variety of embossed edges popular since the 1780s and still a favorite import in the 1820s and 1830s. They might well have been decorated with underglaze blue had they not been discarded. A two-line invoice for a small amount of calcined cobalt was copied into the Louisville pages of the diary:

> Messrs. Lewis & Vodrey  September 29th 1833
> to ½ lb of Blue Calx          $3.50

This seems outrageously expensive for such a small amount, but calx was a refined form of cobalt and such a potent coloring agent that it went far. Surprisingly, there was almost no evidence of blue decoration in what was found at the dig.

Vodrey, who had contributed a testimonial, dissolved along with Jacob Lewis's dream.

The *Louisville Directory for the Year 1836* lists "Lewis's Pottery" at its familiar location on Jackson Street, at the corner of Main, but "Vodry's Pottery" appears for the first time on the north side of Main between Hancock and Jackson. Residential listings for both Vodrey and Frost, however, remained on Lewis's property. There were no other potters listed.

Apparently, Vodrey and Frost had moved across the street to a recently vacated stoneware pottery, where they continued trying to make fine earthenware, but Vodrey, obviously discouraged, was thinking of selling imported wares. From what must have been the depths of depression, he wrote to a brother-in-law in Tunstall, Staffordshire, England, noting that "a M[r]. Kerr has lately opened a la[r]ge house of splended ware from Allcocks, Ridgeways." He suggested that "if it is in your power to send us ware on credit we could pay the cost to this place and remit you money as we sold out."[41]

But the dream of creating an American pottery center had not died. In 1836, Samuel Casseday, now running his queensware store in partnership with Willis Ranney, invited the British potter James Clews to come to Louisville with the idea of establishing a substantial fine earthenware manufactory nearby.[42] No doubt Casseday was unaware that James Clews and his brother, Ralph, had, in November 1834, gone bankrupt in England for a second time.

Clews scouted the surrounding territory and decided that, based on the presence of suitable clay and coal, the best place to establish a pottery on the Staffordshire plan was near Troy, Indiana, some seventy miles down the Ohio from Louisville. Here, in the spring and summer of 1836, Samuel Casseday purchased two parcels of land, totaling fifty-six acres. In December, as buildings and kilns were being constructed, Clews sent abroad for thirty-six potters to run the new enterprise. The cost of bringing these workers and their families to America was advanced by Ralph Clews to his brother James in the amount of $2,700. On January 7, 1837, the Indiana Pottery Company was incorporated by a special act of the Indiana legislature.

*Figure 19* Plates, Staffordshire, 1820–1835. Pearlware. (Private collection; photo, Hans Lorenz.) Examples of embossed-edge plates trimmed in both blue and green made in Staffordshire and exported to the United States in huge quantities in the 1820s.

*Figure 20* Rim sherds from London-shape "dipt" creamware bowls, Lewis Pottery, 1829–1837. One great challenge in ceramic archaeology is identifying the vessel forms; another, is accepting that this identification is never certain. When all the bits and pieces were washed, numbered, and recorded as to where they were found, they were sorted by glaze, color, texture, thickness—any visual means of grouping them. After these ceramic groups were transported to Cincinnati, Bob Genheimer's corps of volunteers glued and assembled the hundreds of jigsaw puzzles. Then, aided by Vodrey's own notes and accounts, by research into contemporary production here and abroad, by visualizing the invisible parts, by guess and by gosh, we reached conclusions—or we did not.

It was capitalized by stock issued at a total of $100,000, owned in shares by eleven partners, including Clews, Casseday, and Jacob Lewis.

The first kiln of ware was drawn at Troy in June. According to local tradition, Clews was an arrogant and demanding master and the English potters he had brought to America were discontented. He had also hired "workingmen from Baltimore...filled with the spirit of freedom and Americanism. They believed they were as good as any men on earth and that they didn't have to bow to any man because he was their employer." Soon the potters were refusing to lift their hats or to bow when Clews passed them at the pottery. The English potters were also uneasy in their rustic surroundings; they began to abscond, some returning home, others finding work elsewhere in the United States.[43] Meanwhile, Jacob Lewis's bad luck continued as the country plunged into the Panic of 1837.

*Figure 21* Sherds from cream-color bowls banded in brown and white, Lewis Pottery, 1829–1837. Twenty-five white-bodied sherds were glazed a cream color. They were from bowls of varying sizes and thicknesses and had differing sets of narrow brown and opaque white slip bands, each line ⅛" wide. The bowl above had a projected diameter of 8".

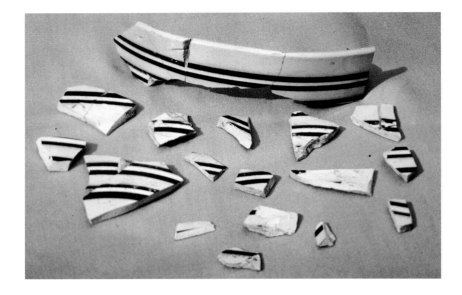

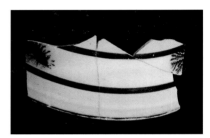

*Figure 22* Sherds from a mocha-decorated creamware bowl, Lewis Pottery, 1829–1837. Projected D. 6¼". This particular bowl had a cream-colored body with a cream-colored glaze and narrow ⅛" lines of white and dark brown slip. On a white band, ⅝" wide, were olive-green dendritic designs. A hasty judgment might have relegated this bowl to the category of "used household detritus" because the brown edge of the rim is almost completely abraded and chipped. But a closer look reveals that the glaze just below the rim is thicker and glossier than elsewhere. It had been dried upside down after being dipped in the glaze, or was fired upside down, causing the melting glaze to pool over the edge and fuse to whatever it was fired in, and it had to be pried loose. Hence, the appearance of wear and tear.

In fact, the glaze has an oddly gritty surface, perhaps a symptom of the trouble with glazing which Anne Royall hinted at after her visit in 1830. When consulted, Dr. Licio Pennisi, of Alfred University's Center for Advanced Ceramic Technology, suggested this might be due to unmelted pulverized fret, glass, or sand in the glaze. A native of Staffordshire, Pat Halfpenny (former curator of the City Museum at Stoke, now director of museum collections at the Winterthur Museum) commented: "We [in Staffordshire] would say the glaze was too thin."

These were the very words used by Jabez Vodrey himself when, having moved across the street to the pottery abandoned by Isaac Dover, he logged several experiments into his diary in February and March 1838. Using pipes for his trials, he first tested a frit that "would not fuse at a good glost heat." He tried a variety of fluxes—borax, egg[shell] lime, calcined bone. Then, on April 2: "Result of the last trials. the pipes dipt in equal parts of Cumberland [clay] and white lead was hardly smooth enough being dipt too thin and I think 6 Parts of lead to 5 parts of Cumberland clay would be good."

On January 4, 1838, the directors of the Indiana Pottery Company, which had been in existence for scarcely more than a year, petitioned the United States Congress for a donation of public land containing the raw materials needed by the pottery. Stating that they had already spent fifty thousand dollars to put their manufactory into operation, they said it would be "impossible ever to make the business yield a profit until workmen can be made of American citizens." They would, therefore, have to "pursue this business at a heavy loss for several years to come" unless they could obtain the "clay, marl, flint, spar and other materials necessary for

the manufacturing of queensware and china . . . found, generally on poor and broken public lands" in Indiana, Illinois, and Missouri.[44]

James Clews left shortly after this petition was denied, and early in 1839 the Indiana Pottery Company hired Jabez Vodrey to manage and revive its pottery in Troy. By that time, Jacob Lewis had used up both his credit and his credibility in Louisville and could see no further business prospects there. He had heard that land formerly occupied by the Chickasaw Nation in the western part of the state was being made available to settlers practically free of charge. Toward the end of the winter he boarded a steamship and traveled west to take a look. In June he filed claims for three lots on the Tennessee River and by year's end he was living in Hickman, Kentucky, and about to open a wood yard.[45]

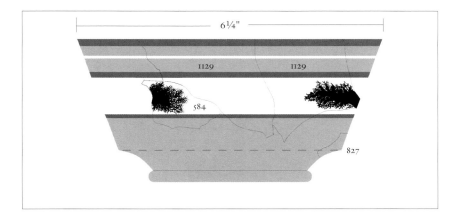

*Figure 23* Projected drawing of bowl shape based on sherds illustrated in fig. 22.

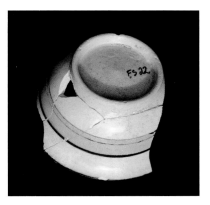

*Figure 24* Cup, Lewis Pottery, 1829–1837. Cream-colored banded in brown and white. H. 1¾". Four large sherds, all apparently clear-glazed with very fine crazing, over a cream-colored body, assembled into an S-curved teacup, the flaring rim thinned at the edge. A small hole between the sherds indicates where a handle may have been attached. Decorated with bands of colored slip, the lower line of brown glaze has completely peeled away, perhaps because it was applied onto the tan slip and not directly onto the body. The shape of the cup, with a different handle, can be found among the early numbers—131 and 136—in the first pattern book of W. Ridgway & Co., a firm established early in 1831. Vodrey must have adapted the shapes he admired among the imported Ridgway designs he had seen at Mr. Kerr's "house of splended ware from Allcocks, Ridgeways," which he wrote about in 1836. The Kerrs later operated a "China Hall" in Philadelphia at the time of the Centennial in 1876, at 1218 Chestnut Street, and another in Ireland.

During the summer of 1856, Jacob Lewis died at the age of eighty-three. No likeness has survived to allow us to study his face, but he must have been a charming and persuasive man. Never possessed of money or means, he was an entrepreneur nonetheless. An eternal optimist, he got along with the potters who worked for him and found ready investors for his various schemes. Though less than skillful in managing his finances, Lewis was probably no worse a businessman than the majority of his contemporaries at a time when manufactories rose with prosperity and crashed with depressions. He had given Louisville its first stoneware pottery and its first

*Figure 25* Sherds, Lewis Pottery, 1829–1837. Slip decorated in Common Cable pattern. A total of thirteen small sherds, all biscuit- and white-bodied, are in this group; one or two have marbleized slip and some are *feathered* at the edges.

*Figure 26* Fragments of cylindrical mugs, or canns, Lewis Pottery, 1829–1837. H. 2½". Nine white-bodied biscuit sherds seemed to group themselves as parts of similar, cylindrical vessels. There were three flat base fragments with turned footrims, wall fragments that were vertical when stood on their rims, and one molded handle. A wide band of brown slip had been applied to the walls, then had been shaved flat and smoothed, the turner's tool leaving traces of horizontal scoring. The upper terminal of the white handle had brown slip adhering to it, and a corresponding lack of slip on a rim fragment revealed its probable location; a shallow flake out of a base was probably where the lower terminal had been attached. From these observations, an overall measurement of the vessel could be projected.

Mugs of a similar size and shape were designated "square chocolates" by Leeds and other English potteries. Vodrey's odd choice of decoration—the broad band of brown slip on the white body—suggests that he may have had this function in mind for these cups.

fineware manufactory. Yet, in the end, his most enduring legacy may have been his great-grandson, for whom the pride of Louisville, the Speed Museum of Art, was named—James Breckinridge Speed.[46]

### Archaeological Research

In 1994 Gary returned to the site of the Lewis Pottery with archaeologist Bob Genheimer, who walked over to the alley and poked around a telephone pole with a stick. A comparatively recent feature, the pole had been sunk deep into the very earth we wanted to examine. Bob straightened up and handed Gary a chunk of sagger material with white glaze clinging to one side. That decided it! We knew that stoneware had been made on the site, before and after Vodrey worked there, and we anticipated that any fineware found would be easily distinguishable as Vodrey's production.

It took three years to organize an excavation. The University of Kentucky agreed to sponsor the project and curate the results. The owners of the parking lot were contacted and agreed to allow the dig. Additional funds were raised from other friends of American ceramics: the American Ceramic Circle, Christina Lee Brown, Emma and Jay Lewis, Dr. Thomas Courtenay, Robert A. Ellison, Barbara and Martin Rosen, Anne and J. Jefferson Miller, and Susan Treitz were all generous contributors. A team of archaeologists, assembled under the aegis of the Kentucky Archaeological Survey, consisted of Kim A. McBride, Ph.D., co-director of the K.A.S. at the University of Kentucky; Jay A. Stottman, M.A., archaeologist for

PITTSBURG
# POTTERY.

TROTTER and Co. having established their manufactory of Queens-ware in Pittsburgh, now commenced fabricating wares similar to those of the potteries of Philadelphia, take this opportunity to inform the public, that they are ready to execute such orders as they will do them the favor to address to the Pottery, corner of seventh and Grant Streets, or to Anthony Beelen & co. or Richd. Brown and Co. where specimens of the ware may be seen.

*List of Articles at present Manufacturing*

| | |
|---|---|
| Wash hand Basins | Coffee pots |
| Ewers | Tea pots |
| Chambers | Coffee cups |
| Dutch jugs | Tea cups |
| Bowls | Chocolates |
| Mugs | Sugar basins |
| Goblets | Butter tubs |
| Pitchers | Baking dishes |

Feb'y 11th 1815.

*Figure 27* Newspaper advertisement for the Pittsburg Pottery, 11 February 1815. (Courtesy, American Antiquarian Society.) Chocolates, mugs, and cups, but no saucers or plates, were being made by Alexander Trotter. An ambitious potter, he left Philadelphia to form his own company but his western venture succumbed to bad times after the end of the War of 1812. By 1819, he had moved again to try his luck in Baltimore.

*Figure 28* Sherds from unidentified vessels, Lewis Pottery, 1829–1837. Whiteware. The only traces of blue found on fragments at the Lewis Pottery site appeared on these tiny sherds. The dollop of yellow-green had a burst bubble in its center. Many had a smooth, opaque enamel-like surface.

*Figure 29* Unglazed lid fragments, Lewis Pottery, 1829–1837. There were three intriguing sherds each with a layer of black clay embedded at the core. In one, the ¹⁄₁₆" thickness was so consistent and precisely centered between cream-colored layers that it appeared to be a deliberately placed lamination. However, in the two assembled pieces shown above the black layer wobbles in thickness, and does not extend to the edge, or to the center of the lid, where an empty crater marks the spot where a finial had blown off during firing.

Opinions vary about the cause or intent—one expert suggesting that clays with different expansion rates might have been utilized to counteract a tendency to warp; another, that the black layer is the result of bloat caused by accidental conditions in the kiln.

the Universities of Louisville and Kentucky; and Robert A. Genheimer, M.A., archaeological collections manager at the Cincinnati Museum of Natural History.

The excavation finally began on the unseasonably cold and wet morning of May 29, 1997. Jay and Bob studied the insurance maps and decided to avoid areas of previous construction around the periphery of the lot. The backhoe operator struck his first blow at the rear center of the parking lot, and homed in on the foundation of a kiln, which extended just to the wall of the adjacent building, although a sizable portion of it was under a sunken

*Figure 30* The lid illustrated in figure 29 bears a strong resemblance to the family's "cookie jar," believed to have been made by Jabez at a somewhat later date, possibly in Troy. Interestingly, its large, flat lid was made without a finial.

Two similar, smaller jars in the East Liverpool Museum of Ceramics have been attributed to the East Liverpool pottery of Vodrey & Brother in the 1860s. These jars were also made without finials.

*Figure 31* Sherds from salve jars, Lewis Pottery, 1829–1837. Five fragments that appear to be from ointment pots or jars of a yellowish enamel-type glaze. One retains an arc of a foot ring; another interior piece retains a bit of the vessel wall. A druggist named Peter Gardner was listed in the *Louisville City Directory for the Year 1832* "at Mr. Lewis; s[outh] s[ide] Main b.[etween] Jackson and Preston." This explains the finding of small round jar fragments found among the pottery wasters. Gardner probably had his pharmacy in the pottery store that was located on the side of the Lewis property. There were no subsequent directories until 1838, and he is not listed again.

*Figure 32* Tobacco pipes, Lewis Pottery, circa 1815–1840s. Earthenware and stoneware. Tobacco pipes were everywhere on the lot. Some were complete, but most were in pieces; some were warped, and some all but melted; some were saltglazed stoneware, redware, even yellow ware—mementos of every potter who ever worked the site. All were the short, stubby shape typically found in American archaeology in date contexts through the late nineteenth century, the kind that were meant to have a stiff reed stem inserted into the stub.

*Figure 33* Tobacco pipes, Lewis Pottery, 1829–1837. Whiteware. There were no white biscuit earthenware pipes and no long stems, broken or otherwise, of the sort still being imported from England. But there were, scattered throughout, white-bodied pipes with a longer bowl shape than all the others, which had an innovative ivory white glaze—smooth and opaque, like that found on some of the decorated sherds at the site—and these had to have been made by Vodrey. We know that by 1838 Vodrey was experimenting with marbled and painted pipes, the latter being decorated with underglaze color. In 1839 he was selling plain and marbled pipes at $1 per hundred, while painted pipes were at $1.50 per hundred. He had been making pipes since his arrival in Pittsburgh in 1827 and to him they were something of a bread-and-butter line. They were priced by the hundred but were often shipped by the barrel, as many as five thousand at a time. In constant demand, they represented a steady income to the potter.

concrete loading platform. It yielded up warped stoneware smoking pipes and, on a lower level, on the floor of yet an earlier kiln, wasters of redware pipes. Predictably, salt-glazed stoneware represented the preponderance of what was found on the site—but a discussion of that stoneware is not within the purview of this article.

It takes a while for the untrained eye to distinguish the coal, clinkers, charcoal, and burnt kiln bricks from the household glass, china, and potters' wasters. At first the mud seemed to have colored everything gray. Tiny bits of refined white earthenware had all but disintegrated into the earth. Some sherds had flaked to half their thicknesses; some colors had dissolved off their surfaces.

Our test trenches revealed gobs of potter's clay of all kinds, some of it colored, kept moist and still workable from the years underground and by the weather that kept us shivering. Still clinging to the wet clay and randomly scattered throughout the lot was what we had hoped to find— wasters of fineware production in abundant variety, if not quantity. As is common in urban archaeology, we had a "disturbed" site. This meant there were no neatly stratified deposits, divided by periods of time, by which we could date the artifacts. In fact, we were lucky that anything remained after a hundred and fifty years.

While there is much documentary evidence of early ceramics production in America, there are remarkably few examples that can reliably be attributed to a site or to the potters who made them. What was found at the Lewis Pottery site is proof of the virtuoso skills of the potters who worked there, and reveals their naive and quixotic sense of design—but that is, after all, the essence of the American craftsman's divergence from the English model, from its sense of perfection and symmetry. It is this very freedom and imagination, liberally mixed with foreign influences, that epitomizes the difference.

The diary, the research surrounding it, and the archaeology provide a unique cross-reference, each shedding light on the other. With Jabez Vodrey still looking over our shoulders, we hope to have volume 1 of a book on his world ready for publication soon.

1. David Buten and Jane Perkins Claney, *Eighteenth Century Wedgwood: A Guide for Collectors and Connoisseurs* (New York: Methuen, Inc., 1980), p. 17ff.

2. For further information on the early Philadelphia fineware potters, see Susan H. Myers, *Handcraft to Industry, Philadelphia Ceramics in the First Half of the Nineteenth Century* (Washington, D.C.: Smithsonian Institution Press, 1980). *The Commonwealth,* November 12, 1806. A more detailed account of early fineware potters working on the banks of the Ohio River and elsewhere in the Midwest will appear in a forthcoming book, tentatively titled *The Western World of Jabez Vodrey, A Pioneer American Potter* by the authors of this article.

3. Small enough to be tucked into a jacket pocket, *The Navigator,* a guide for boatmen and settlers published intermittently from 1801 to 1824, contained maps of the primary midwestern rivers, together with specific instructions on how to avoid sandbars, rocks, and other hazards when negotiating every bend. Landings at new and old communities along the shore were described and occasionally manufactories and stores, and their proprietors, were commented upon.

4. Edwin AtLee Barber, *Tin Enamelled Pottery* (New York: Doubleday, Page & Co., 1907), p. 5.

5. Heinrich Ries, *The Clays and Clay Industries of New Jersey,* vol. 6, part 3, of *Final Report of the State Geologist, Geological Survey of New Jersey* (Trenton, N.J.: 1904), p. 296.

6. *The Pittsburgh Gazette,* 11 January 1820. The term would persist in the invoices of American potteries into the last quarter of the nineteenth century.

7. George Dangerfield, *The Era of Good Feelings* (New York: Harcourt Brace & Co., 1952), p. 176.

8. Courtesy of the Museum of Early Southern Decorative Arts, Winston-Salem, North Carolina.

9. Catherine Elizabeth Reiser, *Pittsburgh's Commercial Development 1800–1850* (Harrisburg, Pa.: Pennsylvania Historical and Museum Commission, 1951), pp. 33–34. Richard C. Wade, *The Urban Frontier* (Cambridge, Mass.: Harvard University Press, 1959), p. 14.

10. Statutes, 14th Congress, Chapter 107, p. 310.

11. George L. Miller, "A Revised Set of CC Index Values for Classification and Economic Scaling of English Ceramics from 1787 to 1880," *Historical Archaeology* 25, no. 1 (1991): 3.

12 . For further information on the causes and effects of the Panic of 1819, especially in the Western Country, see Thomas H. Greer, "Economic and Social Effects of the Depression of 1819 in the Old Northwest," *Indiana Magazine of History* 44, no. 3 (September 1948): 230.

13. An impressive book by R. T. Haines Halsey, *Pictures of Early New York on Dark Blue Staffordshire Pottery* (New York: Dodd, Mead, 1899), provides historical descriptions of the print images and illustrates many of these early dishes in vivid color.

14. Occasionally a source states that 1819 is the year Louisville's first pottery came into being. This may be due to an extremely early book, H. McMurtrie, M.D., *Sketches of Louisville & Environs,* published by S. Penn of Louisville in 1819, in which it was stated that there was one pottery in the town "at this time."

15. From evidence presented in litigation between Jacob Lewis and Louisville merchants, Southard & Starr, between 1826 and 1828, particularly cases 1444 and 3349, Old Circuit Court, Common Law, Jefferson County, Kentucky State Archives, Frankfort.

16. Probably the celebrated whiteware manufactory of David E. Seixas, which, according to Edwin AtLee Barber, closed in 1822. Edwin AtLee Barber, *The Pottery and Porcelain of the United States* and *Marks of American Potters,* combined ed. (New York: Feingold and Lewis, 1976), p. 115. Information on Lewis's attempts to have clays tested in 1823, 1825, and 1828 is found in "A brief view of efforts made to get a Fine Ware pottery established in Louisville, Kentucky," appended to *Memorial of Certain Citizens of Louisville, Kentucky,* 23rd Congress, 1st sess., document 366.

17. Originally reported in a publication known either as the *American* or *Pittsburgh Pottery and Glassware Reporter;* reprinted in part in *The Brick, Pottery and Glass Journal* (August 1879), but more completely in *The Potters Gazette* 8, no. 40 (August 21, 1879).

18. Journal and ledgers of Jabez Vodrey in the possession of his descendants in East Liverpool, Ohio (hereinafter referred to as "Vodrey diary"), November 11, 1849.

19. *The Potters Gazette*.

20. "First Geological Survey of Pennsylvania," in *Annual Report of the Pennsylvania State College* (1897), p. 50. Also, Wilbur Stout states, "The coal formations of eastern and southwestern Ohio supplied the settlers with buff-burning clays for stoneware, yellow ware, and rockingham." *Ohio Geological Survey, Bulletin No. 26* (1923), p. 9.

21. *The Potters Gazette*.

22. Ibid.

23. From 23rd Congress, "A brief view of efforts made"

24. Ibid.

25. Laws of Kentucky, chap. 193.

26. Anne Royall, *Mrs. Royall's Southern Tour, or Second Series of the Black Book*, vol. 3 (Washington, D.C.: 1831), pp. 205, 206.

27. Ibid., p. 211.

28 Ibid., pp. 212, 213. In manuscripts of this time, England is often considered part of Europe.

29. From 23rd Congress, *Memorial of Certain Citizens*

30. Benjamin Tucker to John F. Anderson, 4 December 1830, and to Jacob Lewis, 22 January 1831. Courtesy of the Philadelphia Museum of Art.

31. Courtesy of several individuals, including J. Jefferson Miller II and Susan H. Myers.

32. Document in possession of Jabez Vodrey's descendants.

33. Ibid.

34. Ibid. No marked ware and no such books have yet been found.

35. Ibid.

36. Vodrey diary.

37. Ibid.

38. *Louisville Directory for 1844–45*, p. 55.

39. From 23rd Congress, "A brief view of efforts made"

40. Old Circuit Court of Common Law, Jefferson County, Kentucky, bk. 30, pp. 162, 371, Kentucky State Archives, Frankfort.

41. Document in possession of Jabez Vodrey's descendants.

42. Information on the Indiana Pottery Co., including its petition to the United States Congress, in Frank Stefano, Jr., "James Clews, Nineteenth-Century Potter, Part II: The American Experience, *Antiques* (March 1974): 553–555.

43. "Henry Clews the Financier Spent His Boyhood in Troy," *Evansville (Ind.) Courier*, 10 February 1907. Courtesy of Frank Stefano, Jr.

44. "James Clews, Nineteenth-Century Potter"

45. Plat maps and documents in the archives of the Filson Club, Louisville, Kentucky.

46. Vital statistics, copied from the Lewis-Shallcross family bible by a descendant, in the possession of the Filson Club. Lewis's eldest daughter, Mary Zane Lewis (1806–?), married steamboat captain John Shallcross (1799–1866) on December 3, 1822. Their eldest daughter, Mary Ellen (1824–1844), married William Pope Speed on January 30, 1843, and died during or shortly after the birth of James Breckinridge Speed on January 4, 1844.

**THE TROY DAWSON CHAPPELL COLLECTION**
**OF EARLY ENGLISH POTTERY**

A Curious and picked Collection of POTTERY WARES, made of refined Englifh Materials & Devices, with the Forms being in the fafhionable Tafte for a variety of *ufeful and ornamental* Purpofes, and confifting of a Selection of Images, Choices of finely painted Delph, STONE China of feveral Kinds, elegant Lots of Cream Colour, and a rich Sortment of other Staffordfhire EARTHEN goods.

The Undertaker of this general SHEWING humbly hopes this Manner of prefenting his Affemblage to the Publick will meet with favourable Encouragement.

T. D. CHAPPELL.

# Troy D. Chappell, collector

# An Adventure with Early English Pottery

▼ AS A COLLECTOR, I am essentially curious, eager to discover, acquire, and learn. I was introduced to American and British decorative arts through the Colonial Williamsburg collections more than fifty years ago. Although evolving in several directions, my interest in English pottery began in earnest about 1969.[1]

After organizing my thoughts, the goal was to assemble and contrast pieces to demonstrate most of the manufacturing materials and forming techniques, manners of shaped and colored decorations, and progression of styles that dominated English trade and perceptions through the period of about 1630 to 1780. The mock eighteenth-century newspaper notice included in this article summarizes the breadth of my collecting project.

English pottery can be divided into two general categories: (1) earthenware, composed of low-fired clays that are usually covered in a lead glaze to reduce porosity and (2) higher-fired stoneware, its semivitrified composition providing an equivalent imperviousness to liquids. Within these two groups there are many distinct types of English pottery, including delftware or tin-glazed earthenware, slipware, redware, agateware, salt-glazed stoneware, and cream-colored ware.

Seventeenth-century slipware and delftware anchor the collection since the offhand medieval and earlier pottery was made for restricted local or personal needs as the occasion demanded and does not seem to have been well organized for distribution. At the other end of the time spectrum, products introduced later than 1780 creamware are curtailed because my scope seeks to reveal the sensibilities or amplifications of independent workers before the advent of absolute duplications through improved power machinery.

Some collectors focus on dated or unusual specimens, while others care for handsome objects. I try to emphasize the diverse and sometimes subtle ways by which potters and decorators produced their wares. For example, delft artisans painted quickly on porous tin-glazed surfaces with tinted solutions that did not show great distinctions of color; yet they achieved shaded perspectives, balanced polychrome coloration, and incredible fine-line imagery, much as would miniaturists. Notwithstanding this, my favorite delft piece shows how a few brushstrokes can convey the tranquility and beauty of a swan beside a ruined column (fig. 14). Another major interest for me lies in the fabrication of molds for slip casting or press molding. The carving of models to make these molds indicates tremendous proficiency with the materials at hand and in dirty work environ-

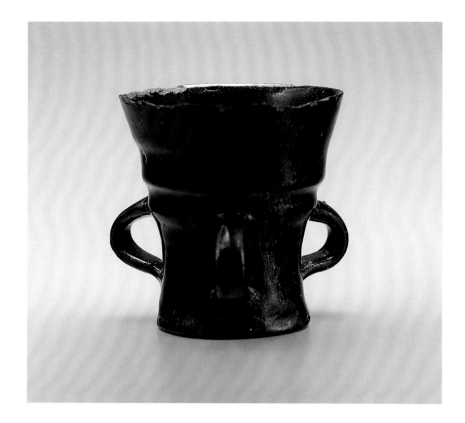

*Figure 1* Three-handled cup, possibly Staffordshire, 1640–1660. Black lead-glazed earthenware. H. 3½". (All objects from the Troy D. Chappell Collection; photos, Gavin Ashworth.) This multi-handled cup is a remnant of medieval communal drinking vessels made by localized potteries throughout England. Fragments of similar cups have been found on early-seventeenth-century settlements in the Chesapeake region.

ments. Subsequently, complex multipart master and working molds are made from the models. These molds were critical to the potter's need to produce many items quickly and efficiently and to sell wares promptly for a profit. Commerce, after all, not patronage or artistic exploration, drove the daily operations of the English potter.

Assembling an instructive collection of seventeenth- and eighteenth-century English pottery is a fascinating experience in light of the diversity of technical innovations and style transitions. Among the period manufacturing techniques represented by the collection are hand modeling, wheel throwing, lathe turning, slip casting and press molding. The judicious study of this body of work can provide many insights into the origins of the patterns and shapes that correspond to technological capabilities and social fashion.

The objects illustrated in this article represent an overview of the collection that at present numbers approximately 240 pieces. Several infrequently encountered forms and patterns of English pottery were chosen in the winnowing process. In addition, many of these pieces have never been illustrated elsewhere; most of the rest are shown for the first time in almost thirty years. Taken as a group, the choices promote the charm of handwork that was especially fluent during the middle part of the eighteenth century.

My favorite in the collection to date is a salt-glazed stoneware cream pot that presents a graceful, silver shape with sweeping tripod having one "tapping" foot (fig. 11). The body is highlighted with an added accent of blue

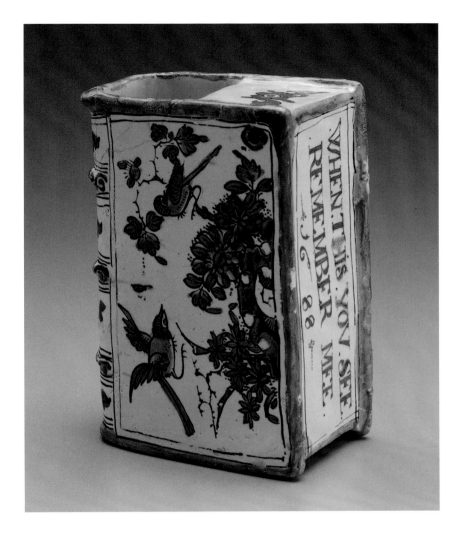

*Figure 2* Hand warmer, probably London, dated 1688. Delftware (tin-glazed earthenware). H. 4⅞". Molded in the style of a book, this object was thought to hold hot water. Inscribed "WHEN THIS YOV SEE / REMEMBER MEE / 1688."

applied relief, a technologically difficult use of colored clay. The circumstance of its coming into the fold is a classic story of collector patience. Initially, I had seen this piece illustrated and I sensed that it was archetypal. Over a twenty-year period, I passed over two other related pieces that did not measure up as well in my mind. One day, an American ceramic dealer's brochure appeared in the mail and amazingly the same little jug was there. I was able to obtain the very pot I had seen published years before. I hope that kind of magic will come again!

*Development of the Collection*
The idea of forming a collection began inadvertently with the purchase of an attractive white salt-glazed deep dish. Within a year, my interests had grown to encompass a fuller array of useful and ornamental pottery. From the outset I perceived that a comprehensive collection might not be possible. Instead, I sought to assemble a representative grouping. If I were to begin today, I would concentrate on English delftware regardless of period. I find delftware refreshing because of its variety of designs, colors, and shapes in a medium easily reflecting the touch of an individual potter or decorator.

*Figure 3* Dish, probably London, ca. 1690. Delftware. D. 8¾". This press-molded dish is of a type made in England and on the Continent. No foot ring is present, often an English feature.

*Figure 4* Mug, attributed to David and John Philip Elers, probably Staffordshire, ca. 1695. Unglazed red stoneware. H. 3⅝". The mug was slip cast and subsequently turned on a lathe. The branch and leaf sprigs were mold applied.

Starting off I ran into the ordinary bumps and bungles. An early visit to a dealer was less than successful when I asked for the wrong thing based on a limited knowledge of the distinction among specific pottery types. After this blunder, the importance of seeing and understanding the subtleties of English pottery wares became one of my lifelong learning experiences. Many dealers and curators were very helpful with the reliable information they passed on to me. The generosity of these dealers led to my acquaintance with specialty libraries in their New York antique shops and I acquired many of the same books for my reference library. Although many volumes written in the early twentieth century are fanciful or outdated, they still contain many unique illustrations that provide important reference material.

Today, archaeologists and researchers provide new discoveries in journals and independent volumes. And the largesse of museum donors and private collectors has made it possible to share treasures in stunning detail with wonderful illustrated books. Great progress has been made in understanding the production, distribution, and use of early English pottery. These clarifications, though, also bring dilemmas to long-term students who are particularly freighted about choosing between old and new mindsets for attributing or dating pottery. So, we now tend to jot down things with pencils having erasers.

I have written a personal-use catalog of the collection that serves as a guide to new acquisitions, records discoveries such as provenance, and integrates findings from recent research. Only this year, a teapot on my initial want list has made it to my cabinet. When the time comes for me to relinquish my stewardship over these wares, there will remain a memory book showing a record of why and how well one collector, on a compressed scale, was able to represent the history and workmanship of a nascent industry.

*Figure 5* Cup, probably Staffordshire, 1690–1700. Slipware, combed or feathered. H. 4". The potter added the unusual "S" pattern in the decoration.

*Figure 6* Dish or charger, probably London, 1702–1714. Delftware. D. 14". Inscribed "A R" for Anna Regina or Queen Anne. The back of this charger has a lead glaze over the tin glaze and a low pedestal foot.

This gamut ranges from splashes and dabs, filling for cast or incised relief, mold-applied blue clay, color dips, and enamel highlights. Enameled scenes and colored ground wares open the door to other opportunities. Later pottery, especially creamware, lends itself to a variety of factory and decorator assignments. The whole realm of parallel designs makes fruitful study, as do regional and site-specific characteristics.

After all is said and done, why pursue collecting? There are several admirable reasons ranging from preservation to education, but from a simple perspective I find it is fun to converge along multiple critical paths reaching a project goal. In other words, it is like connect-the-dots to complete a picture.

I also collect for pleasure, for the aesthetics, and to assuage an inner challenge to piece together a historical puzzle in industrial development. This

*Figure 14* Plate, Bristol, 1740–1760. Delftware. D. 9".

*Figure 15* Plate, London, 1745–1750. Delft-
ware. D. 9". The card motifs are painted in
the reserve area of a dense cobalt "pow-
der" ground.

*Figure 16* Jug, Staffordshire, 1750–1765. Slipware. H. 5½". The checkerboard slip decoration is highlighted with cobalt blue.

*Figure 17* Teapot, Staffordshire, 1750–1760. Salt-glazed stoneware. H. 4⅛". (Ex-collection: Mrs. Eugenia Cary Stoller.)

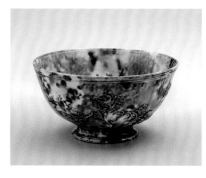

*Figure 18* Bowl, Staffordshire, 1750–1760. Cream-colored earthenware. D. 4½". Mold-applied sprig decoration and underglaze oxide colors. (Ex-collection: Sir Victor and Lady Gollancz.)

*Figure 19* Sauceboat, Staffordshire, 1750–1760. Salt-glazed stoneware. L. 6⅝". After a silver shape, this sauceboat was slip cast and highlighted with dabbed cobalt blue.

*Figure 20* Teapot, Staffordshire, 1755–1760. Colored-body earthenware. H. 4¾"

*Figure 21* Teapot, Staffordshire, 1755–1765. Salt-glazed stoneware. H. 4⅞". The polychrome decoration was enameled over the salt glaze and refired to set the colors.

*Figure 22* Teapot, Staffordshire, 1755–1765. Salt-glazed stoneware. H. 3⅞". (Ex-collection: Mrs. Russell S. Carter.)

*Figure 23* Chimney vase, probably Liverpool, ca. 1755. Delftware. H. 5⅜". This type of decoration is generally referred to as the Fazackerly colors.

*Figure 25* Water bottle, probably Liverpool, ca. 1760. Delftware. H. 8¼". The painted scenes include both Western and chinoiserie images.

*Figure 24* Wall tile, attributed to John Sadler printshop, Liverpool, 1756–1757. Delftware. W. 5". Woodblock print after Nilson of Augsburg.

*Figure 26* Teapot, probably Staffordshire, ca. 1760. Cream-colored earthenware. H. 4¾". A very unusual teapot with mold-applied brown clay and underglaze oxide colors.

is done with an eye to studying and finding quality items of many forms and patterns while insuring they are true and fair representatives of the time. Ultimately, I guess, all is rooted in my engineering proclivity.

I must be careful, however, not to become caught up seeking just those unusually designed or nearly perfectly formed items that are not representative of the period's more typical household objects. The exceptions are those objects associated with marriage, avocation, trade, or political commemoration. It should be remembered that the bulk of the production was probably unadorned and therefore more frequently discarded through passing years. Pristine and/or commissioned works were specialties often destined, like silverware, for ostentatious display in upper-strata homes.

One can read, study pictures, and view objects behind glass. Yet the most significant insights come from lifting and handling many items yourself. Avail yourself of occasions to do so with a compatriot at shops, auctions,

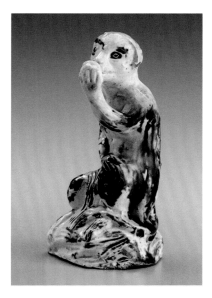

*Figure 27* Monkey figure, Staffordshire, ca. 1760. Cream-colored earthenware. H. 4½". This press-molded figure is highlighted in underglaze oxide colors.

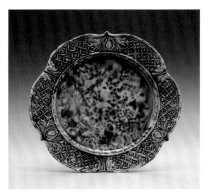

*Figure 28* Plate, Staffordshire, ca. 1760. Cream-colored earthenware. D. 9⅛". A very unusual press-molded plate with underglaze oxide colors.

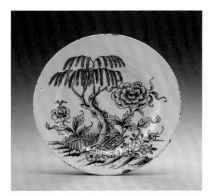

*Figure 29* Plate, Liverpool, ca. 1760–1765. Delftware. D. 8⅝". (Ex-collection: Frederic H. Garner, Moorwood Collection.)

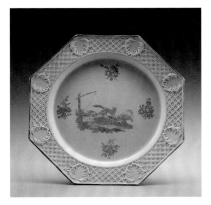

*Figure 30* Plate, possibly Liverpool or Staffordshire, 1760–1765. Salt-glazed stoneware. D. 8½". Three-color transfer print of Aesop's *The Fox and the Goat*. (Ex-collection: Joseph E. Lowy.)

*Figure 31* Teapot, Staffordshire, ca. 1765. Salt-glazed stoneware. H. 3¾". The colors on this pot appear to have been added over the saltglaze and refired with a lead glaze.

*Figure 32* Milk jug, Staffordshire, ca. 1765. Cream-colored earthenware. H. 3½". This press-molded pineapple jug is highlighted with underglaze oxide colors. Similar fragments have been excavated in Williamsburg, Virginia.

*Figure 33* Wall tile, attributed to John Sadler and/or Guy Green printshop, Liverpool, 1764–1775. Delftware. W. 5⅛". Transfer printed after an engraving depicting a Turkish merchant. (Ex-collection: Louis L. Lipski.)

*Figure 34* Teapot, attributed to William Greatbatch, Staffordshire (Fenton), 1770–1782. Creamware. H. 5½". Gilding and enamel decoration of Cybele and Bacchus as satyrs.

and museum reserve areas. You will need to use several of the senses for comparison judgments.

Today, ceramic repair borders on complete re-creation of the object, making handling the wares essential. I can accept mild blemishes, but not eyesores. Small imperfections, however, can reveal insights into technological processes not otherwise detectable. Small chips or uncovered spots, for example, can show the succession of glaze or slip applications.

The acquisition phase of collecting is perhaps the most daunting. Availability and price in the markets can cause serious consternation about whether or not to purchase at the moment. This is surely a longstanding lament among collectors. Through the years there has been only one instance when I felt I found a real bargain. We all hope to repeat similar exciting situations!

All collectors usually have a haunting memory of *the* missed chance. Early on, these lost opportunities happened more frequently to me because

*Figure 35* Dish, probably Staffordshire, 1770–1775. Creamware. L. 9⅜". Transfer-print decoration of Blindman's Buff. The rim border elements are very unusual as each is nonrepeating. Smooth bottom.

initially I was annoyed by chips and hairlines. Later it can be sobering to find one's unrealized purchase in some museum storage area.

One disadvantage of developing an American collection of English pottery is that much of the current research is based on archaeological finds associated with factory sites, which of course are in England. From our once-colonial shores, however, there are now notable revelations about this same microcosm of household ceramics. In fact a considerable profusion of imported examples has been identified from historical records and from items recovered at early domestic American sites.

Finally, I have gathered some advice for newcomers collecting English pottery; namely: (1) refrain from using personal generic names (Astbury, Whieldon, Bowen), (2) use archaeological finds and marked specimens to assign source attributions, because many potters made similar goods, (3) remember that ground color is often more the function of cleanliness of

*Figure 36* Plate, London, dated 1776. Delftware. D. 9". Inscribed "STEPHEN DELL" on front and "1776" on back.

*Figure 37* Cup, possibly Yorkshire (Swinton), dated 1777. Slipware. H. 3". Slip-trailed decoration includes the initials "I S."

*Figure 38* Bowl, London, 1780–1790. Delftware. D. 5⅞". A late example of English delftware. Similar neoclassical decoration was also used on creamware and pearlware.

materials and firing conditions than age or origin, (4) develop and hold, within reason, your own assessments of dating variations among scholars in order to bridge unexplained time gaps, (5) remember that the field is not closed since exciting authentic items do appear, (6) minimize the use of subjective word evaluations (rare, unique, fine), and (7) follow your instincts and be patient in reaching your goals.

*Figure 39* Basket and stand, probably Yorkshire, 1780–1790. Creamware. L. 6⅜". Intended for confectionery or dessert. The detachable stand has a smooth bottom.

*Figure 40* Troy D. Chappell.

## Continued Journey of Thoughts

Have you ever wondered who has held the very same piece that you now own? Between the maker and the last collector those persons are usually anonymous. I try to update provenance on every item, and I keep note card guides to similar examples. Perhaps such searches for satisfying associations are a subtle spur onward for everyone, beyond the value of any newly discovered information about history.

Apart from limited bequests, my accumulated wares will eventually filter down to future ceramic hunters. To record my ownership in the larger chain of the collecting continuum, I have affixed my personal label to those objects in my care. Its design was adapted from the incised border of a salt-glazed stoneware mug.

Because I prefer a variety of different wares, I have chosen to mingle them radically while they are on private display at home. Aside from space considerations, I like the banked effect of mixed textures, colors, and reflections. In imagining a public exhibition of my wares I would add supplementary texts, drawings, and miniature dioramas that would explain potting site layouts, materials preparations, transportation of wares, and differentiation of constructions and functions among firing ovens and kilns. Samples of pot-working tools would also be at hand.

As remarked, there are many approaches and satisfactions when collecting ceramics. I earnestly invite readers to find their own path. In doing so they may develop an enthusiasm as great as my own.

1. Adapted from the definitive, on-going manuscript catalog of the Troy Dawson Chappell Collection, *An English Pottery Heritage—A Survey of Earthenware and Stoneware 1630–1780*.

# New Discoveries

# New Discoveries

## Merry Abbitt Outlaw

*Gather up the fragments that remain, that nothing be lost.*
*John 6:12*

Of all material things, ceramics are among the most important objects to collectors, social historians, potters, art historians, and museum curators. They incite desire for ownership, reveal patterns of past human behavior, inspire creativity, illustrate trends in art, and appeal to aesthetic senses. Because of their wide appeal, it is not uncommon for distinguished ceramic collections, formerly privately owned, to become prominent features of museums and educational institutions.

To historical archaeologists working both in North America and abroad, ceramics are arguably *the* single most important cultural artifact type. Their importance is twofold: first, they are ubiquitous on historic sites and often reveal such significant information for site interpretation as dates of occupation and functional uses of space; and second, because of the rapid evolution of ceramic wares—forms, designs, functions—they are used to document broader patterns of daily life and behavior through time.

It is not surprising, then, that most of the articles in "New Discoveries" are contributions by historical archaeologists working in both the New and Old Worlds. Chronicling a diversity of newly discovered, or rediscovered, vessel shapes and wares ranging in date from the early seventeenth century to the early twentieth century, they include finds of two remarkable American stoneware pottery sites—one near Trenton, New Jersey, and the other near Trenton, South Carolina. The articles are not exclusively archaeological, however. Also reported are such recently discovered antiques as the delft figural salt found during a historical society's collection reassessment and the stoneware punch pot located during a historic house's acquisition program.

From the English Border ware double dish recovered from the first permanent English settlement at Jamestown, Virginia, to the stoneware pottery site in South Carolina, these new discoveries help fill the gaps in our knowledge about ceramics used, manufactured, or discarded in historic America. Like the painstakingly mended ceramics sherds that become nearly complete vessels in the archaeologist's laboratory, these contributions are fragments of our American ceramic heritage, which, when carefully pieced together, contribute to a meaningful whole.

## Charlotte Wilcoxen

## Journey of Discovery: A Retrospective

*Figure 1* Dish, polychrome majolica, Netherlandish, 1620–40. Tin-glazed earthenware with lead glaze on back. D. 10". (Private collection; photo, Gavin Ashworth.)

During the winter of 1970/71 in Albany, New York, the 1624 Dutch fortress, Fort Orange, was partially excavated under the direction of New York state archaeologist Paul R. Huey. The excavation was a salvage project; installation of pylons for a new bridge over the Hudson was planned for the spring of 1971.

Families of Indian traders had lived in the fort, and hundreds of tin-glazed earthenware sherds from their households were recovered. As a collector of Dutch delft, I examined these artifacts and noticed that, in addition to delft sherds whose surfaces were entirely covered by a tin glaze, there were also fragments with a tin glaze only on the obverse side and a transparent lead glaze over a clay slip on the reverse. Paul Huey had noticed this earlier, forewarned to watch for their occurrence by Ivor Noël Hume, the former director of the Department of Archaeology of the Colonial Williamsburg Foundation in Virginia.

I had read about majolica from Antwerp that was entirely tin glazed and of museum quality. These Fort Orange sherds, however, were cruder in design and potting. We needed more information for identification, but found the printed word a language barrier; so I volunteered to travel to the Netherlands and consult Dutch experts.

In Amsterdam, the Dutch ceramics department at the Rijksmuseum was closed for renovations and its director was on leave. Therefore, I went first to the Boymans–van Beuningen Museum in Rotterdam. The curator who met me instantly understood my quandary. She explained that the Fort Orange sherds which were tin glazed on only one side are Dutch majolica

*Figure 2* Dish, blue-painted majolica, Netherlandish, 1610–30. Tin-glazed earthenware with lead glaze on back. D. 8". (Private collection; photo, Gavin Ashworth.)

("j" pronounced as "y"), an earthenware forerunner of delft introduced into the Netherlands around 1550 by the first or second generation Italian potters of Antwerp. Cost-conscious Dutch potters immediately began to copy the majolica, but because tin was rare and expensive, they limited the tin glaze to the front surface. About 1600, Chinese porcelain was imported into Holland and became extremely popular. Dutch potters also copied porcelain forms and decoration, and by about 1660 majolica ceased to be made, except in Friesland. The two earthenware forms are now considered distinct from each other; the majolica has an Italian design tradition (except for one stylized Chinese Wan-li pattern) whereas the delft follows the blue-and-white Chinese decorative style.

The museum's curator and I next proceeded to a large room with tiers of wide, shallow drawers holding sherds. Pointing out the drawers with early-seventeenth-century majolica, she left me alone to study them— perched on a ladder six feet above the floor. Unlike the plow-zone sherds commonly found in North America, these fragments, retrieved from such locations as canal beds or construction sites, were roughly five or six inches square with colorful decorations. The most poignant, however, were those recovered from earth churned up by Germany's terrible World War II bombings of Rotterdam. The sherds exactly duplicated the patterns of those from Fort Orange.

Before returning to the United States, I visited four other museums and talked with the city archaeologist of Amsterdam and with a prominent majolica collector. From my research, I gained priceless insights about

Dutch ceramics. This information was particularly valuable in explaining this delft dichotomy to American archaeologists who, in turn, would determine ethnic influences and chronology.

Since my trip, a number of books and articles on Dutch majolica have been published. Some have English texts or, if Dutch, English summaries. And at least one is bilingual throughout.

Charlotte Wilcoxen

Author of *Dutch Trade and Ceramics in America in the Seventeenth Century*, published in 1987 by the Albany Institute of History & Art (Albany, New York), Charlotte Wilcoxen continues to be actively involved in ceramic research at the age of ninety-five.

SELECT ANNOTATED BIBLIOGRAPHY

Huey, Paul R. "Aspects of Continuity and Change in Colonial Dutch Material Culture at Fort Orange, 1624–1664." Ph.D. diss., University of Michigan, 1988.

Korf, Dingeman. *Nederlandse majolica*. Haarlem: DeHaan, 1981. In Dutch. This book has several hundred illustrations, and with the aid of a Dutch dictionary, the captions are easy to read.

Scholten, Frits. *The Edwin van Drecht Collection of Dutch Majolica and Delftware*. Amsterdam: E. van Drecht, 1993. Bilingual, Dutch and English. A fine and unusual book, this reference has scores of color illustrations and short captions.

Van Dam, J. D. "Geleyersgoet en Hollants porceleyn: Ontwikkelingen in de Nederlandse aardewerk-industrie, 1560–1660." *Medelingenblad, Nederlandse, vereniging van vriended van de ceramiek* 108 (1982): 13–88. In Dutch with an English summary. Occupying the entire issue of this serial publication, this article includes scores of illustrations covering both delft (faïence) and majolica plates.

Wilcoxen, Charlotte. "Dutch Majolica of the Seventeenth Century." *American Ceramic Circle Bulletin*, no. 3 (1982): 17–28.

———. *Dutch Trade and Ceramics in America in the Seventeenth Century*. Albany: Lane Press of Albany, 1987.

Jacqueline Pearce and
Beverly Straube

## The Double Dish
## Dilemma

*Figure 1* Double-wall vessel, Hampshire Surrey Border ware, ca. 1610. Lead-glazed earthenware. L. 9.1". (Object # 850-JR. Association for the Preservation of Virginia Antiquities, Jamestown Rediscovery collection; photo, Gavin Ashworth.)

Through the centuries, clay vessels have been produced in a wide range of shapes and sizes as dictated by the needs of society. While ceramics have been primarily used for processes involved with the preparation, consumption, and storage of food, they have also served to supplement many other aspects of human existence from lighting the dark night to disposal of bodily waste.

The function of most ceramic forms from America's colonial past is readily known through the similarity of forms used in modern times. Early cookbooks, inventories, advertisements, and paintings have also shed light on the functions of different ceramic vessels. But, occasionally, a rare form will surface whose purpose remains elusive. Such is the case with a double dish that was excavated in 1997 from the site of James Fort in Jamestown, Virginia (fig. 1).[1]

The dish was found in a refuse pit with a fill date of circa 1610. It consists of two deep straight-sided compartments.[2] The larger compartment is ovoid in shape and has a horizontal loop handle attached to each of its narrow ends. A slightly shallower, and much narrower, compartment is attached to the front of the vessel. Its base is pierced with a line of four holes, each almost one-quarter of an inch in diameter. This piercing, along with the lower profile of the secondary dish, suggests that perhaps some substance was to spill out of the larger bowl and drain through the smaller. The vessel is glazed only on the interior of the large compartment and over the exterior rim cordoning of both sections.

Although unique in America, the double dish form is known in England where at least twenty-two vessels have been excavated from late-sixteenth- and early-seventeenth-century contexts (fig. 2).[3] There, "they have been variously described as flower vases, and as ecclesiastical Holy Water containers."[4] More recent speculation has considered candle or soap making. None of these explanations are entirely satisfying, as evidenced by the re-

Figure 2 Group shot of double-wall vessels in the collections of the Museum of London. *Counterclockwise from the bottom left:* 79.120/7, London redware, H. 3.9", W. 6.9"; A5352, London redware (shot on side), H. 3.7", W. 6.3"; A5143, London redware (single lobe), H. 2.6", W 6"; A27902, Hampshire Surrey Border ware (BORDG), H. 3.1", W. 5.3". (Courtesy, Museum of London.)

Figure 3 Lid, with view of nude male, London redware, sixteenth/seventeenth century. Lead-glazed earthenware. H. about 3". (A10669. Courtesy, Museum of London.)

cently released glossary of ceramic forms by the Medieval Pottery Research Group. It documents the form as "a rare ceramic form, presumably with a specific function which remains unknown."[5]

None of the vessels show signs of sooting or burning, so the form does not appear to have been used in the warming or cooking of food. All double dishes have a perforated front, or smaller compartment, with anywhere from two to four round holes in the base. Finally, all the known examples are one of two wares: green-glazed Border ware,[6] as is the Jamestown vessel, and a yellow-slipped London redware designated Post-Medieval Slipped Redware Yellow (PMSRY).[7] These were the two mainstream pottery industries that supplied much of London's pottery during the sixteenth and early seventeenth centuries.

Although the main form produced by the two industries remains unaltered, there are some interesting differences between the two products.[8] Unlike the Border ware examples, the redware vessels are crudely made and thickly potted with heavy knife trimming around the base and lower sides. Some have sgraffito decoration in simple geometric patterns arranged along straight and zigzag lines; others display floral or foliate patterns. All double dishes have two handles, although the form varies from vertical and horizontal loops in Border ware to chunky, solid lugs in PMSRY. Finally, there is a PMSRY lid in the Museum of London collection that appears to fit the ovoid shape of the larger compartment (fig. 3). The lid consists of a steeply pitched roof with a gable on each side. Strangely, a naked male figure stands by one gable and a naked female at the other. Is this a clue as to the vessel's possible use? Could it be a ceremonial vessel, perhaps commemorating a betrothal?

The limited late-sixteenth-century through early-seventeenth-century context for the double dish form, as well as its confinement to solely English contexts, suggest that the form is responding to some new cultural development at the end of the Tudor period. It is surprising that no other ceramic industry in the London area made the double dish. One might

expect to see it in delft or in fine redwares from Essex, but perhaps this like-lihood has chronological implications. The double dish form may simply have gone out of vogue by the time these two industries had begun to flourish during the first half of the seventeenth century.

Jacqueline Pearce
Senior Archaeologist
Specialist Services
The Museum of London
<http://www.molas.org.uk/pmpot.html>

Beverly Straube
Curator, Jamestown Rediscovery
Association for the Preservation of Virginia Antiquities
<http://www.apva.org/staff.html>

1. Object # 850-JR. In the collection of the Jamestown Rediscovery of the Association for the Preservation of Virginia Antiquities.

2. The vessel measures 9.1 in. long and 5.1 in. wide overall. The height of the large compartment is 3 in. and the smaller is 2.7 in.

3. Fifteen double dishes have been recognized in the Museum of London collection. At least three of these vessels have been found in Basing House, Hampshire, England (Stephen Moorhouse, "Finds from Basing House, Hampshire," *Post-Medieval Archaeology* 4 [1970]: 50); three are in the British Museum and one is in the Ashmolean Museum, Oxford (Moorhouse, "Finds," p. 51).

4. Moorhouse, "Finds," p. 51.

5. Medieval Pottery Research Group, "A Guide to the Classification of Medieval Ceramic Forms," Occasional Paper No. 1 (London: British Library Cataloging Publication, 1998).

6. Border ware derives its name from its area of production—a number of potting centers situated along the borders of Surrey and Hampshire counties in England. This area was a major supplier of London's domestic earthenware from the late sixteenth century through the late seventeenth century.

7. Post-Medieval Slipped Redware Yellow (PMSRY) is a term applied to white-slipped red-wares, with a clear lead glaze appearing yellow, that were produced in London-area kilns during the sixteenth and early seventeenth centuries. This ware was usually reserved for the more decorative redware forms, whereas the unslipped redwares of the region were produced for the utilitarian kitchen and storage functions.

8. Both types appear to have been made by throwing an open-based cylinder then deliberately deforming it into a roughly subrectangular vessel. The second, smaller compartment would have been made in the same way from a smaller cylinder, then cut across the diameter and luted onto one side of the main dish. A slab of rolled-out clay was cut to the shape of the double-compartmented form, secured to the base, and trimmed to remove excess clay.

*Margaret K. Hofer*

## A Rediscovery at The New-York Historical Society

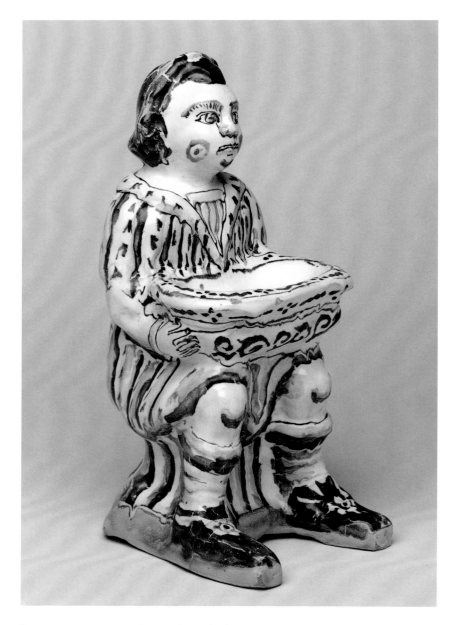

*Figure 1* Figural salt, polychrome decoration, London, dated 1673. Tin-glazed earthenware. H. 7¾". (Courtesy, New-York Historical Society.)

In 1974, an extraordinary figural object was donated to the New-York Historical Society as part of a group of objects passed down through a prominent New York family. Accessioned and erroneously cataloged as a "porcelain seated lady" of questionable date, it was placed in storage. During recent recataloging of the historical society's collections, however, this exciting object was rediscovered and subsequently identified as a rare and important seventeenth-century English delft salt.

Made in London, the salt takes the form of a seated young man, probably a servant or waiter, holding an oval basin (fig. 1). The press-molded figure is wearing a decorative open-necked tunic, stockings, and square-toed shoes, all delineated in cobalt with green highlights. The basin on his lap is decorated with cobalt scrolls and bears the initials "P" over "I S" and the date "1673" (fig. 2). Molded examples of delft were produced in far

fewer numbers than wheel-turned forms, partially because of the coarse clays used by English and continental potters. Surviving delft animal and figural forms are, thus, exceedingly rare.

The historical society's salt, the only one of its type in an American museum, increases the number of known examples to five. Only two others are dated: a 1657 example with candleholders applied to the back of the seated figure,[1] and a 1676 figure that holds a flat, star-shaped tray.[2] The other known examples were made between 1655 and 1680.[3] They are related to Flemish prototypes from the late sixteenth to early seventeenth centuries that were inspired by Italian maiolica. The elaborate form and decorative detail lavished on these figural salts reflects the great value placed on salt as a commodity. Prized as a preservative and a seasoning, salt played a central role in seventeenth-century cuisine and occupied a prominent place on the dining table.

The historical society's example is unique because of its possible American provenance. The salt was a gift from Mrs. Nathaniel McLean Sage on behalf of her friend Lucille de Luze Foley, a descendent of Major General Philip Schuyler (1733–1804). Also included in the bequest of family pieces were several examples of colonial American silver that descended in the Schuyler family. Prominent among the pieces was a footed salver made in New York about the same time as the 1695 marriage of Johannes and

*Figure 2* Detail of date and initials in the basin of the figure illustrated in fig. 1. (Courtesy, New-York Historical Society.)

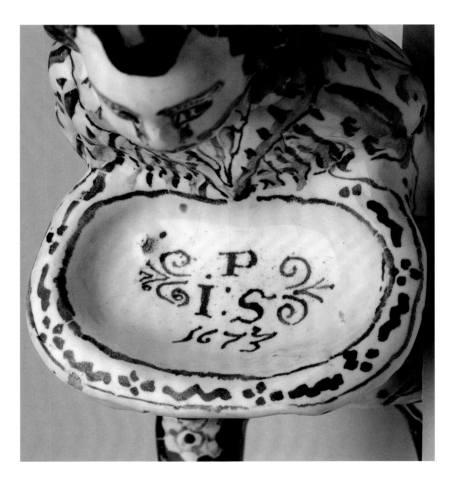

Elizabeth Staats Schuyler. Genealogical research is underway to determine whether the initials in the salt's basin can be linked to a member of the extended Schuyler family.

In November 2000, the salt was placed on permanent exhibition in the historical society's Henry Luce III Center for the Study of American Culture, a newly constructed study facility housing 40,000 fine and decorative arts items from the society's permanent collection.

Margaret K. Hofer
Associate Curator of Decorative Arts
The New-York Historical Society

1. Michael Archer, *Delftware: The Tin-Glazed Earthenware of the British Isles: A Catalogue of the Collection in the Victoria and Albert Museum* (London: Stationery Office, 1997), p. 325.

2. Leslie B. Grigsby, *The Longridge Collection of English Slipware and Delftware*, 2 vols. (London: Jonathan Horne Publications, 2000), vol. 2: 236–37.

3. These examples are recorded in Grigsby, *The Longridge Collection of English Slipware and Delftware,* and in Bernard Rackham, *Catalogue of the Glaisher Collection of Pottery and Porcelain in the Fitzwilliam Museum,* 2 vols. (Cambridge: Cambridge University Press, 1935).

*Taft Kiser*

# Seventeenth-Century Donyatt Pottery in the Chesapeake

Today, largely as a result of the surge of archaeological research in the last three decades, historical archaeologists are readily able to identify most historic ceramic wares. This has not always been the case, however, as evidenced by the example of a slip-decorated redware jug (fig. 1) recovered in 1935 by the National Park Service, Colonial National Historical Park, from a colonial period well at Jamestown Island, Virginia. It was cataloged following its recovery as eighteenth-century American slipware, "probably of local manufacture and representative of the middle eighteenth century."[1]

Recent archaeological research in the Chesapeake has discovered similar types of pottery in seventeenth-century contexts. These discoveries, along with consultation with English ceramic specialists, have helped to attribute these wares as products of the Donyatt potting region.[2]

Located about ten miles southeast of Taunton, England, Donyatt lies in a well-known potting area, with competing kilns including Chard, Honiton, and Wrangway. Donyatt was the largest, burning its first pots in the eleventh century and continuing until the 1930s. Early postmedieval potteries typically had small distribution areas, but Donyatt's advantageous location allowed its wares to reach the ports of Bristol, Plymouth, Exeter, and Lyme Regis.[3]

Donyatt potters produced many elaborate forms such as puzzle jugs, but much of the production was utilitarian, with a plain lead glaze. By 1600, they used splashes of copper oxide green to color their wares.

Potters also began producing sgraffito slipwares by 1600. The earliest examples are decorated with simple patterns of incised lines. The decoration became more elaborate through time, as demonstrated on a circa 1666–1690 bottle decorated with birds and letters from St. Mary's City, Maryland.

Wet-sgraffito decoration, made by brushing a light slip on a darker, wet clay body, is the most common type of sgraffito on Chesapeake examples.

*Figure 1* Jug, Donyatt, England, 1600–1650. Lead-glazed earthenware. H. 9". Catalog no. Colo-J-7584. (Courtesy, National Park Service, Colonial National Historical Park; photo, Gavin Ashworth.)

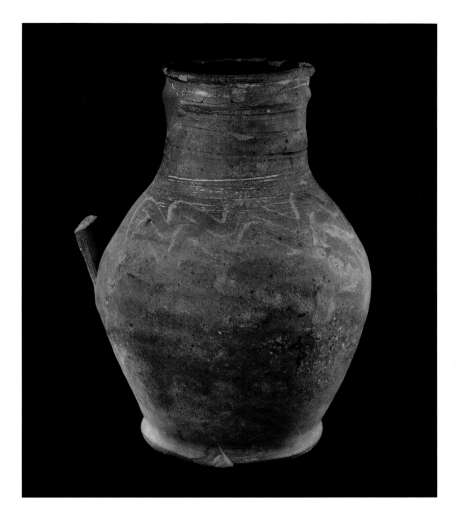

A comb or stick was then incised through the wet slip revealing the clay body beneath. Even the potter's fingers were sometimes used to create some of the wet sgraffito designs.

Donyatt potters also employed simple slip-trailed devices to decorate their products, such as a spiral spinning out from the center of a dish, which was common from circa 1630 to 1720. As well, sgraffito decoration was sometimes used in combination with slip trailing.

A total of thirty-three Donyatt vessels have now been identified from seventeen sites in the Chesapeake region. The earliest example is from a circa 1620–1622 context at Martin's Hundred and the latest from circa 1765 at Williamsburg. Shapes represented in the Chesapeake include dishes, bowls, jugs and jars, one bottle, and one chafing dish, and most are slip decorated with one of the distinctive slip techniques employed by the Donyatt potters.

And what of the redware jug in the museum collection of the National Park Service at Jamestown? In the early 1990s, while examining the pottery collection at Jamestown, curator Beverly Straube spotted the "eighteenth-century American jug." Familiar with the wares of the Donyatt potters, she immediately recognized its misclassification. In a momentary glance, almost

four centuries of history came full circle with the reclamation of the jug's rightful heritage. The latest catalog entry correctly identifies it as Donyatt slipware, circa 1600–1650.

Taft Kiser
Historical Archaeologist and Ceramic Specialist
<agoode@erols.com>

1. John L. Cotter, *Archeological Excavations at Jamestown, Virginia* (Washington, D.C.: Government Printing Office, 1958), pp. 70–74, pl. 78. Although shown in pl. 78 with seventeenth-century slipware, it is identified as eighteenth-century American in the text on p. 70.

2. Richard Coleman-Smith and Terry Pearson, *Excavations in the Donyatt Potteries* (Chichester, Eng.: Phillimore & Co. Ltd., 1998); John P. Allan, *Medieval and Post-Medieval Finds from Exeter, 1971–1980* (Exeter: Exeter City Council and the University of Exeter, 1984), p. 135.

3. Coleman-Smith and Pearson, *Excavations*, pp. 401–402.

## Robert Hunter and George L. Miller

## All in the Family: A Staffordshire Soup Plate and the American Market

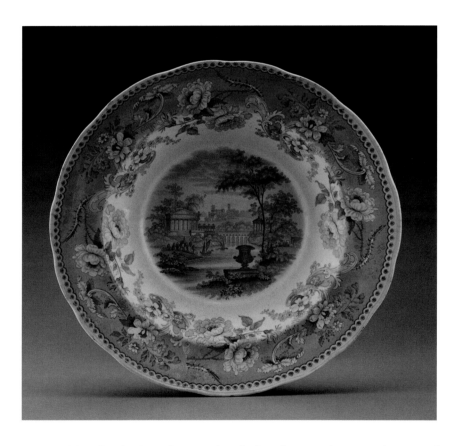

*Figure 1* Soup plate, Florentine Villas pattern; Job and John Jackson, Burslem, ca. 1830. White earthenware. D. 10". (Private collection; photo, Gavin Ashworth.)

Competition for the American market during the years between the War of 1812 and the Civil War was fierce among England's Staffordshire potters who dominated the ceramic trade. Struggling to find new commerce, the potters took advantage of the lull between American military conflicts by shipping wares on consignment—and glutting the American market. Above and beyond what American importers had ordered, the abundance of wares had a backlash effect. In a market where supply was greater than

demand, ceramic prices fell dramatically. For example, the trade discount from the standard Staffordshire pricing agreement jumped from 25 percent in 1816 to 45 percent by the 1840s.[1]

In an effort to best their competitors, the Staffordshire potters introduced hundreds of new designs with the hope of finding one that would become popular. So eager were they to gain an edge, they even copied each other's successful patterns.[2]

The recent identification of two artifacts provides a firsthand look at the jockeying for position in the Staffordshire empire. The artifacts—a simple blue-and-white soup plate and an American-bound letter—tell the story of intense rivalry not only among potters but also among kinsmen vying for the lucrative favor of the American merchants.

The ten-inch soup plate manufactured by Job and John Jackson of Burslem, England, is printed in the light blue version of Florentine Villas, a commonly produced pattern in the 1830s.[3] Less common, however, is the underglaze inscription on the plate's reverse. The inscription reads:

<div align="center">

PRESENTED TO<br>
J. Greenfield Esq<sup>r</sup>.<br>
as a small<br>
TESTIMONY OF ESTEEM<br>
from his friends<br>
JOB & JOHN JACKSON

</div>

At first glance, this modest remembrance appears to be nothing more than a friendly gesture from the Jackson brothers to Mr. John Greenfield,

*Figure 2* Detail of the printed inscription on the reverse of the soup plate illustrated in fig. 1. (Photo, Gavin Ashworth.)

a well-known ceramic importer operating out of New York City. When coupled with a letter that has reemerged almost 170 years after it was posted, however, it takes on a more sinister slant.

Potters James and Ralph Clews of Cobridge, England, wrote the letter to New York merchants Ogden, Ferguson & Co., colleagues of Mr. Greenfield, to complain about the shady business practices of their nephews, Job and John Jackson.[4] The Clews wrote:

> Cobridge, 31st December 1830
> To Messrs Ogden, Ferguson & Co.
>
> Dear Sirs
>
> It is now a length of time since we had thy pleasure—and our motive in now writing you is we are informed that one of our nephews [the Jacksons] are leaving thus[?] Per the Packet Ship of tomorrow for New York purposely to establish a connexion [sic] in our line of business—they have been in our Manufactory under our bringing up, consequently all well acquainted with the names of all our customers, and to our very great surprise and disgrace have sent to each [or] nearly so small consignments of their ware to introduce it. We are not afraid of their doing us harm as they are of no extent. About 25£ to 30 is all they can make weekly. And what business they have to go with the America Trade astonishes us much.
>
> It is not at all improbable that he may make use of our name to the Dealers as a passport to introduce himself to their notice, therefore should this be the case be good enough to apprize them that their [sic] is no connexion [sic] betwixt us in anyway; when we have no doubt they will act accordingly. We regret exceedingly that our Spring orders already received are not more extensive, but hope we shall very shortly have a further supply. We have had the pleasure of a visit from your Mr. Ogden whose personal acquaintance we were very much please to make and the arrangements we have made, in conveying on our future business we are induced to think will be the means of keeping us going with a plentiful supply of orders. How is it Messrs Greenfield have been doing, so little of late, and as yet we have not our spring order from Mr Garretson—or Messrs Webb—but hope shortly to receive both.
>
> Wishing you the Complements of the Season—requesting to kindly remembered to your Mr. Jno. Ogden Junr.
>
> > Believe us
> > > Dear Sirs
> > > > Yours very Truly
> > > > > R. & J. Clews

As detailed in their letter, the Clews brothers were incensed that the Jacksons had absconded with their American customer list. The Clews also were aware that their nephews had sent an introductory consignment of their own products to some of the Clewses' most important clients. Clearly, John Greenfield was an important customer for the Clews brothers; examples of their wares survive bearing "J. Greenfield" importer marks.[5]

The inscribed soup plate reflects the well-calculated attempt by the Jacksons to woo John Greenfield away from their uncles' business. "We are not afraid of their doing us harm as they are of no extent," assured the Clews.

Brave words, perhaps, from potters whose rise to or fall from fortune depended heavily on the patronage of merchants more than three thousand miles and a continent away. Unfortunately, the Jacksons' collusion apparently had already taken its toll, as the Clewses' letter also laments: "How is it Messrs Greenfield have been doing, so little of late, and as yet we have not our spring order from Mr. Garretson—or Messrs Webb."

The long-term success of the Jackson brothers in soliciting the business of their uncles' customers appears to be moot, however. As indicated by the records of the *Staffordshire Advertiser,* both Jackson brothers are listed as bankrupt by 1835. The uncles, James and Ralph Clews, did not fare any better. They declared bankruptcy for a second time in 1834.[6] Perhaps these lessons helped James Clews decide that it was better to switch than fight. By 1836 he had come to America to establish a new earthenware pottery in Indiana.[7]

ACKNOWLEDGMENT

The authors wish to thank Nancy Dickinson for her research with the Clews correspondence.

Robert Hunter
Editor, Ceramics in America
<CeramicJournal@aol.com>

George L. Miller
Historical Archaeologist
URS Corporation
<george_miller@urscorp.com>

1. For a summary of English ceramic price history, see George L. Miller, "A Revised Set of CC Index Values for Classification and Economic Scaling of English Ceramics from 1787 to 1880," *Historical Archaeology* 25, no. 1 (1991): 1–25.

2. For example, Ralph and James Clews had an agent in America who would purchase examples of their competitors' wares that were selling well and ship them back to Staffordshire for the Clews brothers to have copied. In 1833, they wrote a letter asking their agent to send a plate of the latest Ridgway pattern if he thought it worth copying. This practice is described in George L. Miller, Ann Smart Martin, and Nancy S. Dickinson, "Changing Consumption Patterns: English Ceramics and the American Market from 1770 to 1840," in *Everyday Life in the Early Republic,* edited by Catherine E. Hutchins (Winterthur, Del.: Winterthur Museum, 1994), p. 232.

3. This soup plate was illustrated in the *The Transfer Collector's Club Bulletin* (Spring 2000).

4. The New-York Historical Society, Record Group 1420, Ferguson & Day and Successors, Merchants in New York City, commission merchants, 1796–1849. Ca. 100 feet of documents. 1820–1825: Ogden, Day & Co.; 1825–1841: Ogden, Ferguson & Co.; 1825–1841: Jonathan Ogden.

5. Ellouise Baker Larson, *American Historical Views on Staffordshire China* (New York: Dover Publications Inc., 1975), p. 58, lists the following mark on a Clews table service of the Landing of Lafayette at Castle Garden New York, August 1824 pattern: "J. GREENFIELD'S / CHINA STORE / NO. 77 PEARL STREET / NEW YORK."

6. Rodney Hampson, "Pottery References in Staffordshire Advertiser 1795–1865," *Northern Ceramic Society Occasional Publication* no. 4 (2000), 29, 66.

7. See Diana and J. Garrison Stradling, "American Queensware—The Louisville Experience, 1829–37," in this issue of *Ceramics in America.*

## Carl Steen

## Industrial Pottery in the Old Edgefield District

The Edgefield-Aiken area of South Carolina is well known for its large-scale production of unique and beautiful alkaline-glazed stoneware. Yet, despite easy access to one of the world's largest and purest deposits of high-grade kaolin, the area's industrial production of refined earthenware and porcelain never fully developed. Two nineteenth-century industrial pottery operations did exist, however, and have been the subject of recent research.[1]

The first, the Southern Porcelain Company, was near Bath, South Carolina. The Southern Porcelain Company was first noted in the literature by Edwin AtLee Barber[2] and most recently studied in detail by ceramic historian Garrison Stradling.[3] Potters and businessmen associated with the U.S. Pottery Company in Bennington, Vermont, established the Southern Porcelain Company in 1856. Using northern workmen and managers, they made a variety of wares, including plain white and cream-colored earthenware, high-fired ironstone, porcelaneous stoneware, true porcelain, and Rockingham-type wares. In addition, they produced alkaline-glazed stoneware, porcelain insulators, and firebrick. The factory continued in operation until 1864, when a fire reduced it to rubble.

Examples of the marks used and wares produced at Southern Porcelain are shown in figure 1. Made available for study by a local collector, sherds from the site were analyzed in the summer and fall of 2000.

*Figure 1* Southern Porcelain Company marks. Top: "S.P. Company/Kaolin/ eagle/S.C." in a shield. Note the hand inscribed "X" on each sherd. *Bottom:* (*Left*) Very light mark "S.P./Company/ eagle/Kaolin/S.C." in a diamond-shaped cartouche. (*Center*) "S.P./Company/ Kaolin/S.C." in a shield. (*Right*) Four lines of print, but only one is legible: "S.C." The latter is alkaline-glazed stoneware while the others are biscuit. (Courtesy, Diachronic Research.)

The other, lesser-known, nineteenth-century industrial pottery was the South Carolina Pottery Company located about ten miles away from the Southern Porcelain Company at Miles Mill near the Edgefield-Aiken border. In 1885 the *Aiken Journal and Review* noted that "Messrs. Craig of New York, Jervey of Charleston, and Cahill of Edgefield" had established a pottery for the manufacture of "chinaware and porcelain." The newspaper went on to say that Mr. Craig was "fully informed in all the details of the

*Figure 2* "S.C.P.Co." mark on biscuit from the kiln. South Carolina Pottery Company. (Courtesy, Diachronic Research.)

business, having spent ten years in China." The pottery appears to have been in operation until 1887—only about two years.

Limited archaeological excavations at the site in 1995 revealed that Craig and his workers made Rockingham-type earthenware and Victorian majolica as well as yellowware, whiteware, and stoneware. Examples of pitchers, bowls, cups, plates, and other forms were found. Most were slip cast and showed some type of molded decoration. A single marked example was found—a bowl that carries the mark "S.C.P. Co." (fig. 2). As Mr. Stradling pointed out, this mark has been mistaken for the Southern Porcelain Company's "S.P.Co." mark more than once.

Several antique vessels produced by the company have been identified over the past few years, some of which match biscuit-fired sherds found at the site. One parallel is a molded bowl with a rusticated wood grain exterior and a single rose branch on the side (fig. 3). It is marked on the base with "S.C.P.Co."

*Figure 3* Majolica bowl with rose, and biscuit example from the site, marked "S.C.P.Co." South Carolina Pottery Company. (Courtesy, the Ferrell Collection.)

Another match found is a commemorative plate inscribed "Merry X-Mas and Happy New Year" in a plaque centered on an elaborately decorated background (fig. 4). Yet another plate, an antique owned by a local collector, is glazed and decorated with majolica-type splashes of brown, blue, and green. It is interesting to note that this example also exactly matches one made at about the same time at the Eureka Pottery, in Trenton, New Jersey, which itself was a copy of a Wedgwood pattern.[4]

Collected by a local resident, a biscuit-fired Rebekah at the Well teapot is marked "31/FIREPROOF." The fireproof mark has been found in many contexts, including the J. Mayer Pottery of Trenton, New Jersey. Presumably Mr. Craig obtained his molds and supplies, and, perhaps, his training there.

The South Carolina Pottery Company stoneware jugs are wheel thrown, glazed with a smooth feldspathic slip glaze in white—a classic Bristol-type glaze—and cinnamon brown. The jugs are wide rimmed, angular shouldered, and cylindrical bodied. A continuous line of impressed circles marks the top of the shoulder and the upper body. The vertical handles are attached at the neck just below the rim and to the shoulder. These jugs are distinctly different in form, decoration, and glaze from the wares of other local potters.

It is surprising, then, that none of Craig's wares have been identified in archaeological contexts elsewhere in the state. This gap may result because of the difficulty in distinguishing his products—particularly the seldom-marked yellowware, whiteware, and Rockingham-type ware—from those that were made extensively elsewhere. The stonewares made at this site are distinctive, though, and should be easy to identify.

Similarly, recognizable products of the Southern Porcelain Company, which was in business much longer, are few. And none have been identified

in domestic archaeological contexts, possibly due to the lack of comprehensive study of both these potteries. With further excavations and analyses, perhaps some headway can be made in attributing unmarked wares, and these two doomed attempts at industrial activity in the ultra-agrarian South will be better understood.

ACKNOWLEDGMENT

The author thanks Steve and Terry Ferrell for allowing him to photograph vessels in their collection and Gary Dexter for serving as a go-between and obtaining marked Southern Porcelain sherds for photography.

Carl Steen
President
Diachronic Research Foundation

1. Carl Steen, *An Archaeological Survey of Pottery Production Sites in the Old Edgefield District of South Carolina* (Columbia, S.C.: Diachronic Research Foundation, 1994).

2. Edwin Atlee Barber, *The Pottery and Porcelain of the United States* (New York: Feingold and Lewis, 1904).

3. J. Garrison Stradling, "The Southern Porcelain Company, S.C.: A Reassessment," *Journal of Early Southern Decorative Arts* 22, no. 2 (1996): 1–39.

4 Marilyn Karmason and Joan Stacke, *Majolica: A Complete History and Illustrated Survey* (New York: Harry M. Abrams, 1989), p. 189.

*Mark M. Newell*

A Spectacular
Find at the Joseph
Gregory Baynham
Pottery Site

In the fall of 1997, the Georgia Archaeological Institute (GAI) in Augusta began the second phase of a program to reevaluate certain nineteenth-century pottery sites within South Carolina's Old Edgefield District. Pottery production in this area had started at the turn of the nineteenth century.[1] The Edgefield potters characteristically used wood ash to make alkaline glazes that produced spectacular effects and colors on their vessels, many of which were further enhanced with sgraffito and kaolin slip-trailed decorations. The alkaline-glaze tradition died out shortly after the turn of the twentieth century.

One pottery site examined near Trenton, South Carolina, was operated by Joseph Gregory Baynham. Earlier research suggested that Baynham was not part of the Edgefield alkaline-glaze tradition and had arrived in the area in 1900 from Ohio.[2] However, subsequent family[3] and collector interviews[4] and archival research conducted by GAI indicated that Baynham had come to the area in 1865 and was well known for both alkaline glaze and Albany slipwares.

The site was resurveyed by GAI in the summer of 1997 and archaeological testing quickly confirmed that Baynham not only occupied the area in the 1870s but had built his operation on top of an older pottery operated by Lewis Miles and his son John. Prior to the survey, it had been generally accepted that in thirty years of collector interest, all of the known Edgefield pottery sites had been significantly disturbed by amateur researchers and

so-called pot hunters. Thus, the discovery of intact vessels on the site was not expected.

One test unit, excavated close to a series of mounds, was thought to represent the remains of a ground-hog kiln. A two-inch layer of humus was removed at the location by archaeologist Nick Nichols. But instead of finding soil, Nichols encountered an intact three-gallon stacker jug. Carefully removing the jug so that testing could continue, Nichols then discovered that more three-gallon stacker jugs lay beneath and on all four sides of the first find.

*Figure 1* Seven-meter trench opened up over seventeen-meter feature showing grid installation. (Courtesy, Georgia Archaeological Institute.)

*Figure 2* Detail of a single grid unit showing partially excavated vessels.

*Figure 3* A sample of recovered vessels. *Back row:* (*Left*) Three-gallon ovoid jug. H. 15⅕". Stoneware with alkaline ash run glaze. (*Center*) Five-gallon two-handled ovoid jug. H. 17". Stoneware with alkaline glaze. (*Right*) Three-gallon ovoid jug. H. 15⅕". Stoneware with alkaline glaze. *Front Row:* (*Left*) One-quart stacker jug with alkaline glaze. H. 8¼". Note the root growing through handle loop. (*Right*) One-quart stacker jug. H. 8⅓". Stoneware with Albany slip glaze. This neck style is attributed to Thomas Hahn, son of W. F. Hahn. All vessels circa 1883–1889.

Work elsewhere on the site was called to a halt as a larger two-meter by seven-meter area was cleared. Eventually more excavation exposed the entire feature, a sixteen-meter-long gully running roughly from north to south that had been filled with intact jugs (fig. 1). Excavation of the feature's upper section, consisting of five layers of vessels ranging in size from one quart to five gallons, was completed in the winter of 1997; the lower section, during the 1998–1999 season (fig. 2).

Vessel styles included stacker jugs, round-shouldered "beehive" jugs, and transitional, slope-shouldered stacker jugs (fig. 3). In addition, poultry fountains, churns, preserve jars, deep bowls (commonly called cream risers), and spectacular three- and five-gallon ovoid vessels were found. A number of South Carolina glass dispensary bottles and patent medicine bottles were recovered as well.

*Figure 4* One-quart stacker jug stamped "MARK." Mark Baynham, 1883–1889. H. 8¼". Stoneware with alkaline glaze. A cylindrical neck is a diagnostic of this potter.

*Figure 5* Three-gallon, single-handled, ovoid jug, ca. 1883–1889. H. 15". Stoneware with alkaline glaze. This neck style is attributed to Thomas Hahn.

In all, a total of 674 intact vessels were excavated. An additional 100 vessels were represented as sherds that will eventually be reassembled. GAI, a private research foundation with mostly volunteer staff, continues to catalog and analyze the finds. A final report has been produced, and some preliminary statements can now be made.[5]

Based on the presence of the tightly datable dispensary bottles and other documentary evidence, it appears that the gully was filled with rejected vessels made between 1883 and 1889. Vessel styles have also helped identify four particular potters: Mark Baynham (fig. 4) and Horace Baynham, both sons of the owner, and W. F. Hahn and his son Thomas L. Hahn (fig. 5).

Analysis of the vessels confirmed that ovoid, beehive, and stacker forms were all being made concurrently, contrary to the belief that the ovoid and beehive forms were earlier in tradition than the stacker jugs. Other evidence from the site shows that the use of alkaline glazes extended well into the twentieth century. It was also apparent that there was no clear-cut transition from locally-made alkaline glazes to commercially-made slip glazes. Many vessels demonstrated that both types of glazes were used at the same time.

Most intriguing, preliminary analysis has produced a large number of vessels with identifiable fingerprints in the glaze on bases and handles. Nichols is now collecting data on the fingerprints with the help of a protocol developed by the Savannah Police Department. He hopes to match prints taken from other area sites.

As full statistical analysis nears completion, indications are that it will throw new light on the production of the Joseph Gregory Baynham pottery. Expectations are high that evaluation of the data will also provide a unique glimpse into the day-to-day work of four well-known Edgefield potters.

Mark M. Newell, Ph.D.
Director
Georgia Archaeological Institute
<mmnewell@yahoo.com>

1. Catherine W. Horne, ed., *Crossroads of Clay* (Columbia, S.C.: McKissick Museum, University of South Carolina, 1990).

2. George Castille, Carl Steen, and Cinda Baldwin, *An Archaeological Survey of Alkaline Glazed Stoneware Production Sites in the Old Edgefield District* (Columbia, S.C.: McKissick Museum, University of South Carolina, 1988); and Carl Steen, *An Archaeological Survey of Pottery Production Sites in the Old Edgefield District of South Carolina* (Columbia, S.C.: Diachronic Research Foundation, 1994).

3. Nancy Baynham, *Baynham, A South Carolina Family* (Augusta, Ga.: Hamburg Press, 2000).

4. Mark Newell and Nick Nichols, *The Riverfront Potters of North Augusta* (Augusta, Ga.: Georgia Archaeological Institute, 1998).

5. Mark Newell, *Joseph G. Baynham: A Re-Evaluation of 38ED221* (Augusta, Ga.: Georgia Archaeological Institute, 2000).

*Figure 1* Ceramics recovered from Burslem Market Place excavation: teapot, dark blue printed pattern; egg cup, Sicilian pattern; sugar bowl, Cupid Holding a Tazza to a Swan pattern; Enoch Wood & Sons, Burslem, Staffordshire, ca. 1835. White earthenware. (Courtesy, Potteries Museum & Art Gallery.)

## Catherine Banks

## Enoch Wood Ceramics Excavated in Burslem, Stoke-on-Trent

During excavations on the site of Burslem Market Place in 1998, a large deposit of early-nineteenth-century pottery was recovered. It was quickly recognized as an assemblage of wares made by the well-known factory of Enoch Wood & Sons.

Ceramics recovered from the site include printed wares decorated with a variety of designs: European Scenery, English Cities, Cupid Holding a Tazza to a Swan, Fountain, Venetian Scenery, Pagoda, Oberwessel on the Rhine, and La Fayette at the Tomb of Franklin (figs. 1, 2). The assemblage also contained dark blue-painted tea wares (fig. 3) and polychrome-painted and -printed wares (fig. 4), including previously unidentified printed and painted decorations. Also found were lusterwares; industrial slipwares with mocha, cat's eye, trailed, cable, and banded decoration; shell-edged and embossed-edged tablewares; and sanitary ware.

Born into a family of potters in 1759, Enoch Wood was an extremely successful pottery manufacturer. He ran his business from the Fountain Place Works in Burslem built in 1789, just a few hundred yards up the road from the excavation site. A substantial potworks, it was described in 1829 as encompassing "the sites of five old factories,"[1] and in the 1830s as employing some thousand workers.

It is believed that the recently discovered Market Place deposit of Wood's pottery is a cache that was deliberately buried about 1835–1836, prior to the building of a new meat market. Many complete and near-com-

*Figure 2*  Plate, European Scenery pattern; Enoch Wood & Sons, Burslem, ca. 1835. White earthenware. Scale is in centimeters. (Courtesy, Potteries Museum & Art Gallery.)

*Figure 3*  Blue-painted cover and cup sherds; attributed to Enoch Wood & Sons, Burslem, ca. 1835. White earthenware. Scale is in centimeters. (Courtesy, Potteries Museum & Art Gallery.)

plete pieces were found, some of which seem to have been deliberately placed under upturned toilet bowls, indicating that it was a cache rather than just a pottery dump.

This is not the first known incidence of a cache of Enoch Wood's wares being unearthed in Burslem. In 1938, a deposit of figures was found in a workman's trench outside the town hall, and in 1974, a large cache of earthenwares was discovered in the foundations of St. Paul's Church during its demolition.[2] The St. Paul's deposit included dark blue-printed wares made

specifically for the American market, with scenes of Gilpin's Mills on the Brandywine Creek and Catskill House, Hudson, as well as those from the French Views series and the English Cities series. Also recovered from the site were painted wares, lusterwares, and figurals.[3]

During construction work in Burslem, Wood regularly recovered old pottery that he then displayed in his factory museum to inspire his workers.[4] This predilection, combined with his keen interest in antiquities, probably led him to bury caches of his ceramics all around town.

Described in 1843 as being employed in the manufacture of earthenware of every variety, Enoch Wood & Sons was reckoned to be among "the largest exporters of that article from Staffordshire to the United States of America."[5] The factory had commercial links with merchants in the United States. In 1844 to 1845, three businesses, including Enoch Wood, Jr., were listed at 97 Water Street in New York City as conducting the American trade of Enoch Wood & Sons of Burslem.[6]

Catherine Banks
Museum Officer (Archaeology)
The Potteries Museum & Art Gallery
Hanley, Stoke-on-Trent STI 3DE
<www.stoke.gov.uk/museums>

1. Simeon Shaw, *History of the Staffordshire Potteries* (1829; reprint, Newton Abbot, Devon, England: David & Charles, Ltd. and Wakefield, Yorkshire, Eng.: S. R. Publishers Ltd., 1970), p. 30.

2. The pottery recovered from these sites is in the ceramics collection at the Potteries Museum & Art Gallery, Stoke-on-Trent.

3. St. Paul's Church was built in 1828. It may have been Enoch Wood's fault that the church

had to be later demolished, as it has been suggested that the cache of ceramics buried under the foundations had made the structure unstable.

4. Miranda F. Goodby, "The Lost Collection of Enoch Wood," *Journal of the Northern Ceramics Society* 9 (1992): 123–151.

5. John Ward, *The Borough of Stoke-on-Trent* (1843; reprint, Hanley, Stoke-on-Trent, Eng.: Webberley Ltd., 1984), p. 264.

6. Neil Ewins, "Supplying the Present Wants of our Yankee Cousins, Staffordshire Ceramics and the American Market 1775–1880," *Journal of Ceramic History* 15 (1997): 90.

*Joyce Geary Volk*

# A Warner House Search...

*Figure 1* Photograph of Eveline Sherburne (1839–1929) taken around 1927 by her great-nephew, Sherburne Klein, in the parlor of the Warner House, Portsmouth, New Hampshire. (Courtesy, Warner House.)

*Figure 2* Detail of the punch pot in the ca. 1927 archival photograph illustrated in figure 1. (Courtesy, Warner House.)

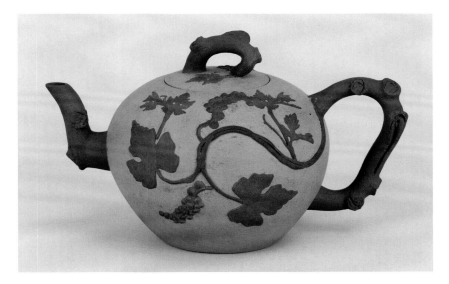

*Figure 3* The replacement punch pot, possibly Yixing, ca. 1780. Unglazed stoneware. H. 6½". (Photo, Craig McDougal.)

The photograph shows the eighty-eight-year-old Eveline Sherburne seated in the parlor of the Warner House, Portsmouth, New Hampshire, around 1927 (fig. 1). She and her nephew, only seven years younger, were the last family descendants living in the 1716–1718 house. After their deaths in 1929 and 1930, it was sold by their heirs and became the Warner House Association, opening to the public as a historic property in 1932.

In front of Miss Sherburne is a card table with a punch pot prominently placed at its center (fig. 2). The 1930 probate inventory lists the piece as "1 Terra Cotta Tea Pot, grapevine band, and cover." As we were interpreting the parlor to the period of 1900 to 1930, we were anxious to find this pot, or a close duplicate, to display there. We broadcast our search in several ways, and one resulted in success. Carl Crossman, a good friend of the

Warner House, was shown the archival photograph and, with his amazing visual memory, reported to us in February 2000 that he had seen a very similar example in a dealer's shop. We contacted the dealer; he sent photographs, we agreed on the price, and the punch pot (fig. 3) is now happily residing on the correct table (another recent purchase) in the parlor. The match is not exact, but certainly close enough to meet our constant attempts to be historically accurate.

## Louise Richardson

## ...And the Find!

The punch pot acquired by the Warner House is buff-colored stoneware with applied decoration. It has an unglazed mat surface and was fired at a high temperature that rendered the body impervious to liquids.

The pot's greatest height is 6½"; its greatest width, 11". With the exception of a repaired handle, minor wear on the base, and tiny chips on the spout tip and cover, it is in excellent condition.

Its handle, spout, and finial are formed in red clay as the pruned woody stems of grapevines. The decoration consists of a trail of leaves and bunches of grapes sprigged on, and vines made of rolled clay that circle the diameter of the pot.

Although similar pots were made in the eighteenth century in both China and England, the Warner House acquisition appears to be of Chinese manufacture. Buff-bodied stoneware from England is rare, though some sherds have been recovered from the William Greatbatch site.[1] Most revealing is a distinct ridge on the interior shoulder of the pot corresponding to a faint line on the exterior that may be a result of the slab construction used by Chinese potters.

ACKNOWLEDGMENT
We would like to thank Carl Crossman for his educated eye.

Joyce Geary Volk
Art Historian and Consultant
Curator, Warner House Association

Louise Richardson
Board Member, Warner House Association
Past President, China Students Club of Boston

1. Diana Edwards and Rodney Hampson, *English Dry-Bodied Stoneware* (Woodbridge, Suffolk, Eng.: Antique Collectors' Club, 1998), p. 53.

## Richard Hunter

## Eighteenth-Century Stoneware Kiln of William Richards Found on the Lamberton Waterfront, Trenton, New Jersey

In May 2000 an eighteenth-century stoneware kiln was discovered on the banks of the Delaware River in Lamberton, New Jersey, the port community of the state's capital, Trenton. This rare find occurred during the reconstruction of New Jersey's Route 29 along the riverbank. Earthmoving machinery grading the road bed exposed a large void that turned out to be the remains of a brick firebox at one end of a kiln (fig. 1). Under archaeological monitoring conditions, specified by a memorandum of agreement and written into the contractor's work specifications, the New Jersey Department of Transportation made provision for a ten-day emergency excavation by the project's archaeological consultant, Hunter Research, Inc. This action enabled the kiln to be exposed and recorded, and a sample of wares and kiln furniture to be recovered.

Documentary references make mention of a stoneware pottery operating in Lamberton in the 1770s, but the precise location of this facility remained unclear until this find. The pottery is securely linked to William Richards, a Philadelphia merchant with fishing and commercial interests in the

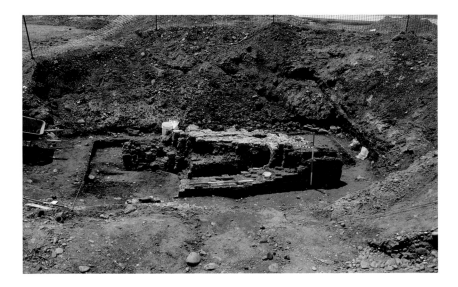

*Figure 1* Side view of the Richards stoneware kiln on the Delaware River waterfront in Lamberton, New Jersey. Scales are in feet and inches. (Courtesy, Hunter Research, Inc., Trenton, New Jersey.)

Delaware Valley, who was leasing property in Lamberton by 1765. In 1774, a newspaper advertisement placed by Richards notes his having erected a manufactory at Lamberton, about a half mile below Trenton, for making the useful Dutch stoneware and sand crucibles.[1] He also had acquired a new boat to service his Lamberton commercial interests, presumably to bring in raw materials and ship out finished products. In 1778, Richards advertised for a potter who knew how to make stoneware, indicating that he was hiring craftsmen to produce his line. The pottery probably ceased operation around the time of Richards's death in 1787.

The kiln was located less than fifty feet or so from the shoreline, within a complex of other late-eighteenth-century buildings, most of which appear to have been warehouses and workshops used by Richards and others involved in shipping goods on the river. The kiln was a rectangular structure measuring 14.5 feet by 8.5 feet with a firebox protruding out an addi-

*Figure 2* Side view of the Richards stone-ware kiln showing vents in the chamber floor. Scales are in feet and inches.

*Figure 3* End view of the Richards kiln displaying an opening for one of the two fireboxes in foreground with the floor of the kiln chamber beyond. Scales are in feet and inches.

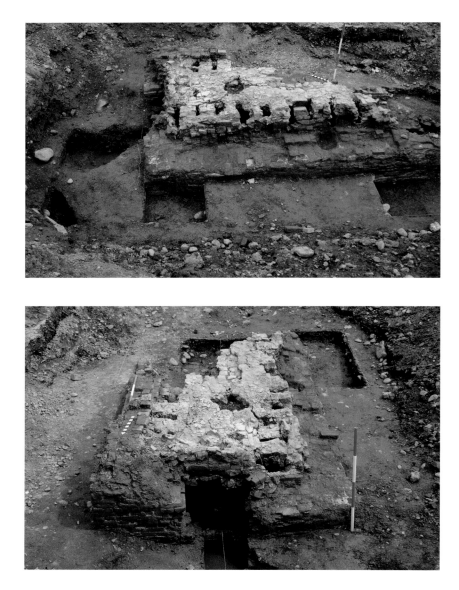

tional three feet from each end. Much of the structure stood to a height of around four feet and most of the kiln's upper chamber floor (8.5 feet by 3 feet in plan) survived intact (fig. 2). The kiln, an updraft type, most likely had an upper chamber with an arched roof. The better preserved of the two domed fireboxes, 1.8 feet wide by 4.2 feet high, was still connected to the kiln's flue system, which essentially consisted of a single ring-like, vented conduit circling beneath the chamber floor (fig. 3). This firebox sat over an ash- and lime-filled, brick-lined trough straddled by iron pigs that served both as a grate for wood fuel and as integral supporting elements within the overall kiln structure. The two troughs at either end of the kiln fed into an ash pit.

A mass of wasters and kiln furniture was gathered from the soils around the kiln, sufficient to characterize the site's production and the mode of stacking wares in the kiln chamber. The Richards's pottery manufactured a variety of salt-glazed, gray fabric vessels including milk pans, plates, bottles,

*Figure 4* Pipkin recovered from the Richards kiln. Salt-glazed stoneware. Scale is in inches and centimeters.

*Figure 5* Two small sampler vessels or condiment pots from the Richards site. Salt-glazed stoneware. Scale is in inches and centimeters.

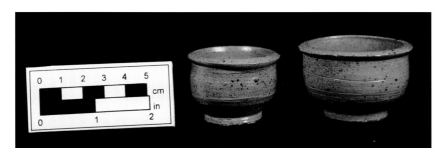

*Figure 6* Chamberpot. Salt-glazed stoneware. Example of typical Richards multi-lobed floral design highlighted in cobalt. Scale is in inches and centimeters.

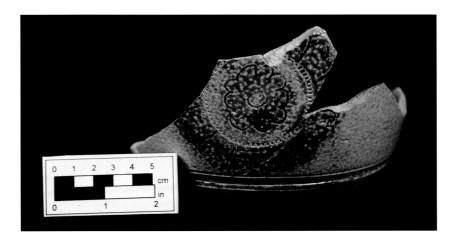

jugs, tankards, porringers, bowls, crocks, pipkins (fig. 4), condiment pots (fig. 5), and chamber pots. As well, the pottery produced more unusual items, like inkwells, candlestick holders, and a press-molded teapot with lion paw feet. Several different base and handle styles are evident, but the most distinctive feature of the Richards's output was the use of certain decorative treatments: incised multi-lobed flowers (fig. 6), fishscale triangles, and checkerboards; molded or sprigged designs of floral reliefs and Bellarmine-like faces (fig. 7); rouletted "penny" medallions; and fleurs-de-lis and watch spring motifs painted in cobalt blue. One intriguing sherd was found bearing the impressed typeset initials "WR," presumably reflecting the pottery's ownership. Both formal and makeshift kiln furniture items were recovered. Props, shelves, and large cylindrical saggars with cut holes (fig. 8) fall within the former category; wads, pads, pillows, crescents, and abundant brick fragments represent the bulk of the latter.

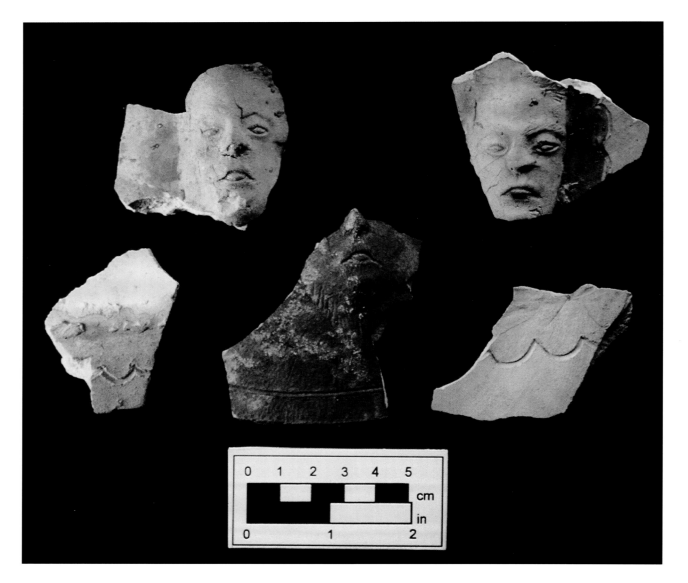

*Figure 7* Examples of applied molded Bellarmine-like faces on sherds found during excavations. Scale is in inches and centimeters.

The identification of the Richards's pottery is of great historical and archaeological interest, not just in the regional context of stoneware production in the middle colonies, but also because Richards had business interests in the Caribbean and we may expect these wares to be found far afield in the New World. The site is one of only three archaeologically documented eighteenth-century stoneware kilns on the eastern seaboard (the other two are in Yorktown, Virginia,[2] and Cheesequake, New Jersey). It was deemed impractical to remove the kiln physically from the riverbank; doing so would likely result in structural damage and create a major long-term conservation issue. More important, removal of the kiln would sever it from its archaeological context when it is clear that substantial unexam-

Figure 8 Cylindrical sagger with cut holes, excavated at the Richards stoneware kiln. Scale is in inches and centimeters.

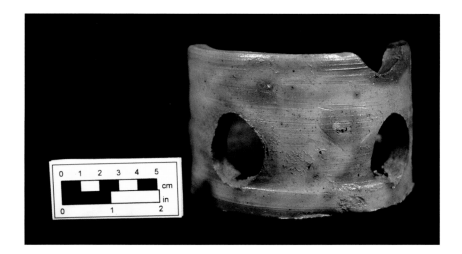

ined remains will still exist along the riverbank even after the highway's construction. On this basis, the kiln has been left in place—packed in sand, marked on the highway as-built drawings—and now lies sealed beneath the roadway, awaiting reexamination several decades hence.

Richard Hunter, Ph.D.
President and Principal Archaeologist
Hunter Research, Inc.
< rwhunter@hunterresearch.com >
< http://www.hunterresearch.com >

1. Reprinted in *New York Gazette* and the *Weekly Mercury*, August 22, 1774. Reprinted in *Newspaper Extracts*, vol. 10, 1773–1774, *New Jersey Archives First Series*, edited by William Nelson, vol. 29 (Paterson, N.J.: Call Printing and Publishing, 1917).
2. Norman F. Barka, "The Kiln and Ceramics of the 'Poor Potter' of Yorktown: A Preliminary Report," in *Ceramics in America*, edited by Ian M. G. Quimby. Winterthur Conference Report (Winterthur, Del.: Winterthur Museum, 1972), pp. 291–318.

## Book Reviews

Leslie B. Grigsby, with contributions by Michael Archer, Margaret Mac-Farlane, and Jonathan Horne. *The Longridge Collection of English Slipware and Delftware*. London: Jonathan Horne, 2000. Vol. 1 (slipware), approx. 180 pp.; vol. 2 (delftware), approx. 500 pp.; approx. 1,000 color illus., charts of dish and plate profiles, glossary, bibliography and short title list, index. $395.00.

When I saw the Longridge collection several years ago, my reaction was, how could such an important group of seventeenth- and eighteenth-century objects have been assembled in the last decades of the twentieth century? I had this reaction again when I first thumbed through the newly published catalog, *The Longridge Collection of English Slipware and Delftware*. This American collection was formed during the period when everyone, myself included, was saying, "Nothing good comes on the market anymore. Everything has been bought up." Ms. Grigsby's catalog proves how wrong we were. Not only does the collection include some of the rarest and most important objects in these wares, it does so in quantity. This quantity is not for the sake of quantity alone, but to make the collection as complete as possible. I feel I can safely say there is not a more important collection of either delft (132 dated pieces) or slipware (55 dated pieces) in private hands today. And only one or two museum collections could possibly compete with this collection.

If one word could describe the publications by Leslie Grigsby, the author of these spectacular two volumes as well as other important catalogs, it would be "thorough." In addition to the basic catalog, in its simplest form a listing of objects along with their important facts, Ms. Grigsby also presents background material complete enough to consider this publication two monographs: one on slipware and the other on delft. She includes a discussion of the forms, materials, and technology—including the firing process—and who used them and how. Also included is a timeline incorporating relevant royal and other important personages who lived during the wares' period of production (ca. 1628–1770). The timeline also features illustrations of the personages' likenesses or monograms taken from the pieces in the collection. If a beginning student of delftware or slipware were to ask me, "What single book has answers to my many questions?" I would say, "If it is slipware you want, see volume one of the Longridge collection, and if it is delft that interests you, see volume two."

The catalog layout of each object is clearly delineated. Using different but complementary typefaces and well-designed spacing, Ms. Grigsby has put together an easy-to-use format. Vital statistics are on the left, with each entry clearly separated. The listings include form, provenance, date, and dimensions, followed by the important categories of body clay, glaze, shape, and decoration. A discussion of the piece is found on the right. This arrangement permits the reader to skim the pages to find specific information quickly. Cleverly, in order to discuss so many objects and avoid repetition, Ms. Grigsby has also combined two or three very similar objects into a single grouping whenever possible.

As further illustration of my statement about Ms. Grigsby's thoroughness, one need only look at the end of the book, which begins with charts of dish and plate profiles. Following is an extremely important and complete "Bibliography and Short Title List," with more than 350 titles listed. A glossary precedes the most comprehensive index I have ever seen.

The objects in this collection are rare and important, and they are visually pleasing to most people, both in and out of the ceramic field. It would therefore be a shame not to show each piece to its fullest grandeur. Wisely, Gavin Ashworth was chosen to photograph the collection. Ashworth is, rightly, considered the top photographer of ceramics today. He has the ability to present the shininess of the glaze without bothersome reflections and, at the same time, to show the object's true three-dimensionality. And as someone who has looked at thousands of pieces of slipware and delftware, I can say that the colors—the blues, the manganese, and the ground colors in their various shades of white—are quite true.

It would be impossible to pick out the most important pieces in the catalog. So many are significant for so many different reasons. I mention only a few that strike my fancy and that say something to me. First, among the slipwares, I would choose two sgraffito dishes: (1) the dish with the royal arms, because this type of decoration is normally found only on globular jugs and not as decoration on a flat, dish surface, and (2) the dish with the depiction of the two cockerels, because it surprisingly reminds me of American folk art. The rarity of these two pieces is amplified in view of the fact that only a very small handful of English sgraffito dishes have survived above ground.

From the hundreds of examples of delft, I would choose the four-part punch or wassail bowl, for three reasons. First, it is complete. Why wasn't at least one part smashed and thrown away, back when it was just an old pot? Second, with its monumental form, it bears a crown like a king. Third, its decoration is extraordinary. Decorations so completely cover the piece that the only place the decorator could find to record the owner's initials and date was inside the second section hidden beneath the top cover. The beautifully painted scene of a stag hunt covering the bowl's entire exterior has great charm, while Bacchus astride a barrel on the bowl's interior imparts a touch of humor.

An encyclopedic collection like the Longridge collection gives one the opportunity to make detailed comparisons. For instance, the large number of blue dash, ornate-rimmed, and simple-rimmed chargers incorporating categories of central designs including Adam and Eve, tulip, oakleaf, and royal, facilitates comparisons, determination of dates, and places of production—an effect Ms. Grigsby wisely uses to best advantage. The abundance of animals and human figures in the Longridge collection (more than I realized have survived since the seventeenth and early eighteenth centuries) provides an important source of comparisons as well as a chance to enjoy objects of naive charm.

Jonathan Horne's preface, which puts the collection into perspective, talks about collecting, collectors, and collections, starting in the eighteenth

century with the famous connoisseur Horace Walpole. He mentions many twentieth-century collectors, some of whom were gone before I came into the ceramics world. Others such as the Tilleys, Louis Lipski, and Tom Burnes I had the privilege to know and learn from. It is indeed exciting to me to see many of the pieces they owned or handled in the Longridge collection and presented with all their importance in these volumes. The Longridge collection is one of the very few really great collections of the twentieth century. It is fortunate for the world to be able to learn of it in such a brilliant and scholarly way as presented by Leslie Grigsby.

John C. Austin
Consulting Curator of Ceramics and Glass
Colonial Williamsburg Foundation

---

Chris Green. *John Dwight's Fulham Pottery, Excavations 1971–79*. London: English Heritage, Archaeological Report 6, 1999. xvi + 380 pp.; 259 bw and 8 color illus., 16 tables, 18 appendices, bibliography, index. $45.00.

The archaeological excavation of kiln sites is often the only way to obtain information about kiln size and design. The recovery of associated ceramic products can also pinpoint pottery types to a specific potter, locale, or both. Archaeological context very often dates pottery and waster assemblages as well.

Pottery manufacturing sites are important sources of information about the industrial and economic past. Such is the case with the Fulham pottery site near the City of London, where archaeological research has revealed new information about master potter John Dwight. When I visited Fulham in the 1970s, I was very impressed by the importance and complexity of the Fulham site, and overwhelmed by the amount of waste pottery that had been excavated—an estimated seventeen tons. I wondered how the archaeologists ever would find the time and dedication to study the massive amount of pottery recovered from the site. Obviously they did, as Chris Green's long-awaited book attests.

The book focuses on the life and pottery of John Dwight, one of England's premier potters, who not only experimented with the manufacture of porcelain but also was the first English potter to make stoneware successfully. Dwight, born sometime between 1633 and 1636, worked at his factory in Fulham from ca. 1672 to the time of his death in 1703. Historical documentation on Dwight was assembled by Haselgrove and Murray;[1] the majority of evidence on Dwight's work, however, comes from nearly a decade of archaeological rescue between 1971–1979. Most of the fieldwork and laboratory work was carried out by an amateur group, the Archaeological Section of the Fulham and Hammersmith Historical Society, continuing a laudatory English tradition of weekend volunteerism.

The book is divided into three parts, the site (59 pages), the pottery products (116 pages), and the appendices (192 pages). The site report consists of six chapters: a historical outline; an interesting discussion of the topographical setting of the site before Dwight established the pottery in

ca. 1672; a detailed description of Dwight and post-Dwight structural developments at Fulham, from ca. 1672 to the later nineteenth century; the evidence for Dwight's early experiments at the site, ca. 1672–1674; Dwight's stoneware production, 1675–1703; and pottery production in the seventeenth through nineteenth centuries by Dwight's descendants and others.

Although the structural finds of the Dwight period survive in poor condition due to later disturbances, Green discusses Dwight's stoneware kilns and their possible derivation. Because many of the original publications and reports are difficult to obtain, it is quite useful to have various other kiln sites with accompanying kiln plans described in one place. Rectangular kilns were used at Fulham until ca. 1780 when circular, bottle-type kilns appeared. Figure 22 shows a reconstruction of a rectangular stoneware kiln and part of its load, ca.1685; these kilns were vertical updraft kilns with the load chamber above the firebox. Figure 23 shows the plans of Fulham kilns compared with four other kiln sites. As Green discusses, there is a definite similarity in plans. Notably, it appears that Dwight's kilns were in the London delft industry tradition, not in the Rhenish tradition as represented by an early kiln at Woolwich. The English kilns at Fulham, Vauxhall, and Southwark show striking similarities to the kilns excavated in Yorktown, Virginia.[2]

A common ancestor to the seventeenth- and eighteenth-century English chimneyless delftware kilns appears to be the Italian tradition represented by the 1548 tin-glazing kiln of Piccolpasso. Green points out that the tin glaze kiln seems to have been the standard for stoneware production throughout the late seventeenth and eighteenth centuries. He makes an interesting observation, that "by Dwight's time kiln styles were technically interchangeable, and it was simply custom or tradition which led them to be so rigidly maintained and regionalised." In other words, as has been shown in Yorktown, the rectangular kilns could be used for both tin and lead glaze manufacture as well as for salt-glazed stoneware.

The second part of the book deals exclusively with the products manufactured at Fulham, from Dwight's time to the twentieth century. Until 1675, Dwight experimented with an impressive array of finewares based upon Rhenish, Chinese, Dutch, and English products. Site evidence, consisting of fragments of mostly Chinese-inspired miniature vases, thrown and lathe turned, indicate that Dwight's early period was spent experimenting with porcelain manufacture. But sherds found at the site show his efforts to have been unsuccessful. Other porcelain experiments or trials involved engobes, vapor, or dipped glazes. Numerous drawings of these test vessels, test chips, and fragments of nicely sculpted white statuary attest to Dwight's advanced outlook and abilities. As early as ca. 1675, Dwight also copied Chinese red and bronze-colored unglazed stonewares such as Yixing teapots. He manufactured chemical wares and crucibles, and experimented with the manufacture of porringers painted to look like delftwares. He imitated a variety of Raeren-Westerwald-type vessels with applied strip and other kinds of decoration. Common stonewares, mostly tankards, gorges, and bottles, formed the majority of Fulham's seventeenth-century production.

Bellarmine masks and medallions were applied to bottles at certain periods. The author gives pointers on how to distinguish between the products of Fulham and contemporary German products before 1685, and how to date Fulham stonewares in two-year intervals beginning in ca. 1673–1674. In the 1680s Dwight made and sold a variety of finewares such as white china, marbled ware, and red stoneware.

Green also describes a large variety of finewares and common stonewares produced by Fulham potters in the eighteenth, nineteenth, and twentieth centuries. This summary of later Fulham wares will be extremely useful to archaeologists working in England and America.

The third part of Green's book consists of eighteen appendices that account for nearly one-half of the book's content. Examples of the subject matter include the following: kiln debris and kiln furniture; applied decoration on seventeenth-century stonewares; ale-measure marks (excise stamps) on eighteenth-century drinking vessels; index of excavated features; and Doulton and Watts's price list of 1873. These detailed studies will be of great use to students of ceramics.

Chris Green's book represents the most thorough publication to date on the archaeology of a specific pottery site. Although his work, in the best of British tradition, is largely descriptive, the author does discuss such other issues as landscape, geographic distribution of Dwight's pottery, quantification, terminology, and so forth. The maps, drawings and photographs are excellent. A Harris Matrix drawing of the stratigraphy and features may have simplified the evolution of structural evidence at the site.

Prior to reading this book, John Dwight was an oft-mentioned but "fuzzy" figure. Now, thanks to the archaeology and the book, archaeologists and students of ceramics will have a much better understanding of Dwight, a remarkable and prolific potter, and the role he played in the English ceramic industry.

Norman F. Barka
College of William and Mary

1. Dennis Haselgrove and J. Murray, eds., "John Dwight's Fulham Pottery, 1672–1978: A Collection of Documentary Sources," *Journal of Ceramic History* 11 (1979).

2. Norman F. Barka, "The Kiln and Ceramics of the 'Poor Potter' of Yorktown: A Preliminary Report," *Ceramics in America,* edited by Ian M. G. Quimby (Winterthur, Del.: Winterthur Museum, 1972), pp. 291–318.

Jill Beute Koverman, editor. *"I made this jar . . ." The Life and Works of the Enslaved African-American Potter, Dave.* Columbia, S.C.: McKissick Museum, University of South Carolina, 1998. 101 pp.; 18 color and 36 bw illus., bibliography. $25.00.

The recent exhibition *"I made this jar..." The Life and Works of the Enslaved African-American Potter, Dave* at the Winterthur Museum and the accompanying catalog can serve to introduce the works of this talented nineteenth-century potter to students of decorative arts, ceramic historians, archaeologists,

and anyone interested in the work of traditional craftsmen, specifically African-American craftsmen. David Drake was a master potter who made, in addition to the familiar range of jars, jugs, pitchers, and so on, very large storage jars whose construction took not only considerable skill but also considerable strength. However, it is the poems that he inscribed on his pots rather than his potting skills that have brought him out of the obscurity that is commonly the lot of traditional craftsmen.

Dave was born into slavery in Edgefield, South Carolina, about 1800. He apparently learned the art of throwing pots during his teens, possibly from Harvey Drake, whose surname Dave took after emancipation. During his enslavement, he was owned by various members of the interrelated (through both marriage and business) Drake, Landrum, and Miles families. The research of Jill Beute Koverman, also curator of the exhibit, has brought to light records of these families that indicate Dave was a valuable craftsman whose skills were recognized by his owners, all of whom were either potters themselves or involved in the mercantile aspects of the potter's trade. Dave's skill as a potter and poet was first recognized in the twentieth century by collectors and museum curators in the South who were intrigued by the inscriptions on some very large (over twenty-five gallons) jars. Dave signed and dated a number of his pots, as did other potters, but the verses on the jars are unique for his time and place. The exhibit and catalog present his pots to the public as works of art and as records of Dave's commentaries on his world.

The exhibit at Winterthur was visually impressive but, in some ways, scholastically frustrating for a person interested in the history of pottery making in North America. The dramatic presentation of Dave's large jars created, for at least some viewers, a feeling of awe. The jars are immense and, under museum lighting, exhibit particularly lustrous glazes. This inevitably led to questions. How did he make these vessels? What glaze techniques did he use? How did his work differ from that of his contemporaries? These technological questions were not addressed adequately in the text that accompanied the exhibit.

Other aspects of the pots and the life of their maker were probably more immediately intriguing to most visitors. As a result, two subjects in particular were emphasized in the exhibit: Dave's poetry and his life as an enslaved craftsman. The short poems that Dave inscribed on many of his large jars have attracted popular and scholarly attention. Of the hundreds of surviving vessels that have been attributed to Dave, twenty-seven are known to have inscriptions, generally two short lines of rhyming verse. The verses discuss the functions of his pots ("A very large jar which has four handles / pack it full of fresh meat—then light candles"), religious issues ("I saw a leppard & a lion's face / then I felt the need of grace"), daily events ("the fourth of july is surely come / to blow the fife—and beat the drum"), and his life ("Dave belongs to Mr. Miles / Wher the oven bakes & the pots bile" and "I wonder where is all my relations / Friendship to all—and every nation").

The exhibit was sponsored by and first shown at the McKissick Museum of the University of South Carolina, where a superlative collection of

southern decorative arts is housed. The catalog is much more than a simple description of the works on display. Its six essays are intended to place Dave's work in the context of his specific time and place. The first, by Koverman, is a synopsis of previous and current research about South Carolina pottery in general and Dave in particular. The goals of her research are those of an art historian: analyze the style of Dave's work; map the development of his craft over the course of a lifetime; and reveal Dave's own life history, or at least as much of it as can be revealed by documentary research. Koverman also asks the question of who Dave's audience might have been. Were the verses possibly intended for his fellow enslaved workers and is their meaning overt, covert, or both?

The second essay, by historian Orville Vernon Burton, is concerned with the Edgefield district of South Carolina as it was in the nineteenth century. This gracefully written piece discusses the political and economic history of the area and includes information about the daily lives of the enslaved people who lived and worked there, especially the strictures and restrictions under which they existed. Dave as an individual is not emphasized but Burton does note that Dave's versification fits into the story-telling tradition of the district. Folktales told by enslaved people usually contained moral messages, often cryptic, with religious allusions, as do Dave's poems.

James A. Miller's short essay places Dave's verses in the context of African-American poetry in the eighteenth and nineteenth centuries, in the "evolving tradition of African-American literary practices." Dave, Miller states, was part of the second generation of African-American poets—people born into slavery at a time when they were generally forbidden to read and write. Miller analyzes Dave's verses as literature and as clues to his thoughts and feelings as a creative and sensible man working under limitations that ranged from the social conventions of his time to the difficulties of revising verses incised into clay.

The subject of poetry on pots is continued in the next essay by John A. Burrison, a folklorist. Burrison begins by discussing the English and German traditions of writing on clay. Most of the potters in the eastern part of the United States worked in one or a combination of these traditions, but the only American potters who consistently wrote on their wares were the Pennsylvania German craftsmen. Burrison comes to the conclusion that Dave "was working independently of any tradition of pot-poetry, and that he chose this means of expression to declare his status as a literate slave."

The following essay, by Joe L. and Fred E. Holcombe, was especially interesting to this reviewer. The Holcombes have been engaged in archaeological investigations of pottery sites in the Edgefield district since the 1970s. The sites they have excavated include four where Dave most probably worked. From these sites they have amassed a large collection of wasters with unique characteristics that most credibly identify them as Dave's work. The Holcombes' well-illustrated account of their excavations and analyses should be of value to students of material culture, particularly historical archaeologists, when trying to identify sherds or whole vessels as Dave's workmanship.

The closing piece, also by Koverman, delves into the possible sources—from the eruption of Mount Vesuvius to the apocalypse—that inspired Dave's poems. She ends by listing all of Dave's known verses in chronological order. The catalog concludes with an inventory of the vessels that were on exhibit.

The subjects covered by the catalog's essays are commendable pieces of research, coherently and interestingly presented. The faults of the catalog are few; the most notable, the omission (except for the Holcombes' essay) of figure or photographic plate numbers. And it is sometimes unclear which illustration is referenced in the text. The catalog also would have benefited by the inclusion of more essays: one on the technology of producing alkaline-glazed stonewares and the skills necessary to produce these literary pots; another comparing Dave's works to those of his contemporaries, both enslaved and free; and, perhaps, another on the role of these vessels, especially the very large jars, in the daily lives of the people who used them.

Meta F. Janowitz
URS Corp., and The Cooper Union for the Advancement of Science and Art

---

Robert Copeland. *Spode's Willow Pattern and Other Designs After the Chinese.* London: Studio Vista, 1999. 3rd edition. 214 pages with nine appendices, glossary, terminology, references, and index. 400 bw illustrations, 50 color plates. $60.00.

In the seventeenth century, a fascination with things Chinese swept through Europe and North America as trade with the East introduced the West to tea, spices, fine silks, lacquered items—and porcelain. For much of the eighteenth century, consumers unable to afford expensive Chinese porcelains contented themselves with painted renditions of Chinese-style designs on less costly ceramics like delft and the later refined earthenwares. With the late-eighteenth-century advent of printed underglaze designs in blue on white-bodied ceramics, production of the complex landscapes and geometric borders typical of Chinese porcelains became more cost efficient for the potteries and, thus, more affordable for consumers. This new technology revolutionized the Staffordshire ceramic industry and paved the way for the production of a number of decorative patterns copied directly from or inspired by Chinese porcelain.

Robert Copeland's volume, *Spode's Willow Pattern and Other Designs After the Chinese,* examines the influence of Chinese porcelain on the English printed earthenware, porcelain, and bone china industries of the late eighteenth and nineteenth centuries. Copeland, whose great-great-grandfather William Copeland III was Josiah Spode's original business partner, made his career at the Spode factory. While Spode and its products are the primary focus of the book, the author does not restrict his discussion of Chinese-influenced ceramics to that particular manufacturer. Although many of the illustrated vessels are either marked as or attributed to Spode, Copeland also features the works of a number of English factories, including Caughley, Herculaneum, New Hall, and Joshua Heath. A

variety of sources are used in this study, including Spode factory correspondence, engraved copper plates, pattern books, test prints on paper and fabric, ceramic vessels, and archaeological material excavated from both Spode factory waster pits and North American sites.

The volume's early chapters focus on providing the reader with a historical context for the development of Chinese-influenced ceramics, as well as details of the manufacturing process. Copeland treats the reader to a concise yet clear overview of the diverse factors that affected the Staffordshire industry during the eighteenth century, including consumer desire for Chinese motifs, the development of refined white-bodied earthenwares and colorless lead glazes, and economic and political factors affecting overseas trade with China. These early chapters also provide detailed step-by-step descriptions with accompanying illustrations of two distinctive printing processes used to decorate ceramics—underglaze printing with tissue paper and the lesser-known overglaze process of bat printing. In the latter procedure, a skilled craftsperson used thin sheets, or bats, of glue to transfer the engraved design to the glazed ceramic vessel.

Later chapters examine over seventy individual Chinese-influenced patterns on English wares, with an emphasis on landscape designs. Some of the more commonly produced patterns, such as Willow, Mandarin, Rock, Two Temples (also called Broseley), Buffalo, Long Bridge, Trophies, and Fitzhugh, are the subjects of individual chapters. Less common patterns form segments within chapters organized around design-related themes. One chapter, for example, deals with patterns for which there are no known Chinese prototypes. Basic defining characteristics are provided for each pattern, as well as discussions on design variations, alternate pattern names, and production dates. For three patterns (Two Temples, Long Bridge, and Buffalo), Copeland provides illustrated, analytical charts comparing how different manufacturers depicted specific design elements in these patterns. He cautions, however, that it is virtually impossible to attribute unmarked ceramics to specific manufacturers based solely on the pattern because potters both lent and sold used, engraved copper plates.

Copeland does an excellent job of documenting the various landscape patterns (many of which, to the untrained eye, are remarkably similar), assembling and illustrating the original Chinese porcelains and their English counterparts in bone china, earthenware, porcelain, and stone china. General dating considerations based on print color and engraving style are provided, but Copeland cautions that precise dating of early pieces is difficult. Some of the earliest printed patterns, such as Mandarin, Buffalo, and Two Temples, were copied directly from Chinese porcelain motifs. Other designs, including Bungalow, Buddleia, and Forest Landscape, were European interpretations of Chinese-style landscapes for which no known Chinese prototypes exist.

The most enduring and best known of the Chinese-influenced patterns is, of course, Willow. Believed to have been based on the Chinese Mandarin pattern, Willow was first introduced around 1795 by Josiah Spode and was produced by numerous other potters in the intervening centuries. Copeland traces the different versions of Willow produced by Spode and provides a

newly added appendix that reproduces, in facsimile, the 1849 publication of the Willow pattern's origin.

Originally published in 1980, this expanded third edition of Copeland's volume has undergone significant revisions from its first edition. Four new chapters and an equal number of appendices have been added. Copeland has also included new information from both earlier and later periods, extending the temporal range of the original work.

One new chapter focuses on Spode's late-eighteenth-century Chinese-influenced wares. Another chapter, organized in table format, provides information on landscape patterns reproduced by Spode during the late-nineteenth-century revival of interest in Chinese designs. Arranged by pattern, the table provides data on Spode's factory pattern number, vessel shapes, body fabric, print color, and decorative detailing. Although the chapter title informs the reader that the recorded ceramics date to the late nineteenth and early twentieth centuries, no dating information is provided for the specific patterns.

Another new chapter provides updated information on specific patterns discussed earlier in the volume, while the final chapter also expands on earlier information about the Spode factory practice of creating special orders to match customers' Chinese porcelain. These two chapters read as addenda to the earlier editions. It is regrettable that the decision was made not to integrate the research into the original text.

The volume's appendices provide a variety of information, including figures on tea importation, recipes for cobalt, date ranges for printed and impressed Spode marks, and typical Chinese-influenced border designs. New appendices include a brief discussion of the American colonial revolts against taxation on tea imports and a list of relevant articles on chinoiserie published since 1980.

The volume includes four hundred black-and-white illustrations and photographs and fifty color plates, forty-six of which were added for the third edition. Photographs are clear and reproduced at a scale that provides the reader with substantial detail for each vessel. The figure captioning is largely outstanding—information on vessel dimensions and color is provided, as well as drawings of manufacturers' marks. Serious readers will appreciate Copeland's system of documenting and standardizing vessel print colors. He provides color samples depicting the various shades of cobalt used in Chinese-style patterns; each color is provided with a name, using British Standards Institution numbers and British Colour Council names, as well as Munsell color references.

Copeland provides a number of useful identification aids for collectors and scholars alike. One table cross-references the Spode names for various patterns with other ceramic researchers' (Coysh,[1] des Fontaines,[2] and Whiter[3]) designations for the same pattern. A glossary of terms describes individual design elements in Chinese-influenced patterns and a list of ceramic manufacturing terminology. Lengthy notes accompany each chapter.

Minor format and editorial choices make the book somewhat difficult to use as a ready reference. Many of the pattern names are not included in the

photograph captions, making it necessary to search for the figure reference within the book text. General date ranges for vessel production also would have been very useful in the captions. At least one of the photographs seems to be missing a caption altogether. Perhaps due to the large number of new photographs included in this edition, photograph placement is sometimes arbitrary. For example, figure 20 in chapter 8 seems out of place between figures 15 and 16. I was also left wishing for a final chapter that summarized the research and placed it within the larger context of the Staffordshire ceramic industry. All in all, however, these problems are minor and do little to detract from the overall value of this volume.

Copeland has assembled a vast amount of information on a previously little understood component of the English ceramic industry. Serious collectors and scholars will want to make this much-updated, informative reference part of their libraries. Given the vast influence of the Chinese trade on England and the American colonies, this volume is an invaluable resource.

Patricia M. Samford
Tryon Palace Historic Sites & Gardens, New Bern, North Carolina

1. A. W. Coysh, *Blue and White Transfer Ware, 1780–1840* (Newton Abbott, Woodbridge, Suffolk, Eng.: David and Charles, 1970). A. W. Coysh, *Blue Printed Earthenware, 1800–1850* (Newton Abbott, Woodbridge, Suffolk, Eng.: David and Charles, 1972).
2. J. K. des Fontaines, "Underglaze Blue-Printed Earthenware with Particular Reference to Spode," *English Ceramic Circle Transactions* 7, pt. 2 (1969).
3. Leonard Whiter, *Spode: A History of the Family, Factory and Wares from 1733 to 1933* (London: Barrie & Jenkins, 1970).

---

Maurice Hillis and Roderick Jellicoe. *The Liverpool Porcelain of William Reid: A Catalogue of Porcelain and Excavated Shards.* London: Roderick Jellicoe, 2000. 48 pp.; 64 color illus., bibliography. £35 (hardcover); £15 (softcover).

Curators and collectors of American furniture have an axiom: "If it's odd and it's made of cherry, then it's from Connecticut." The corollary for devotees of ceramics might well be, "If it's odd and it's English porcelain, it must be from Liverpool." Such a sentiment hints at the confusion surrounding the study of Liverpool porcelain but does a disservice to the rich complexity of items hailing from this important center of ceramics production. The March 15 to April 1, 2000, exhibition on the porcelain of William Reid, and accompanying brief catalog by Maurice Hillis and Roderick Jellicoe, are among the most recent efforts to sort out the attribution and chronology of these wares. The catalog has a modest cost and, although text is minimal, it contains numerous color photographs of good quality. The publication is a useful reference in the rapidly evolving study of William Reid and Liverpool porcelain.

This latest exploration focuses on archaeological sherds recovered from a site located on the south side of Brownlow Hill Road. The factory was purpose-built by William Reid for the production of soft-paste porcelain and was offering wares for sale by November 12, 1756. Reid occupied the site for only five years, for in 1761 he and his three business partners were

bankrupt. According to Hillis and Jellicoe, "the factory was kept in operation under the temporary control of the mysterious Wm. Ball before passing, in 1763, into the control of the potter James Pennington who manufactured porcelain there until about 1767." Thus, in the short span of eleven years, three different proprietors operated from this one location.

In 1997 and again in 1998 the site was excavated under the direction of the Field Archaeology Unit of the National Museums and Galleries on Merseyside (NMGM). These explorations were undertaken prior to redevelopment of the property and were, by necessity, brief. A synopsis of the 1997 excavation was published by Myra Brown, Curator of Ceramics at NMGM, and Rob Philpot, Curator of Roman and Later Archaeology at NMGM.[1] Recognizing that the site could yield more archaeological information than the construction timetable would permit, a Liverpool porcelain enthusiast persuaded the contractor to allow five individuals (including Hillis and Jellicoe) to act as a "rescue group," observing the 1999 construction and recovering a considerable number of sherds as they were exposed. By Hillis and Jellicoe's own assertion, their catalog is not meant to be the definitive publication on the excavations and rescue actions; more is forthcoming, although it is not clear to this reviewer if further publications will be produced by the NMGM Field Archaeology Unit, the rescue group, or both.

After providing a short overview of the factory's site and history and the excavations of the late 1990s, Hillis and Jellicoe summarize the salient features of the porcelain of William Reid & Co. This is followed by a fully illustrated survey of the accompanying exhibition in which fifty-six objects from both public and private collections are presented and compared to pictured sherds recovered principally through the rescue group's activities. Hillis and Jellicoe's characterization of William Reid's production is daunting, although for students of Liverpool porcelain it is not without precedent. They explain, for instance:

> that the colour of the porcelain varies widely. The glazed body can appear pure white, grey, blue or green. . . . The translucency of the porcelain shards also varies. It can be clear [presumably this means white], yellow, buff or occasionally green. Equally, the potting features displayed by the shards are diverse. For example, many wares such as mugs, sauceboats and coffee cans feature footrims, the profiles of which can vary considerably. Other such wares have flat bases. Bases can be unglazed, glazed or partially glazed. A wide variety of moulded wares was produced, often in a surprising number of variations within an overall design.

Given such diverse features, how does one recognize the porcelain of William Reid? For Hillis and Jellicoe, the answer seems to lie entirely in the sherds from the site. This is troubling for several reasons. First, the authors state that they have focused on the wares of Reid with only minor attributions to James Pennington, the last porcelain producer on the site. The "mysterious Wm. Ball" is only fleetingly mentioned in connection with one of the extant objects, and an explanation of how the sherds can be related specifically to either Reid or Pennington is never offered. The site was continuously used as a porcelain manufactory for eleven years; given

such a narrow time frame, how were the deposits stratified to distinguish the production of one maker from another? Indeed, given the narrow time span under consideration, was this possible? This topic is not addressed, and so the reader is left to wonder—or simply to accept that Hillis and Jellicoe had some means of distinguishing one manufacturer from another.

Of second and greater concern is the seeming total reliance on archaeology as the definitive means of attributing extant wares to William Reid exclusively. The individual object entries compare the form and/or decoration of each piece to sherds illustrated at the end of the catalog. A careful reading of the object entries reveals that the majority of objects presented have been reattributed (often several times during the 1990s alone) to various potteries, most especially to those of Samuel Gilbody the younger and Richard Chaffers. These two potters were producing soft-paste porcelain in Liverpool at adjacent sites at approximately the same time as William Reid; their factories were located less than one-half mile away from the Brownlow Hill site.

Research on the manufacturers of English salt-glazed stoneware and creamware indicates that specialist modelers may have sold molds to many different potteries. Ceramic molds also sometimes changed hands as partial payments of debts.[2] In light of such practices, isn't it safe to assume that the presence of a given molded form or attribute at an archaeological site confirms that such wares were made at that location without necessarily conferring exclusivity to that manufacturer in the absence of additional compelling information?

Analysis and attribution of the sherds recovered from the Brownlow Hill site are further complicated by the presence of a large number of fragments with overglaze decoration, including polychrome enameling, gilding, and on-glaze transfer printing. Hillis and Jellicoe note that this is a very unusual feature since, typically, few technical problems arise during the final stages of overglaze decoration that would result in pieces being discarded as wasters unfit for sale. They relate that the "hundreds" of porcelain sherds with this embellishment constitute "a unique ceramic survival." And such fragments "are not wasters but are closely related to the wasted material and the circumstances that lead to their being dumped are at present obscure."

The difficulties caused by these non-waster porcelain sherds on the site are especially evident in the entry for catalog item number 31, a milk jug attributed by Hillis and Jellicoe to William Reid. They state:

> It is just conceivable that this piece is Vauxhall. A jug, apparently of this type, has been illustrated and described as being decorated with polychrome prints. . . . At the time, that jug was attributed to a supposed Liverpool factory in Ranelagh St., believed to have been operated by Wm. Ball. It is now known that there was no such factory and polychrome printing is currently considered to be characteristic of the London porcelain factory at Vauxhall and, indeed, exclusive to it. Only one shard with the criss-cross type of moulding [seen on the jug in the catalog] has as yet been identified at Brownlow Hill and is not definitely a waster. Nevertheless, this jug seems so closely related to other pieces of Wm. Reid's porcelain that we feel justified in our attribution.

Despite these concerns, this catalog can be of real value to scholars of Liverpool porcelain if used with due care. Few sites in Liverpool have had the benefit of formal archaeological excavation. The authenticity of sherds recovered through such endeavors is undeniable; they hold the potential to reveal what was on a given site at a given point in time. Great care must be taken in interpreting such materials, and the need for caution is significantly enhanced when sherds are recovered in rescue operations. But the reality of modern redevelopment often begs that rescue actions be taken, especially when construction will compromise the integrity of a site. The current academic standards for the cataloging and analysis of formally recovered archaeological materials impose demands that, coupled with economic considerations, frequently slow the process of publication to a decade or more. Hillis and Jellicoe's endeavors have the real value of providing a glimpse at the evidence in a timelier manner. No doubt there will be more information forthcoming, and some of the authors' conclusions will be revised in the years to come, perhaps by the authors themselves. Meanwhile, they have spread more pieces of the puzzle before us as we endeavor to understand the "odd English porcelain that must be from Liverpool."

Janine E. Skerry
Colonial Williamsburg Foundation

1. E. M. Brown and R. A. Philpott, "An Archaeological Trial Excavation on the Site of William Reid's China Manufactory on Brownlow Hill, Liverpool, 1997," *Northern Ceramic Society Newsletter,* no. 111 (1998): 48–52.

2. David Barker and Pat Halfpenny, *Unearthing Staffordshire: Towards a New Understanding of 18th Century Ceramics* (Stoke-on-Trent, Eng.: City of Stoke-on-Trent Museum & Art Gallery, 1990), pp. 7–11.

---

Geoffrey A. Godden, F.R.S.A. *Godden's Guide to Ironstone, Stone, & Granite Wares.* Woodbridge, Suffolk: Antique Collector's Club, 1999. 399 pp.; 285 bw and color illus., three appendices, bibliography, index. $89.95.

In his preface, Geoffrey Godden states that the nineteenth-century durable ironstone china, stone china, or granite wares "stimulated the industry and prolonged the British hold on all overseas markets." Indeed, he demonstrates that English potteries produced ironstone dishes that helped feed the world for a hundred years.

The author describes how the bodies discussed in this book were originally produced to emulate the salable Chinese export-market porcelains so desirable in England during the late eighteenth century. He explains the role played by tariffs, the English East India Company's discontinuance of importations, and the resulting "great void that occurred in the market for middle-range tablewares." Thus, Godden explains how English innovators finally perfected hardy, inexpensive bodies that would attract customers in both home and world markets.

In the first half of this book, Godden discusses and illustrates the history of the discovery of the sturdy opaque bodies with colorful decorations reminiscent of the oriental wares. Excellent new photographs are used in

this discourse. The content of the material is similar to his earlier text, *Mason's China and the Ironstone Wares*, including both information on Mason's work and his main Staffordshire rivals, the firms of Davenport, Hicks & Meigh, Ridgway, and Spode. American collectors of these colorful, now expensive and rare dishes will enjoy his presentation. Those more interested in mid-Victorian English china can trace some shapes, lines, finials, and jugs that would be echoed in the later transfer-decorated and all-white ironstone wares.

During the twentieth century, Americans became fascinated with the strong, attractive, useful tablewares with English backstamps that had survived for one and a half centuries in attics, pantries, back-room cupboards, and cellars. As these old dishes were rediscovered, curious collectors began to ask English ceramic authorities for information. Certainly, many of those collectors referred often to such earlier landmark books by Godden as his *Encyclopaedia of British Pottery and Porcelain Marks* and his revision of Llewellynn Jewitt's classic, *The Ceramic Art of Great Britain*, that provide important ceramic history for the present work.

Twentieth-century American collectors eager for information on the wares began to gather data on marks, shapes, and registrations, and to photograph and record sherds and whole vessels. Godden states, "It is perhaps a pity that the white ironstone-type wares were almost wholly made for the export market." This was also true for the popular flow blue, mulberry, and copper-enhanced dishes that were shipped to North America. Most of these mid-century wares were neither appreciated nor sold in large numbers in the land where they were created. Therefore, few English records of these wares are known to exist. Godden provides some answers to the American collectors' questions.

Many American readers will be interested in Chapter 5 on the later (post-1830) ironstone and granite wares. Godden's discussion of hotel, steamship, and railroad china is especially educational. He notes that Staffordshire potteries produced and marketed thousands of tons of white ironstone, useful wares so highly popular in the United States. He refers to this white granite as the dominant type of pottery in use from the 1850s until the end of the nineteenth century. Yet he provides little information on the "gap" years from about 1830 to 1880. Serious Americans readers may feel disappointed by most of the quotes and other data, which are mostly derived from late-nineteenth-century records. Even pertinent records previously known and published in Jewitt's ceramic history have been omitted. British authorities acknowledge that the patent registries from 1841 to 1883 are in fragile shape, rather difficult to access, and not yet duplicated for the Public Record House at Kew, Surry.

Godden distinguishes between the post-1813 ironstone tablewares, which were made of a less expensive and less durable earthenware, and Mason's earlier ironstone bodies. In doing this however, he also minimizes the importance of the transfer prints on the later ironstone-type bodies. He fails to make it clear that from about 1840 most flow blue and mulberry treatments, both brushstroke (painted) and transfer, were applied to ironstone-type

bodies. This also is true for those ironstone bodies embellished with "tea leaf" or other copper luster decorations. Firms that produced the all-white ironstone also decorated the same pieces in flow blue, mulberry, and copper luster. The bodies are usually identical, although Godden fails to make this clear in his discussion.

Chapter 6 on identification is of particular use for American collectors hungry for information. Readers will need to study and restudy the clear, well-worded rules for dating on pages 174–176, which the author laughingly calls "helpful Godden guides." These rules precede "An Alphabetical List of British Manufacturers of Ironstone-Type Wares," which comprises the bulk of the book. With his knowledge of and access to English records, the author instructs on dates, locations, kinds of bodies, trade names, photographs, and pertinent details about labor relations and partnerships. He includes helpful accounts of more than three hundred nineteenth-century English pottery businesses. Many a "dish detective" will find clues and solve mysteries by studying the facts found in this second half of the volume.

The final chapter briefly discusses the non-British manufacturers, with an emphasis on American potters. Much of Godden's information is taken from the records of the United States Potters' Association. The records from the 1870s and 1880s include reports on labor problems, measures, materials, wages, and tariffs. Although the association's president claimed that American pottery's "quality also has been improved until our stone china is fully equal to, if not superior to, any of the same grades made in England," many collectors feel that the American potters rarely made ceramics that could compete with the English products.

This American reader senses that Mr. Godden does not understand the effect of the American Civil War on the country's economy or on the emerging potteries. The quotes concerning Pennsylvania clay are confusing, and quotes concerning American potteries' purchase of clays and materials from England are not placed into context. Sources of clay used in native potteries in New Jersey, Ohio, Vermont, and other sites are not mentioned. Mr. Godden does include a few valuable sources of additional information for those individuals interested in exploring the history of American pottery manufacturers.

In Appendix I, Godden includes two very helpful lists of makers' marks: one contains potters' initials arranged in alphabetical order and the other provides trade names and descriptions, usually relating to bodies. Potters' initials and descriptive terms such as Berlin ironstone, granite opaque pearl, imperial granite, opaque stone china, and so on, are followed by the names of their manufacturers. Many collectors could initiate a search for the maker of a piece from these comprehensive pages.

"Registered Marks, Patterns or Forms: British Ironstone Manufacturers in 1885 and 1900," the title of the handy Appendix II, is, perhaps, deceptive. The title cites the dates 1885 and 1900, but the text refers mostly to registrations from 1842 to 1883, the "gap" years. The author explains the deciphering of the registration numbers and includes the list of numbers used from 1884 to the present. Unfortunately, Godden's list of registered designs or shapes

relating to ironstone-type wares includes only those patterns or shapes already identified in the United States. The American researcher wanting to identify a ceramic piece with a registration mark would do better to consult the more complete listing in Cushion's marks handbook.[1]

However, the reader can only be delighted with the opening pages of this second appendix, especially the illustrations. The first page displays a photograph of a previously undiscovered (in America, that is) shape, a molded jug by E. Jones recorded just a few years before the diamond-shaped marks were used. The facing page illustrates two examples taken from English registry books — just the kinds of illustrations that ironstone researchers are hungry to see. The first is a typical drawing submitted to London's Office of Registry of Designs on May 30, 1842, by James Edwards, a pioneer in the design and manufacture of white ironstone. Collectors have nicknamed that shape Fluted Double Swirl, and a number of these pieces are known. The second reveals the transfer-printed design for the Boston Mails view.

Both of these illustrations suggest that there must be many drawings or pictures of mid-Victorian export wares in existence at the registry that would interest American collectors. Certainly, the potters' shape names included among these records would add to the bank of ironstone knowledge in the United States. For researchers able to travel to England, the author succinctly tells the reader how to access the data housed at the Public Record Office at Kew. He includes the exact address, telephone number, and possible difficulties that an investigator might encounter.

Serious students of mid-Victorian ironstone-type earthenware exports need to add this carefully researched reference text to their libraries. The continuing efforts of Geoffrey Godden and other English authorities to ferret out ceramic facts of interest during this time period are appreciated worldwide.

Jean Wetherbee
White Ironstone China Association

1. J. P. Cushion, *Handbook of Porcelain & Pottery Marks*, 4th ed. (London: Faber and Faber, 1980).

---

Peter Williams and Pat Halfpenny. *A Passion for Pottery: Further Selections from the Henry H. Weldon Collection.* London: Sotheby's, 2000. 369 pp.; color photography by Gavin Ashworth. $350.00.

Peter Williams and Pat Halfpenny's book about the Weldon collection of seventeenth- and eighteenth-century British pottery inspires lust in the heart of any collector of this material. The collection, built over the past twenty years, may be the best private collection of its type in the world. The two handsome volumes devoted to cataloging this extraordinary collection, with their splendid photographs, informative and well-written texts, and handsome formats, are manna to students and collectors. Williams and Halfpenny have continued the high scholarly standards established by Leslie B. Grigsby with the first Weldon catalog, *English Pottery, 1650–1800:*

*The Henry H. Weldon Collection* (Sotheby's, 1990). Gavin Ashworth's exquisite photographs in both volumes are a delight for the student or collector who seeks to study clear, large-format pictures that reveal details and convey accurate color. Jeanne Snyder's design is clean; her choices of paper stock, layout, and typeface make page-turning a pleasure.

Letitia Roberts states in her foreword that education is a lifelong passion of the Weldons, who envisioned the original book as "not just a catalogue of the collection, but a real textbook." Both of the Weldon catalogs have fulfilled their goal of providing teaching tools. One wishes—because of their usefulness as textbooks—that subsidies had been available to lower the price of such important and useful publications. The high price of both books puts them out of the range of many students and, as the cost of art books escalates, of museum libraries forced to choose among important publications. This said, the Weldon volumes prove more useful reference works than several lesser volumes.

All serious collectors eventually realize that mistakes are the best teachers. Henry and Jimmy Weldon's lessons began when they suspected that a small minority of pieces from their early collecting years were not what they purported to be. One must admire the Weldons for getting back on the collecting horse after difficulties that would have daunted most ardent collectors. They proved their abiding passion for pottery and are especially to be commended for the efforts they have made to help others learn from their hard-earned lessons. They have lectured on their collection and on the fakes and have lent both fakes and authentic pieces to major museums for study and exhibition. They actively participated in the trial of the accused forger and shared their problem pieces as a focus of a Sotheby's seminar on fakes. By these educational efforts the Weldons have generously helped other collectors avoid the pitfalls that led to the fraud so cleverly perpetrated upon them.

The Weldons, with Pat Halfpenny (currently chief curator at the Winterthur Museum; at press time, keeper of ceramics at the City Museum in Stoke-on-Trent and one of the world's leading authorities on eighteenth-century English pottery), serve as admirable examples to museums, which sometimes are reluctant to take a public stand in this sort of controversy. A fascinating and distinguishing aspect of this catalog is Halfpenny's essay on the curatorial process of sorting period pieces from extremely clever fakes. In "Collector Beware" she describes the process she used during the trial of the accused pottery faker by "translat[ing] connoisseurship into quantifiable observations" for the British Crown Prosecution Service. Her clearly detailed detective story—as fascinating as any best-selling thriller—even delights with an amazing surprise ending.

Roberts notes several valuable principles of collecting ceramics that have guided the Weldons. She cites the significance of keeping abreast of the latest archaeological excavations, which have been rapidly rewriting ceramic history and attributions in the past two decades. Roberts also emphasizes the importance of seeking provenanced pieces when building a collection.

The Weldons seem to have a genuine appreciation for generations of collectors passing the torch by studying and cherishing special objects. Object history became increasingly important to the Weldons after the problematic pieces from the first catalog were all realized to be without provenance older than about a decade. Ironically, provenance in this Weldon catalog is noted only selectively. While many significant former owners are cited, dealers who sold pieces to the Weldons are mentioned only when a piece was featured in dealers' publications.

One conspicuous lapse in citing object history involves an important tea party group (no. 212). When this piece was sold at Sotheby's in the mid-1990s it fetched a landmark price that generated considerable publicity; it was purchased by another prominent collector of British pottery. The authors note that this remarkable social history tableau was sold at Sotheby's, London, in 1980, but their list of its provenance neglects to include the 1990s New York auction or the most recent pre-Weldon owner. Sound scholarship dictates noting all known previous owners, both dealers and collectors.

The entries are uniformly well written, and the authors avoid jargon. There is only occasional need for clarification. One such entry is number 85, a toy sugar bowl and saucer that appear to be solid agate-swirled colored clays blended throughout the entire body, rather than just on the surface. These pieces are grouped with creamware, rather than agate, however, and are described as "rouletted and inlaid with fine spiraling striations of blue and brown clay," a representation that does not fully explain the process. The authors note that this decoration possibly matches contemporary descriptions of "dip't and turn'd" wares, but do not footnote the source of the period quote. It seems possible that the toy pieces represent creamware with surface agate decoration, what Rickard and Carpentier term "inlaid patterns on dipped wares," which were then turned on a lathe to smooth the inlaid clay and, finally, rouletted.[1]

Several vocabulary choices might have been improved. The term "Chinaman" (p. 12), although used for years in decorative arts scholarship, is now considered offensive. The designation of "associated" lids seems awkward. This terminology avoids the straightforward acknowledgment that a top and bottom did not start life together. When this term is used, as with the designations of later color, it raises questions in the reader's mind: What was the lid's shape, fit, lack of rim overhang?

Condition and conservation reports would have been useful components of each entry. Such reports are the accepted scholarly standard in furniture catalogs. This landmark catalog could have pushed ceramic scholarship in that direction. Ceramics collectors too often have unrealistic expectations of near-perfect condition in a medium of inherent fragility. Analysis of the condition of objects in such a superlative collection would have been a progressive addition to this important contribution to ceramic scholarship.

As an aspect of condition, one wants to know more of the authors' thinking when they state that color might be later decoration. How could a collector make the same determination? Regarding teapot number 30

they say that the decoration was "possibly added later," cite it as "almost identical" to a pot in the Metropolitan Museum, but then fail to clarify whether the Metropolitan's example is decorated in the period or later. Numbers 21, 24, and 46 are also cited as having suspicious decoration. As a teaching tool, these slightly suspect examples might have been advantageously grouped as case studies. Their interspersion with pristine examples in the collection confers a misleading credence, particularly with salt-glazed stoneware fruit dish number 46; the added color is such a major change to an otherwise run-of-the-mill object, one questions whether it merits a whole-page photograph.

Two organizational issues would have made the book an easier reference source. The categorization of objects within typological groupings is random. For instance, within the section on "lead glazed cream coloured earthenwares—tea and coffee wares," why not group together the "green and gold" (as Josiah Wedgwood called such underglazed oxide pieces) and other like wares? It is frustrating to try to survey all tea wares of like body and decoration because wares are interspersed rather than grouped. Also confusing is the use of Weldon accession numbers as reference numbers in the essays, which makes cross-referencing difficult. It would have been straightforward to use book entry numbers, designating whether the object is in catalog one or two.

The gilding on the blackware teapot number 139 is cited as an exceptional example of japanned decoration. Given its rarity, one yearns to see its other side, which is not illustrated. The photographic approach in the book proves the success of the Weldons' goal of educating via publication of their collection. The large photograph enables one to see that the japanned design is similar to that on a cast-iron stoveplate made about 1770 at Isaac Zane's Marlboro Furnace near Winchester, Virginia. The common design source was undoubtedly Lock and Copeland's *New Book of Ornaments*, published in London in 1752.[2] Leslie Grigsby explored many such pattern book relationships on British pottery in the first catalog of the Weldon collection and later in a series of articles in *Antiques*.

*A Passion for Pottery* must be in the library of any serious collector or student of British ceramics. Its photographs alone provide an invaluable resource. Combined with superbly educational text, the book sets a new high bar towards which other scholars will aim in ceramic publishing.

Elizabeth Gusler
Vice President, George Washington's Fredericksburg Foundation

1. Jonathan Rickard and Donald Carpentier, "Methods of Slip Decoration on Fine Utilitarian Earthenware," *American Ceramic Circle Journal* 10 (1997): 38, 46.

2. Morrison H. Heckscher and Leslie Greene Bowman, *American Rococo, 1750–1775: Elegance in Ornament* (New York: Metropolitan Museum of Art and Los Angeles County Museum of Art, 1992), pp. 5, 225.

*Compiled by*
*Amy C. Earls*

Checklist of Articles
and Books on
Ceramics in
America Published
1998–2000

▼ THE FOLLOWING LIST includes publications about ceramics in America published in the years 1998, 1999, and the first half of 2000. This bibliography should help foster communication by exposing readers to books and articles produced in a range of disciplines—ceramic history, social history, museology, collecting, archaeology, and studio pottery. The selection process is aimed at including works on ceramics used or made in North America from the time of European colonization through the present day. Although the definition of American-made pottery is straightforward, the selection of works on ceramics used or potentially used in America is more problematic, as many archaeologically recovered fragments have yet to be identified as to country of origin.

The format of this bibliography most closely follows the checklist of recent publications on glass in the Corning Museum of Glass's *Journal of Glass Studies.* Another guide was Gerald Ward's bibliography in *American Furniture,* which references state of the art scholarly research. The fields of ceramics and furniture differ in significant ways, however. One difference is that archaeologists usually are faced with the common, utilitarian wares of any given period. Furniture research is biased more toward surviving pieces, which tend to be high-end products. Another difference is the important contributions that collectors without university, museum, or historical society affiliations have made to the field of ceramics research. Because antique ceramics are less expensive than antique furniture, many more personal collections exist and have been the subject of publication. Online auctions and commercial sites will make access to ceramic data even easier in the future. I decided to include popular collectibles books, despite their lack of peer review and professional editing, in the expectation that the illustrations may be valuable in their own right.

Most of the entries are the result of online searches of the following databases: Online Computer Library Center's World Catalog First Search, and R. R. Bowker's Books in Print for books; ABC-CLIO's America: History and Life and also Historical Abstracts, and H. W. Wilson's Art Full Text and Retrospective for journals; and Bell and Howell's ProQuest's PA Research and PA Research II for popular magazines. Because I have not been able personally to examine most of the publications, my selection was based on full text (generally available for popular magazine articles only) online, abstracts, if available, and quite often on title and keywords alone. In addition, I examined recent journals and newsletters of national and regional ceramic and historical archaeological societies.

Dependence on online searches has enabled me to produce a wide-ranging, although by no means comprehensive or complete, bibliography of recent publications concerning ceramics in America. References range from popular books and auction catalogs aimed at a collector's audience to dissertations with a theoretical bent. The burden is on the reader to examine and select the references. I have tried to be as inclusive as possible in the hope that readers will find a few unfamiliar references. I did not, however, include new editions of collectors' books in which the revision was confined to updating the prices.

I would like to highlight one work in the following list—Rodney Hampson's *Pottery References in the Staffordshire Advertiser, 1795–1865*. Publication of this invaluable work by the Northern Ceramic Society was made possible by advance subscription. Hampson has abstracted ceramics references from *Staffordshire Advertiser* issues dating from 1795 through 1865 in sufficient detail that even those who cannot consult the original newspapers or microfilms in England can find valuable historical details about these potteries that are not available in Godden's encyclopedia of marks. For example, with reference to the New Discoveries entry on the competition between the Clews and Jackson brothers in this issue, Hampson's book provides details on the Clews' bankruptcy, including occupation of their potworks by other firms and auctioning of their utensils, as well as newsworthy events at their related businesses, such as a colliery and flint mill.

I profess some alarm at an apparent trend toward producing extremely expensive catalogs of private collections. I wonder how many collectors or dealers, not to mention students, could afford to purchase these books and whether alternative formats, such as CD-ROM, that would reach a larger audience have been considered.

This checklist is intended to provide a service to the reader. Comments, suggestions, corrections, and additional references for 1998 through the present would be appreciated for subsequent issues of the journal. I would appreciate readers calling to my attention important publications in museum or university bulletins and non-technical works on conservation. I issue a special call to archaeologists for help with the so-called gray literature of contract or rescue archaeology reports. Please address all communications to the Book and Exhibit Review Editor, *Ceramics in America*, P.O. Box 121, Florence, New Jersey, 08518, U.S.A. <trentonpots@yahoo.com>. I thank Recording for the Blind and Dyslexic for access to Princeton University's Firestone Library and online databases.

Adams, Elizabeth. "Women in the Eighteenth Century Ceramic Trade and Some Detailed Prices of That Time." *Northern Ceramic Society Journal* 16 (1999): 1–21.

Allan, John. "Producers, Distributors and Redistributors: The Role of the South Western Ports in the Seventeenth Century Ceramics Trades." In *Old and New Worlds*, edited by Geoff Egan and Ronn L .Michael, 278–88. Oxford: Oxbow Books, 1999.

Archamboult, Florence. *Occupied Japan for the Home*. A Schiffer Book for Collectors. Atglen, Pa.: Schiffer, 2000.

Arend, Liana Paredes, and Hillwood Museum and Gardens Staff. *Sèvres Porcelain at Hillwood*. The Hillwood Collection Series. Washington, D.C.: Hillwood Museum and Gardens, 1998.

Arman, David, and Linda Arman. *Anglo-American Ceramics: Transfer-Printed Creamware and Pearlware for the American Market, 1760–1860*. Part 1. Portsmouth, R.I.: Oakland Press, 1998.

Armes, Pat, and Keith Armes. *The Collector's Guide to Lady Figurine Planters*. A Schiffer Book for Collectors. Atglen, Pa.: Schiffer, 2000.

*Art Nouveau Glass and Ceramics*. Centuries of Style. Hoo, Kent, England: Grange Books, 1998.

Askey, Derek. *Stoneware Bottles, 1500–1949*. 2nd updated ed. Brighton, England: BBR, 1998.

Atterbury, Paul. *The Dictionary of Minton*. Rev. ed. Woodbridge, Suff., England: Antique Collectors' Club, 1998.

Atterbury, Paul, Ellen Denker, and Maureen Batkim. *Miller's 20th Century Ceramics: A Collector's Guide to British and North American Factory-Produced Ceramics*. London: Miller's, 1999.

Ballay, Ute. "Clay Menageries." *Antiques & Collecting Magazine* (May 2000).

Barker, David. "Bits & Bobs—The Development of Kiln Furniture in the 18th Century Staffordshire Pottery Industry." *English Ceramic Circle Transactions* 16, pt. 3 (1998): 318–41.

——. *A New Perspective of the Staffordshire Potteries*. London: Jonathan Horne, 1998.

——. "The Ceramic Revolution 1650–1850." In Egan and Michael, *Old and New Worlds*, 226–34.

Barker, David, and Sam Cole, eds. *Digging for Early Porcelain: The Archaeology of Six 18th-Century British Porcelain Factories*. Stoke-on-Trent, Staffs., England: City Museum and Art Gallery, 1998.

——. "The Longton Hall–West Pans Puzzle." In Barker and Cole, *Digging for Early Porcelain*, 35–39.

——. "William Littler at Longton Hall." In Barker and Cole, *Digging for Early Porcelain*, 4–21.

Barker, David, and Wendy Horton. "The Development of the Coalport Chinaworks: Analysis of Ceramic Finds." *Post-Medieval Archaeology* 33 (1999): 3–93.

Bassett, Mark T. *Introducing Roseville Pottery*. A Schiffer Book for Collectors. Atglen, Pa.: Schiffer, 1999.

——. *Bassett's Roseville Prices*. A Schiffer Book for Collectors. Atglen, Pa.: Schiffer, 2000.

Batkin, Maureen. "Wedgwood and the Arts and Crafts Movement: Alfred (1865–1960) and Louise (1882–1956) Powell's Association With the Sapperton Group." In McLeod and Boyle, *The Heritage of Wedgwood*, 187–211.

Beaman, Thomas E., Jr., and John J. Mintz. "Iberian Olive Jars at Brunswick Town and Other British Colonial Sites: Three Models for Consideration." *Southeastern Archaeology* 17, no. 1 (1998): 92–102.

Bess, Phyllis, and Tom Bess. *Frankoma and Other Oklahoma Potteries*. Rev. and exp. 3rd ed. A Schiffer Book for Collectors. Atglen, Pa.: Schiffer, 2000.

Bilotti, Lawrence. "Making History." *Country Living* (April 2000): 37–38.

Bimson, Mavis. "The Ceramic Catalogue of W. L. Little." *English Ceramic Circle Transactions* 16, pt. 3 (1998): 299–300.

Black, John. "The Frequency of Use of Colours on English Delftware: The Problem of Manganese Purple." *English Ceramic Circle Transactions* 17, pt. 1 (1999): 65–68.

——. "The Organisation of Delftware Pothouses and the Role of Women in Management." *Northern Ceramic Society Journal* 16 (1999): 31–37.

Blake, Marie E., and Martha Doty Freeman. *Nineteenth-Century Transfer-Printed Ceramics from the Texas Coast: The Quintana Collection*. Austin, Tex.: Prewitt and Associates, 1998.

Blaszczyk, Regina Lee. *Imagining Consumers: Design and Innovation from Wedgwood to Corning*. Studies in Industry and Society. Baltimore: Johns Hopkins University Press, 2000.

Blenkinship, Barbara. *Wetheriggs Pottery: A History and Collectors' Guide*. [London?]: Spencer, 1998.

Bomm, John, and Nancy Bomm. *Roseville in All Its Splendor*. Gas City, Ind.: L-W Book Sales, 1998.

Boone, Mary Lou. *Terre et Feu: Four Centuries of French Ceramics from the Boone Collection*. Exhibit catalog, Clark Humanities Museum, Scripps College, January 26–March 27, 1998. Claremont, Calif.: Clark Humanities Museum, 1998.

Bowers, Ken. "The Worcester Mark on G. F. Bowers Wares." *Northern Ceramic Society Newsletter*, no. 111 (1998): 34–42.

Brewer, Robin. *Noritake Dinnerware: Identification Made Easy*. A Schiffer Book for Collectors. Atglen, Pa.: Schiffer, 1999.

Bricknell, Brian R. *William John Coffee: 1773–c. 1846: Modeller, Sculptor, Painter and Ornamentalist: His Life and Work Reviewed*. [Grantham, Lincs., England]: Derby Porcelain International Society, 1998.

Brierley, John S. W. "Royal Lancastrian Pottery Ltd 1971–1975." *Northern Ceramic Society Journal* 15 (1998): 83–107.

——. "Royal Lancastrian Pottery Part II." *Northern Ceramic Society Journal* 16 (1999): 39–45.

Broughton, Renard. "Yorkshire Pottery: Identifying Early Blue Printed Patterns of the circa. [*sic*] 1785–1810 Period." *Northern Ceramic Society Newsletter,* no. 109 (1998): 4–16.

Bumpus, Bernard. *Collecting Rhead Pottery: Charlotte, Frederick, Frederick Hurten.* London: Francis Joseph, 1999.

Burman, Lionel. "Liverpool Advertiser 1756—Excerpts." *English Ceramic Circle Transactions* 17, pt. 1 (1999): 34–46.

Busby, Eileen R. *Royal Winton Porcelain: Ceramics Fit for a King.* Marietta, Ga.: Antique Publications, 1998.

Butler, Robert, Samantha Adams, and Meghan Humphreys. *The American Ceramic Society: 100 Years.* Kansas City, Mo.: Highwater Editions, 1998.

[Butter Pat Collectors International]. *Members of Butter Pat Collectors International Present for Your Pleasure 50 Famous Butter Pats from Their Individual Collections.* [Mass.]: A. Black, 1999.

Calvert, Hilary. *Chameleon Ware Art Pottery: A Collector's Guide to George Clews.* A Schiffer Book for Collectors. Atglen, Pa.: Schiffer, 1998.

Carney, Margaret. *Charles Fergus Binns: The Father of American Studio Ceramics, Including a Catalogue Raisonné.* Exhibit catalog, International Museum of Ceramic Art, New York State College of Ceramics, Alfred University, April 18–July 23, 1998. New York: Hudson Hills, 1998.

——. *Lost Molds and Found Dinnerware: Rediscovering Eva Zeisel's Hallcraft.* Exhibit catalog, International Museum of Ceramic Art, New York State College of Ceramics, Alfred University, February 11–September 9, 1999. Alfred, N.Y.: International Museum of Ceramic Art, 1999.

Casey, Andrew. *Twentieth Century British Ceramic Designers.* Wood-bridge, Suff., England: Antique Collectors' Club, 2000.

Cassidy-Geiger, Maureen. "The Porcelain Decoration of Ignaz Bottengruber." *Metropolitan Museum Journal* 33 (1998): 245–62.

Chase, Juliet. "Overglaze-Printed Worcester Porcelain at Winterthur." *Ars Ceramica* (1998/1999): 48–53.

Cheek, Charles D. "Massachusetts Bay Foodways: Regional and Class Influences." *Historical Archaeology* 32, no. 3 (1998): 153–72.

"The China Circle: The Export of Chinese Porcelain Round the World." 13-article special issue. *Oriental Art* 45, no. 1 (spring 1999).

Choi, Kee Il. "Chinese Export Porcelains for America." *Oriental Art* 45, no. 1 (spring 1999): 90–97.

[Christie's Amsterdam]. *Chinese and Japanese Ceramics and Works of Art.* Auction catalog, Christie's Amsterdam, May 13, 1998. Amsterdam: Christie's Amsterdam, 1998.

[——]. *Chinese and Japanese Ceramics and Works of Art.* Auction catalog, Christie's Amsterdam, May 12, 1999. Amsterdam: Christie's Amsterdam, 1999.

[Christie's East]. *European Furniture and Decorative Arts Including Ceramics.* Auction catalog, Christie's East, January 26–27, 2000. New York: Christie's East, 2000.

[Christie's New York]. *Vincennes and Sèvres Porcelain from a New England Collection.* Auction catalog, Christie's New York, May 5, 1999. New York: Christie's New York, 1999.

[Christie's South Kensington]. *British and Continental Ceramics.* Auction catalog, Christie's South Kensington, January 29, 1998. London: Christie's South Kensington, 1998.

[——]. *British and Continental Furniture from 1860 to the Present Day and 20th Century British Decorative Arts.* Auction catalog, Christie's South Kensington, October 28–29, 1998. London: Christie's South Kensington, 1998.

[——]. *20th Century British Decorative Arts.* Auction catalog, Christie's South Kensington, February 13, 1998. London: Christie's South Kensington, 1998.

[——]. *British and Continental Ceramics and Glass.* Auction catalog, Christie's South Kensington, December 2, 1999. London: Christie's South Kensington, 1999.

[——]. *19th Century British and Continental Ceramics.* Auction catalog, Christie's South Kensington, July 1, 1999. London: Christie's South Kensington, 1999.

[——]. *20th Century British Decorative Arts.* Auction catalog, Christie's South Kensington, July 21, 1999. London: Christie's South Kensington, 1999.

[——]. *20th Century British Decorative Arts and Furniture from 1860 to the Present Day.* Auction catalog, Christie's South Kensington, October 27, 1999. London: Christie's South Kensington, 1999.

[——]. *Chintz, Beswick, Doulton, Poole and Carlton Ware.* Auction catalog, Christie's South Kensington, August 19, 1999. London: Christie's South Kensington, 1999.

[——]. *Moorcroft Pottery.* Auction catalog, Christie's South Kensington, October 8, 1999. London: Christie's South Kensington, 1999.

[——]. *British and Continental Ceramics.* Auction catalog, Christie's South Kensington, February 10, 2000. London: Christie's South Kensington, 2000.

Cil, Sakine. "The Relationship between 20th Century Ceramics and Painting." *Ceramics,* no. 33 (1998): 8–14.

[Cincinnati Art Galleries]. *Roseville 2000.* Auction catalog, Cincinnati Art Galleries, June 2, 2000. Cincinnati, Ohio: Cincinnati Art Galleries, 2000.

Clark, Phyllis Blair. *Functional Ceramics.* Exhibit catalog, Wayne Center for the Arts, March 19–April 17, 1999. Wooster, Ohio: Wayne Center for the Arts, 1999.

Cleggett, Mavis. "A Chamberlain Dessert Service for America." *Northern Ceramic Society Journal* 16 (1999): 77–83.

Clements, Monica Lynn, and Patricia Rosser Clements. *Popular Souvenir Plates*. A Schiffer Book for Collectors. Atglen, Pa.: Schiffer, 1998.

Cliff, Stafford. *English Archive of Design and Decoration*. New York: Harry N. Abrams, 1998.

Cluett, Robert E. *George Jones Ceramics, 1861–1951*. A Schiffer Book for Collectors. Atglen, Pa.: Schiffer, 1998.

Cockerill, John. "The Clarence Potteries, Norton, Stockton-on-Tees." *Northern Ceramic Society Newsletter*, no. 112 (1998): 34–44.

——. "Thomas Snowball's Iron Lustre." *Northern Ceramic Society Newsletter*, no. 112 (1998): 14–17.

Cole, Sam. "Early Worcester." In Barker and Cole, *Digging for Early Porcelain*, 63–75.

——. "Samuel Gilbody of Liverpool." In Barker and Cole, *Digging for Early Porcelain*, 76–84.

Collard, Elizabeth, and Winnipeg Art Gallery. *The Canadiana Connection: 19th Century Pottery Made for the Canadian Market*. Focus, no. 2. Winnipeg: Winnipeg Art Gallery, 1998.

Collard, Elizabeth, and Winnipeg Art Gallery. *The Decorative Element: British Earthenware, Mid 18th-Early 20th Century, Collection of the Winnipeg Art Gallery*. Focus, no. 3. Winnipeg: Winnipeg Art Gallery, 2000.

[Conestoga Auction Co.]. *The J. Harlan Miller Collection*. Auction catalog, Conestoga Auction Co., Manheim, Pa., October 17, 1998. Manheim, Pa.: Conestoga Auction Co., 1998.

Conroy, Barbara J. *Restaurant China: Identification & Value Guide for Restaurant, Airline, Ship & Railroad Dinnerware*, vols. 1 and 2. Paducah, Ky.: Collector Books, 1998–1999.

Cooke, Nigel T. "Dated 18th Century Worcester Porcelain—An Update (1751–1790)." *Northern Ceramic Society Newsletter*, no. 112 (1998): 25–28.

Copeland, Robert. *Spode*. Princes Risborough, Bucks., England: Shire, 1998.

——. *Spode's Willow Pattern and Other Designs after the Chinese*. 3rd ed. London: Studio Vista, 2000. Distributed in the U.S. by Sterling.

Coupe, Elizabeth R. *Collecting Burleigh Jugs: A Photographic Guide to the Art Deco Jugs and Fancies of Burgess and Leigh*. Melton Mowbray, England: Letterbox, 1998.

Cox, Alwyn. "Recent Excavations at the Swinton/Rockingham Pottery: The Brameld Period, 1806–42." *English Ceramic Circle Transactions* 17, pt. 1 (1999): 86–114.

Crass, David Colin, Bruce R. Penner, and Tammy R. Forehand. "Gentility and Material Culture on the Carolina Frontier." *Historical Archaeology* 33, no. 3 (1999): 14–31.

Cunningham, Helen C. *Clarice Cliff and Her Contemporaries: Susie Cooper, Keith Murray, Charlotte Rhead, and the Carlton Ware Designers*. A Schiffer Book for Collectors. Atglen, Pa.: Schiffer, 1999.

Cunningham, Jo. *Homer Laughlin China: "A Giant among Dishes," 1873–1937*. A Schiffer Book for Collectors. Atglen, Pa.: Schiffer, 1998.

——. *Homer Laughlin China: 1940s & 1950s*. A Schiffer Book for Collectors. Atglen, Pa.: Schiffer, 2000.

Davey, Peter J. "A Nineteenth-Century Export Ceramic Assemblage from Poyll Vaaish." In *Recent Archaeological Research on the Isle of Man*, edited by Peter J. Davey, 281–302. BAR [British Archaeological Reports] British Series, no. 278. Oxford: Archaeopress, 1999.

Dawson, David, and Oliver Kent. "Reduction Fired Low-Temperature Ceramics." *Post-Medieval Archaeology* 33 (1999): 164–78.

Day, Marc. *Selected Papers on Buyer-Supplier Interaction in the UK Tableware Supply Chain*. (A collection of papers relating to a three-year DTI/EPSRC-sponsored doctoral study in the UK tableware industry.) Stoke-on-Trent, Staffs., England: CERAM Research and Birchall Centre for Inorganic Chemistry, 1999.

Décarie-Audet, Louise. *Le grès français de Place-Royale*. 2nd ed. Collection Patrimoines, no. 46. Québec: Ministère de la culture et des communications, 1999.

DeGroft, Aaron. "Eloquent Vessels/Poetics of Power: The Heroic Stoneware of 'Dave the Potter.'" *Winterthur Portfolio* 33, no. 4 (1998): 249–60.

Desens, Rainer, and Luitwin Gisbert von Boch-Galhau. *Villeroy & Boch: 250 Years of European Industrial History, 1748–1998*. Mettlach, Germany: Villeroy & Boch Aktiengesellschaft, 1998.

Deverill, Ian, and C. Barry Sheppard. *Billingsley Mansfield: An Exhibition to Celebrate the Millennium and the Bicentenary of William Billingsley's Mansfield Porcelain-Decorating Establishment, 1799–1802*. [Pinxton, England]: Pinxton Porcelain Society, 1999.

Devine, Joe, Leslie C. Wolfe, and Marjorie A. Wolfe. *Royal Copley (Plus Royal Windsor and Spaulding)*. Book 2. Paducah, Ky.: Collector Books, 1999.

Dewolf, Helen C. "Chinese Porcelain and Seventeenth-Century Port Royal, Jamaica." Ph.D. dissertation, Anthropology Department, Texas A&M University, 1998.

Diehl, Michael, Jennifer A. Waters, and J. Homer Thiel. "Acculturation and the Composition of the Diet of Tucson's Overseas Chinese Gardeners at the Turn of the Century." *Historical Archaeology* 32, no. 4 (1998): 19–33.

Dommel, Darlene Hurst. *Collector's Encyclopedia of Rosemeade Pottery: Identification & Values*. Paducah, Ky.: Collector Books, 2000.

Dudson, Audrey M. *A Pottery Panorama*. Stoke-on-Trent, Staffs., England: Dudson, 1999.

Duncan, Alastair. *The Paris Salons, 1895–1914*. Vol. 4, *Ceramics and Glass*. Woodbridge, Suff., England: Antique Collectors' Club, 1998.

Edwards, Diana, and Rodney Hampson. *English Dry-Bodied Stoneware: Wedgwood and Contemporary*

*Manufacturers, 1774–1830*. Wappingers Falls, N.Y.: Antique Collectors' Club, 1998.

"Eighteenth-Century Markets and Manufactures in England and France." *Journal of Design History* 12 (1999): 185–292.

Elliott, Gordon. *John and David Elers and Their Contemporaries*. London: Jonathan Horne, 1998.

Emmerson, Robin. "John Devaere's Work in Rome for Wedgwood." *Ars Ceramica* (1998/1999): 54–61.

———. "Stubbs and Wedgwood: New Evidence from the Oven Books." *Apollo* (August 1999): 50–55.

*English China Marks* [previously published 1883(?) as *English China and China Marks*]. Edmonton, Alb., Canada: Shorthorn Press, 1999.

Ewins, Neil. "A Picture of Midwest American Ceramics 'Taste': Staffordshire Ceramics for the St. Louis Market." In McLeod, *Wedgwood*, 178–99.

Fennimore, Donald L., and Patricia A. Halfpenny. *Campbell Collection of Soup Tureens at Winterthur*. Winterthur, Del.: Henry Francis du Pont Winterthur Museum, 2000.

Fernández de Vega, Ricardo Rodolfo. "The Dialectic between the Archaeological and Historical Records: Consumer Choice and Symbolic Value in 19th Century British Pottery from the Warren Hause Site." M.S. thesis, Department of Anthropology, University of Wisconsin, Milwaukee, 1998.

Fischler, George, and Barrett Gould. *Scandinavian Ceramics and Glass: 1940s to 1980s*. A Schiffer Book for Collectors. Atglen, Pa.: Schiffer, 2000.

Fisk, Geoffrey. "Matchings Produced by Spode." *Northern Ceramic Society Journal* 15 (1998): 109–29.

Fitts, Robert K. "The Archaeology of Middle-Class Domesticity and Gentility in Victorian Brooklyn." *Historical Archaeology* 33, no. 1 (1999): 39–62.

Ford, Geoff. *Encyclopaedia of Australian Potters' Marks*. Wodonga, Vic., Australia: Salt Glaze Press, 1998.

Forrest, Tim, and Paul Atterbury. *The Marshall Guide to Antique China & Silver: An Illustrated Guide to Tableware, Identifying Period, Detail and Design*. London: Marshall, 1998.

Francis, Peter, and Linda Canning. *Belfast Creamware: The Downshire Pottery*. Belfast: Institute of Irish Studies, Queen's University of Belfast, 1998.

Freestone, Ian, and David Gaimster, eds. *Pottery in the Making: Ceramic Traditions*. Washington, D.C.: Smithsonian Institution Press, 1998.

Frelinghuysen, Alice Cooney. "Paris Porcelain in America." *The Magazine Antiques* (April 1998): 554–63.

———. "Union Porcelain Works: Cup and Saucer." *The Metropolitan Museum of Art Bulletin* 56, no. 2 (fall 1998): 56–57.

———. "Emily Johnston de Forest." *The Magazine Antiques* (January 2000): 192–97.

Furniss, David A., J. Richard Wagner, and Judith Wagner. *Adams Ceramics: Staffordshire Potters & Pots, 1779–1998*. A Schiffer Book for Collectors. Atglen, Pa.: Schiffer, 1999.

Gabszewicz, Anton. *Made at New Canton: Bow Porcelain from the Collection of the London Borough of Newham*. Exhibit catalog, Christie's, Newham Museum at Manor Park Library, Potteries Museum & Art Gallery, and Museum of Worcester Porcelain. London: English Ceramic Circle, the London Borough of Newham, and the Newham Millennium Celebrations 2000 Committee, 2000.

Gabszewicz, Anton, and Roderick Jellicoe. *Isleworth Porcelain*. [London: Exhibit catalog E. & H. Manners], 1998.

Gaimster, David R. M., ed. *Maiolica in the North: The Archaeology of Tin-Glazed Earthenware in North-West Europe, c. 1500–1600*. Proceedings of a colloquium hosted by the Department of Medieval and Later Antiquities, British Museum, March 6–7, 1997. British Museum Occasional Paper, no. 122. London: British Museum, 1999.

———. "The Post Medieval Ceramic Revolution in Southern Britain c. 1450–1650." In Egan and Michael, *Old and New Worlds*, 214–25.

Garman, James C., and Paul A. Russo. "'A Disregard of Every Sentiment of Humanity': The Town Farm and Class Realignment in Nineteenth-Century Rural New England." *Historical Archaeology* 33, no. 1 (1999): 118–35.

Gater, Sharon. "Alfred and Louise Powell and After—the Legacy of Arts and Crafts at Wedgwood." In McLeod, *Wedgwood*, 145–56.

———. "Harry Barnard—Pioneer Potter and Philosopher." In McLeod, *Wedgwood*, 133–44.

———. "Some of Wedgwood's Unsung Heroes: Nineteenth-Century Travellers at Home and Abroad." *Ars Ceramica* (1998/1999): 68–74.

Gessner, Wanda. *Spaghetti Art Ware: Poodles & Other Collectible Ceramics*. A Schiffer Book for Collectors. Atglen, Pa.: Schiffer, 1998.

Gibson, Michael. *19th Century Lustreware*. Woodbridge, Suff., England: Antique Collectors' Club, 1999.

Gifford, David Edwin. *Collector's Guide to Camark Pottery: Identification & Values*. Book 2. Paducah, Ky.: Collector Books, 1999.

Glassie, Henry H. *The Potter's Art*. Bloomington: Indiana University Press, 2000.

Gleeson, Janet. *The Arcanum: The Extraordinary True Story*. New York: Warner Books, 1999.

Godden, Geoffrey A. *Godden's Guide to Ironstone, Stone & Granite Wares*. Woodbridge, Suff., England: Antique Collectors' Club, 1999.

———. *New Handbook of British Pottery & Porcelain Marks*. 2nd rev. and enl. ed. London: Barrie and Jenkins, 1999.

Goodby, Miranda. "Porcelain Production in Newcastle-under-Lyme." In Barker and Cole, *Digging for Early Porcelain*, 54–62.

Goodfellow, Peter. "The Keeling Potteries in Tunstall." *Northern Ceramic Society Journal* 16 (1999): 125–28.

Goss, Steven. *British Tea and Coffee Cups—1745–1940*. Princes Risborough, Bucks., England: Shire, 2000.

Greeley, Alexandra. *Asian Tureens*. New York: Macmillan, 1998.

Green, Chris. *John Dwight's Fulham Pottery: Excavations 1971–1979*. English Heritage, Archaeological Report no. 6. London: English Heritage, 1999.

Griffin, John D. "'Fired Earth'—Some Shards from Rawmarsh." *Northern Ceramic Society Newsletter*, no. 115 (1999): 16–20.

Griffin, Leonard, and Michael Slaney. *Taking Tea with Clarice Cliff: A Celebration of Her Art Deco Teaware*. London: Pavilion, 1998.

——. *The Fantastic Flowers of Clarice Cliff: A Celebration of Her Floral Designs*. New York: Harry N. Abrams, 1998.

Grigsby, Leslie B. "Dated English Delftware and Slipware in the Longridge Collection." *The Magazine Antiques* (June 1999): 876–85.

——. *The Longridge Collection of English Slipware and Delftware*. London: Jonathan Horne, 2000.

Gusler, Elizabeth Pitzer. "'All the Appendages for an Handsome Tea Table': Private Tea and Tea Wares in Colonial Virginia." In McLeod and Boyle, *The Heritage of Wedgwood*, 101–25.

Gutter, Malcolm. *Through the Looking Glass: Viewing Böttger and Other Red Stoneware*. San Francisco: Malcolm D. Gutter, 1998.

Hampson, Rodney. "John Bartlam's Companions to America in 1763." *Northern Ceramic Society Journal* 15 (1998): 79–82.

——. *Pottery References in The Staffordshire Advertiser, 1795–1865*. Northern Ceramic Society, Occasional Publication no. 4. Stoke-on-Trent, Staffs., England: Northern Ceramic Society, 2000.

Hanson, Bob, Craig Nissen, and Margaret Hanson. *McCoy Pottery:*

*Collector's Reference & Value Guide Featuring the Top 100 Findables*. Vol. 2. Paducah, Ky.: Collector Books, 1999.

Harding, Adrian, and Nicholas Harding. *Victorian Staffordshire Figures 1835–1875: Religious, Hunters, Pastoral, Occupations, Children & Animals, Cottages & Castles, Sport & Miscellaneous*. Book 2. A Schiffer Book for Collectors. Atglen, Pa.: Schiffer, 1998.

——. *Victorian Staffordshire Figures, 1835–1875: Portraits, Military, Theatrical, Religious, Hunters, Pastoral, Occupations, Animals, Cottages, Sport, Miscellaneous*. Book 3. A Schiffer Book for Collectors. Atglen, Pa.: Schiffer, 2000.

Harding, Kit, Adrian Harding, and Nicholas Harding. *Staffordshire Figures of the 19th & 20th Centuries*. Miller's Collector's Guide. Tenterden, England: Miller's, 2000.

Hardy, Meredith D. "A Question of Origin: Archaeological Evidence of 18th Century Spanish Trading Practices in the New Orleans Colony, Hermann-Grima House 160R45." M.S. thesis, College of Urban and Public Affairs, University of New Orleans, 1998.

Harran, Jim, and Susan Harran. *Collectible Cups & Saucers*. Book 2. Paducah, Ky.: Collector Books, 2000.

Hart, John P., and Charles L. Fisher, eds. *Nineteenth- and Early Twentieth-Century Domestic Site Archaeology in New York State*. New York State Museum Bulletin 495. Albany: New York State Museum, 2000.

Haselgrove, Dennis, and Jan van Loo. "Pieter van den Ancker and Imports of Frechen Stoneware Bottles and Drinking Pots in Restoration London c. 1660–67." *Post-Medieval Archaeology* 32 (1998): 45–74.

Hawes, Vivian S. "Aesop's Fables on Two Early Chelsea Plates." *Ars Ceramica* (1998/1999): 34–37.

Hayward, Leslie, and Paul Atterbury. *Poole Pottery: Carter & Company and Their Successors, 1873–1998*.

Shepton Beauchamp, Som., England: Richard Dennis, 1998.

Heck, Dana B., and Joseph F. Balicki. "Katherine Naylor's 'House of Office': A Seventeenth-Century Privy." *Historical Archaeology* 32, no. 3 (1998): 24–37.

Helm, Peter, and Keith Farmer. "Hilditch Since 1982." *Northern Ceramic Society Journal* 16 (1999): 85–96.

Henzke, Lucile. *Art Pottery of America*. Rev. 3rd ed. A Schiffer Book for Collectors. Atglen, Pa.: Schiffer, 1999.

Hildyard, Robin. *European Ceramics*. London: V&A, 1999.

Hillis, Maurice, and Roderick Jellicoe. *The Liverpool Porcelain of William Reid: A Catalogue of Porcelain and Excavated Shards*. Exhibit catalog, Roderick Jellicoe, London, March 15–April 1, 2000. London: Roderick Jellicoe, 2000.

Holdaway, Minnie. "Moulded Porcelain Wares Made by William Littler at West Pans." In Barker and Cole, *Digging for Early Porcelain*, 22–34.

Holgate, David. "A New Hall Dessert Service." *Northern Ceramic Society Journal* 15 (1998): 47–54.

[Homer Laughlin China Collectors Association]. *Fiesta, Harlequin, & Kitchen Kraft Tablewares: The Homer Laughlin China Collectors Association Guide*. A Schiffer Book for Collectors. Atglen, Pa.: Schiffer, 2000.

Horsley, Tony. *Distinguished Extinguishers*. [London?]: [Anthony J. Horsley], 1999. (English pottery figures.)

Howard, David Sanctuary. "The Blossoming of Famille Rose." *Oriental Art* 44, no. 2 (summer 1998): 20–23.

——. "The British East India Company's Trading to China in Porcelain." *Oriental Art* 45, no. 1 (spring 1999): 45–51.

Howell, Sarah. "Spode You Like." *World of Interiors* (June 1999): 102–7. (Pattern books.)

Hoyte, Anthony. *The Charles Norman Collection of 18th Century Derby Porcelain: Supplementary Catalogue*.

[London?]: Trustees of the Charles Norman Collection, 1999.

Hyman, Neil. "William Ridgway's Pattern No. 1, and Some Unrecognised Offspring." *Northern Ceramic Society Newsletter*, no. 113 (1999): 9–15.

*International Directory of Importers: Kitchenware, Tableware and Glassware*. Rev. ed. Poulsbo, Wash.: Interdata, 2000.

Ironside, Margaret. "Yellow Shells." *Northern Ceramic Society Newsletter*, no. 113 (1999): 26–33.

———. "Yellow Shells." *Northern Ceramic Society Newsletter*, no. 114 (1999): 20.

———. "Cup Shapes—'Yellow Shell' Pattern." *Northern Ceramic Society Newsletter*, no. 115 (1999): 38–40.

Irvine, Louise. *Royal Doulton Series Ware: New Discoveries*. Vol. 5. Shepton Beauchamp, Som., England: Richard Dennis, 1998.

Jenkins, Steven, and Stephen P. McKay. *Portmeirion Pottery*. Shepton Beauchamp, Som., England: Richard Dennis, 2000.

Jones, Simon. "Staffordshire Animals." *Antiques & Collecting Magazine* (July 1999).

Jörg, Christiaan. "Yixing and Its European Imitations." In McLeod and Boyle, *The Heritage of Wedgwood*, 13–24.

Kamm, Dorothy. *Antique Trader's Comprehensive Guide to American Painted Porcelain, With Values*. 2nd ed. Dubuque, Iowa: Antique Trader Books, 1999.

Katz, Marshall P. *Portuguese Palissy Ware: A Survey of Ceramics from Caldas da Rainha, 1853–1920*. New York: Hudson Hills, 1999.

Keefe, John W., and John E. Bullard. *Paris Porcelains in the New Orleans Museum*. New Orleans: New Orleans Museum of Art, 1998.

Keller, Joe, and David Ross. *Russel Wright Dinnerware, Pottery & More: An Identification and Price Guide*. A Schiffer Book for Collectors. Atglen, Pa.: Schiffer, 2000.

Kelly, Henry E. *Scottish Ceramics*. A Schiffer Book for Collectors. Atglen, Pa.: Schiffer, 1999.

Kenny, Adele. *Staffordshire Animals: A Collector's Guide to History, Styles, and Values*. A Schiffer Book for Collectors. Atglen, Pa.: Schiffer, 1998.

Ketchum, William C., and Elizabeth von Habsburg. *The Antique Hunter's Guide to American Pottery and Porcelain*. Rev. ed. New York: Black Dog and Leventhal, 2000.

Keynes, Milo. "The Portland Vase: Sir William Hamilton, Josiah Wedgwood and the Darwins." *Notes and Records of the Royal Society of London* 52, no. 2 (1998): 237–59.

Klapthor, Margaret Brown. *Official White House China: 1789 to the Present*. 2nd ed. New York: Harry N. Abrams, 1999.

Koehn, Nancy F. "Josiah Wedgwood, 1730–1795: Brand Creation in the First Consumer Society." Graduate School of Business Administration, Division of Research, Working Paper 00-018. [Boston]: Division of Research, Harvard Business School, 1999.

Komodore, Bill. "19th-Century Texas Vernacular Ceramics." *Ceramics Monthly* (May 1999): 41–44.

Komodore, Bill, and Brookhaven College Studio Gallery. *Texas Vernacular Ceramics, 1845–1945: A Selection from the Bill Komodore Collection*. Exhibit catalog, Brookhaven College Center for the Arts, Studio Gallery, March 4–30, 1998. Farmers Branch, Tex.: Brookhaven College, 1998.

Koverman, Jill B. *I Made This Jar...: The Life and Works of the Enslaved African-American Potter, Dave*. Columbia: University of South Carolina and McKissick Museum, 1998.

Kowalsky, Arnold A., and Dorothy E. Kowalsky. *Encyclopedia of Marks on American, English, and European Earthenware, Ironstone, Stoneware, 1780–1980: Makers, Marks, and Patterns in Blue and White, Historic Blue, Flow Blue, Mulberry, Romantic Transferware, Tea Leaf, and White Ironstone*. A Schiffer Book for Collectors. Atglen, Pa.: Schiffer, 1999.

Kudriavtseva, Tamara. *The Tsars' White Gold: The Imperial Russian Porcelain Factory in St. Petersburg, 1760–1850*. Stuttgart: Arnoldsche, 2000.

Lang, Gordon. *Pottery & Porcelain Marks*. London: Miller's, 2000.

Lange, Amanda. "English Ceramic Wall Pockets." *Ars Ceramica* (1998/1999): 38–47.

Lawler-Mecca, Jennifer. "The Art of Dining." M.F.A. thesis, School of Art, East Carolina University (N.C.), 1999.

Leath, Robert A. "'After the Chinese Taste': Chinese Export Porcelain and Chinoiserie Design in Eighteenth-Century Charleston." *Historical Archaeology* 33, no. 3 (1999): 48–61.

Ledger, A. P., and Derby Porcelain International Society. *A Bibliography of Derby Porcelain Arranged in Chronological Order*. Grantham, Lincs., England: Derby Porcelain International Society, 1998.

Leibe, Frankie, Beverley Adams, and Beth Adams. *Ceramics of the '20s & '30s: A Collector's Guide*. Miller's Collector's Guides, no. 2. London: Miller's, 1999. Distributed in the U.S. by Antique Collectors' Club.

Levin, Elaine. *The History of American Ceramics: 1607 to the Present from Pikkpkins and Bean Pots to Contemporary Forms*. New York: Harry N. Abrams, 1998.

Lewis, Faith. "The Levine Collection at the Sands Point Preserve." *Ars Ceramica* (1998/1999): 8–22.

Lewis, Griselda. *Collector's History of English Pottery*. 4th ed. Wappingers Falls, N.Y.: Antique Collectors' Club, 1999.

Lindsay, Irene, and Ralph Lindsay. *ABC Plates & Mugs: Identification and Value Guide*. Paducah, Ky.: Collector Books, 1998.

Lockett, Terence. "English Porcelain and Colonial America." *English Ceramic Circle Transactions* 16, pt. 3 (1998): 283–97.

———. "Herbert Minton and Josiah Wedgwood." In McLeod and Boyle, *The Heritage of Wedgwood*, 149–63.

Luckin, Richard W. *Dining on Rails: An Encyclopedia of Railroad China*. 4th ed. Golden, Colo.: R K Publishing, 1998.

———. *Syracuse China and the Railroads*. Golden, Colo.: R K Publishing, 1999.

Macfarlane, Margaret C. "Oriental Influences on English Tin-Glazed Teaware c. 1650–1780." In McLeod and Boyle, *The Heritage of Wedgwood*, 25–52.

Magoon, Dane T. "The Ceramics of Craftsman Robert Hay and Family: An Analysis of Middle Class Consumer-Choice in Antebellum New Bern, North Carolina." M.A. thesis, Department of Anthropology, East Carolina University (N.C.), 1998.

Majewski, Teresita, and Vergil E. Noble. "British Ceramics on the American Colonial Frontier 1760–1800." In Egan and Michael, *Old and New Worlds*, 299–309.

Makus, Horst. *Adrien Dalpayrat, 1844–1910: French Ceramics of Art Nouveau*. Stuttgart: Arnoldsche, 1998.

———. *Day to Day of Modernism: Ceramics in the Fifties*. Stuttgart: Arnoldsche, 1998.

Mallet, John. "Chelsea Gold Anchor Vases—Part I." *English Ceramic Circle Transactions* 17, pt. 1 (1999): 126–61.

Maneker, Roberta. "Jazzed-Up Ceramics." *Art and Antiques* (March 2000). (Clarice Cliff ceramics.)

Markin, Trevor. "The Booth Family of Potters at Cliff Bank, Stoke-on-Trent." *Northern Ceramic Society Journal* 15 (1998): 17–46.

———. "Ralph Baddeley, Potter, of Shelton, Stoke on Trent." *Northern Ceramic Society Journal* 16 (1999): 97–124.

Marple, Leland, and Carol Marple. *R. S. Prussia: The Art Nouveau Years*. A Schiffer Book for Collectors. Atglen, Pa.: Schiffer, 1998.

———. *R. S. Prussia: The Wreath and Star*. A Schiffer Book for Collectors. Atglen, Pa.: Schiffer, 2000.

Martin, Ann Smart. *Makers and Users: American Decorative Arts, 1630–1820, from the Chipstone Collection*. Exhibit catalog, Elvehjem Museum of Art, University of Wisconsin, August 21–October 24, 1999. Madison, Wis.: Elvehjem Museum of Art, 1999.

Massey, Roger. "Jacques Louis Brolliet and the Oxford China Manufactory of 1755." *English Ceramic Circle Transactions* 17, pt. 1 (1999): 121–25.

Mawston, Colin. *British Art Deco Ceramics*. A Schiffer Book for Collectors. Atglen, Pa.: Schiffer, 2000.

McCarthy, Ruth. *Lefton China*. A Schiffer Book for Collectors. Atglen, Pa.: Schiffer, 1998.

McGarva, Andrew. *Country Pottery: Traditional Earthenware of Britain*. London: A. & C. Black, 2000.

McInnis, Maurie D. "'An Idea of Grandeur': Furnishing the Classical Interior in Charleston, 1815–1840." *Historical Archaeology* 33, no. 3 (1999): 32–47.

McIntyre, Stella. "Spode on a Grecian Urn." *World of Interiors* (February 2000): 84–89.

McKelway, Henry S. *Slaves and Master in the Upland South: Data Recovery in the Mabry Site (40KN86), Knox County, Tennessee*. Tennessee Department of Transportation, Office of Environmental Planning and Permits, Publications in Archaeology, no. 6. Nashville, Tenn.: Tennessee Department of Transportation, 2000.

McKeown, Julie. *Royal Doulton*. Princes Risborough, Bucks., England: Shire, 1998.

McLeod, Keith A. *Wedgwood: Production for Elegance, Fashion and Taste*. Proceedings of the Wedgwood International Seminar, nos. 41 and 42. Toronto: Wedgwood International Seminar, 1998.

McLeod, Keith A., and James R. Boyle, eds. *The Heritage of Wedgwood*. Proceedings of the Wedgwood International Seminar, nos. 36, 37, and 38. Toronto: Wedgwood International Seminar, 1998.

McQuade, Margaret Connors. *Talavera Poblana: Four Centuries of a Mexican Ceramic Tradition*. Exhibit catalog, Americas Society Art Gallery, Hispanic Society of America, and Museo Amparo. New York: Americas Society, 1999.

———. "Talavera Poblana: The Renaissance of a Mexican Ceramic Tradition." *The Magazine Antiques* (December 1999).

Meadows, Adela. *Quimper Pottery: A Guide to Origins, Styles, and Values*. A Schiffer Book for Collectors. Atglen, Pa.: Schiffer, 1998.

Melton, Nigel, and Keith Scott. "Polesworth: A North Warwickshire Country Pottery." *Post-Medieval Archaeology* 33 (1999): 94–126.

Miller, Charles L. *Depression Era Dime Store: Kitchen, Home, and Garden*. A Schiffer Book for Collectors. Atglen, Pa.: Schiffer, 2000.

Miller, George L. "The Association of Earthen Ware Dealers of Boston." In McLeod and Boyle, *The Heritage of Wedgwood*, 126–48.

Miller, Lynn. "Egyptian Influences on Wedgwood." In McLeod, *Wedgwood*, 110–32.

Miller, Michael R. *A Collector's Guide to Arizona Bottles & Stoneware: A History of Merchant Containers in Arizona*. Peoria, Ariz.: Miller Antiques, 1999.

Miller, Muriel M. *The Chintz Collectors Handbook*. London: Francis Joseph, 1998.

———. *The Royal Winton Collectors Handbook from 1925: Cottage Ware, Art Deco, Lustre Ware, Pastels, Etc.* London: Francis Joseph, 1998.

[Mint Museum of Art]. *William Littler: An English Potter, 1728–1784*. Charlotte, N.C.: Mint Museum of Art, 1998.

Moorcroft, Walter. *Walter Moorcroft: Memories of Life and Living*. Shepton Beauchamp, Som., England: Richard Dennis, 1999.

Morris, Donald. *The Potteries: A Photographic Record*. Wilmslow, Cheshire, England: Sigma, 1998.

Mosse, Nicholas. *Irish Country: Decorating with Pottery, Fabric, and*

*Furniture*. New York: Hearst, 1999.

Mullins, Paul R. *Race and Affluence: An Archaeology of African-American and Consumer Culture*. New York: Kluwer Academic/Plenum, 1999.

Munier-Wroblewska, Mia. *Die Goldmacher: Die Erfinder des Meissener Porzellans*. Heilbronn, Germany: E. Salzer, 1998.

Murnaghan, Diana Edwards. "Black Is Sterling: Wedgwood's Basalt Competitors." In McLeod and Boyle, *The Heritage of Wedgwood*, 164–86.

Neale, Gillian. *Blue & White Pottery*. Miller's Collector's Guides, no. 7. London: Miller's, 2000.

Nenk, Beverley S., and Michael J. Hughes. "Post Medieval Redware Pottery of London and Essex." In Egan and Michael, *Old and New Worlds*, 235–45.

Newell, Mark M., Nick Nichols, and Nancy Fulmer Baynham. "The River Front Potters of North Augusta: Preliminary Report." Georgia Archaeological Institute, Research Manuscript HC01-15. Augusta, Ga.: Georgia Archaeological Institute, 1998.

Nicholson, Nick, and Marilyn Nicholson. *Kenton Hills Porcelains, Inc.: The Story of a Small Art Pottery, 1939–1944*. Loveland, Ohio: D. A. Nicholson, 1998.

O'Neill, Ann Marie. *Popular Quimper*. A Schiffer Book for Collectors. Atglen, Pa.: Schiffer, 2000.

Owen, J. V. "On the Earliest Products (ca. 1751–1752) of the Worcester Porcelain Manufactory: Evidence from Sherds from the Warmstry House Site, England." *Historical Archaeology* 32, no. 4 (1998): 63–75.

Owen, J. V., and T. E. Day. "Eighteenth Century Phosphatic Porcelain: Bow & Lowestoft, Further Confirmation of Their Compositional Distinction." *English Ceramic Circle Transactions* 16, pt. 3 (1998): 342–44.

Owen, Nancy Elizabeth. *Rookwood and the Industry of Art: Women, Culture, and Commerce, 1880–1913*.

Athens, Ohio: Ohio University Press, 2000.

Page, Bob, Dale Frederiksen, Dean Six, and Jaime Robinson. *Franciscan: An American Dinnerware Tradition*. Greensboro, N.C.: Page/Frederiksen, 1999.

Panas, Timothy. "A Statistical Comparison of Spode/Copeland Ceramics Between Historic Métis and European Occupations in Central Alberta." M.A. thesis, Department of Anthropology, University of Montana, Missoula, 1999.

Panayotidis, E. Lisa. "The Sins of Wallpaper and Other Tasteful Transgressions: The Aesthetic Movement in England, 1860–85." In McLeod, *Wedgwood*, 157–77.

Pasquali, Jim, and Martha Sanford. *Sanford's Guide to Garden City Pottery: A Hidden Treasure of Northern California*. [Campbell, Calif.]: Adelmore, 1999.

Peakt, Tim H. "Brownfield Plate Designs." *Antiques & Collecting Magazine* (November 1998).

Pearce, Jacqueline. "A Rare Delftware Hebrew Plate and Associated Assemblage from an Excavation in Mitre Street, City of London." *Post-Medieval Archaeology* 32 (1998): 95–112.

———. "The Pottery Industry of the Surrey-Hampshire Borders in the 16th and 17th Centuries." In Egan and Michael, *Old and New Worlds*, 246–63.

Pegrum, Brenda. *Painted Ceramics: Colour and Imagery on Clay*. Marlborough, Wilts., England: Crowood, 1999.

Peña, Elizabeth S., and Jacqueline Denmon. "The Social Organization of a Boardinghouse: Archaeological Evidence from the Buffalo Waterfront." *Historical Archaeology* 34, no. 1 (2000): 79–96.

Pendergast, David M. "A Wedgwood Potato(e) Pasty: A Lesson from the Past." *Ars Ceramica* (1998/1999): 62–67.

Pendery, Steven R. "Portuguese Tin-Glazed Earthenware in Seventeenth-Century New England: A

Preliminary Study." *Historical Archaeology* 33, no. 4 (1999): 58–77.

Peters, Lynn. *Surface Decoration for Low-Fire Ceramics: Slips, Terra Sigillata, Underglazes, Glazes, Maiolica, Overglaze Enamels, and Decals*. Asheville, N.C.: Lark, 1999.

[Phillips International Auctioneers and Valuers]. *The Watney Collection*. Auction catalog, Phillips International Auctioneers and Valuers, September 22, 1999. London: Phillips International Auctioneers and Valuers, 1999.

Pine, Nicholas J. *Goss and Other Crested China*. Princes Risborough, Bucks., England: Shire, 1999.

Pomfret, Roger. "Tams, Anderson & Tams:—A Phantom Factory Revealed—As a Phantom." *Northern Ceramic Society Newsletter*, no. 112 (1998): 54–57.

———. "New Hall—The Enigma Variation." *Northern Ceramic Society Journal* 16 (1999): 23–29.

Potter, John. "The Limehouse Story." In Barker and Cole, *Digging for Early Porcelain*, 40–53.

[Potteries Museum & Art Gallery]. *Potteries Pots: The Best in the World, Ceramics at the Potteries Museum & Art Gallery, Stoke-on-Trent*. Norwich, England: Jarrold, 1999.

Potts, Keith. "Leon Potts—Designer and Modeller, Shorter & Son Ltd., Stoke on Trent." *Northern Ceramic Society Newsletter*, no. 114 (1999): 13–16.

Prescott-Walker, Robert. *Collecting Shelley Pottery*. London: Francis Joseph, 1999.

Priestman, Geoffrey. "Early Minton Blue and White Printed Table Wares." *Northern Ceramic Society Journal* 15 (1998): 55–78.

*Quimper Faïence*. Stonington, Conn.: Quimper Faïence, 1998.

Rader, John R. *Warwick China: The Company Built by People*. A Schiffer Book for Collectors. Atglen, Pa.: Schiffer, 2000.

Raeburn, Michael, Ludmila Voronokhina, and Andrew Nurnberg, eds. *Green Frog Service*. Wappingers

Falls, N.Y.: Antique Collectors' Club, 1998.

Rans, Jon, and Mark Eckelman. *Collector's Encyclopedia of Muncie Pottery: Identification & Values.* Paducah, Ky.: Collector Books, 1999.

Rasmussen, Margaret Byrd Adams. "A Crusade for Porcelain in America: The Mission of English Ceramist Charles Fergus Binns, 1897 to 1922." M.A. thesis, Department of History, University of Rochester (N.Y.), 1999.

Reckner, Paul E., and Stephen A. Brighton. "'Free from All Vicious Habits': Archaeological Perspectives on Class Conflict and the Rhetoric of Temperance." *Historical Archaeology* 33, no. 1 (1999): 63–86.

Redstone, David. "William Sanders' Mortlake Pottery." *English Ceramic Circle Transactions* 17, pt. 1 (1999): 79–85.

Reginster Le Clanche, Francoise. "Nevers: quatre siècles de faïence." *Connaissance des Arts* (June 1998): 86–93.

Reiss, Ray. *Red Wing Art Pottery Two: Including Pottery Made for Rum Rill.* Chicago: Property, 2000.

Richards, Sarah. *Eighteenth-Century Ceramics: Products for a Civilized Society.* New York: Saint Martin's, 1999.

Richey, Tina A. "Fulper Pottery." *Antiques & Collecting Magazine* (January 1999).

———. "Hedi Schoop Pottery." *Antiques & Collecting Magazine* (December 1999).

———. "Sascha Brastoff Pottery." *Antiques & Collecting Magazine* (May 2000).

Rickard, Jonathan. "'Descend We Now to Vases and Crockery Wares': Mocha and Related Utilitarian Slip Decorated Refined Earthenwares in Context." In McLeod and Boyle, *The Heritage of Wedgwood,* 229–49.

Roberts, Gaye Blake. "Chinoiserie to the Picturesque." In McLeod, *Wedgwood,* 63–83.

———. "Wedgwood & the Dutch Connection." In McLeod and

Boyle, *The Heritage of Wedgwood,* 53–78.

———. "Wedgwood and Neo-Classicism." In McLeod, *Wedgwood,* 84–109.

Roberts, Gaye Blake, Wedgwood Museum, and Friends of Blue. *True Blue: Transfer Printed Earthenware.* Exhibit catalog, British blue transfer-printed earthenware, to celebrate the 25th anniversary of the Friends of Blue, Wedgwood Museum, Barlaston, Stoke-on-Trent, Staffs., March 21–July 12, 1998. East Hagbourne, England: Friends of Blue, 1998.

Rock, Joe. "The 'A' Marked Porcelain: Further Evidence for the Scottish Option." *English Ceramic Circle Transactions* 17, pt. 1 (1999): 69–78.

Rondot, Bertrand, ed. Exhibit catalog, "Discovering the Secrets of Soft-Paste Porcelain at the Saint-Cloud Manufactory, ca. 1690–1766," Bard Graduate Center for Studies in the Decorative Arts, New York City, July 14–Oct. 24, 1999. New Haven, Conn.: Yale University Press, 1999.

Ross, Kurt C. "The Archaeology of 19th-Century Virginia Coarsewares." In *The Archaeology of 19th-Century Virginia,* edited by John H. Sprinkle, Jr., and Theodore R. Reinhart, 193–252. Archaeological Society of Virginia, Special Publication no. 36. Richmond, Va.: Archaeological Society of Virginia, 1999.

Ruffin, Frances, and John Ruffin. *Blue Ridge China Traditions.* A Schiffer Book for Collectors. Atglen, Pa.: Schiffer, 1999.

Runge, Robert C., Jr. *Collector's Encyclopedia of Stangl Dinnerware.* Paducah, Ky.: Collector Books, 2000.

Russell, Joseph Christian. "A Comparative Study of the Use of Colonoware Among Garrison Forces of the First Spanish Period Occupation of St. Augustine." M.A. thesis, Florida State University, 1999.

Sandon, John. "Harry Sheldon, 1915–1995." *Ars Ceramica* (1998/1999): 76–83.

Sargeant, Margaret. *Royal Crown Derby.* Princes Risborough, Bucks., England: Shire, 2000.

Scammell, Stephen W. *The History of the David William Scammell Family in America and Scammell's Lamberton China.* [U.S.A.: S. Scammell?], 1998.

Scarlett, Timothy J. "Narcissus's Mirror: Manufacture and Modernism in the American Great Basin—The Case of Pottery." *International Journal of Historical Archaeology* 3, no. 3: 167–75.

Schaefer, Richard G. *A Typology of Seventeenth-Century Dutch Ceramics and Its Implications for American Historical Archaeology.* BAR [British Archaeological Reports] International Series 702. Oxford: J. and E. Hedges, 1998.

Schiffer, Nancy N. *Japanese Porcelain, 1800–1950.* Exp. 2nd ed. A Schiffer Book for Collectors. Atglen, Pa.: Schiffer, 1999.

———. *Imari, Satsuma and Other Japanese Export Ceramics.* A Schiffer Book for Collectors. Atglen, Pa.: Schiffer, 2000.

———. *Japanese Export Ceramics, 1860–1920.* A Schiffer Book for Collectors. Atglen, Pa.: Schiffer, 2000.

Sekers, David. *The Potteries.* Princes Risborough, Bucks., England: Shire, 1998.

*Sèvres, 1756–1783: la conquête de la porcelaine dure, histoire inédite de la manufacture au XVIII-e siècle.* Dossier de l'art, no. 54. Dijon: Editions Faton, 1999.

Sibson, Florence. "History of the West Cumberland Potteries—Part One." *Northern Ceramic Society Newsletter,* no. 111 (1998): 20–27.

———. "History of the West Cumberland Potteries—Part 2." *Northern Ceramic Society Newsletter,* no. 112 (1998): 8–12.

———. "The History of the West Cumberland Potteries." *Northern Ceramic Society Newsletter,* no. 115 (1999): 21–22.

———. "History of the West Cumberland Potteries—Part 3." *Northern*

*Ceramic Society Newsletter*, no. 118 (2000): 21–24.

Simpson, Richard V. "John D. Larkin's Buffalo Pottery Deldare Ware." *Antiques & Collecting Magazine* (February 1999).

———. "Rookwood Pottery." *Antiques & Collecting Magazine* (September 1999).

[Sioux City Art Center]. *Suited to a Tea.* Exhibit catalog, Sioux City Art Center. Sioux City, Iowa: Sioux City Art Center, 1999.

Smith, L. Richard. *Josiah Wedgwood's Slave Medallion.* Rev. 2nd ed. Sidney: Wedgwood Society of New South Wales, 1999.

Smith, Richard Coleman. "A Review of the Donyatt Potteries, Somerset, and an Interim Report of Their Products Recorded in Colonies in Virginia and Maryland." In Egan and Michael, *Old and New Worlds,* 269–77.

Smith, Timothy J. *Universal Dinnerware and Its Predecessors* [Cambridge Art Pottery, The Guernsey Earthenware Co., The Oxford Pottery Co., The Atlas-Globe China Co.]. A Schiffer Book for Collectors. Atglen, Pa.: Schiffer, 2000.

Snyder, Jeffrey B. *Depression Pottery.* A Schiffer Book for Collectors. Atglen, Pa.: Schiffer, 1999.

———. *McCoy Pottery.* A Schiffer Book for Collectors. Atglen, Pa.: Schiffer, 1999.

———. *Beautiful Bauer: A Pictorial Study with Prices.* A Schiffer Book for Collectors. Atglen, Pa.: Schiffer, 2000.

———. *Fiesta: Homer Laughlin China Company's Colorful Dinnerware.* Rev. and exp. 3rd ed. A Schiffer Book for Collectors. Atglen, Pa.: Schiffer, 2000.

———. *Flow Blue: A Closer Look.* A Schiffer Book for Collectors. Atglen, Pa.: Schiffer, 2000.

———. *Historical Staffordshire: American Patriots & Views.* Rev. and exp. 2nd ed. A Schiffer Book for Collectors. Atglen, Pa.: Schiffer, 2000.

———. *Hull Pottery: Decades of Design.* A Schiffer Book for Collectors. Atglen, Pa.: Schiffer, 2000.

———. *A Pocket Guide to Flow Blue.* Rev. and exp. 2nd ed. A Schiffer Book for Collectors. Atglen, Pa.: Schiffer, 2000.

South, Stanley. "Excavating the Pottery of John Bartlam: America's First Creamware Potter." In Egan and Michael, *Old and New Worlds,* 289–98.

———. *Historical Archaeology in Wachovia: Excavating Eighteenth-Century Bethabara and Moravian Pottery.* Norwell, Mass.: Kluwer-Academic, 1999.

Spain, David H. *Collecting Noritake, A to Z: Art Deco & More, A Pictorial Record and Guide to Values.* A Schiffer Book for Collectors. Atglen, Pa.: Schiffer, 1999.

Staniforth, M. *Chinese Export Porcelain from the Wreck of the Sydney Cove (1797).* Australian Institute of Maritime Archaeology, Special Publication no. 12. Adelaide, S. Aust.: Brolga Press for the Australian Institute for Maritime Archaeology, 1998.

Steen, Carl. "Pottery, Intercolonial Trade, and Revolution: Domestic Earthenwares and the Development of an American Social Identity." *Historical Archaeology* 33, no. 3 (1999): 62–72.

Stephenson, Roy. "Tin Glazed Ware in London: A Review." In Egan and Michael, *Old and New Worlds,* 264–68.

Stevenson, Greg. *Art Deco Ceramics.* Princes Risborough, Bucks., England: Shire, 1998.

Stovin, Peter. "19th Century Cambridge College Ceramics and a Comparison with Oxford Colleges." *Northern Ceramic Society Journal* 16 (1999): 51–75.

Swaab, Shirley S. "The Art of Identification." In McLeod, *Wedgwood,* 48–62.

Tait, Hugh. "Nicholas Sprimont at Chelsea, His Apprentice William Brown, and the 'Anchor-and-Dagger' Mark." *Ars Ceramica* (1998/1999): 24–33.

Thiel, J. Homer. *Phoenix's Hidden History: Archaeological Investigations at Blocks 72 and 73.* Center for Desert Archaeology, Anthropological Papers, no. 26. Tucson, Ariz.: Center for Desert Archaeology, 1998.

Thornton, David. "The Bow Factory Site and Its Environs: A Reexamination." *English Ceramic Circle Transactions* 16, pt. 3 (1998): 269–79.

Travis, Nora. *Evolution of Haviland China Design.* A Schiffer Book for Collectors. Atglen, Pa.: Schiffer, 2000.

Treadway Gallery. *Rookwood.* Auction catalog, Museum Center at Union Terminal, Cincinnati, June 3, 2000. Cincinnati, Ohio: Treadway Gallery, 2000.

Treadway Gallery and John Toomey Gallery. *The Arts & Crafts Price Guide: Ceramics; Newcomb, Grueby, Van Briggle, Marblehead, Rookwood, Teco, Fulper, Assorted Ceramics; A Decade of Auction Results, 1987–1997.* Auction catalog. Cincinnati, Ohio: Treadway Gallery, 1998.

Tyler, Kieron. "The Production of Tin-Glazed Ware on the North Bank of the Thames: Excavations at the Site of the Hermitage Pothouse, Wapping." *Post-Medieval Archaeology* 33 (1999): 127–63.

Vedrenne, Elisabeth. "L'atelier du bleu à Sevres." *L'Oeil* (Lausanne, Switzerland), no. 496 (May 1998): 54–61.

Venable, Charles L., Ellen P. Denker, Katherine C. Grier, and Stephen G. Harrison. *China and Glass in America, 1880–1980: From Tabletop to TV Tray.* Dallas: Dallas Museum of Art, 2000.

Victoria and Albert Museum and Anthony Ray. *Spanish Pottery 1248–1898: With a Catalogue of the Collection in the Victoria and Albert Museum.* London: V&A, 2000.

Vincentelli, Moira. *Women and Ceramics: Gendered Vessels.* Studies in Design and Material Culture.

Manchester, England: Manchester University Press, 2000.

Waggoner, Jason S. "Three Out of Many: Prominent Potteries of East Liverpool, Ohio, 1840–1999." M.A. thesis, Kent State University (Ohio), 1999.

Walford, Tom. "Creamware and Saltglaze Sherds from Nottingham Road Derby—with Acknowledgments to William Greatbatch." *English Ceramic Circle Transactions* 17, pt. 1 (1999): 115–20.

Wall, Diana DiZerega. "Examining Gender, Class, and Ethnicity in Nineteenth-Century New York City." *Historical Archaeology* 33, no. 1 (1999): 102–17.

Ward, Betty, and Nancy Schiffer. *Weller, Roseville, and Related Zanesville Art Pottery and Tiles.* A Schiffer Book for Collectors. Atglen, Pa.: Schiffer, 2000.

Watson, Pat, and Howard Watson. *Collecting Art Deco Ceramics.* 2nd ed. London: Francis Joseph, 1998.

Watts, Andrew. "The Archbishop of Canterbury and Lambeth Stoneware Potteries." *English Ceramic Circle Transactions* 17, pt. 1 (1999): 15–28.

Watts, Vera B. "Highlights From the Delhom Collection." In McLeod and Boyle, *The Heritage of Wedgwood,* 250–71.

Wedgwood, Martin. "A Wedgwood Family Collection." In McLeod and Boyle, *The Heritage of Wedgwood,* 272–82.

Welsh, Jo Anne P. *Chintz Ceramics.* Rev. and exp. 3rd ed. Atglen, Pa.: Schiffer, 2000.

White, Carole Bess. *The Collector's Guide to Made in Japan Ceramics: Identification & Values.* Book 3. Paducah, Ky.: Collector Books, 1998.

Wienczkowski, Lisa M. "Jens Jensen and the Creative Realm Beyond Rookwood: The Transition from Pottery Decoration to Painting." M.A. thesis, Art History Department, University of Cincinnati (Ohio), 1998.

Williams, Laurence W. *Collector's Guide to Souvenir China: Keepsakes of a Golden Era, Identification and Values.* Paducah, Ky.: Collector Books, 1998.

Williams, Peter, and Pat Halfpenny. *A Passion for Pottery: Further Selections from the Henry H. Weldon Collection.* London: Sotheby's, 2000.

Williams, Petra, and Marguerite R. Weber. *Staffordshire III: Romantic Transfer Patterns: Cup Plates and Early Victorian China.* Jeffersontown, Ky.: Fountain House East, 1998.

Wills, Geoffrey. *Wedgwood.* Upland, Pa.: DIANE, 1998.

Wyman, Colin. "A Review of Early Transfer Printing Techniques."

*English Ceramic Circle Transactions* 16, pt. 3 (1998): 307–16.

Yamin, Rebecca. "Lurid Tales and Homely Stories of New York's Notorious Five Points." *Historical Archaeology* 32, no. 1 (1998): 74–85.

Yates-Owen, Eric, and Robert L. Fournier. *British Studio Potters' Marks.* London: A. & C. Black, 1999.

Yeh, P'ei-lan. *Porcelains with Cloisonné Enamel Decoration and Famille Rose Decoration.* Beijing: Commercial Press, 1999.

Young, Hilary. *English Porcelain: 1745–1795, Its Makers, Design, Marketing & Consumption.* London: V&A, 1999.

———. "Evidence for Wood and Coal Firing and the Design of Kilns in the 18th Century English Porcelain Industry." *English Ceramic Circle Transactions* 17, pt. 1 (1999): 1–14.

———. "Manufacturing Outside the Capital: The British Porcelain Factories, Their Sales Networks and Their Artists, 1745–1795." *Journal of Design History* 12, no. 3 (1999): 257–69.

Zierden, Martha. "A Trans-Atlantic Merchant's House in Charleston: Archaeological Exploration of Refinement and Subsistence in an Urban Setting." *Historical Archaeology* 33, no. 3 (1999): 73–87.

# Index

Copeland period of Spode factory, 87, 88(fig. 14)

Copper luster, 260

Copper oxide glaze, 122, 220

Copper plates, Staffordshire-made, 83

Costrels: Martincamp, 56, 58(&figs. 15&16); northern Italian, 59

Courtenay, Thomas, 180

Cox, Alwyn, 121

Cox, Angela, 121

Coysh, 254

Crafts, Thomas, 130

Cramer, Zadok, 164

Cream-colored ware, 187. *See also* Creamware; *see under* Earthenware

Cream jugs: China glaze, 147(fig. 20), 148(fig. 21); creamware, 148(fig. 21); salt-glazed stoneware, 188–189, 195(fig. 11)

Cream risers, 231

Creamware, 76–77; archaeological excavation of, 80(fig. 6); basket and stand, 207(fig. 39); vs. China glaze, 154, 156; coffee pot, 41(fig. 23); collecting, 197; cream jugs, 148(fig. 21); dishes, 152(fig. 26), 205(fig. 35); jugs, 35(fig. 9), 119(fig. 6); Leeds factory and, 74; Lewis Pottery rim sherds, 177(fig. 20); marbled slip on, 117; mugs, 117(fig. 3), 138(fig. 4); plates, 137(fig. 2), 152(fig. 26), 155(fig. 28); price-fixing agreement for, 145; punch bowls, 139(fig. 6), 149(fig. 22); reverse of plate, 8(fig. 11), 9; spill vase, 140(fig. 9); success of, 140, 147; teapot fragment, 80(fig. 7); teapots, 41(fig. 21), 45(fig. 29), 204(fig. 34); tureen, 40(fig. 20); water bottle and basin, 120(fig. 9); William Greatbatch tea canister, 84(fig. 8). *See also* China glaze; Pearlware

Crossman, Carl, 237–238

Crown cam, 116

Cuban trade, in Staffordshire ceramics, 91

Cucurbits, 49(fig. 4)

Cultural significance, of ceramics, 29–46

Cumbria, 77

Cupid Holding a Tazza to a Swan pattern, 233(&fig. 1)

Cups: China glaze, 150(fig. 24); Lewis pottery, 179(fig. 24); slip-ware, 98, 103(fig. 10), 111(fig. 28), 191(fig. 5), 206(fig. 37); slipware tyg, 42(fig. 24); three-handled earthenware, 188(fig. 1); two-handled slipware, 75(fig. 3), 115(fig. 1); whiteware, 87(fig. 13)

Curators, role of, 9

Curiosity cabinets, 52

Dating, rules for nineteenth-century English pottery, 260

Dave, an African-American potter, 250–252

Davenport, Bodley & Sons, 91

Davenport, Hicks & Meigh, 259

Decanters, Frechen stoneware, 68(fig. 33), 69

Decoration: analysis of, 34; blue-printed patterns, 141, 147, 233(&fig. 1), 235; cat's eye, 126(&fig. 20), 127–130(figs.); of cheaper Staffordshire wares, 87; China glaze and, 154, 156; cole slaw, 121; influence of Chinese style on, 117, 157–158, 213; of northern Italian ceramics, 61–64; styles of, 38–39; transfer-print, 205(fig. 35); under-glaze, 169(fig. 7). *See also* Cobalt; Mocha decoration; Slip decoration

Decorative formula, 34

Decorative motifs/patterns: Adam and Eve, 246; American scenery and events, 167; Broseley, 78, 253; Buddleia, 253; Buffalo, 253; Bungalow, 253; cable, 128(&fig. 28), 130(fig. 31); Canova, 129; Canton, 158(fig. 31); card motif, 198(fig. 15); checkerboards, 241; Chinese house pattern, 137(fig. 2); Common Cable, 180(fig. 25); Cupid Holding a Tazza to a Swan, 233(&fig. 1); Eagle, 87(fig. 13); English Cities, 233; in English slipware, 100(fig. 5); European Scenery, 233, 234(fig. 3); figurative, 61–62(&fig. 24); fishscale triangles, 241; Fitzhugh, 253; fleurs-de-lis, 241; floral reliefs, 241; Florentine Villas, 222(fig. 1), 223; Forest Landscape, 253; Fountain, 233; incised multilobed flowers, 241(&fig. 6); La Fayette at the Tomb of Franklin, 233; land-scape, 253–254; Long Bridge, 253; majolica, 213; Mandarin, 253; Manilla, 86(fig. 10); mythological, 65; oakleaf, 246; Oberwessel on the Rhine, 233; Pagoda, 233; Park Scenery, 129; political, 65–70(&figs.); Rock, 253; rouletted "penny" medallions, 241; Royal, 89, 91(&fig. 20), 246; Seven Electors, 65–68(&figs. 28&30); Sicilian, 233(fig. 1); Trophies, 253; tulip, 246; twig, 128, 129(figs. 29&30); Two Temples, 253; used by Enoch Wood and Sons, 233; Venetian Scenery, 233; Washington Vase, 86(figs. 11&12); watch spring, 241; willow, 78, 252–255

Decorators, 97, 137–145

*Defense,* 153

Delft painters: cobalt blue and, 138–139; vs. slipware potters, 97

Delftfield Pottery (Glasgow), 92(n11)

Delftware, 76, 164, 187, 245–247; bowl, 206(fig. 38); chimney vase, 201(fig. 23); collecting, 189, 196; decline of, 138(&table 1); dishes, 190(fig. 3), 192(fig. 6), 196(fig. 13); English, 7(fig. 9); figural salt, 218–220(&figs.); hand warmer, 189(fig. 2); kilns, 248; plates, 193(fig. 7), 197(fig. 14), 198(fig. 15), 203(fig. 29), 206(fig. 36); sugar basin and cover, 194(fig. 9); wall tiles, 202(fig. 24), 204(fig. 33); water bottle, 202(fig. 25). *See also* Faience; Majolica; Tin-glazed earthenware

D'Entrecolles, Pere, 135, 147

Derbyshire, creamware teapot, 45(fig. 29)

des Fontaines, 254

Design motifs, Raeren stoneware, 65–68(&figs.)

*Dessert de Gaufreetes, Le* (Baugin), 57(fig. 14)

Dicing, 115

Dipped fan, 130–131(&figs.)

Dipped glazes, 248

Dipped wares, 115–119; most common form, 121. *See also* Mocha decoration; Mochaware; Slip decoration

Dishes: blue-painted majolica, 213(fig. 2); China glaze, 151(fig. 25), 152(fig. 26), 158(fig. 32); creamware, 152(fig. 26), 205(fig. 35); delftware, 190(fig. 3), 192(fig. 6), 196(fig. 13); double, 215–217(&figs.); hard-paste porcelain, 51(fig. 6); James and

33(fig. 7), 177(fig. 19). *See* China glaze

"Pearlware: Forgotten Milestone of English Ceramic History" (Hume), 148

Pennington, James, 256

Pennisi, Licio, 178(fig. 22)

Pennsylvania German potters, 251

Persian colors, 87

Peruvian stirrup vessel, 31(fig. 5)

Petuntse, 135–136

Phillips, George, 91

Phillips and Bagster, 82–83

Phillips & Company, G., 129

Philpot, Rob, 256

Piccolpasso, 248

Pipes, tobacco, 182(fig. 32), 183(&fig. 33)

Pipkin: lead-glazed earthenware, 13(fig. 21); salt-glazed stoneware, 241(fig. 4)

Pisanware, 59–64(&figs.)

Pitchers: Frost & Vodrey whiteware, 166(fig. 3), 167(figs.); William Wotton, 25(n2)

Pittsburgh, eighteenth-century ceramic production in, 164

Pittsburg Pottery, advertisement for, 181(fig. 27)

*Plan of the City of Louisville And its environs in 1831*, 171(fig. 11), 173(figs.)

Plaque, Jabez and Sarah Vodrey whiteware, 170(figs.)

Plaster molds, 30

Plates: biscuit, 228(fig. 4); China glaze, 136(fig. 1), 152(fig. 26), 154(fig. 27), 155(fig. 28), 156(fig. 29); cream-colored earthenware, 203(fig. 28); creamware, 9(fig. 11), 9, 137(fig. 2), 152(fig. 26), 155(fig. 28); delftware, 193(fig. 7), 197(fig. 14), 198(fig. 15), 203(fig. 29), 206(fig. 36); pearlware, 33(fig. 7), 177(fig. 19); polychrome-printed earthenware, 234(fig. 2); salt-glazed stoneware, 203(fig. 30); slipware, 98; white earthenware, 234(fig. 3); whiteware, 79(fig. 4), 86(fig. 11), 169(fig. 7)

Platter, 40; decoration of, 38–39

Plot, Robert, 95, 97

PMSRY. *See* Post-Medieval Slipped Redware Yellow

Podmore, Walker & Company,

86–87(&figs.); cat's eye and cable decoration, 128, 130(fig. 31); white-ware plate, 86(fig. 11)

Poetry, on pots, 250–252

Political imagery, on ceramics, 65–70(&figs.)

Polychrome colors, 149(fig. 22)

Polychrome enameling, 257

Polychrome-painted China glaze, 141(fig. 11)

Porcelain: Chinese export, 17, 18(fig. 27), 21; John Dwight's experiments with, 247, 248; quest for Chinese-style in England, 135–137. *See also* Hard-paste porcelain; Soft-paste porcelain

Porcelain insulators, 226

Porcelaine de terre, 81, 91

Porcelaine opaque, 81

Porphyry, 118

Port Royal (Jamaica), 75(fig. 2)

Portland vase, 31(fig. 5)

Portugal: as conduit for Chinese porcelain, 52; as source of ceramics found in Jamestown, 47

Portuguese tin-glazed wares, 53–55(&figs.)

Posset pot, 84; tin-glazed earthen-ware, 8(fig. 10), 9

Post-Medieval Slipped Redware Yellow (PMSRY), 216, 217(n7)

Pots, Martincamp, 56

Potsherds. *See* Sherds

Potteries Museum & Art Gallery, 85, 91

Potters: eighteenth-century migration of, 77; migration of from Stafford-shire to United States, 82

Potters Manufacturers Association, 145

*Pottery References in the Staffordshire Advertiser, 1795–1865* (Hampson), 266, 271

Poultry fountains, 231

Powers, of ceramics, 30

Prentice, George D., 172

Press-molded dish: delftware, 190(fig. 3); Staffordshire slipware, 105(fig. 14)

Press-molded foliate terminals, 117(fig. 3)

Press-molded handle, 132(fig. 35)

Press-molding, 187, 188; at Lewis Pottery, 168(fig. 6)

Price, William, 164, 166(fig. 3), 167

Price-cutting, in Staffordshire, 144–145

Price-fixing agreement, 144

Price-fixing lists, 83, 148

Price list, Vodrey Pottery, 165(fig. 2)

Private ceramic collections, 4–6(&figs.)

Protestant Union, 66–67

Provenance, 191, 193, 195; collecting and, 207, 262–263; figural salt, 219

Public ceramic collections, 4–6(&figs.)

Punch bowls, 42, 246; China glaze, 139(fig. 6), 149(figs.); creamware, 139(fig. 6), 149(fig. 22); unglazed stoneware, 236–238(&figs.)

Puzzle jugs, 42, 220

Queen Charlotte, 156

Queen's Ware. *See* Queensware

Queensware, in Louisville, 163–185(&figs.). *See also* Frost & Vodrey; Lewis Pottery Company; Vodrey, Jabez

Rabbit figure, Lewis Pottery, 168(fig. 6)

Raeren stoneware, 64–68(&figs.)

Railroad china, 259

Ranney, Willis, 176

*Reader's Digest*, 22

Rebekah at the Well teapot, 228

Recipes, mocha solution, 125(&fig. 19)

*Recueil d'Antiquitiés egyptiennes, etrusques, grecques et romaines* (Caylus), 33(fig. 6), 46(n7)

Red earthenware, 76

Red stoneware, 249

Redware, 34, 187; double dish, 216(&fig. 2); tobacco pipes, 182(fig. 32), 183(&fig. 33); white-slipped, 216, 217(n7)

Registration mark, 260–261

Reid, William, catalogue of, 255–258

Reilly, Robin, 153

Relief decoration, 31(fig. 5); on stoneware, 64–68(&figs.)

Repairs, 14–18, 26(n15); collecting and, 204; evidence of, 34

Richards, William, 239–243

Rickard, Jonathan, xiii

Ridgway & Company, 179(fig. 24), 259

Ridgway patterns, 225(n2)

Ritual use, of ceramics, 34, 36–37

Roberts, Letitia, 262

Rock pattern, 253